HAUNTED BY HISTORY

SEPARATING THE FACTS AND LEGENDS OF EIGHT HISTORIC HOTELS AND INNS IN SOUTHERN CALIFORNIA

VOLUME 1

CRAIG OWENS

A PUBLICATION OF BIZARRE LOS ANGELES
SAD HILL LLC

HAUNTED BY HISTORY:

Separating the Facts and Legends of Eight Historic Hotels and Inns in Southern California

ISBN 978-0-9976881-0-8
Copyright © 2017 by Sad Hill LLC
Contemporary Photographs © 2017 by Craig Owens

Sad Hill LLC
340 S. Lemon Ave., #7234
Walnut, CA 91789
www.bizarrela.com

Printed in China
First Printing, 2017
Cover design, book design, and production by Sherry Wachter.

Although the author and publisher have made every effort to ensure that the information in this book was correct at press time, the author and publisher do not assume, and hereby disclaim, any liability to any party for any loss, damage, or disruption caused by errors or omissions, whether such errors or omissions result from negligence, accident, or any other cause.

1 2 3 4 5 6 7 8 9

*For All
Who Ever Wanted
to Time Travel.*

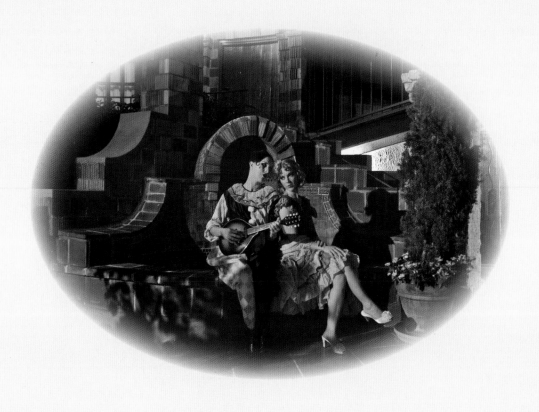

A fantasy at the Mission Inn.
PHOTOGRAPHER: CRAIG OWENS

ACKNOWLEDGMENTS

I would like to thank the following people who made this book possible.

HISTORIANS/ARCHIVISTS: Mitch Stone, Craig Held, David Lewis, Jeanne Orcutt, Charles Nelson Johnson, Maurice Hodgen, and Cynthia Thompson. Thanks also to the Blanchard Library in Santa Paula, the Museum of Ventura County, Authentic Entertainment, and the Julian Pioneer Museum for their support.

A SPECIAL THANKS TO HOTEL OWNERS: Rosanna and Tom Jennett, Nona and Richard Bogatch, and Steve Ballinger and family. Thanks also goes to Dustin Aremburg (general manager of the Glen Tavern Inn), Sara Hermansson (Alexandria Ballrooms), and Kate Panzer (former manager of the Banning House Lodge). Thanks again to the owners, managers, and staffs at the Mission Inn, Hotel del Coronado, and the Wyndham Garden Pierpont Inn. May all of these businesses enjoy many years of success in providing happy memories for all guests. I'd also like to acknowledge the vendors who contributed to the book: Thank you, Shon LeBlanc (The Costume House in North Hollywood), Will Britten, Bobbi Constantine (Western Costumes), Nicole Loretta (Paper Moon Vintage), and Daniel Schwartz (Sports & Movie Stuff).

SPECIAL THANKS TO MY FAMILY: Jamison Tucker (my brother); Cynthia Tucker (my mom); Lena Owens (my wife); Katya, Liza, and Michael Owens (my children); and F.H. Tubb (my father). Special thanks to my late grandparents, H.C. and Mary Tucker, who gave me more than 40 years of unconditional love. I love you all. Don't you ever forget it.

THANKS ALSO TO MY FRIENDS AND CO-WORKERS. Patrick Cronen, who came up with the name for this book. Barbara Ardinger, PhD., my primary editor, for reading an onslaught of chapter drafts. Sherry Wachter, for her design skills. I'd also like to thank Johanna Serrano, Peter Borosh, Ginger Pauley, Renee Paulette, and Melinda Mauskemo for going beyond the call of duty on these photo shoots. All of you were real problem solvers. I also have to thank editors Maureen R. Michelson, Brenda Salamone, and Sue Jorgenson for their editing and proofreading skills in making this book as good as I know how to make it.

THANK YOU, BILL AND SHANNON JERALDS, for your wonderful handcrafted angels, your friendship, and your willingness to share your paranormal experiences. Thanks to Alexis Justman, and others for also sharing their paranormal stories and insights with me.

THANKS TO THE FOLLOWING BETA READERS for providing valuable feedback in the early stages of book building: Cathie Driscoll-Curtis, Jarrod McCormick, Ryan Hopkins, Susan Logan, and Delfina Hallett.

Lastly, thanks to all of you who follow Bizarre Los Angeles on Facebook, Twitter, Instagram, and other social media sites. I'm grateful to you all.

INTRODUCTION

"When people die, is it true that they touch the sky?"
MICHAEL OWENS
MY FOUR-YEAR-OLD SON

I have always believed in ghosts. I must admit, however, that I am a reluctant believer. My fascination with the paranormal can best be traced back to 1971, when I was a boy of six living with my parents at an Air Force base in Columbus, Mississippi. My mother had become friends with Robert and Donna Snow, who had bought and restored the Waverley Plantation (spelled Waverly back then), an Antebellum mansion located outside the town of West Point, Mississippi. When the Snows first acquired the mansion and its grounds in 1962, it was badly dilapidated, and to help pay for the restoration, they conducted tours and operated an antiques store.

The Snows were convinced that their home was haunted by a young girl who called out "Momma!" from one of the upstairs bedrooms. Donna had also seen the ghost girl standing near the stairs outside the room, and she and Robert had both witnessed mysterious indentations on the bed in that room.

Because I had become friends with the Snows' youngest son, Gage, I spent quite a lot of time on the property and even stayed the entire night in the house once or twice.

But I have no memory of meeting the ghost girl.

In fact, I didn't have my first ghost experience until I was 20 years-old and living in Odessa, Texas. But I didn't recognize it for what it was. At that time, I was enrolled at Odessa City College and working the graveyard shift at a local television station. I had just moved into a furnished, cone-shaped, Japanese Mid-Century Modern, efficiency apartment on the west side of town to be closer to my grandparents.

My thoughts in those days were on leaving Odessa, not on ghosts. However, one late afternoon when I was eating alone at the kitchen counter, I felt a tapping on my shoulder. I turned around to see who it was. No one was there. Months later, I felt

a sudden blast of hot air on the back of my neck as I made my bed. While these two incidents temporarily spooked me, I rationalized them away by telling myself that I was tired and my imagination was playing tricks on me.

My rationalization turned out to be wrong. A year later, after I had moved out of the apartment, I was introduced to the person who had moved in after me. The new tenant immediately asked me if the place was haunted. When I said no, he told me that he had felt a strange tapping on his shoulder in the kitchen, and a sudden blast of hot air on the back of his neck as he stood over the bed. I was stunned to hear this, so I told him that I, too, had experienced those things. I also told him that right after I had moved into the efficiency, I would come home from work to find a ceramic mouse lying on the floor four to six feet away from where I had placed it. I never understood why (or how) the mouse fell so far from its perch night after night, but the behavior stopped after a week, and I forgot about it.

I also told him that many months into my residency, I heard my clock radio suddenly change stations on its own. While this spooked me, I still refused to believe that the apartment was haunted. However, the new tenant that I told this to thought otherwise. After our conversation, he gave a 30-day notice and moved out. The unit then became a storage space, and to the best of my knowledge, it hasn't been rented as an apartment ever since.

For the next ten or so years, I had no ghostly experiences. After leaving Odessa, I earned a communications degree from Southern Methodist University in Dallas, Texas. In 1994, I moved to Los Angeles to find work in the entertainment industry.

Los Angeles had everything I loved, including an amazing history and many old buildings. I explored the city, looking for landmarks that I had heard about all my life. My fascination with Old Hollywood buildings soon led me to become a preservationist. I even made up my mind to live in structures built before 1935.

I also became interested in the city's ghost lore, even though I struggled to believe many of the ghost stories I had heard. Then something spooky happened to me while I was working as a script production assistant on a sitcom at the Warner Bros. lot in Burbank in 1999.

On Halloween night, the sitcom's cast and crew left early, and I was called to the studio to photocopy revised scripts in the middle of the afternoon. Four hours later, as the sun was beginning to set, I entered one of the darkened old soundstages and flipped on the overhead work lights so I could deliver a handful of revised scripts. After climbing the wooden stairs that led up to a few tiny offices, I began to hear the faint sounds of a woman reciting something unintelligible somewhere below in the

stage area. At first, I thought it was a Halloween prank or a radio left on after hours, so I stood at the railing and listened for 20 minutes as the woman's voice faded in and out. During this time, it became fairly obvious to me that I wasn't hearing a radio, television, or walkie-talkie because there were no blips, static, squawks, commercial breaks, or station identifications. The overhead work lights also behaved strangely while I was there. Half of the lights didn't turn on like they were supposed to, while those that did, flickered erratically.

At last, as I descended the stairs, the soundstage grew silent. I walked around the stage, looking for someone or something that might have been responsible for the voice I'd heard. I couldn't find anything.

The lights continued to strangely flicker as I walked toward the stage exit. I then heard the distinct sound of high heels and swishing fabric about 20 feet behind me. I stopped and spun around. No one was there! I noticed, however, that the footsteps had stopped about half a second after mine had stopped, which I thought was odd. When I started walking again, the phantom footsteps and swishing skirt returned, only this time the sounds were closer to me. I turned around again and saw nothing. I then hurried to the stage door, flipped off the lights, and exited the building. Still thinking it could have been a Halloween trick, I waited outside for 15 minutes so I could catch the prankster as he came through the door from the darkened soundstage. No one ever came out.

In 2005, I went to work for the International Cinematographers Guild (IATSE Local 600), which inspired me to return to photography, which I had studied at SMU. I left the guild in 2009 to pursue my own creative projects. It was a gutsy decision, but I had written a screenplay about the fall of a fictional silent film star in the late 1920s and wanted to build a promotional website that would evoke that period. For the website, I chose to shoot vintage style photos at the Mission Inn in Riverside and the Pierpont Inn in Ventura because I felt that both hotels evoked the right era. After witnessing paranormal activity at both hotels, I became more interested in ghosts than in marketing my screenplay.

In 2011, I decided to embark on an ambitious book project that focuses on Southern California's haunted hotels. But I didn't want it to be a typical ghost book. I wanted it to offer a detailed history filled with historical images as well as those taken by me in the most haunted sections of each hotel.

My photo shoots became a group effort, and I was fortunate enough to work with many talented models and actors. During our visits to these haunted hotels, many odd things happened that made us believe that many of these locations were indeed

haunted. A few of us even stayed up all night testing for Electronic Voice Phenomena (EVPs) using high quality audio recorders to see if our vintage themed shoots were somehow stirring up paranormal activity. We weren't trying to be scientific in our paranormal investigations, nor were we out to prove that ghosts exist. We were, however, checking to see if each of the hotel's paranormal claims had merit.

I then spent the next few years researching the history of each location.

As the book project neared completion, I met with Patrick Cronen, who participated at the Mission Inn photo shoot. During our visit, we talked about the process of researching haunted places and how I had become more interested in the location's real history than its ghosts. Patrick magically summed up our discussion by saying that what I was really trying to find out was if these hotels were "haunted by history." Because I loved his turn of phrase, *Haunted by History* became the title of the book.

I sincerely hope this book inspires you to explore these historic hotels and inns with a new perspective. And if you have a ghost story or a piece of historical information to share, please feel free to contact me. I'd love to hear from you.

—CRAIG OWENS
JANUARY 2017

Vamping it up at the Pierpont Inn.

THE HOTELS

SOUTHERN CALIFORNIA

Santa
Barbara

VICTORIAN ROSE
BED & BREAKFAST

THE GLEN TAVERN INN

THE WYNDAM
GARDEN
PIERPONT INN

Ventura

Santa Paula

THE ALEXANDRIA HOTEL

Los Angeles

THE MISSION INN

Riverside

BANNING HOUSE LODGE

Catalina

Julian

THE JULIAN
GOLD RUSH HOTEL

San Diego

Coronado
Peninsula

HOTEL
DEL CORONADO

CONTENTS

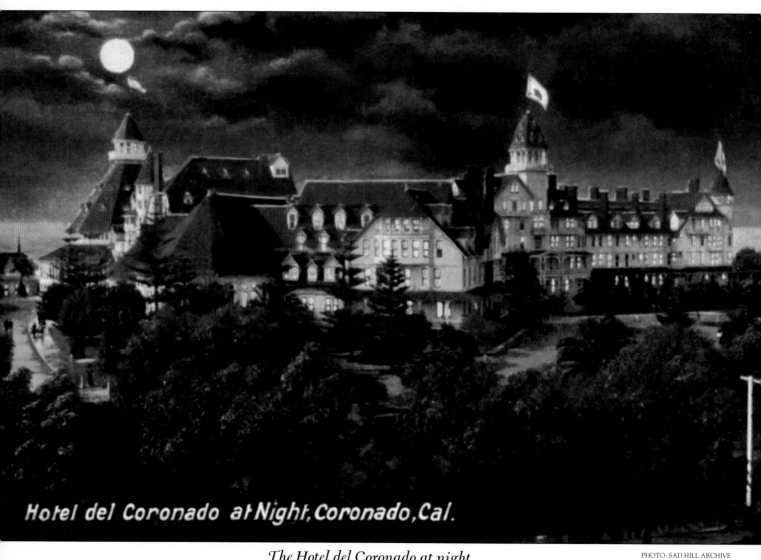

Hotel del Coronado at Night, Coronado, Cal.

The Hotel del Coronado at night

1

THE HOTEL DEL CORONADO
1500 Orange Avenue, Coronado, CA 92118

The Coronado Peninsula, a four-mile-long strip of land located a little over a mile off the coast of San Diego, had an inconspicuous history prior to 1886. Archaeologists and scholars believe that Native Americans used the land for fishing and gathering shellfish, and later, European whale hunters used it as a campsite. In 1846, Alta California Governor Pío Pico gave the peninsula, titled the Peninsula de San Diego Rancho, as a land grant to San Diego mayor Don Pedro C. Carillo. It then was used to raise cattle, but the sparse terrain and lack of fresh water made it difficult for livestock to survive. Three years later, Carillo sold the rancho for $1,000 to an American named Captain Bezer Simmons, who then sold parts of the peninsula to speculators. The land continued changing hands until 1877, when the entire peninsula, now called the Island of San Diego, was foreclosed and purchased by Colonel George W. Grannis for $116, 377.[1]

In 1884, Elisha Spurr Babcock Jr., a 36-year-old former railroad promoter and civil engineer, arrived in San Diego from Evanston, Indiana, for a vacation with his wife, Isabel, and two children, Graham and Alfred. They hoped the California sunshine and ocean air would help Elisha recover from symptoms that might develop into tuberculosis. After his health improved, the Babcocks briefly returned to Indiana in 1885 to pack before permanently moving to San Diego.

In 1885, when the first railroads arrived, land speculators predicted that San Diego, one of the oldest villages in Southern California, would soon develop into a major American city. The town's population had already grown from approximately 2,900 residents in 1880 to around 3,500 in 1884.[2] But San Diego was ill equipped to handle so many new arrivals. It needed electricity, adequate public transportation, a modern seaport, and a larger supply of fresh water for citrus farming. After the San

Diego Water Company could no longer meet rising demands, city officials awarded a new contract to the Flume Company to build an elaborate trestle system to pump fresh water from a distant mountain reservoir into San Diego, a project that would take four years to complete.

Elisha S. Babcock, circa 1900.

PHOTO: SAN DIEGO HISTORICAL SOCIETY

Babcock, meanwhile, had formed a friendship with another recent arrival, Hampton L. Story, who had retired from the Story & Clark Piano Company in Chicago. Together, they hunted and fished twice a week for sport, occasionally rowing a small boat to the Island of San Diego to shoot quail, rabbits, and other small game. But Babcock was an idea man who believed that San Diego was on the verge of greatness. His wife, Isabel, recalled how her husband brought Story to their home for lunch one afternoon. After the meal, as Story reclined on the couch with his eyes closed, Babcock told him, "We're too young to retire. We ought to build a hotel, Story—the biggest wooden structure in the world, the smartest hostelry on any coast, a hotel to which no caravansary of the ancients could be compared. We ought to build it on that spot across the bay where we sunburned yesterday."[3]

Though it was an expensive idea, Story reluctantly agreed to invest. Pooling their monies together, the two men found a third investor, Jacob Gruendike, president of the First National Bank of San Diego, and on November 19, 1885, they purchased the Island of San Diego for $110,000 and rechristened it Coronado. Babcock then recruited his brother-in-law, Heber Ingle, a railroad stockholder, as a fourth investor.

Babcock then became a stakeholder in the Flume Company and began drilling in the dry San Diego Riverbed near Old Town to find a water supply for the peninsula. However, he wanted a better quality of water and exclusive rights to Coronado, so in March 1886, Babcock, Story, Gruendike, and Inger formed the San Diego and Coronado Water Company, capitalizing it with $500,000.[4] Babcock then proceeded to purchase a reservoir near the Otay River, a 25-mile waterway that begins at San Miguel Mountain and ends at San Diego Bay. This allowed him to pipe mineral water from the Otay's source to the Coronado peninsula. Next, Babcock recruited Josephus Collett, president of the Rose Polytechnic School of Terre Haute, Indiana, to invest in

his business, and on April 7, 1886, the Coronado Beach Company was incorporated, with an initial capitalization of $1 million.[5]

The Coronado Beach Company quickly created new franchises, including a two-and-a-half mile Coronado Railroad line to be built on the peninsula, a wharf, a rail car system in San Diego, and the San Diego and Coronado Ferry Company to haul passengers and supplies back and forth.

On April 16, 1886, workers began to clear the sagebrush, plant trees, and design streets on Coronado. This was quickly followed by the construction of an electrical power plant and the installation of telephone lines from the peninsula to San Diego. But all of the work proved difficult to manage, so Babcock sought the help of one of his close friends from Evanston, Captain Charles H. Hinde, a semi-retired railroad executive and riverboat captain, who moved to San Diego with his wife to manage the company's business affairs.

With help from Rand McNally and the Atchison, Topeka and Santa Fe Railroad, the Coronado Beach Company coordinated a nationwide marketing campaign. A pavilion was built on the peninsula to entertain visitors and on July 4, 1886, Coronado held its first Fourth of July celebration, starting an annual tradition. In the meantime, Babcock and Story met with architects James, Marshall, and Watson Reid, brothers from Evanston, Indiana, about designing an upscale health resort overlooking Glorietta Bay that would become "the talk of the Western world."[6]

Needing to raise additional capital, the Coronado Beach Company held a land auction in November 1886 for which more than 6,000 people were ferried to the peninsula, and treated to a motor and buggy tour and a free meal. The land auction was a success, and the Coronado Beach Company recouped its initial $110,000 investment. They continued selling plots, raising an additional $2 million. With the new income, the company purchased exclusive rights to raw lumber owned by the Dolbeer and Carson Lumber Company of Eureka, California, and granite from a quarry in the Temecula Valley Canyon, which was later mixed with concrete for the hotel's foundation. Metal workshops and kilns were constructed on the peninsula for working iron, making bricks, and mixing concrete. Soon the Reid brothers arrived by train, and on January 12, 1887, Isabel Babcock presided over the groundbreaking ceremony for the Hotel del Coronado.

Large outdoor arc lights were installed at the worksite so that plumbers, carpenters, and other craftsmen, many of them Chinese laborers from San Francisco and Oakland, could work 24 hours a day on building the hotel. At times, construction went faster than the hotel's architectural drawings could be rendered, forcing

carpenters to make creative decisions in fitting parts of the building together.

Other services and amenities were soon established on Coronado, including a postal service and a sewage system. Before the end of 1887, the peninsula had a schoolhouse, small hotels, a few mansions, a racetrack, a plant nursery, a church, and a boathouse. Even an ostrich farm briefly appeared near the hotel construction site. The Coronado Beach Company, meanwhile, maintained a strict no-saloon policy on the peninsula, though workers and visitors frequently brought their own liquor from San Diego.

The Hotel del Coronado, a quadrangle shaped building that sat on seven and a half acres overlooking the Mexican mountains and the Pacific Ocean, became a showpiece of Queen Anne Revival architecture. The sides of the wood building ranged from three to five floors, with balconies, turrets, stained glass, a red roof, and other architectural novelties. One of the unique additions to the new hotel was its grand ballroom, which measured 156 feet long, 66 feet wide, and 33 feet high, with a ceiling of sugar pine that was custom-fitted to eliminate the need for support posts. The ballroom's intricate woodwork was likewise carefully fitted in place and secured with wood pegs instead of nails.[7]

In August of 1887, John Diedrich Spreckels and his brother Adolph arrived in San Diego to purchase supplies for

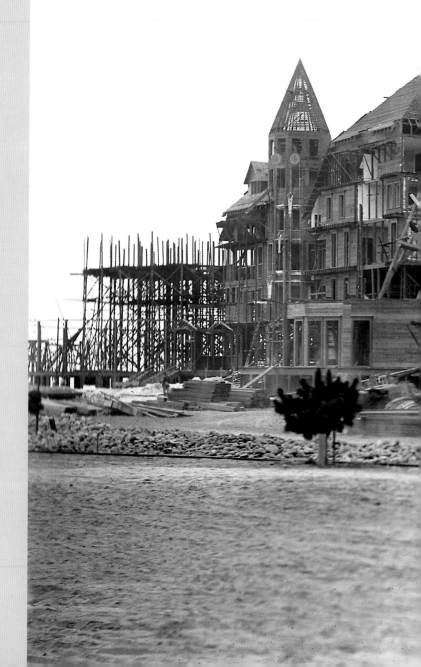

The Hotel del Coronado under construction in 1887.

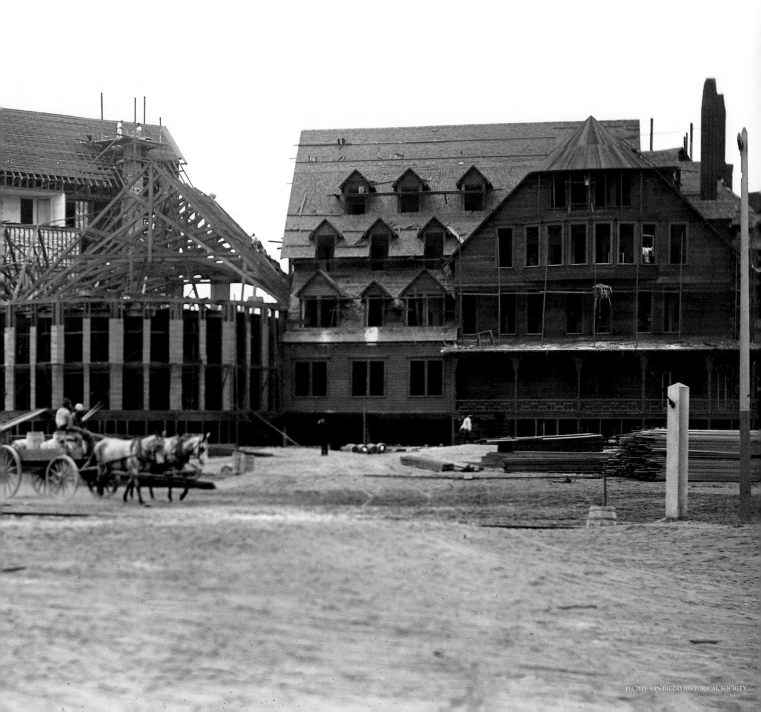

John's yacht, the *Lurline*. The brothers were the wealthy sons of Hawaii's sugar king, Claus Spreckels, who was based out of San Francisco. Both John and Adolph happened to be acquaintances of Captain Hinde, who introduced them to Babcock. Impressed by San Diego's natural seaport, the brothers decided to invest in San Diego, so they built warehouses, coal bins, and a 2,500-foot wharf for incoming ships. The wharf aided the Coronado Beach Company, and benefited their transportation business, the Oceanic Steamship Company. As a token of good will, John also loaned Babcock $100,000.[8]

When Babcock announced that the Hotel del Coronado would open in November of 1887, more than 300 prospective hotel employees arrived from the East Coast to work as chambermaids, porters, waiters, cooks, managers, and gardeners. On September 3, 1887, the first dinner was held in the grand ballroom to celebrate the birthday of Mrs. O.C. Miller, the wife of one of the construction superintendents. That same month, Mr. and Mrs. H.H. Wilkins became the first couple to make a reservation at the hotel, selecting their room from a construction blueprint.[9] However, completion of the hotel fell behind schedule, and the November opening was pushed to December 15 before being postponed again to 1888. Ceiling frescoes on the first floor had not yet been created, furniture and employee uniforms had not arrived, the hotel's steam heating system still had not been installed, and workers were scrambling to complete the rotunda.

The Coronado Beach Company had gone over budget by ordering china tableware from Paris, glassware from Belgium, toiletries from Great Britain, 21,000 yards of carpet from Lowell, Massachusetts, and custom-built, carved "Coronado diner" chairs from Boston.[10] On January 1, 1888, Babcock announced his intentions to add a small electric railroad to run along the hotel's verandas and carry guests from one section of the hotel to another.[11] However, the added cost of constructing the railroad, not to mention the delays it incurred, forced him to abandon the idea.

At the behest of nervous investors, Babcock announced a temporary opening of the hotel on February 1, 1888. Employees scrambled to place linens, washbasins, and sinks in guest rooms, while carpenters and painters worked feverishly to complete the exterior of the building. Around mid-January, architect James W. Reid became the first person to spend the night in the hotel;[12] however, the first person to officially sign the registry at the hotel's opening was Nelson Morris, a director of the Atchison, Topeka and Santa Fe Railway Company, who arrived from Chicago with his party. They occupied Rooms 138 and 141.[13]

Employee uniforms arrived during the first week of the hotel's operation. Bellboys, messengers, and elevator employees wore gray corduroy uniforms with black trim and

matching hats; waiters were in black dress suits; and porters dressed in navy blue uniforms.[14] Within the next couple of weeks, additional furnishings arrived, and visitors had to navigate around stacks of new furniture until it was placed in the proper rooms. Carpenters and painters continued to work ten-hour work days to finish painting the outside of the hotel, as electricians made last minute conversions to electric lighting in certain sections of the hotel, including the public restrooms.

The Hotel del Coronado never had a grand opening celebration. Instead, it opened section by section. On February 11, R. Studebaker and a group of women were the first guests to ride the hotel's brass passenger elevator, one of the first to be installed by the Otis Elevator Company. Three days later, on February 14, the reading and smoking lounges opened; and on February 19, the dining room began serving meals.

By the spring of 1888, the construction of the Hotel del Coronado had cost $600,000, plus an additional $400,000 spent on furnishings. It offered a total of 750 rooms, with the most spacious suites located on the ground floor. There was a grand main entrance and a smaller entrance designed for discreet check-ins by unescorted female travelers. The hotel had a breakfast room, a banquet hall, a separate dining room for children and nurses, employee dining rooms, and additional rooms for private functions. The main level had ten parlors, two billiard rooms (with two tables each) for women, a theatrical stage, and 60 sitting rooms for reading, writing, musical programs, playing cards, and board games. Barbers, pharmacists, and curiosity shops occupied the retail spaces. The basement contained public toilets, an aquarium (where guests could select their own fish for dinner), a restaurant and bar (the only one allowed to operate on Coronado), four bowling lanes, a shooting gallery, shuffleboard games, billiard tables for men, a dark room for amateur photographers, and a health spa. The basement also housed repair workshops, storage rooms, and a wine cellar. Outside the hotel were power, ice, and water plants, a steam laundry building, cold storage warehouses, and a fire department. There was a tunnel built between the industrial area and the basement in which electric lines and water pipes pumped steam, mineral, and salt water into the hotel. The hotel's power plant also provided electricity to the entire peninsula.

For hunters, the hotel used a small piece of land known as North Island, which was offset by a narrow, shallow strip of water called the Spanish Bight, for shooting rabbit and quail. Other outdoor amenities included swimming pools, bathhouses, a pleasure pier, fishing excursions, and boat tours.

Room rates started at a minimum of $3 per night for transient guests, with weekly rates discounted to $2.50 a night, and monthly rates at $2 per night, depending on the

room's location.[15] Because electricity was an innovative technology, each room had a sign reading, *This room is equipped with EDISON ELECTRIC LIGHT. Do not attempt to light with match. Simply turn key on wall by door. The use of electricity is in no way harmful to health, nor does it affect the soundness of sleep.*[16] However, in many of the rooms, an oil lamp was installed next to the electric light in case the electricity failed.

Despite enthusiastic reviews by the hotel's first guests, the first few months of operation were filled with problems: union carpenters called a strike for shorter days and were replaced by non-union workers; painters perched on scaffolding were still

The Hotel del Coronado in the 1890s.

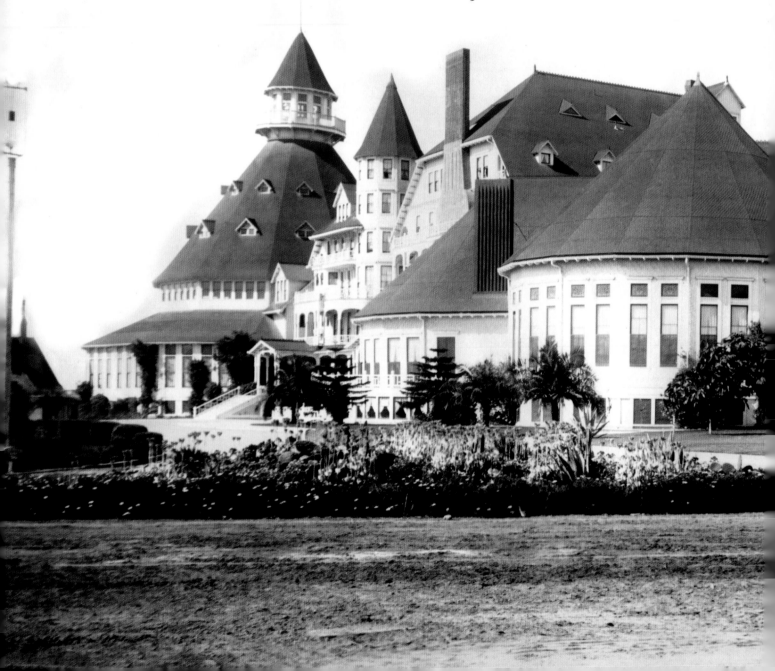

making last minute touches to the outside of the hotel; the new sewer system required additional fittings; and the hotel's telephone service to San Diego had poor reception. During its first two months of operation, the hotel lost $60,000.[7] To cut expenses, management began hiring Chinese laborers at lower wages, keeping them largely out of sight, and in August of 1888, Elisha Babcock took over as general manager.

During the construction of the hotel, San Diego's population had exploded from 4,000 to around 40,000 in just three years, but in 1888, San Diego County entered a recession that was made worse after the Hotel del Coronado was completed. Adding

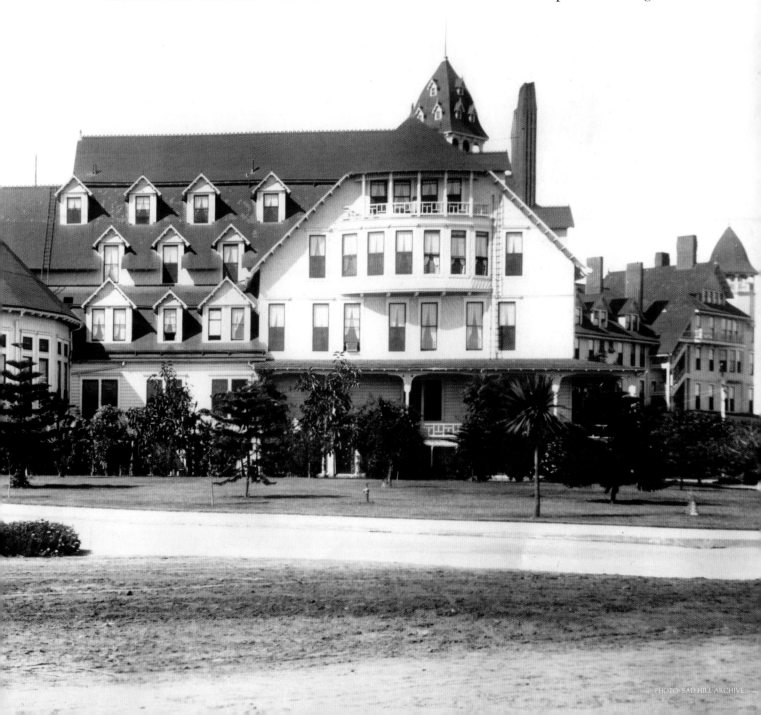

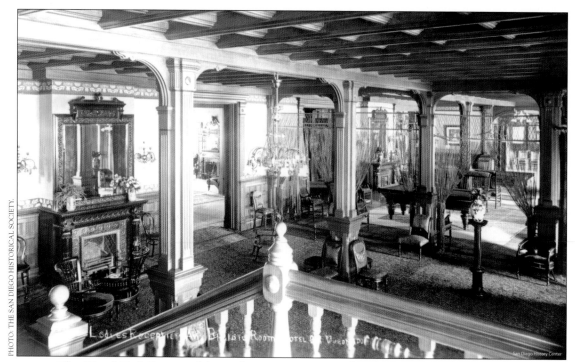

PHOTO: THE SAN DIEGO HISTORICAL SOCIETY.

The Hotel Del Coronado's Ladies Reception and Billiard Room in the 1890s.

to the county's woes was the Santa Fe Railroad's decision to make Los Angeles its new western hub, thus moving its offices north of San Diego. While Los Angeles continued to boom, an estimated 10,000 people left San Diego after the bust.[18] In 1889, the *Oregonian* newspaper wrote, "Pitiful stories come from the wreck of the tremendous boom that left so many monuments of folly and ruin over Southern California a year or so ago.... The big Hotel del Coronado that cost over $1,000,000 has little to do. Its two proprietors have failed. One is a beggar, as to property, and the other has gone insane."[19]

On Christmas Eve 1888, a storm sent 30-foot waves crashing against the hotel, damaging its promenade deck and requiring repairs to be made to the hotel and the construction of a seawall. Story then told Babcock that he intended to sell his holdings in the Coronado Beach Company, and demanded that Babcock find a buyer. Under pressure, Babcock made a special trip to San Francisco to ask John Spreckels for financial help, even though Babcock still owed him $100,000. In May of 1889, rumors circulated that the hotel was for sale. However, in late July, a series of private negotiations concluded, and an announcement was made that John Spreckels had bought Story's one-third interest in the Coronado Beach Company for $511,050.[20] With Spreckels on board as vice-president, the company was refinanced to approximately $3

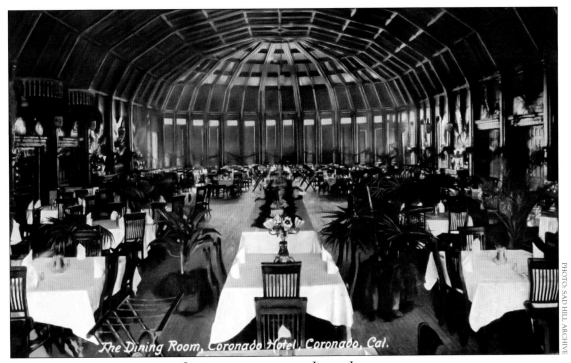

The Dining Room in the early 1900s.

million. Babcock continued to serve as the company's president while Captain Hinde served as general manager of the Spreckels Brothers Commercial Company as well as a director for the Coronado Beach Company.

As San Diego's economy worsened and the San Diego Board of Trustees tried to incorporate Coronado as a part of the city, voters defeated their attempt to annex the peninsula. According to local legend, shortly after the vote took place, a San Diego citizen filed a complaint against a bartender at the Hotel del Coronado for not closing the hotel bar on Election Day.[21] Outraged by the complaint, Coronado residents launched their own campaign, and on December 15, 1890, the State of California officially designated Coronado an independent city.

The hotel entertained many famous guests in its early years, including newspaper publisher Joseph Pulitzer, actress Lillian Langtry, author Charles Dudley Warner, King Kalakaua of Hawaii, and President Benjamin Harrison. To bolster tourism, the hotel added an indoor plunge in 1891, followed a year later by the opening of a small zoo located between the ice plant and the engine house. The zoo featured a monkey, exotic birds, South American deer, and a small population of seals. In 1893, the hotel received an additional $70,000 refurbishment of its rooms and bathrooms, plus a new paint job for the exterior.[22]

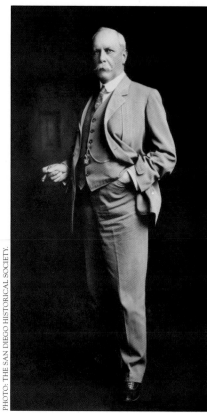

John D. Spreckels, circa 1900.

During this time, John Spreckels began buying businesses in San Diego, including, in 1890, the *Union* newspaper, which he turned over to Babcock to manage. With Babcock's help, Spreckels monopolized the city's public transportation business and introduced San Diego's first electric railcar service in 1892, with his brother Adolph as its president. Meanwhile, the Coronado Beach Company consolidated all its franchises, forcing Gruendike, Ingle, and Collett to sell their holdings back to the company.

Because Babcock wanted exclusive ownership of San Diego's water rights, he merged most of his holdings with those of the San Diego Water Company, thus stopping the company from merging with the Flume Company.[23] Tensions between the two water companies escalated, and in 1890, a court order demanded that both companies consolidate. Babcock refused, and in 1894, he resigned as president of the San Diego Water Company.[24]

The following year, Babcock convinced Spreckels to purchase the Mt. Tecate Land and Water Company, located outside San Diego. Babcock then sold Spreckels half of his Otay Lake holdings, and, together, the two men formed a new company called the Southern California Mountain Water Company. Babcock then began using the *San Diego Union* to launch a campaign accusing the now consolidated Flume Company of providing poor service to the citizens of San Diego, a complaint that resonated with many citizens and local politicians.

Rumors soon spread that Spreckels and Babcock were privately feuding. Spreckels tried to quash these rumors by telling the *Union,* "I do not say that without Mr. Babcock there would be no Hotel del Coronado, no bunkers, no ships in this harbor, and no electric railway system, but I doubt it. And especially do I doubt that these things would have come at the time they did, just after the boom, when there was no business. He induced me to invest at that time, and I still have faith in San Diego and am satisfied with those investments."[25]

In May of 1896, Babcock persuaded city leaders to introduce a ballot measure that would allow his Southern California Mountain Water Company to construct three

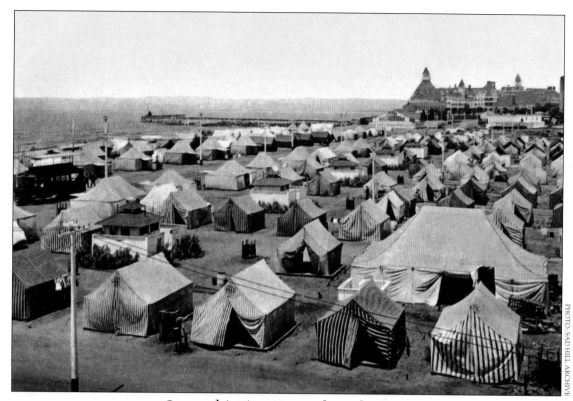

Coronado's Tent City in the early 1900s.

dams—the Otay, the Barrett, and the Moreno. After the measure passed, Babcock's every move was scrutinized by his enemies, and in March of 1897 an engineer accused him of violating the city's contract by not constructing the Moreno Dam according to specifications. Babcock abruptly left the hotel to personally supervise the construction of the troubled dam site, and a man named A. W. Bailey took over as manager of the hotel. The *Evening Tribune*, a rival San Diego newspaper, later reported that Spreckels had fired Babcock from the hotel, a rumor that the *Union* vehemently denied.[26] However, Babcock and Spreckels' relationship had soured. In April of 1898, Babcock returned as the hotel manager after construction of the dam temporarily shut down. Months later, when construction resumed, Babcock had little to do with the water project. By this time, he had begun investing in outside business ventures. He also worked more closely with his two adult sons, Graham and Arnold, who assisted him at the hotel and served as officers in the Coronado Beach Company.

In 1899, after the *Union* accused the Santa Fe Railroad of scaling back its services to San Diego, a heated, closed-door meeting took place at the Hotel del Coronado between a Los Angeles judge, a Santa Fe Railroad executive, and Babcock. According

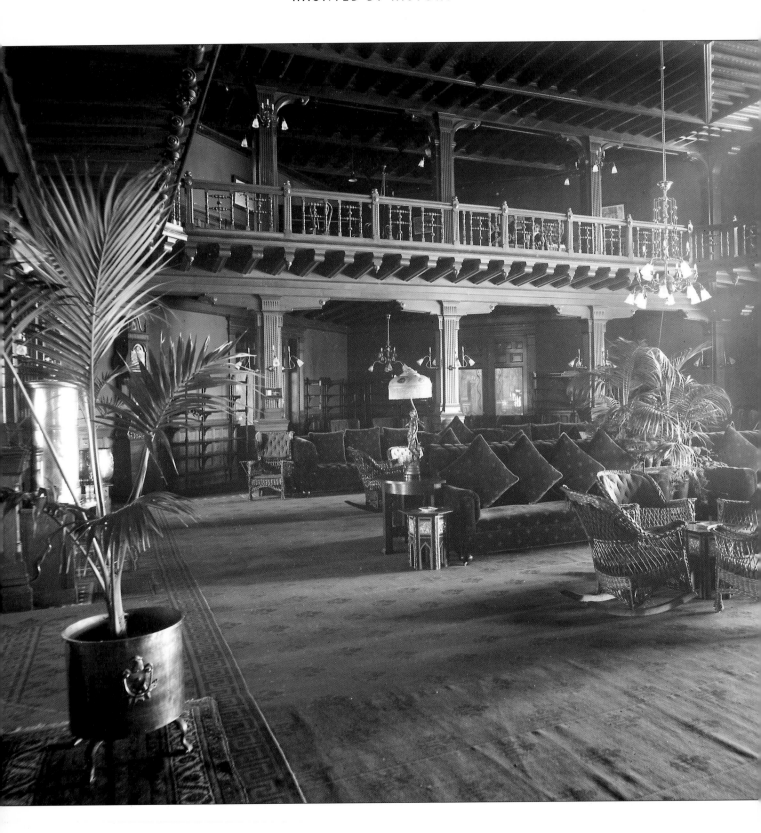

to the *Union*, Babcock and the Santa Fe Railroad executive came up with the idea for a tent city to be built on Coronado. When the railroad agreed to invest in the new resort, the Coronado Beach Company converted a mile-long strip of land south of the hotel into a summertime resort to attract middle-class visitors.[27]

The first Tent City opened on June 10, 1900, and was a huge success. Advertised as a luxury resort for "those who chose the freedom of a tent rather than the luxury of a hotel,"[28] it offered 500 tents of various sizes, all of them equipped with furniture, electricity, plumbing, and bedding, plus newspaper delivery and laundry service. Electric streetcar tracks were installed, and the Santa Fe Railroad offered special rates for out-of-town visitors traveling to Coronado. From June to September, guests were entertained by the Tent City Band and a thrilling Fourth of July fireworks display. Following its debut, Tent City grew over the next decade by adding a dance pavilion, a floating casino, a children's playground, shops and markets, eateries, reading and writing tents, pool halls, a bar, a skating rink, and a shallow swimming pool.

Meanwhile, the Hotel del Coronado underwent a major renovation that necessitated a temporary closure between May and December 1, 1902. During this time, a new kitchen with modern equipment was built, and the basement underwent a massive transformation as storage spaces and workshops were moved to different locations. In keeping with the changing times, one of the women's billiard rooms was converted into a news and cigar stand with a telegraph office.[29]

As Spreckels' San Diego investments blossomed, rumors of Babcock's unhappiness continued, and he finally tendered his resignation as manager of the hotel on August 30, 1903. While the *Union* provided little insight as to why he had resigned, the *Riverside Independent Enterprise*

Left: The Hotel del Coronado's lobby, circa 1913.

claimed that Babcock was tired and in ill health after many years of service. The newspaper also speculated that he was "disappointed in not being able to keep his son, Graham E. Babcock, as his assistant in the hotel."[30] Babcock's resignation went into effect in January 1904, when he sold his remaining interest in the Coronado Beach Company to Spreckels. However, he still retained his co-ownership of the California Mountain Water Company. Elisha's resignation was followed months later by his son Arnold's departure after he had secured a government contract to expand San Diego's jetty.

In 1905, as work on the Moreno Dam neared completion, John Spreckels attempted to take the Southern California Water Company away from Babcock and his son Graham, who by now, was also listed as a part owner. This led to a lawsuit, and Babcock made public his bad feelings by acknowledging that Spreckels had ordered him to make secret deals with politicians to get what he wanted. Spreckels remained quiet and settled the lawsuit in May of 1906 by buying Elisha and Graham Babcocks' stakes in the water company. However, Babcock's allegations motivated San Diegans to pass a new city charter that reduced the size of its governing body, hoping that fewer politicians would help limit Spreckels' power.

After Babcock's departure, the Hotel del Coronado sponsored motorcar races, and in 1904, introduced the first electrically-lit, outdoor Christmas tree. The hotel also attracted high-profile citizens and celebrities. One of its famous guests was author L. Frank Baum, best known for *The Wonderful Wizard of Oz* (published in 1900), who first visited the hotel in 1904, and loved Coronado so much that he lived on the peninsula for the next few winters seasons while he wrote the sequels to his famous novel.

Following the San Francisco earthquake of 1906, Spreckels decided to permanently move to Southern California. He accordingly built a mansion on Glorietta Boulevard in Coronado, and in 1908 he and his family moved in. He then continued to make improvements to San Diego and Coronado. In 1911, he closed the jackrabbit hunting ground on North Island and leased it, free of charge, to aviator Glenn L. Curtiss, who opened the Navy's first flying school. Shortly thereafter, the U.S. military gradually began using the North Island for storage and training purposes.

In 1913, Spreckels sold his water company to the City of San Diego for $4.5 million. Two years later, he created Balboa Park, where he built a pavilion, donated a $125,000 pipe organ, and transferred many of the zoo animals from the Hotel del Coronado.[31] His last major project was the construction of the San Diego and Arizona Railroad, a huge undertaking that was completed in 1919.

Notable personalities who visited the hotel in the 1910s included Sarah Bernhardt, Thomas Edison, Harvey Firestone, Henry Ford, former U.S. President William Howard Taft, and William Randolph Hearst. The hotel and North Island also served as filming locations for several movies, notably *The Pearl of the Pacific* (1914), *A Girl From Yesterday* (1915), and *The Married Virgin* (1918).

When the First World War broke out in Europe, military personnel began conducting drills on the

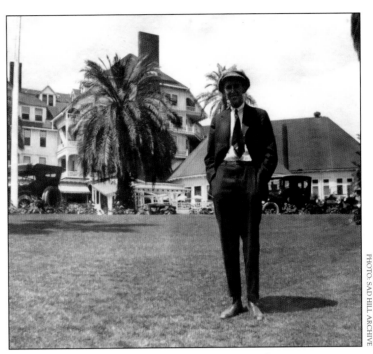

A dapper gentleman poses in front of the hotel in 1918.

beaches near the hotel, and in 1917, the U.S. government initiated condemnation proceedings in order to take full ownership of North Island. Spreckels sued for financial compensation, and in 1921, the U.S. Supreme Court awarded him $5 million, plus an additional $1,098,333 for accrued interest.[32] A Naval Air Station was established after the war, with Lieutenant Theodore G. "Spuds" Ellyson as its first commanding officer.

The 1920s was a robust decade for San Diego and Coronado. Prohibition had very little impact on the Hotel del Coronado's business. Although a wet bar was no longer permitted in Tent City, illegal alcohol was easy to buy in Mexico. It is also generally believed that the Hotel del Coronado might have opened its bar for well-to-do travelers.

On April 20, 1920, a British battle cruiser, the HMS *Renown*, accompanied by six destroyers, 12 seaplanes, a squadron of Sopwiths and Hanriots, and a dirigible, brought 26-year-old Edward, Prince of Wales and heir to the British throne, to San Diego. His one-day stopover was celebrated by a lavish banquet, a reception, and a ball held in his honor at the Hotel del Coronado. For many years, people believed that Edward's future wife, Wallis Warfield Simpson, the wife of a Navy aviator at the time, first met Prince Edward at the ball, but this event never happened.[33]

17

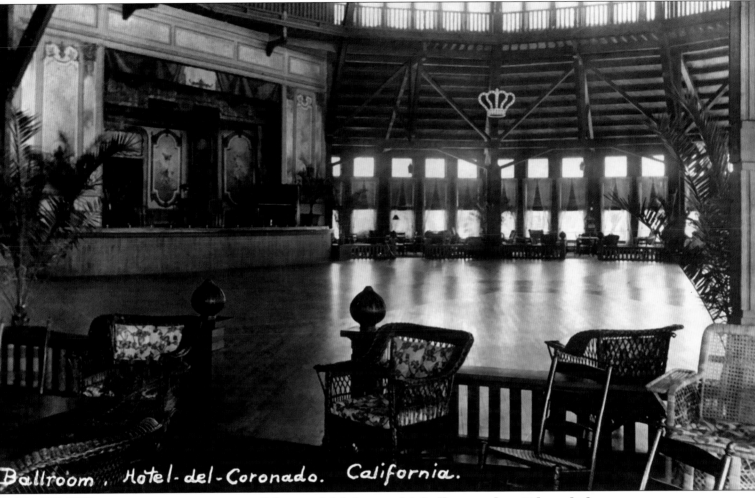

A vintage view of the Hotel del Coronado's ballroom where Edward, the Prince of Wales, and Col. Charles Lindbergh, were once honored.

Film studios continued to use the hotel and airfield as shooting locations for such films as *Beyond the Rocks* (1922), *The Coast of Folly* (1924), and *My Husband's Wives* (1924). Among the Hollywood film professionals who stayed at the hotel during the Twenties were Douglas Fairbanks Sr., Mary Pickford, Gloria Swanson, Lois Wilson, Carl Laemmle, Mauritz Stiller, Victor Seastrom, Greta Garbo, Norma and Natalie Talmadge, Joe Schenk, Buster Keaton, Charles Chaplin, Pola Negri, Rudolph Valentino, Louis B. Mayer, Irving Thalberg, and Norma Shearer.

By the mid-1920s, many of Coronado's pioneers were now gone. Captain Hinde had died in 1915, Elisha Babcock in 1922, and Hampton Story in 1925. John Spreckels quietly met his maker at the age of 73 on June 7, 1926, leaving behind an estate worth $15,111,854[34] to his family, now headed by his son Claus.

18

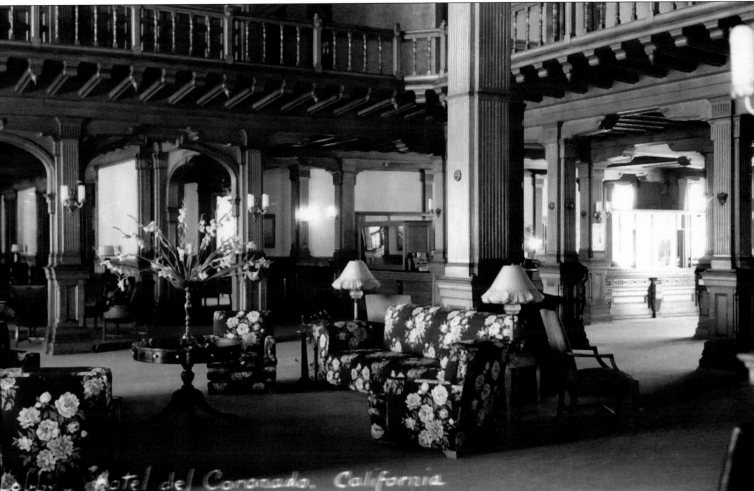

The Hotel del Coronado's lobby in the 1930s.

The hotel, meanwhile, continued to attract considerable attention, adding to its fame. On September 21, 1927, the hotel hosted a citizens' banquet in honor of Col. Charles Lindbergh's world-record, non-stop flight from New York City to Paris in an airplane built in San Diego. Will Rogers was on hand to deliver a speech to an estimated 700 attendees while a model of the *Spirit of St. Louis*, suspended from a wire, circled the ballroom's ceiling. In the mid-1930s, the hotel made news when President Franklin Delano Roosevelt and his wife Eleanor paid a special visit.

Hollywood film crews were still staying at the hotel while shooting scenes for *The Flying Fleet* (1929), with Ramon Novarro and Anita Page; *Hell Divers* (1931) with Clark Gable and Wallace Beery; *Devil Dogs of the Air* (1934) with James Cagney, Pat O'Brien, and Margaret Lindsey; *Yours for the Asking* (1936) with George Raft, Dolores

19

A Catch of Fish Hotel del Coronado

A couple poses next to a "catch of fish" in the 1930s.

Costello, and Ida Lupino; and *Dive Bomber* (1939) with Errol Flynn, Fred MacMurray, and Alexis Smith.

The hotel underwent a number of structural changes in the 1930s as a new banquet facility known as the Circus Room opened in the basement in 1937 and new hallways were created, altering the sizes of many rooms. But like most businesses, the hotel lost money during the Great Depression. Hoping to attract more visitors to Tent City, the Spreckels family decided to convert it into a year-round resort. Wooden cottages soon replaced the old canvas tents, and the dance pavilion was turned into a movie house. The old streetcar tracks were removed so that roadways could be widened for automobile travel. However, these changes failed to increase tourism, and in 1939, Tent City was closed and dismantled.

After the United States entered the Second World War, the hotel and surrounding areas began to have enforced blackouts, and at the suggestion of military officers and guests, many of the hotel's fireplaces were rendered inoperable. The Navy also removed the narrow Spanish Bight waterway, effectively merging North Island to the Coronado peninsula. As the Navy and Coast Guard boosted their presence in San Diego, the U.S. military declared the hotel a social center for officers. This order led to a purging of employees and guests. One victim of the purge was a long-time resident manager named Alberto M. Campione, an Italian man employed at the hotel since 1934, who was now deemed "potentially dangerous to the country's security" because of his nationality and ordered to leave the West Coast.[35]

In January of 1948, the Spreckels family sold all of its Coronado property, including the hotel, to Robert A. Nordblom, an East Coast investor, for more than $2 million.[36] Nordblom then subdivided the property, and on March 30, two days after the sale had been finalized, he sold the hotel to Barry Goodman of Kansas City for $1,700,000.[37] When Goodman discovered that the Spreckels family had given steep discounts to socialites to lure wealthy visitors to the hotel, he ordered rate increases on these tenants, whom he referred to as "display guests." "We're not holding anybody up," Goodman said, "but we've got to put this place on a paying basis. … Money didn't mean anything to Spreckels apparently."[38]

Goodman paid for a $300,000 renovation that included the conversion of a balcony area into 36 new suites. Workers also applied thick coats of white paint throughout the hotel, possibly to hide a lot of much-needed repair work. During this renovation, Goodman opened the Luau Room, a South Pacific island-themed restaurant that offered exotic drinks and dishes.

But the renovations were not enough, and following Goodman's unexpected death in 1951, the hotel was placed in a family trust. While it still attracted Hollywood stars like Greta Garbo, Ann Sheridan, Ronald and Nancy Reagan, Richard Boone, Doris Day, and Jane Russell, the Hotel del Coronado was not quite the grand dame that she had once been. According to San Diego historian Burke Ormsby, "The furniture was a combination of sagging wicker, 1920 overstuffed, 1930 chrome and 1950 Grand Rapids. A slightly musty air of neglect hung about the upper rooms."[39]

The hotel was eventually placed on the market in 1958, the same year movie director Billy Wilder chose it for exterior shots for his Jazz Age comedy *Some Like It Hot*. In September, cast members Marilyn Monroe, Jack Lemmon, Tony Curtis, and Joe E. Brown arrived at the hotel. Monroe's presence caused such a sensation that

PHOTO: LIBRARY OF CONGRESS

Hotel Del Coronado in 1980.

the hotel and surrounding grounds were crowded with photographers, newshounds, and fans hoping to catch a glimpse of her.[40]

The hotel was sold in the spring of 1960 for $2,300,000 to Coronado Beach, Inc., owned by San Diego businessman John Alessio and his brothers.[41] The Alessios paid for extensive renovations, during which the registration desk and offices were moved from the back of the lobby to the front in order to make way for a new room and a glass wall that faced the courtyard. The old rocking-chair veranda on the second floor was converted into a glass-walled Promenade Room, and the basement area was modified to provide new retail spaces. The Crown Ballroom also received a major alteration. Its ceiling was lowered from 67 feet to 36 feet, eliminating the high windows that had once brightly lit and ventilated the room. The Alessios also furnished the ballroom with new, custom-made chandeliers and wall paneling. Additional changes included a large chandelier in the lobby, carpets and wallpaper throughout, a *porte cochere* with a luggage ramp, an outside entry to the basement arcade shops, and an auxiliary kitchen that linked the newly expanded Windsor and Crystal Ballrooms.

After all this work, the Alessios sold the hotel in 1963 to another businessman, M. Larry Lawrence, for more than $7 million. Lawrence and his investors formed Hotel del Coronado, Inc. and decided on ambitious plans for the hotel property, though at first, they had considered tearing the main hotel down. "Our original plan was to buy the Del just for the value of the land," Lawrence said. "We were going to build condos. But I couldn't tear her down. I have to confess I fell in love when I first

set eyes on her."[42] Further restorations were made to the Victorian building and in 1964, the hotel became a state historic landmark.

The hotel continued to attract heads of state. In 1970, President Richard Nixon held a state dinner at the Hotel del Coronado for Mexico's President Gustavo Diaz Ordaz that was attended by California Governor Ronald Reagan and former president Lyndon B. Johnson. Other presidents who later visited the hotel included Gerald Ford, Jimmy Carter, George H.W. Bush, Bill Clinton, George W. Bush, and Barack Obama.

The first movie to shoot entirely on location at the Del was a little known horror film called *Wicked, Wicked* (1973). Author Richard Matheson also used the hotel as a backdrop for his science fiction novel, *Bid Time Return* (1975), which was later adapted as the film *Somewhere in Time* (1980) with Christopher Reeve and Jane Seymour. In the movie, however, the setting was changed from the Del to a location on the East Coast. The hotel was also an easily recognizable location for *The Stunt Man* (1980) starring Peter O'Toole.

In the 1970s, Lawrence and Hotel del Coronado, Inc., added new buildings to the property, including the Grande Hall (1972) and the Ocean Towers (1973 and 1977). In 1977, the Del was awarded National Historic Landmark status, and in the late 1980s, Lawrence oversaw the installation of an intricate $8 million fire sprinkler system to protect the wooden structure from fire. "Considering the number of modern sprinklers we've put in," Lawrence quipped, "our guests are more likely to be drowned than burned."[43] After Lawrence discovered that a gazebo had once existed in the courtyard, he paid for an exact replica to be built.

Lawrence passed away in 1996, and the Del was sold to Travelers Group of New York, which then sold it to Lowe Enterprises Investment Management in 1997 for $330 million.[44] In 2001, the new owners completed a major $55 million restoration, and in 2003 the property was sold to CNL Hospitality Properties Inc. and KSL Recreation Corp for $385 million.[45] As of 2016, the majority stakeholder in the hotel is Blackstone Group LP, which continues to make sure the Hotel del Coronado remains a first-class luxury hotel.

The Hauntings

Rumors of ghosts haunting the Hotel del Coronado have been told for many years, though no one is sure when these rumors first began. One of the first public mentions of a haunting occurred on December 22, 1961, when *Union* newspaper columnist Eileen Jackson wrote, "Victorian ghosts of the rococo 73-year old Hotel del Coronado had to have been confused by the piñatas and south of the border decorations adorning the hotel during a holiday fiesta."[46] But Jackson didn't elaborate on the ghosts that she had mentioned, and many years later, Christine Donovan, the hotel's historian, found an internal memo from the 1960s advising employees not to discuss the hotel's ghosts with anyone.

Over time, word leaked out that an oddly shaped room on the top floor was said to be haunted by a female ghost from the Victorian era. This was Room 502, which was later renumbered as 3502 before being changed again to 3519. In 1977, paranormal author Antoinette May shared two versions of the legend of Room 502 with the *Union*.

Sonya Macari stands in front of Room 3327, the room where Kate Morgan, the Del's most famous ghost, is said to haunt.

24

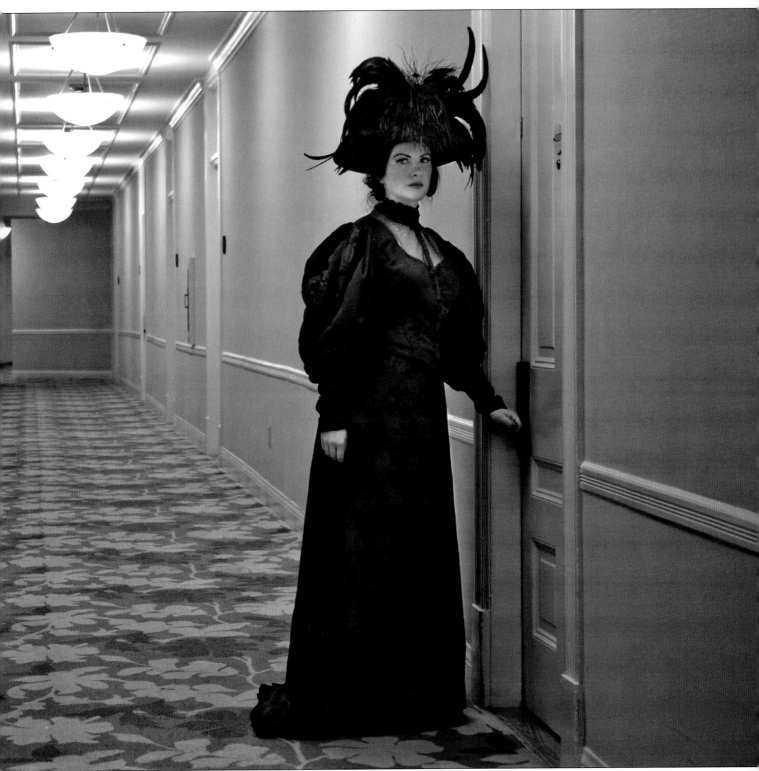

25

"One is that a young woman disappeared from that room, without a trace, about the turn of the century. The other is that she committed suicide in that room. The owner at that time, Elisha Babcock, refused to discuss the matter, but he did have the room boarded up."[47] But there were more variations to the legend of Room 502 than what May recounted. One version maintained that after the woman had committed suicide, Babcock had her body secretly removed and disposed of to avoid scandal. Other versions claimed that a murderous husband had entombed his adulterous wife in one of the walls of the room, or that the woman had been murdered by either a violent sea captain or the captain's jealous wife.

Hotel guests and employees reported flickering lights in the hallway outside the room. People felt cold spots, and either saw objects being moved inside Room 502, or noticed that they were no longer where they were supposed to be. As May told the *Union*, "I understand that 502 is sometimes rented when the hotel is full, but that some persons have been unhappy in the room, so uncomfortable, that they have checked out."[48]

In October of 1979, *Union* reporter Greg Bear wrote that "In the hotel's early days, a female guest entered Room 502 and never came out—or so the story goes. Details have long since been forgotten, and no one knows whether she was kidnapped, murdered, or simply absorbed into the woodwork."[49] Bear also speculated that Richard Matheson might have adapted the room's legend into his 1975 novel, *Bid Time Return*, when he had his protagonist disappear in Room 527.

For his article, Bear interviewed a security guard who told him about a couple of hotel housekeepers who occasionally pushed playing cards under the door to Room 502 on evenings when it was unoccupied, only to find the cards later in the hallway near the door. Bear doubted the story's credibility, commenting that, considering the change in floor levels between the hallway and Room 502, pushing the cards back and forth would have bent them into an L-shape. He also found no evidence of paranormal activity during his overnight investigation of the room.

In 1981, a hotel spokesperson told the *Union* that the hotel preferred "to avoid any more publicity about the well-known ghost tale,"[50] adding that plenty of guests, including psychic mediums, had reported no paranormal encounters while staying in Room 502. But rumors persisted that the Hotel del Coronado was haunted, and that eyewitnesses had seen the ghost of a woman wearing period clothing in other parts of the hotel. For instance, in 1982, a hotel guest named Karen Leakas was returning to her room at the back of the hotel when she saw a dark-haired woman dressed in Edwardian fashion standing in the hallway. The apparition made eye contact with

Leakas, smiled, and gave a genteel nod before entering the room adjacent to hers. Leakas had described the ghost as being a pale gray-white in color and wearing a custom-tailored dress that was tight at the waist and had a high starched collar and voile-like, puffy sleeves.[51]

Room 502's haunted reputation again made the news in May 1983 when a Secret Service agent assigned to protect Vice President George H.W. Bush during his visit to the hotel saw a local news broadcast, claiming that his room was haunted by a female ghost. An hour later, the agent called the front desk and asked hotel employee Barbara Harns to move him to one of the Ocean Towers. As he later told hotel manager John Wilson, "You know, I'm not afraid of ghosts. But when I closed my eyes, the pipes started to rattle and the drapes started to move."[52] In a 1992 television interview, however, the agent told a different story, saying that he had heard the sounds of a loud party directly over his room, which prompted him to call the front desk and complain. When the desk clerk informed him that he was on the top floor, he got spooked and asked for a room change.[53]

In 1983, Richard L. Carrico, a college professor and historian, interviewed housekeepers who told stories about soap, lampshades, and closet hangers frequently being rearranged in Room 502 when the room was unoccupied. They also told him that a few employees had threatened to quit if they were ordered to clean that room alone at night.[54] In an article titled "A Ghost Story," published in the October 1983 edition of *San Diego Home and Garden Magazine*, Carrico wrote that while he was researching the history of the hotel, he came across a mysterious suicide in 1892 of an Iowa woman named Kate Morgan, who he claimed had once occupied Room 502. He claimed that Morgan was married to a gambler when she checked into the Del because she registered under a false identity and told hotel staff that she was expecting the company of a man. Carrico then surmised that after the man failed to show up, she aborted her baby before killing herself on the outside steps of the hotel…and that, according to legend, her ghost now haunts Room 502, still hoping that her lover will arrive some day. After Carrico's article was published, Kate Morgan became the Del's most famous ghost. But the mystery behind her death has been a topic of discussion and misrepresentation among historians and paranormal writers ever since.[55]

To understand the Kate Morgan legend, one must look at the published information surrounding her death. The coroner's report and various 1892 newspaper articles identified her as a woman in her mid-20s (described by an employee as a "rather peculiar person"[56]), who arrived at the hotel on the afternoon of November 24, 1892,

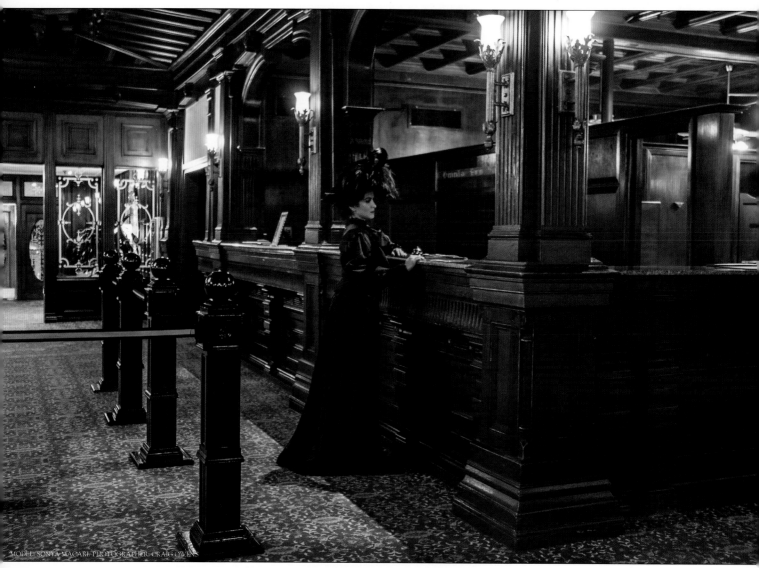

MODEL: SONYA MACARI PHOTOGRAPHER: CRAIG OWENS

The Del's registration desk.

carrying a valise. She didn't sign the register herself, but requested that the hotel clerk sign her name as Miss Lottie A. Bernard from Detroit. That night, she told bellboy Harry West that she suffered from neuralgia and that she was expecting her brother, a doctor, to arrive for treatment.

The next morning, Lottie Bernard (as she was known) approached the front desk and asked the clerk, G.M. Gomer, for advice on how to claim her trunks at the San Diego train station. She said that her brother, Dr. Anderson, had the claim checks in his possession, but that he had been called away to either Los Angeles or San Francisco

on unexpected business after the train had stopped in Orange, California. She also said that she expected her brother to arrive at the hotel around noon. Her brother never arrived, and the following day, she looked sick as she entered the hotel's drugstore and asked a man named T.J. Fisher if the store carried anything for pain. Fisher referred her to the drugstore manager, who recommended that she see a doctor. She declined the suggestion and said that her brother would be arriving shortly. Later that day, she sent bellboy West to the drugstore to get an empty pint bottle and a sponge.

There are no details of what happened on November 27, and it is generally assumed that the woman stayed in her room. At the inquest, desk clerk Gomer stated that at some point during her stay, he had sent a hotel housekeeper to try and persuade her to see the house physician, but she again refused. Bellboy West also commented that Lottie Bernard had slept most of the afternoon, but he didn't provide specific times and dates.

On November 28, the woman was seen again, now looking worse and barely able to walk. According to the coroner's report, she had sent bellboy West to the bar for a glass of wine before asking him to prepare her bath. When West brought her a pitcher of ice water, she told him that she planned to soak in the bathtub for an hour and a half to two hours. West's account differs from an article published later in the *San Diego Union*, which stated that an unnamed female housekeeper had prepared the bath, and that the housekeeper (who was not present at the inquest) had tried to persuade her not to bathe in her weakened condition.[57] Around noon, West was again called to Lottie Bernard's room and asked to dry her hair. She said she had fallen in the tub and gotten her hair wet, an incident that the *Union* later speculated was a failed suicide attempt to induce drowning.[58] At the time, Bernard appeared to be in pain and groaned often, and she sent West back down to the bar again to get a whiskey cocktail.

After West informed the front desk that he had been attending to Lottie Bernard, Gomer paid a personal visit to the room and found her in bed and under the blankets in a cold room. Concerned about her fall, Gomer urged her to see the house physician, but she refused. He then suggested that she light a fire in the fireplace to warm herself, and she replied that she was comfortable without a fire. At some point during the conversation, she claimed that she had been diagnosed with stomach cancer, that her doctors had said that it was terminal, and that her brother, Dr. Anderson of Indianapolis (or Minneapolis, as some newspapers state), would be arriving to the hotel to care for her.

Looking around the room, Gomer noticed that she had two to three letters with envelopes addressed to "Lottie Bernard, Detroit" lying on the writing desk. The *Union* claimed that on one of the envelopes were the written words "Coronado," "Lillian Russell," and "I don't know any such man."[59] Knowing that she had not received any

mail through the front desk, Gomer asked if she had retrieved her luggage. When she replied that she had not, Gomer asked if she had funds to help her through her condition, to which Lottie Bernard replied that she had a little money. Gomer then asked if she had tried calling her brother on the telephone, and she replied that she was unsure if her brother was in Los Angeles, Orange, or San Francisco. When Gomer asked if there was anyone else she could contact to request additional funds, she suggested that he send a telegram to Mr. G.I. Allen in Hamburg, Iowa. Gomer followed her instructions and sent a telegram later that day.

At some point in the afternoon, Lottie Bernard again rang for bellboy West and requested matches so that she could burn papers in the fireplace. Later, she appeared in the drugstore and told Fisher that she planned to visit San Diego to personally search for her trunks at the train station.

When Lottie Bernard visited San Diego, she looked very ill. She entered the Ship Chandlery store between 4:00 and 5:00 p.m., and asked a clerk named Frank Heath if the store sold cartridges. Heath recommended that she go to Chick's Gun Shop on Sixth Street. The time frame suggests, however, that she might have already visited the gun store because Mr. Chick recalled a woman entering his store around 3:00 p.m., asking to buy a pistol and cartridges as a Christmas gift for a friend. Chick then sold her a .44 American Bulldog and a few cartridges and showed her how to load it before she left the store and headed toward the intersection of Fifth and D Streets.

Around 6:30 p.m., bellboy West saw Lottie Bernard gazing out at the ocean from a second-floor veranda. Approximately half an hour later, she asked the front desk if there was any word from her brother. The *Union* reported that she was last seen on the veranda between 9:00 and 10:00 p.m., dressed in black with a lace shawl over her head as she watched a tempest blow in from the ocean.[60]

Around 7:30 the next morning, a hotel electrician named David Crone discovered Lottie Bernard's body, in wet clothing, on the exterior staircase leading from the beach to the hotel. He also saw a .44 American Bulldog pistol near the body and blood on the stairs. Crone quickly notified management, which then ordered employees to place a canvas sheet over the body. San Diego's Deputy Coroner, H.J. Stetson, arrived around 9:30 a.m., and after discovering traces of rust on the pistol, he concluded that Lottie Bernard had committed suicide during a rainstorm between 1:00 and 2:00 a.m., though an exact time was never officially determined. After the body was removed, Stetson investigated her room and found a valise with a key, a nightdress, a hat, a penknife, handkerchiefs (with embroidered monograms), a bottle of camphor, a bottle of alcohol (possibly brandy), quinine pills, and a purse containing a small ring and cash

amounting to $16.50. Her bed appeared untouched, and police found ash remnants of paper in the fireplace.

After the hotel offices opened, desk clerk Gomer received a telegram from a bank in Hamburg, Iowa, floating a $25 credit line for Lottie Bernard. Gomer informed the bank that she had committed suicide and that they should contact the San Diego coroner's office for details.

On November 30, Dr. B.F. Mertzman examined Lottie Bernard's body shortly before the coroner's inquest. During his testimony, he said that she had been shot in the right temple with a bullet that could have been fired from a .38 or .40 caliber revolver. He added that there was no exit wound, meaning that the bullet was still lodged in her brain. Later in the inquest, Mr. Chick, the gun store owner, refused to positively identify the corpse or the revolver found at the death scene as the weapon he had sold to Lottie Bernard.

The San Diego coroner's office concluded that the woman had committed suicide, but could not positively identify her as Lottie Bernard. Hoping to find someone to claim the body, the police department created a sketch of the woman's face, which was sent to large city newspapers across the country, and her description was telegraphed to police stations nationwide, seeking additional information. The description was as follows: "Height, 5 feet 6 inches; complexion, fair, but sallow; medium length black hair; two small moles on left cheek; broad features; high cheekbones; brown eyes; weight, 150 pounds; age, about 26; good teeth, plain gold ring on third finger of left hand; ring of pure gold, with four pearls and blue stone in center; black corset."[61]

While the coroner's office hoped that a family member would come forward to positively identify the body, no one did, which made the *Union* suspicious. The newspaper began its own investigation into Lottie Bernard's death and eventually concluded that there was no Dr. Anderson in Indianapolis (or Minneapolis) and that Lottie Bernard's "brother" might actually have been a lover instead of a family member. The paper also reported that a "prominent physician" who allegedly examined the body (on the same day that Dr. Mertzman had made his examination) had concluded that she was too young and healthy-looking to have had stomach cancer. The physician also hypothesized that she might have been pregnant and had induced a miscarriage by using the medications found in her room, and that her body looked like she had once given birth, but that he had no way of confirming these details without conducting an autopsy. This unnamed physician also said that he had been told by another man, one Charles Stevens, that Lottie Bernard had gone horseback riding and had been in "high spirits" when Stevens had driven her to a

San Diego department store to buy a pair of gloves. The *Union* added that no gloves were ever found in the dead woman's possessions.[62]

The *Union*'s investigation determined that Lottie Bernard had never visited the train depot about her luggage, which had never arrived. Instead, she was believed to have left the train station on Thanksgiving Day with only her valise, and that she had entered the Brewster Hotel to inquire if Dr. and Mrs. Anderson had arrived. When she was informed by the hotel desk clerk that there were no guests by that name, she told the clerk that the couple must have checked in at the Hotel del Coronado and that she would wait for them there.

On December 2, the *Union* reported a new piece of hearsay. A Hotel del Coronado hotel guest named Joseph E. Jones had told an unnamed bellboy that he had traveled in the same railcar from Denver to San Diego as Lottie Bernard, who was accompanied by a "well-dressed gentleman." Jones had witnessed the couple quarreling, and when the train stopped in Orange, California, the well-dressed man disembarked, leaving Lottie Bernard to travel alone to her destination. When the *Union* asked why Jones had waited so long to give his information, he replied that he had wanted to keep his information a secret until after the coroner's inquest so that he wouldn't be called to testify.[63]

The *Union* also reported that Lottie Bernard had enough money to leave generous tips for hotel staff, that she had knowledge of Los Angeles and its hotels, and that she had once told someone that Mr. Allen of Iowa managed her finances. On December 4, the *Union* reported that Mr. G.I. Allen's bank had contacted the coroner's office to inform them that Mr. Allen did not know Lottie Bernard's relatives, but that her husband was rumored to be in Wichita, Kansas.

The investigation took a new twist after a distraught mother in Detroit contacted the San Diego undertakers to say that Lottie Bernard matched the description of her missing daughter, Lizzie Wyllie, who had once worked at a book bindery in Detroit. According to newspapers, Lizzie had been caught having an affair with her married foreman, John Longstreet, costing both of them their jobs. Following their dismissals, the couple disappeared and was believed to be California-bound. It was also revealed that Lizzie Wyllie had a distant aunt named either Lottie or Louisa Anderson.[64] The *Union* reported later that the name Louisa Anderson had been embroidered on the dead woman's handkerchiefs.[65]

Relatives of Lizzie Wyllie who lived in San Diego came to the morgue and positively identified Lottie Bernard as their relative, but then they reversed their story and admitted that they had not actually seen Lizzie Wyllie since she was a young

girl. The *Union* reported that another relative was scheduled to arrive from Pasadena to identify the body, but no one ever showed up.[66]

By December 6, newspapers doubted that Lizzie Wyllie was "the beautiful stranger," so dubbed by the *Union*. Undertakers wired a picture of the dead woman to Detroit for the mother to see. Although Lizzie Wyllie had pierced ears, the dead woman's ears were not pierced. The following day, news reports surfaced that Lizzie Wyllie was alive and living in Ontario, Canada, and that John Longstreet was no longer a suspect.

An artist's sketch of the Beautiful Stranger that appeared in the San Francisco Chronicle in December 1892.

Meanwhile, new information surfaced that Lottie Anderson's husband might have been a gambler named L.A. Bernard, who had been seen in Hamburg, Iowa, but had departed for Topeka, Kansas, on November 6 after asking for money to bring his sick wife in California back to Iowa. An additional newspaper report surfaced that the gambler had been a childhood friend of the mysterious benefactor, G.I. Allen.[67]

A new lead developed when Los Angeles police detectives were called to investigate the disappearance of a missing person named Katie Logan, who was employed as a domestic at the home of Mr. and Mrs. L.A. Grant of South Hill Street in Los Angeles. According to the Grants, Katie Logan had said that she needed to travel to San Diego the day before Thanksgiving to have some papers signed and had promised to be back at their house on Thanksgiving Day in time to cook the evening meal. When she failed to return from her trip, the Grants filed a missing person report.[68]

On December 8, Los Angeles police detectives arrived at the Grants' Hill Street address, entered Katie Logan's room, and opened a weathered trunk. Police discovered a tin box marked *Louisa Anderson* that contained a lock of blonde hair, an assortment of photographs, a letter of recommendation from a man named W.T. Farmer, and an 1886 marriage certificate for Kate F. Farmer and Thomas E. Morgan, who had married in Hamburg, Iowa.[69] The detectives soon learned that Katie Logan was an alias for Kate Morgan, who had claimed that she had been unhappily married to a gambler, whom she had left. They also learned that Kate Morgan had traveled extensively while working a number of odd jobs, and that prior to her arrival in Los Angeles, she had worked for W.T. Farmer, a California relative.

The Los Angeles Police Department and the San Diego Coroner's Office concluded that Lottie Anderson and Kate Morgan were the same person, though they never

explained Kate Morgan's connection to Louisa Anderson. The *Los Angeles Herald* simultaneously reported that photographs found in Katie Logan's trunk did not resemble the dead woman.[70] However, Mr. Grant assured authorities that Kate Morgan perfectly matched the description of Lottie Bernard, even though he never saw the dead body.[71] The case was closed. Shortly after the newspapers identified the corpse as Kate Morgan, a person named A.D. Swarts of Los Angeles wrote a letter to the San Diego coroner's office in which he claimed to have known Kate Morgan since 1869. He said that her grandfather was Joe Chandler of Riverton, Iowa, and that her husband, Thomas Morgan, had many rich family members back east, including one that lived near Hamburg.[72]

The San Diego undertakers cabled Joseph Chandler, asking if he wanted to claim the body. Chandler declined, wiring back with instructions for the undertakers to bury the woman in San Diego and send him the bill.[73] Kate Morgan's body was then buried in an unmarked grave at the Mount Hope Cemetery on December 13, 1892. The day after the funeral, the *Los Angeles Times* printed a letter from Kate Morgan's California relative, W.T. Farmer, who had written to the Los Angeles Police Department to express his doubt that Kate Morgan had committed suicide. He offered no alternative explanation for her death except to say that Kate Morgan came from a well-to-do family, that her husband had been traveling on behalf of a manufacturing company, and that Kate had "a substantial amount of money" when she left his employment.[74] San Diego authorities never reopened the case, and the newspapers ended their investigation.

In 1989, a flamboyant Orange County criminal defense attorney and former Nixon White House aide named Alan M. May, who once described himself as a "bizarre eccentric,"[75] began researching library records for his own book, *The Legend of Kate Morgan: the Hunt for the Haunt of the Hotel del Coronado*. Alan May (no relation to author Antoinette May) wrote that he had spent the night in Room 3502 (formerly 502), hoping to encounter Kate Morgan's ghost, but that his stay was disappointing. In his book, he wrote, "One night in that hot, unventilated, no-view room—about half the size of those in a Motel 6—convinced me that it was a fraud."[76] After looking through the old blueprints and hotel registration books, he discovered that Carrico had identified the wrong room. Room 502/3502 had been a maid's closet around the time of Kate Morgan's death. Kate Morgan, meanwhile, had stayed in Room 302, which was now Room 3327 on the third floor.[77] (Note: Room 502/3502 is now Room 3519. I will use the current room numbers to eliminate confusion.)

May first published his discovery in a pamphlet, which brought him notoriety, especially after hotel executives concurred that he had correctly identified Kate Morgan's room. The pamphlet (which May later expanded into a book) also claimed that

Room 3327 was haunted by Kate Morgan's ghost, that her eyes and smile had glowed back at him from the room's television screen while it was turned off, and that other hotel employees had witnessed the phenomenon after he brought them into the room. He also wrote about how the hotel's computer canceled his room reservation during his stay, and that after discussing the error with the front desk, he discovered that the room had been mysteriously listed as being *out of service*. Finally, he blamed Kate Morgan's ghost for the heavy static on his phone line during his tenure inside the room.

But many (if not all) of May's ghostly encounters were fictionalized so that he could write a mystery story in the guise of a paranormal book. For instance, May wrote about his mysterious obsession with Kate Morgan, asking himself, "What was the madness in my head? Did Kate want a good lawyer to solve her mystery or just someone to haunt?"[78] He soon got his answer when Kate Morgan's ghost confessed that she had chosen him to solve her murder. He then worked *pro bono* for her, though he still couldn't decide whether her ghostly appearances occur in consensual reality or in a dream state. At one point, he wrote:

> *I closed my eyes to think. Then I heard the sound of rustling lace, and I knew without looking, she was back.*
> *"You don't believe it was a suicide?" she asked me in a quizzical tone.*
> *"No, I don't, but since I really don't know who you were, or anything about your past, I can't conclude it was accidental or murder either."*
> *"Do you think I'm pretty?"*
> *"Beautiful, really beautiful," I responded, and I wasn't being polite.*
> *"That's what the newspapers said about me," she sighed, smiled and then again disappeared.*[79]

Kate Morgan's ghost encouraged May to wrap up his investigation before November 24, telling him, "My fate and past are well documented and your training will lead you to them."[80] At one point he inspected the stairs where she died and noticed that an outdoor light bulb no longer worked. After asking an employee about the bulb, he was told that new bulbs never lasted more than a couple of days at that location before burning out, and no one understood why they failed so quickly. Later, as May inspected the outside of the property, he looked up at his room (Room 3327) and noticed that the window curtains had been mysteriously pulled back and that the ceiling fan was turned on, when minutes earlier, the curtains were drawn and the ceiling fan was off. May later determined that housekeeping had not entered his room.

The book's payoff occurred on the evening of November 24, when he checked into Room 3327 and ordered an intimate Thanksgiving dinner for Kate's ghost and himself. Once Kate Morgan materialized, he asked her if she was hungry. "We don't eat," she told him. "But we drink champagne."[81] After the ghost got comfortable with a glass of champagne, May began to rattle off his theory about her being a grafter who had been murdered by her husband, Tom Morgan, who then made her death look like a suicide. She corroborated his findings with either a smile or a frown, and after Morgan's ghost appeared satisfied with his conclusion, she vaguely hinted that she was a distant ancestor of his before she faded away. May then had a sudden epiphany, and after a little research, he suspected that Kate Morgan might have been his great grandmother (though the claim was never proven)!

Because May's findings never explained why Room 3519 (formerly 502) was said to be haunted, he felt compelled to write the following:

> It is said that the poor housekeeper who had tended Kate Morgan at the Del died, or disappeared, from her room at the Hotel del Coronado the day after Kate's funeral. She, of course, lived in the maids' quarters.… Today it is known as [3519]. Hmmmm! But that is another story—or is it?[82]

In 1990, one of Alan May's old army buddies, Gerry Rush, jumped on the same bandwagon by claiming he had been awakened in Room 3519 by the sound of a woman crying in the hallway. He further claimed that as he stepped out of his room to investigate, he saw a female ghost, who told him, "I was murdered. It is not only Kate Morgan in the ground. It is I, the housekeeper."[83]

Despite his implausible murder theory, Alan May was a master promoter who knew how to attract media interest. He bought a marker for Kate Morgan's grave, then told *Orange Coast Magazine*, "I didn't believe in ghosts, but I felt at least the myth of the legend and whoever died here should be pinned down. My thought was to do it pro bono as a historical gift to the hotel."[84] But his gift was anything but historical. In 1991, the CBS series *Haunted Lives: True Ghost Stories* exaggerated his claims by having an actor playing May travel back in time to 1892, where he witnesses (and tries to prevent!) Kate Morgan's murder. But not everyone was thrilled with Alan May's book. The Hotel del Coronado disagreed with his murder theory. So did Richard L. Carrico, who published his book, *San Diego Spirits: Ghosts and Hauntings in America's Southwest Corner*, in which he criticized May's book for its "large doses of speculation mixed with historical fact," and how May "seemingly ignores contradictory information about the identity of the dead woman."[85]

Inside Kate Morgan's Room.

In his book, Carrico offered his own conspiracy theory that is equally speculative. He claimed that Kate Morgan's real identity might have been Lizzie Wyllie and that somehow the two women had known each other from some earlier point in time and had switched identities. He also claimed that a psychic friend who visited Kate Morgan's gravesite had told him that the woman buried there was not Kate Morgan.

By the time Alan May passed away in June of 1991, the speculation behind Kate Morgan's death and the Del's ghost legends was no longer based on facts. Instead, people now began accusing Kate Morgan of murdering the housekeeper and switching identities with her before fleeing the hotel. In 1992, paranormal author Gail White, in her book, *Haunted San Diego*, took a couple of May's paranormal claims and attributed them to unnamed guests staying at the hotel. She also changed other ghost stories that were told before May's book was published. Instead of housekeepers sliding playing cards under the door to room 3519 (formerly 502), she wrote about a maid who "quietly tapped on the door and slipped a note under it inquiring if the occupants wanted their room straightened up" and that the "slip of paper was returned with the message, 'yes,'"[86] even though no one was inside the room at the time. White also changed the Secret Service agent story by claiming that in the midnight hour, "a mysterious light

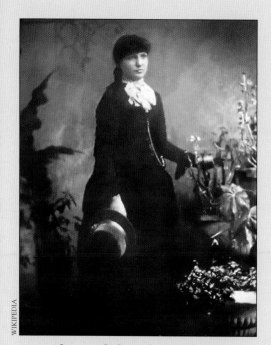

WIKIPEDIA

Photo is believed to be that of Kate Morgan.

While this photo is often touted as the only surviving photo of Kate Morgan, it is not the one that police found in her trunk in Los Angeles in 1892. Morgan's personal belongings were thrown away after police closed her case and no one claimed them. In 2001, Terry Girardot published Kate Morgan's photo, claiming that he had come across it while researching his own genealogy. Girardot also said that he was a distant relative of Tom Morgan, and that Tom had never been a gambler nor murderer. Girardot then theorized that Kate Morgan had left Tom for another man named Albert Allen, who knew the Morgan family, and that Allen might have been the man seen with Kate on the train to San Diego.

enveloped the room in an eerie glow"[87] that prompted his room change to the Oceans Tower.

But White wasn't the only one murdering the Del's ghost legends. In his book, *Haunted Places: The National Directory: Ghostly Abodes, Sacred Sites, UFO Landings and Other Supernatural Locations*, Dennis William Hauck wrote that Tom and Kate Morgan lived in Visalia, California, around the time Kate Morgan became pregnant, and that after Tom tried to end their marriage by letter, Kate checked into Room 3502 (the wrong room) at the Hotel del Coronado, hoping that a stay at the hotel would somehow lead to a reconciliation. Hauck hypothesized that Tom Morgan showed up, and Kate found him with another woman in the hotel's card room. Hauck then wrote, "According to legend, instead of confronting him, she left the hotel and purchased a gun. Alone in her room on Thanksgiving Day [wrong day], she put the gun to her right temple and pulled the trigger. However, a 1989 investigation turned up evidence that Tom Morgan murdered his young wife."[88]

To counter all this wrong information, the Hotel del Coronado published its own book in 2001, *Beautiful Stranger: The Ghost of Kate Morgan and the Hotel del Coronado.* Written by the hotel's historian, Christine Donovan, the book maintained that the dead woman was Kate Morgan and that she committed suicide. "Our goal was to tell a true story," Donovan told the *Los Angeles Times,* "something a history department could stand behind."[89] Donovan argued that while the newspaper investigations provided interesting information, many of its claims were either false, misleading, or based on hearsay coming from unidentified sources. For instance, there is no evidence that Kate Morgan was pregnant or had an abortion. Likewise, there's no documentation

proving that Tom Morgan was a gambler or that Kate had befriended a maid who had mysteriously disappeared. In fact, there is no evidence of Tom Morgan ever being seen in San Diego, let alone at the Hotel del Coronado.

But even the hotel's official record didn't end the speculation. In 2008, John T. Cullen, a former Hotel del Coronado shuttle driver, wrote *Dead Move: Kate Morgan and the Haunting Mystery of Coronado*, in which he claimed that the dead woman was not Kate Morgan, but Lizzie Wyllie, who, along with John Longstreet and another woman named Kate Morgan, had tried unsuccessfully to blackmail John Spreckels, which eventually led to Wyllie's suicide after her cohorts failed to carry out their part of the plan.[90] Years later, San Diego psychic medium Bonnie Vent claimed that Kate Morgan was really Lottie A. Bernard and that she had been fatally shot (possibly by accident) by someone else.[91]

In the meantime, reports of paranormal activity at the hotel yielded very little information as to who or what was really haunting the hotel. In 1992, two paranormal investigators with the Office of Scientific Investigation and Research, Christopher Chacon and Peter Aykroyd, brother of *Ghostbusters* star Dan Aykroyd, investigated Rooms 3519 (the former maid quarters) and 3327 (Kate Morgan's room). Using infrared cameras and devices to measure electromagnetic fields, temperature, and humidity levels, the investigators documented 37 abnormalities in Room 3519, including an ashtray and lamp that moved on their own. One eyewitness to the poltergeist activity was Del public relations manager Nancy Weisinger, who said, "I heard the ashtray flip over, and a glass shattered in the bathroom. It didn't just break; it was as if someone threw it."[92] By contrast, the investigative team could find no signs of paranormal activity inside Room 3327, Kate Morgan's room.[93]

Although Chacon and Aykroyd's findings received national attention, hotel guests and employees still firmly believe that Room 3327 is haunted by Kate Morgan's ghost. Strangely enough, many of their claims are similar to the ones found in Alan May's book. These include flickering lights, electrical device malfunctions, telephones ringing with no one on the line, room reservations suddenly being canceled, the ceiling fan spinning on its own, cabinet drawers and blinds opening by themselves, the television turning off and on under its own power, and the occasional appearance of a Victorian-era woman sitting on the edge of the bed. Other related paranormal activity include the sound of a woman sobbing at night, unused bathroom towels found wadded up in the bathtub, and repeated key card failures.

In 2002, Authentic Entertainment featured the Hotel del Coronado in its series *Haunted Hotels* on the Travel Channel. For the segment, they interviewed bellboy

Wayne Wright, who told them that he had once conducted a V.I.P. tour of the Kate Morgan room when he noticed an indentation on the bed. After trying to smooth the bedding, the indentation would not go away, which then frightened Wright and his guests into leaving the room.[94] The show also interviewed former hotel guest Richard Rodriquez, who claimed that he had awakened around 2:30 a.m. to see a ghostly presence standing at the foot of the bed in the Kate Morgan room, and that this ghost had slowly pulled the blankets over its head. Frightened, Rodriquez closed his eyes, and when he opened them again, the ghost was gone. Shortly thereafter, he heard a female whispering, "Richard, come to the peephole. Come to the peephole, Richard," but he was too frightened to leave the bed.[95]

An apparition thought to be Kate Morgan has occasionally been seen outside the hotel. In 1992, a guest staying in one of the newer beachfront structures claimed that she had gotten up in the night to get a glass of water, and when she looked out the window she saw an apparition with long dark hair and wearing a Victorian white blouse and dark skirt descending the steps of the main hotel building down to the beach. The ghostly woman stopped, looked out along the beach, and then locked eyes with the guest, who was still standing in the darkness in her guest house.[96]

In 2010, a similar story was told to me by a hotel security guard, who claimed that around 1:30 a.m. on a foggy night, he was standing in a dark room in the hotel basement when he saw a woman wearing a long black dress and heels approaching the hotel from the beach. Thinking that he was hidden from sight, he watched the woman scan the horizon. Then she turned to face the hotel and looked directly at him. Embarrassed, the guard exited via the back of the hotel and approached the woman, and as he drew near, he asked her if she was lost and needed assistance. The woman haughtily replied, "Don't worry about me. I know my way around here." And then she walked right past him, eventually disappearing into the early morning fog. Though the woman had seemed real enough, the guard was confused because her high heels had made no sound on the sidewalk.[97]

Kate Morgan's ghost has also been seen near the Est. 1888 gift store, which is located in the lobby. Described as a woman dressed in a black Victorian-era dress and hat, she was once seen inside the store in the early morning hours peering into a jewelry case near the cash register.

The gift store and the other shops on the lobby level have also had intermittent poltergeist-like activity after extensive renovations were completed in 2001.[98] According to Mary Lundeen, the Est. 1888 manager, items occasionally levitate and fly several feet away before crashing to the floor, while other items are oddly rearranged when

MODEL: SONYA MACARI. PHOTOGRAPHER: CRAIG OWENS

Coronado Beach near the hotel.

the store is closed at night. On at least one occasion, a gift shop employee arrived in the morning to discover books oddly stacked near the front door. Another unusual occurrence involved the mysterious restocking of books with the bindings facing the wall, an incident not only encountered in the Est. 1888 store, but also in historian Christine Donovan's executive office.

Lundeen believes that whatever is haunting her store doesn't like Marilyn Monroe or the *Wizard of Oz* display. Over the years, the Monroe and Oz books, coffee mugs, and other memorabilia have occasionally been misplaced, dumped on the floor, or broken. In an online interview posted on YouTube, an employee named Cecilia recalled an incident in which a pair of binoculars displayed on a stand near the front entrance suddenly levitated and flew about four feet, scaring some of the customers

into leaving the store. Cecilia also spoke about an incident in which a game board on display suddenly had three marbles missing. Two months later, two of the marbles mysteriously returned. When Cecilia chided the spirit for playing games with her, a perfume bottle unexpectedly rose and flew near her face from a nearby shelf. Lastly, Cecilia claims that several employees (herself included) had heard a disembodied female voice calling out their names when they were alone in the store.[99]

In early December of 2010, a group of four retired women became so intrigued by the hotel's ghost stories that one of them purchased a book on Kate Morgan. The quartet then went to the lounge area near the Est. 1888 store, opened the book, and placed it on a coffee table. As soon as one of the ladies called out Kate Morgan's name, the overhead chandelier suddenly fell and shattered on top of the book, thoroughly frightening the women. Fortunately, no one was hurt, and the hotel apologized and made amends. Later, as the women were checking out, one of them jokingly told an employee that she would not open the book again until they were safely home.[100]

According to Donovan, paranormal activity occasionally occurs in rooms that are not well-known for being haunted. In 1998, during preparations for a small theatrical event, a wardrobe seamstress and her assistant working in Room 3517 fell asleep after midnight and were awakened around 3:00 a.m. by a knocking sound coming from the coffee table followed by another knocking on the headboard. After yelling for the noises to stop, the seamstress fell back asleep. Both women were later awakened by a whisper saying, "Get up; you've got to see this."[101] Looking around, both women noticed a beautiful sunrise outside their window. Donovan also mentioned a doctor who claimed in 1999 that he had awakened one morning to find one his socks on the floor ten feet away from his shoes, where he had ritualistically placed them.[102]

In 2001, a couple claimed to have had numerous experiences during their stay in Room 3284. The first incident occurred at 4:00 a.m., when they were awakened by their television turning on. On another occasion, the television changed channels by itself. The coup de grace occurred when the two people each woke up at different times during the night and saw a man wearing a white shirt and suspenders and a woman wearing a bonnet having a merry time with four other phantoms inside the room.

Because guests and employees have seen different apparitions over the years, most paranormal enthusiasts believe that Kate Morgan isn't the only ghost haunting the hotel. For example, an employee once saw a male apparition dressed in a 1940s suit standing in the lobby, who vanished in thin air. According to author Gail White, people had seen a phantom night watchman occasionally wander the lobby or one of the ballrooms, tapping his cane on the wooden floor. She described another ghost as

being an elegant woman wearing a formal Victorian evening dress, dancing alone in one of the ballrooms, while others thought they had heard the sounds of a phantom dinner party coming from said ballroom. White also mentioned an unnamed psychic who had picked up on a child ghost named Melissa, who unexpectedly died in the 1950s and now roamed the second floor hallway, while another psychic claimed that the hotel was haunted by two children, male and female, who liked to play on the main staircase and the second floor.

According to Donovan, guests have reported seeing a blonde female apparition, described as a long-faced woman with light, shoulder-length hair and dressed in a "white-smocked gown," or a young female wearing either a layered, tapered, chiffon dress, or a white nightgown.[103]

In researching the hotel's history, I was surprised to learn that there were more than 30 deaths at the Hotel del Coronado between 1890 and 1981, and that a few of them were bizarre suicides and murders (some of them unsolved) that had been forgotten over time. Because of this, I've included a list of names and causes of death at the end of this chapter for those of you looking for more clues as to why the Hotel del Coronado is said to be one of the most haunted hotels in the world.

Our Shoot

I have a special fondness for the Hotel del Coronado and have stayed there as a guest at least five times. But despite my love for adventure and exploring the paranormal, I had not stayed in the haunted rooms, nor had I experienced anything paranormal. Still, I thought it was entirely possible that the Hotel del Coronado could be haunted. The Del's historian, Christine Donavan, certainly believes it is, so I decided to schedule a photo shoot, and to rent the hotel's two most haunted rooms.

Initially, I had chosen to base the shoot around the Kate Morgan legend; however, Shon LeBlanc at the Costume House in North Hollywood, suggested I also add a *Some Like It Hot*-inspired theme. The idea of shooting two men in drag for comedic relief sounded like fun, though I didn't want to make it look too much like the movie. Shon recommended that I hire actors Guy Perry and Michael J. Willet, who agreed to dress in 1920s drag. Filling out the cast were Kristin Curtain, Richard Halpern, Amber Kloss, and Sonya Macari. My brother Jamison and Renee Paulette (as a backup model) agreed to help with the shoot, and Johanna Serrano worked hair and makeup.

In January of 2011, we arrived for three nights. Renee stayed in 3327, the Kate Morgan room, and I

Our Some Like It Hot *tribute at the Hotel del Coronado.*

MODELS: GUY PERRY, MICHAEL J. WILLET, RICHARD HALPERN. PHOTOGRAPHER: CRAIG OWENS

stayed in 3519 on the fifth floor. Everyone else was quartered in a nearby hotel, except for Johanna, who stayed at the Del in a large room on the fifth floor, which was our base camp.

On our first night, we did a small photo shoot in Room 3327 with Sonya dressed as Kate Morgan. Later, Kristin, also dressed in Edwardian clothing, joined us in the lobby for additional photos.

After we ended our shoot for the evening, Renee and I returned to Room 3327 for an EVP session. I was exhausted by then and sat in a chair and asked questions before slipping into a light sleep for ten to 15 seconds, only to stir long enough to ask the next question. It wasn't the best way to look for ghosts, and after spending nearly half an hour asking questions in a semi-conscious state, I ended the session. Although the session produced no positive results, as Renee and I said goodnight near the room's entrance, one of our audio recorders picked up a very faint, high-pitched, youthful voice belonging to either a child or a woman overlapping Renee's voice. What the voice said, however, was unclear.

Back in Room 3519, I turned on several audio recorders before going to sleep. The first night, the recorders captured what sounded like two musical notes perhaps coming from a piano or a wind instrument made of wood. Intermittent bangs and thuds were also recorded, but they were mostly generated by water pipes. The recorders also captured what sounded like distant doors opening and closing, and at some point during the evening, the recorders captured an unusual bang, followed by footsteps walking across the floor in one direction, then coming back. When I awoke around 5:30 a.m., I discovered the bathroom light, which is triggered by the motion sensor, was on.

Renee slept in Room 3327. About 4:00 a.m., she was awakened by the phone ringing. Thinking it was a prank call, she answered, but there was no one there. She heard what sounded like a washing machine, or at least some kind of mechanically generated white noise on the other end.

The next day, we got a late start on the *Some Like It Hot* theme. Richard was the class clown, breaking into impersonations and keeping our morale high as we spent a considerable amount of time shooting in the base camp room. We eventually moved the shoot to Room 3519, but the odd angles and the unusual placement of windows made photography a challenge. We discussed whether Room 3519 was haunted, and a few of the cast members said they felt uncomfortable in the room, while others felt nothing at all. Hotel employees explained that 3519 had once been two separate rooms that were combined some years ago to make one larger one. They also said that the sitting area,

closet, and bathroom were the paranormally active areas, whereas the opposite end of the room was benign. One employee even claimed that a man had died from heart failure in one of the beds a few years ago and suggested that we place watches and jewelry on the table near the sitting area, since past guests had claimed that these articles had been thrown by an unseen force against the door. We followed his suggestion, but nothing happened.

That night, Guy and Michael dressed in full 1920s drag, and we went down to the lobby. The shoot was fun, and late night guests entering and exiting the hotel, asked if we could take photos of them with Guy and Michael. When one of the employees offered to let us into one of the dining rooms for a few pictures, we eagerly accepted and shot into the early morning hours. Due to how late it was, I opted not to investigate after the shoot.

On our last full day, Amber and Richard posed for a few comedic shots before returning to Los Angeles. Later that afternoon, Sonya dressed as Kate Morgan again, and we took photos on the beach amid sand castles, children, and tourists snapping their own photos. Afterward, we had our last meal together before a few of us returned to Room 3327 to take a few more photos of Sonya.

Around 2:30 a.m., Guy, Renee, Jamison, and I decided to squeeze one more quick shoot spoofing the cult film *Wicked, Wicked*. For the photo, I selected a short third-floor hallway near the main elevator. I then quietly posed Renee, wearing a 1970s-era dress, and Guy, dressed as a bellboy and holding a butcher knife. During this time, Jamison had set a live audio recorder near the tripod and camera bag.

After leaving the hallway to pack our gear, a doorknob suddenly turned, and a naked, pot-bellied man, about 65 years old, staggered blindly out of his room and attempted to cross to another room at the far end of the hallway we just left. Not aware that we were sitting nearby, he stopped mid-way and started swaying, as if he were drunk and disoriented.

Jamison, Renee, and Guy lowered their eyes and looked away, but I couldn't help watching, dumbfounded, as the man stood there for what seemed like an eternity. Then he slowly turned around and faced us, blinking his eyes a few times, as if trying to focus. Suddenly, his eyes widened and his jaw dropped. Cupping his hands over his stubby privates, he ran back into his room, slamming the door behind him.

We sat quietly for a few seconds before bursting out in laughter. While I whispered to the others what I had seen, the audio recorder near us captured a possible EVP of male voice speaking in a sing-song voice, saying something unintelligible.

After Jamison and Guy wrapped for the evening, Renee and I walked around the hallways with live audio recorders, making a full sweep of the hotel, but found nothing that we felt was paranormal.

Back in Room 3519, I set up audio recorders again before going to bed. As I slept, the recorders again captured footsteps hurrying in one direction, then going the other way. There were other oddities as well. On three separate occasions, the recorder on the dresser captured a rattling sound as if the dresser's surface were briefly vibrating. The other recorders, meanwhile, appeared unaffected. Two of these vibrations were preceded by small, popping sounds.

While our photo shoot was a grand experience, our mini-investigation raised a number of questions. For instance, was it possible for the phone system to have a bug? Could a sea gull flying near a bathroom window trigger the motion sensors and turn on the bathroom lights? Was the unusual sound of running feet nothing more than curious guests wandering the halls outside Room 3519? While many of the little odd things we encountered were probably not paranormal, the strange vibrating sounds picked up in Room 3519 are interesting, especially given the room's reputation for poltergeist activity. The unusual voices picked up on our recorders in Kate Morgan's room and the third floor hallway also suggest that ghosts might be roaming the halls of this landmark hotel, though it would be a stretch of the imagination to claim that it was the ghost of Kate Morgan.

MODELS: AMBER KLOSS, MICHAEL J. WILLET. PHOTOGRAPHER: CRAIG OWENS

The hallway near Room 3519.

Inside one of the Del's large guest rooms.

MODELS: AMBER KLOSS, MICHAEL J. WILLET, RICHARD HALPERN. PHOTOGRAPHER: CRAIG OWENS

*Two manipulated images taken inside
one of the Hotel del Coronado's ballrooms.*

Photos from our Some Like It Hot *shoot.*

MICHAEL J. WILLET, RICHARD HALPERN, AND GUY PERRY. PHOTOGRAPHER: CRAIG OWENS

MODELS: RICHARD HALPERN, AMBER KLOSS. PHOTOGRAPHER: CRAIG OWENS

The Night Cap.

MODELS: GUY PERRY, RENEE PAULETTE. PHOTOGRAPHER: CRAIG OWENS

*Our tribute to the 1973 horror film, Wicked, Wicked,
shot on location at the Hotel del Coronado.*

Hotel Deaths

The following is a list of names, dates, and details of deaths (other than Kate Morgan) reported in the newspapers between 1890 and 1982. Keep in mind that the hotel was once advertised as a health resort, so many sickly guests chose the Del as an attractive alternative to a hospital or sanitarium. As medicine advanced and Coronado's transportation improved, the number of deaths inside the hotel dramatically dropped.

August 3, 1890: William N. Mann, 42, of Buffalo, NY. No cause of death was given, but the *Union* reported that he had been in ill health when he arrived.[104]

October 24, 1890: Mrs. Mary L.H. Hincks, 48, of Bridgeport, Connecticut, checked into the Del on August 8 with her ill son, Edward, in hopes that his health would improve. However, it was Mrs. Hincks' health that took a turn for the worse. On a Wednesday evening in October, shortly after dinner, she fainted in a hotel card room and was taken to her room. The next day, Dr. Morton, the house physician, concluded that "no serious results were anticipated," but his diagnosis was wrong. Mrs. Hincks passed away on Friday around noon.[105]

February 25, 1893: Allen Manvel, 56, president of the Santa Fe Railroad, had checked in for health reasons in January. Several weeks later, he passed away around 1:00 a.m. from Bright's disease. Manvel was embalmed in the hotel, and his funeral took place inside the Del's white parlor before burial at Mt. Hope. On a macabre note, the San Diego *Union* accidentally reported on March 2 (days after the funeral) that Manvel's health was "improving rapidly."[106]

April 23, 1894: New York banker Jesse Seligman, 67, passed away from pneumonia and Bright's disease.[107]

March 18, 1896: Henry Jarecki, 70, of Erie, Pennsylvania, passed away in one of the hotel's apartments shortly before 8:00 a.m.[108]

January 30, 1899: William Donaldson, 49, of Minneapolis passed. No information provided.[109]

August 23, 1899: General C.W. Blair, 73, of Kansas City passed about 4:00 a.m. of heart failure.[110]

March 14, 1900: C.V.S. Gibbs, 75, an insurance man from San Francisco, was in good health when he brought his sick wife to the Del. However, Mr. Gibbs passed away of apoplexy at 2:00 a.m. after collapsing earlier in the afternoon.[111]

March 13, 1902: Mrs. J.G. Withrow of Chicago. No information provided.[112]

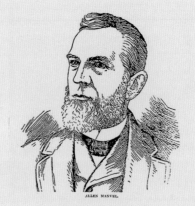

Allen Manvel

November 15, 1904: Stage actress **Isadore Rush,** approximately 38, checked into the Del and was bathing in the Pacific near the breakers when around 3:00 p.m. a large wave knocked her off her feet and carried her into deeper waters. A hotel clerk, E.A. Pitcher, ran into the water and pulled her out of the ocean onto the beach. Several people, including physicians, spent a half hour trying to revive her, but to no avail. Dr. Lorini, who was present, determined that she had died from heart failure caused by the excitement, not from drowning.[113] (Note: Occasionally, there have been reports of an attractive Victorian era woman with lighter hair seen near the beach, which has led some people to believe that a second Victorian or Edwardian female ghost haunts the Del.)

May 1, 1907: Amos J. Anderson, approximately 38, a failed businessman from Colorado Springs, had been staying in Room 328 for a month when he became despondent. After losing his fortune in the Goldfield Mine, he had spent his last days drinking heavily. On March 29, he walked to the front desk and told the clerk, "Well, old man, it's all off. Good-bye." Then he walked out of the hotel. Around 1:00 in the afternoon on May 1, a faint gun shot was heard. Later, two fishermen found his body, and a police investigation determined that Anderson had fired a Colt automatic revolver into his mouth.[114]

May 31, 1908: Guy Clive, 36, a wealthy Englishman that the *Union* described as "courteous but eccentric," was found in a sitting position wedged between two boulders halfway up the Hotel del Coronado's seawall. Clive, a bachelor and avowed "woman hater," had moved to Coronado and had lived for three years with Dr. and Mrs. Meade before moving into the Del. There was initial speculation that Clive had left the hotel around 11:00

Isadore Rush

on Sunday night to sit on the seawall (something he did frequently), become wedged between two boulders. and died from exposure. However, the coroner made a further inspection and found that Clive had been shot through the heart. The following day, a hotel guest found a .32 revolver hidden in a crevice near the death site. An investigation determined that three bullets had been fired.

At the inquest, officials speculated that Clive had fired two shots to see if the revolver worked properly before turning the weapon on himself, using his left hand to pull the trigger while his right hand clutched a handkerchief to hold the barrel in place. Dr. Meade, a family friend, stated that Clive was a melancholy person who suffered from irritable bowels, which he treated with orangeine powders taken

with large doses of alcohol, which could have led to his suicidal state. The *Union* reported that Clive had been a first heir to a vast family fortune, but had refused to return home, despite his mother's pleas. Instead, he had dabbled with toy-making and inventing new gadgets; some of them found in his hotel room. Later, it was discovered that he had filed for patents for a number of these inventions, including safety pin buttons, safety pin clamps, a mechanized Teddy Bear, a toilet paper holder, an assortment of pressed paper products, a sterilized paper cup, a street car fender, and a folding bird cage. Clive was buried in Mt. Hope cemetery.[115] (Note: Clive's alleged hatred of women and his preoccupation with gadgets and children's toys make him a possible suspect behind the poltergeist activity at the 1888 gift shop, especially if one believes that the poltergeist energy shows aggression towards women by throwing perfume bottles, and vandalizing Marilyn Monroe's image. However, more information is needed before a real conclusion can be drawn.)

August 22, 1908: Former Arizona Governor **Nathan Oakes Murphy**, 59, descended from his room to the lobby with his wife and an attorney for the Santa Fe Railroad Company. Not caring to eat, Murphy excused himself and took a brief stroll to the veranda. Returning to the lobby, he collapsed and died from acute hemorrhage of the stomach around 12:55 p.m. His body was quickly taken back to his room to avoid upsetting hotel guests. A decision was then made not to notify Mrs. Murphy until after she finished her meal.[116]

June 18, 1912: Lottie E. Morse, 38, a San Diego resident, died while reading the Bible on the beach around noon.[117]

April 14, 1914: Sir William Whyte, 70, a vice president of the Canadian Pacific Railway passed away from pyelitis and complications of other diseases.[118]

April 7, 1915: Colonel Edward P. Pearson, 78, a Civil War veteran, had been living at the hotel for a year with his 44-year-old wife when he passed.[119]

May 16, 1919: Pietro Gervasoni, 34, hotel kitchen staff, was murdered by fellow employee Emilio Gonzales (sometimes spelled Gonzalez) in the hotel's kitchen. According to witnesses, Gervasoni attacked Gonzales, who grabbed a knife and plunged it into Gervasoni's chest, puncturing his heart.[120]

February 22, 1922: Johnson Letson Walker, 57, a hotel guest from Boston, had a fatal heart attack around 3:30 p.m. on the golf course at the Coronado Country Club.[121]

November 14, 1925: Lieutenant Nathan Green, 25, an officer of the United States destroyer *Moody*, a recent Annapolis graduate, and the son of a Tennessee Supreme Court judge, died under mysterious circumstances. On a Sunday morning around 2:30 a.m., he bade goodnight to friends before leaving a dance at the hotel, where he had been drinking and socializing (though later reports claimed that he had not been drinking).

The next day, his drowned body was found on the sand at the Spanish Bight on North Island by fellow officers after he failed to report for roll call. Green's body wore a white shirt, gray pants, blue wool socks, oxford shoes, and a wrist watch that had stopped at 3:45 a.m. In his pocket was $39. His coat and top hat, which he was wearing when he left the hotel, were later found about 350 feet from where his body was recovered. The coat sleeves had been turned inside out. Authorities deduced that Green was crossing the bridge between Coronado and North

Island around 2:30 and 3:45 a.m. and that he had ripped off his coat in haste before falling into the shallow water and drowning.

Although suicide was ruled out, the Navy suspected foul play after rumors began to spread that Green might have fought a jealous husband, which led to his murder. However, there was no evidence of violence on his body and the reason for his death remains unknown.[122]

May 6, 1926: **Fred W. Dudley,** approximately 57, a Nevada highway contractor and rancher, was found murdered on Coronado Beach in front of the bathhouse around 5:45 a.m. by hotel security. Dudley had traces of cyanide in his stomach and had sustained fatal injuries to the head by a blunt object. Dudley's family thought he had traveled to Florida, not Southern California. Police later determined that the murderers were alcohol smugglers.[123]

June 27, 1929: **Fernando Mercado,** 17, an employee in the hotel's kitchen, drowned off Coronado beach on his day off.[124]

September 5, 1933: Hotel manager **Mel S. Wright,** 57, who had held his position for 20 years, passed away around midnight of heart illness after being ill for seven weeks. His wife and one of his sons were present and were attended to by hotel staff.[125]

July 26, 1934: **Fred J. Rieckelman,** 60, from Cincinnati, suffered a fatal attack in the hotel's lobby.[126]

December 31, 1934: **Louis Upright,** 52, from Los Angeles passed away shortly before attending a New Year's Eve party at the Del (though it is not clear if he died in the hotel).[127]

February 12, 1943: **Jeremiah Hurley,** 84, a director of the Santa Fe Railroad from New Jersey, died in his room.[128]

September 1943: **William John Nettnay,** 8, drowned on Labor Day after his homemade raft capsized off the shores of the Del. The child's death occurred four months after his Navy pilot father died in a plane crash.[129]

March 21, 1948: **Mrs. Nellie Moulder Kerlin,** 76, of Cleveland, had a heart attack in the hotel and passed away in the Coronado Hospital.[130]

March 30, 1950: **Charles Miller,** 72, a night watchman for the hotel, was struck by a motorist in a hit-and-run drunk driving accident on the hotel property and later died from his injuries in a hospital.[131] (Note: Even though Miller's death occurred in 1950, his age and job position match the ghost story about an aged night watchman banging his cane around the lobby and dining room areas.)

December 29, 1952: **Harry V. Reynolds,** 55, president of the Reynolds Industries in Los Angeles, passed away in his room from natural causes.[132]

July 25, 1959: **William G. Waters,** 84, from New York, passed away from a heart attack.[133]

November 5, 1970: **J. Fred Weber,** 57, representing a Newport Beach cable television company, had just finished giving an introductory speech at the California Community Television Association convention when he suddenly slumped in his chair and died from a fatal heart attack in front of approximately 250 industry professionals.[134]

December 1, 1982: **Claude Stewart Webb,** 59, a Hotel del Coronado waiter who had worked his way up to becoming a senior vice president, died in his office from a heart attack.[135]

The Victorian Rose when it still operated as a church in the 1950s.

2

THE VICTORIAN ROSE BED AND BREAKFAST

896 E. Main Street, Ventura, CA 93001

The Victorian Rose Bed & Breakfast, located in the City of Ventura, is one of the most unusually charming overnight stays in Southern California. Originally built in the late 19th century as a Victorian Gothic Church, it now operates as a five-guest room bed and breakfast. The building's architecture stands in sharp contrast to the city's Native American, Spanish, and Mexican influences, which makes the building something of an oddity today. For many locals, however, Ventura's only surviving Victorian church building is still a spiritual place that hearkens back to an earlier time when the city's American pioneers tried to civilize what they felt was a Wild West town.

Ventura went through many changes before becoming a thriving, American coastal city. The town site and surrounding lands were once the home of the Chumash people, who lived in nearby villages and used the coastal land for fishing and canoeing. Then came Juan Rodríguez Cabrillo, who first explored the area for Spain in 1542. Other Spanish expeditions followed, and on March 31, 1782, Franciscan Friar Junípero Serra chose the site to build the Mission San Buenaventura, named for Saint Bonaventure. Converted Chumash who lived in nearby villages were then pressed into labor to build canals, raise livestock, and construct the mission buildings.

Despite floods, fires, and racial tensions, the new mission flourished as an agricultural center until Alta California's Mexican rulers ordered it closed in 1845. The mission's land holdings were then distributed as ranchos to wealthy Mexicans, and the settlement of San Buenaventura continued to operate as an agricultural community, but not as a mission. In 1862, 12 years after California's annexation

into the United States, U.S. President Abraham Lincoln signed a proclamation returning all California missions to the Catholic Church, thus allowing the Mission San Buenaventura to reopen as the community's primary church.

When the City of San Buenaventura was officially incorporated as a part of Santa Barbara County in 1866, it was described as a "little Mexican town with a row of adobe houses on each side of Main Street.... There were a few scattering houses as far east as the present California Street, and beyond that nothing but open plain."[1] Over time, settlers began to arrive from Italy, France, and Germany, and in 1865, approximately 200 Chinese railroad laborers began to settle near the mission grounds in what eventually became known as China Alley.

Thanks to the arrival of a stagecoach line from Sacramento, San Buenaventura's population grew until it became the seat of a new county in 1873. Oil was discovered three years later, bringing even more settlers to Ventura, as the town was now

St. John's Methodist Church, south, in 1890.

unofficially called. Before long, brothels opened near county government buildings, and China Alley operated illegal gambling rooms and opium dens.

Then in 1887, the Southern Pacific Railroad arrived, bringing even more people to town. Many of these early settlers were respectable citizens from the east who built Victorian homes and wanted their own Protestant churches. In 1888, Missouri attorney and businessman L.M. Lloyd purchased approximately 4,000 acres, which he sold for profit, except for one parcel that he donated to his wife's denomination, the Methodist Episcopal Church, South. This newly formed chapter had a local congregation of approximately 13 members. The land was located on the corner of Main and Kalomara Streets about eight blocks from the town center and within walking distance to the Pacific Ocean. Delighted by the donated land, the newly-arrived Bishop R.K. Harvgrove laid the new church's cornerstone on September 30,

A horseless carriage in the early 1900s.

1889. Ventura contractor and architect Selwyn Locke Shaw then began constructing a $7,000 church that was large enough to seat 300 people.

Shaw's design was a picturesque Carpenter Gothic structure, featuring a 96-foot Norwegian steeple (some accounts claim it stood 97 feet) adorned with three different styles of shingling and large stained-glass windows imported from Germany.[2] The interior floor plan was practical, with two vestibules flanking the sanctuary, one for a women's parlor and lecture room, and the other for the minister's study.[3] Facing the pulpit and above the congregational seating, stood the second-floor choir loft. By the time Bishop O.P. Fitzgerald dedicated the completed church, now called St. John's, on September 28, 1890 the congregation had risen from 13 members to 60.[4]

Although St. John's adhered to the denominational policy of rotating its pastors every two to three years, each new pastor encountered the same problems: the church's size and beauty did nothing to attract locals.

In 1894, the Reverend Samuel Chase wrote, "Our location is the source of our defeat in Ventura. There is abundant evidence again of the unwisdom [*sic.*] again of locating a church on a donated lot unless centrally located. A hall down town would serve our purpose much better than this elegant church located as it is out of the center."[5]

Still, there was hope that St. John's would eventually grow its congregation. In 1898, the Reverend R.L. Forbes wrote, "The drift of population toward our part of the city for some months has been very marked and it is safe to predict that our location will be more desirable one year from hence than it is at present."[6]

As Ventura's population grew to 3,000, St. John's membership dropped. In 1902, Reverend Wade Hamilton reported that his congregation now numbered 52, with only 11 members living in Ventura. He then reported that Ventura's other Protestant churches also suffered from small congregations, saying, "The Catholics have the larger part of the people because they are Spanish… So we have plenty of material unworked."[7]

Hamilton made a misstep in September of 1903, when he stated that U.S. President William McKinley's assassination in 1901 was God's response to the united prayers of the Woman's Christian Temperance Union (WCTU). After making his remarks, he was called a "traitorous-tongued temperance crank" by the *Riverside Daily Press*.[8] The *Los Angeles Times* also chimed in, writing, "The temperance women of Ventura [had] no sympathy whatever with the peculiar views of Mr. Hamilton…and…the minister's remarks, so far as Ventura women were concerned, were without warrant and most unwise, to say the least."[9] Although Hamilton was publicly admonished by his superiors, he remained unrepentant and was replaced in November of that year.

Ventura continued to be a hard-drinking, primarily agricultural town until 1915, when another oil strike brought more settlers. As the city became very wealthy, many of the old Victorian buildings were torn down to make way for other popular architectural styles of the day.

Now housed in an old-fashioned building, St. John's survival depended on the charity and support of its small but loyal congregation that paid for the construction of a basement, kitchen, and dining room. Even so, the church still struggled to remain solvent.

VICTORIAN ROSE BED & BREAKFAST

Reverend Strickland inside the sanctuary in 1927.

In 1939, when the Methodist Episcopal Church, South, merged with two other Methodist denominations, St. John's was rechartered to reflect the new order. However, its membership never exceeded 150 worshipers.[10] In September 1958, after a larger Methodist Church was built four blocks away, St. John's leadership sold their Victorian building to the Faith Baptist Church, an independent sect headed by fundamentalist pastor Norman Gundry.[11] Gundry did not stay long at the church, however, and sometime after 1966, the building fell into the possession of the United Pentecostal Church of Ventura.

By the mid-1970s, all of Ventura's Victorian churches except the United Pentecostal church building had been torn down. Taking note of this, the city designated it in 1977 as Ventura's Historic Landmark No. 27. Two years later, Josie Levander, a Thousand Oaks interior decorator, made a deal with the United Pentecostal minister, who agreed to "relinquish" the building to her if she located and purchased a new building for his congregation.[12] She promptly found a new home

for United Pentecostal, and the congregation moved to its new location. Lavender then took over the old church building, only to discover that it had been significantly altered since 1890. The original lecture room had been divided into two and a door now covered its original fireplace. She also discovered that a wall had been plastered over one of the gothic archways and that another wall had been erected for baptisms in the main sanctuary. Fortunately, the basement still held many of the original pieces that previous owners had removed and stored over the years.

Levander spent about $8,000 restoring the building to approximate its original floor plan. She replaced the rotting wood floor with parquet and had the church's exterior painted white with pink and burgundy trim. Although her original intention was to use the church as a studio for her interior decorating business, she opted instead to turn it into an antique store and wedding chapel called the Victorian Rose, named after the stained glass window over the pulpit.[13]

In 1982, Levander sold the building to photographer Phil Knepper and his wife, Yvonne, who continued to rent it out as a wedding chapel. Over the next two decades, hundreds of couples were married at the Victorian Rose, but the Kneppers never had the money to upkeep the old church.

The choir loft before it was converted into a guest room.

VICTORIAN ROSE BED & BREAKFAST

When Richard and Nona Bogatch bought the Victorian Rose in 1997, they spent hundreds of thousands of dollars on restoration to bring the building up to code. Rather than reopen it as a wedding chapel, they decided to convert it into a five room bed-and-breakfast. "We had to redo everything," Richard told the *Los Angeles Times*, "We repaired the ceilings and roofs; there was no plumbing to speak of. We've probably redone every inch of the building. If we didn't have to patch or repair or replaster it, it got painted or primed and so on."[14]

Part of the major remodeling entailed raising the second floor choir loft so that it could be converted into a guest room called the Emperor's Room. To accomplish this, the original staircase was removed and replaced by a 12-foot spiral staircase that led to a newly constructed Juliet balcony, which then served as the front entrance to the

upstairs room. The back of the sanctuary, beneath the Emperor's Room, was then walled in to create the Timeless Treasures Room. The former ministerial office was converted into the Wisteria Gardens Room, and the old reception room was divided into two separate quarters called the Fleur de Lis Room and the Victorian Rose Room. When the restoration was completed, each of the renovated guest rooms had 11-foot ceilings, Victorian wallpaper, antique furnishings, fireplaces, and televisions. The only room not to have its own private bath was the Wisteria Gardens Room, whose toilet and shower were located across the hall.

The opening of the Victorian Rose Bed & Breakfast on June 25, 1999, generated great local interest, especially for those who had remembered it as a church and wedding chapel. To make ends meet, the Bogatch family lived in the basement, where Nona prepared warm breakfasts for guests in the mornings.

In 2002, the Bogatches rescued another Ventura landmark, the Herbert House, formerly located at 351 E. Thompson Boulevard. The house, thought to have been built around 1874, was the oldest inhabited wood structure home in Ventura. After receiving permission from the city to move the building, the Bogatches carefully dismantled the oldest section of the house and reassembled it behind the Victorian Rose, converting it into their new residence.[15]

While the bed and breakfast continued to operate successfully for a number of years, the Bogatches faced health issues that made it difficult to maintain their business. In 2008, they placed the Victorian Rose and the Herbert House on the market, asking $1,995,000.[16] A year later, Doug Kierbel, an ordained interfaith minister from the Cathedral Church of St. John the Divine in Manhattan, and his wife Teri leased the church to be a New Age sanctuary called A Place of Peace. Decorated with Native American, Far Eastern, and other symbols of world religions, A Place of Peace offered lectures, reflexology, sports massage therapy, weddings, yoga, Reiki, meditation, and miracle workshops.[17] But despite their loyal following, their plans to purchase the building fell through, and the Kierbels moved out in the spring of 2010.

The Bogatches reopened the Victorian Rose Bed & Breakfast in August of 2010. Although it now has fewer antiques, it is still heralded for its beauty, delicious breakfasts, and warm hospitality. However, its future remains uncertain. In 2015, the Bogatches once again placed their B&B on the market, hoping to attract a buyer that will take care of the building. As of this writing, the Victorian church building is still for sale.

Right: Inside the sanctuary of the Victorian Rose Bed & Breakfast in 2012.

PHOTOGRAPHER: CRAIG OWENS

The Hauntings

During the Victorian Rose's tenure as a nondenominational wedding chapel, owner Phil Knepper often worked alone in the building, developing and packaging wedding photos. On several occasions, he left a stack of photos on a counter or table, only to come back the next morning to discover that the stacks had been changed, as if someone had rearranged the photos overnight.[18]

When Richard and Nona Bogatch bought the church in 1997, they were unaware that their building might be haunted. After they received the keys, one of their teenage children invited a couple of friends for a visit. That night, the three teenagers were sitting in the pews and talking when they heard the chain of one of the hanging light fixtures start to buckle. Looking up, they saw the fixture begin to swing in circles, before the chain and fixture mysteriously lifted upward at a 45-degree angle. The teens were so frightened, they ran out of the building. "It was almost like something was trying to scare them away," Nona later recalled.[19]

For the next two years, the Bogatches focused their energies on remodeling the church into a bed and breakfast and neither noticed nor even thought about ghosts. However, before their B&B opened in 1999, a few locals began to ask them if they had heard the rumors that their building was haunted. The Bogatches didn't know what to think at first, but following the Victorian Rose's opening in 1999, a few guests reported hearing a feminine voice singing in the former choir loft and/or felt their feet being massaged in the Fleur de Lis Room. Other

Left: The Fleur de Lis Room.

MODELS: SUSAN SLAUGHTER, HERMAN POPPE AND CRAIG OWENS.
PHOTOGRAPHER: CRAIG OWENS (WITH AN ASSIST BY JERRY BALDONADO).

*This photo was inspired by a story about an irate husband walking into
a guest room to find a ministerial ghost in bed with his wife.*

guests began telling the Bogatches that an unseen presence in the Wisteria Gardens and Timeless Treasures Rooms had gently tucked them into bed, while other guests said that they had actually seen the ghost, which was consistently described as a slender, balding, middle-aged or older man wearing a dark suit.[20] Many believed that the man in black was a phantom minister, especially after they had awakened to see him sternly gazing down at them from the foot of the bed before he vanished.

The most bizarre encounter with this ghost occurred late one night when he materialized and crawled into bed next to a woman soon after her husband had gotten up to go to the bathroom. When the woman's husband returned, he, too, saw the apparition before it suddenly vanished. Another version of this story is that the husband saw the ghost lying on top of his wife before it disappeared. As the story goes, the husband became very upset at the apparition, and then at his wife, too, because she did not share his horror. This was said to have happened either in the Wisteria Gardens Room or the Emperor's Room.[21]

Guests have also reported paranormal behavior in the Fleur de Lis Room, such as room keys and earrings disappearing, then reappearing under mysterious circumstances. All of the rooms have sporadic reports of strange bangs, mysterious footsteps, and electric devices that occasionally turn on and off on their own.[22]

In 2000, Richard Senate, a local paranormal investigator, lecturer, author, and self-proclaimed historian, met with the Bogatches while he was looking for a possible commercial event for the Halloween season. In an article he wrote, "Haunted Church Becomes Bed and Breakfast," Senate claimed that "over the decades rumors clung to the towering church...rumors of ghosts." He went on to describe a "phantom singer who on moonlit nights, would appear in the choir loft singing in a wailing soprano," adding that she might have been "killed on her wedding night" or was the victim "of a tragic fall." He also mentioned another spirit, "a former minister," who appeared "near the pulpit, ready to give just one more sermon to his spectral congregation." Senate also reported that one guest had seen the spectral face of a goddess appearing on a wall of the Emperor's Room, while another guest had had an out-of-body experience in one of the guest rooms. Senate wrote that he "had investigated the old church years ago," but that the only information he could glean from psychics was that the church felt haunted. "Like many historic sites," he wrote, "most of these tales are just that, yarns, told and retold over the years until they achieve a certain respectability."[23]

In October of 2001, Senate and his psychic-medium wife, Deborah, held their Halloween event at the Victorian Rose, offering dinner, a paranormal investigation,

and a séance, which he later mischaracterized in his book, *Ghosts of Ventura*, by claiming that "a team was called into [*sic.*] investigate." Senate then went on to report that one of his guests had witnessed her bed "madly vibrating" and that an apparition (presumably the minister) was seen standing near the bathroom entrance in the Timeless Treasures Room. After claiming that the group had made contact with the spirit of the minister (possibly during a séance), Senate concluded that his "ghost hunt was a success in that it confirmed the old stories were true and the Victorian Rose is indeed haunted."[24]

Though the Bogatches were skeptical of Senate's claims, they certainly couldn't discount the dozens of unrelated experiences of a paranormal nature. One of the more dramatic incidents occurred after a mother checked in with her two small children. As the story goes, one of the children had a pre-existing breathing ailment that prevented her from sleeping well at night. But after a peaceful night's sleep at the Victorian Rose, the girl woke up the next morning with a soaking wet pajama top and no cough, as if someone had gently applied a wet compress to her chest during the night.

Nona also recalled another incident that occurred while she and her husband were living in the basement prior to 2002. "We were watching late night TV, and Richard jokingly said [to the alleged ghosts], 'Okay, guys, you can come downstairs tonight.' You know, jokingly? We had an old Charlie McCarthy doll in one of the spare bedrooms, and we hear this big thump and roll. The head fell off right after he said that and rolled onto the floor."[25]

In January of 2002, paranormal author Rob Wlodarski interviewed the Bogatches about their spectral minister and singing ghost for his book, *California Hauntspitality*. Richard told him that their dog, Teddy, frequently got excited and barked outside the Victorian Rose Room and that the room's doorknob occasionally rattled as if someone invisible were

trying to turn it.[26] According to Nona, guests occasionally find their possessions mysteriously misplaced in that room.

In 2002, the Travel Channel featured the Victorian Rose in a segment of its *Haunted Hotel* series. As the Bogatches and Richard Senate were interviewed, Senate declared that the Victorian Rose was one of the most haunted buildings in California. He also mentioned that the hospitality journals the Bogatches left in each guest room had so many paranormal entries they "read like a horror story." After the episode aired in October 2002, the Bogatches received numerous phone calls from people asking about the singing ghost and the spectral minister. But the TV show brought few overnight guests.[27] Richard Bogatch, meanwhile, began researching the church's history and looking for the identity of the woman who allegedly fell to her death from the choir loft. Richard learned that the only person who had fallen from the choir loft had been a boy, and he had only broken his collarbone.[28]

In 2004, author Leslie Rule wrote about the Victorian Rose's singing ghost, claiming that it might be Lynn Marie Mueller, a 21-year-old Pentecostal singer who was brutally raped and murdered on May 29, 1975, in her rental home next door to the church. Around 9:45 that night, Mueller had left the church after an evening service.[29] Her husband was at work, so she called him around 10:00 and they talked for approximately 15 minutes. No one knows for sure what happened next. Shortly after midnight, Mueller's husband came home from work and found her corpse lying in a pool of blood in their bedroom.

Lynn Mueller's murder was so shockingly brutal that Ventura police called a ten-day news blackout. Detectives Robert Haas and Russ Hayes then announced that they were looking for a blond Caucasian male who was supposedly seen near a white, mid-1960s Chevrolet parked outside of Mueller's house.[30] Mueller's parents and the church posted rewards for information leading to the capture of her killer, but no one came forward. Later, Ventura detectives claimed that their main suspect was a man named Larry Junior Jay, who was arrested and convicted in 1977 for the murder of a barmaid during an armed robbery.[31] Although Jay was sentenced to life in prison, he was never tried for Lynn Mueller's murder. The case remains unsolved.

In her book, *Ghosts Among Us*, Rule quotes Richard Bogatch as saying, "Guests report seeing Lynn in the loft. That's where the choir sang." She also wrote that the ghost either manifests in plain sight or is seen in mirror reflections. The description of the singing ghost, however, does not resemble Lynn Mueller. Instead, the ghost is described as looking like an older woman wearing a long skirt and with her hair in a bun.[32] Rule also interviewed former Ventura resident Norma Jean Campanero, who

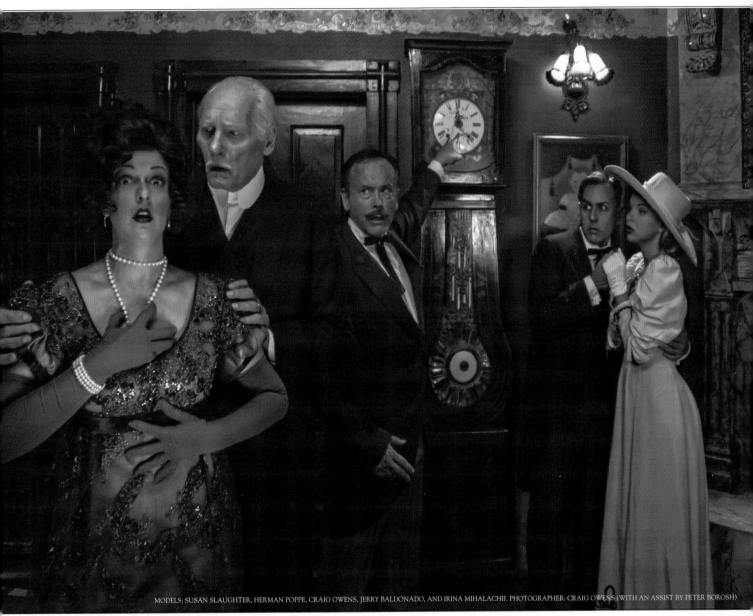

MODELS: SUSAN SLAUGHTER, HERMAN POPPE, CRAIG OWENS, JERRY BALDONADO, AND IRINA MIHALACHII. PHOTOGRAPHER: CRAIG OWENS (WITH AN ASSIST BY PETER BOROSH)

Inside the Timeless Treasures Room.

claimed to have known Lynn Mueller in the 1970s. Campanero described the murdered woman as attractive and having an amazing singing voice. Campanero also noted that Mueller had taught Sunday school, loved children, and had no known enemies.

Rule opined that Mueller's murder might have been connected to a cruel and vindictive (and unnamed) United Pentecostal church leader who might have disapproved of Mueller's dress code and love of rock music and ordered her to wear more conservative clothing. To bolster this speculation, Rule claimed that she had signed testimony from witnesses attesting to the church leader's bothersome character. She also asserted that police detectives should investigate the man's past, as he might have had something to do with the murder.[33] (However, it should be noted that according to the Bogatches, the house next door, where Mueller had actually been murdered, is not thought to be haunted.)

Following the release of Rule's book, Rob Wlodarski brought members of his paranormal group, the International Psychic Research Organization (IPRO), along with the San Diego Ghost Researchers, to the Victorian Rose in December of 2004. Using dowsing rods and psychic medium impressions, the group determined that two ministers, not one, were haunting the old church building. After reaching this conclusion, Wlodarski produced a list of 28 ministers who had served at the church, and asked the spirits to manipulate the dowsing rods to respond yes or no as each minister's name was called. The dowsing rods identified two ghostly clergymen as given in chronological order on the list: Wade Hamilton (No. 8) and S.J. Davis (No. 9), the latter claiming to be 96 years old. Once the rods identified these two spirits, IPRO apparently stopped reciting the other names on their list, leaving 19 ministers' names untested.

Wlodarski next claimed he had encountered the spirit of Lynn Mueller, who told him that she did not want to talk about her death. Instead, she told him she had brought spirit children to the church on their way to the other side. Wlodarski also said that his group had then communicated with the ghost of a Ventura homicide detective whose name sounded like Jim De Santis. Wlodarski alleged that the ghost of the detective told IPRO investigators the murder had been covered up and the slain woman had something to do with the mayor's son. When asked, via the dowsing rods, if De Santis' name could be corroborated by newspaper reports, the rods answered, "Yes."[34] But no one has ever found any records of a Ventura detective by that name, which casts further doubt on Wlodarski's IPRO claims.

By 2006, the Bogatches had grown weary of the many ghost stories being told about their B&B, so they made the decision to stop all paranormal investigations. They said that most of the investigative findings were meaningless and disruptive

to other guests and tenants. "Too many people exploit the paranormal," Nona said. "We didn't want to be in a position to judge people's agendas." The Bogatches asked Senate to stop using their location as a stop on his ghost tours and turned down future requests to investigate the old church building.[35]

In researching the hauntings for this book, Nona arranged for me to interview two friends of hers, Bill and Shannon Jeralds, a couple who have had numerous paranormal encounters at the Victorian Rose.

The Jeralds said that during their first visit to the B&B in 2004, they read their room journal, where past guests had shared their paranormal experiences. When they asked Richard Bogatch about these entries, he dismissively advised the couple not to take the ghost stories too seriously. However, after breakfast the next morning, Shannon went into their room and discovered that all of their belongings left on the bed had been mysteriously placed on the floor... which left them wondering if the stories were true.

Bill and Shannon Jeralds inside their home.

PHOTOGRAPHER: CRAIG OWENS

After the Jeralds moved to Ventura from Los Angeles in 2005, Bill faced a life-threatening illness that eventually brought him back to the Victorian Rose. He had caught a cold that developed into double pneumonia, bacterial sepsis, and acute respiratory distress syndrome, which resulted in a drug-induced coma. Two days later, Bill awoke from his coma and began to fight his way back to health. Suffering from severe memory loss, he began to see what he called his "angel," which he described as an aura of lights that took a human shape. These experiences had a profound effect on him, since prior to his coma, he had no spiritual leanings.

In 2007, Bill got the idea that he should make wooden angels to financially support the family. Shannon thought it was an odd choice, given that he had neither previously demonstrated an appreciation for art, nor shown any artistic talent.

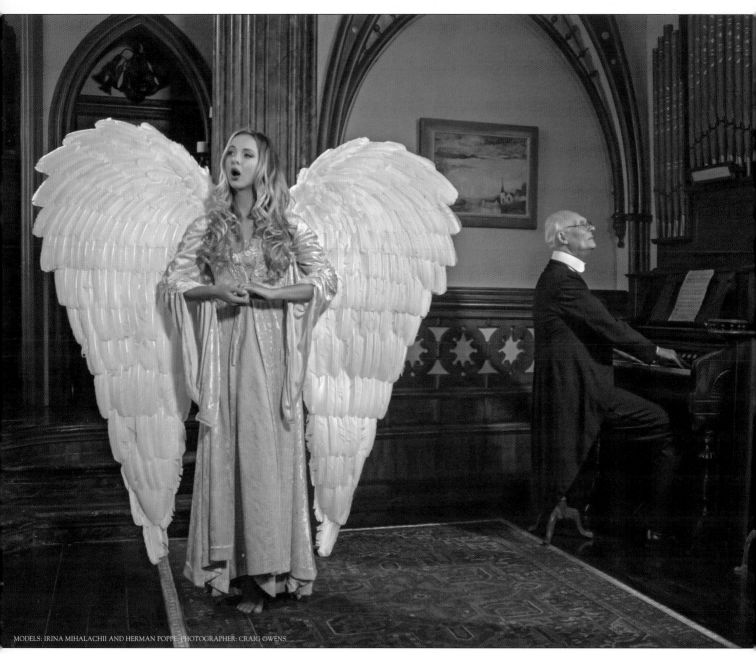

MODELS: IRINA MIHALACHII AND HERMAN POPPE. PHOTOGRAPHER: CRAIG OWENS

Corner of the sanctuary.

However, the Bogatches and the Victorian Rose itself gave Bill the direction he needed. "After my coma I couldn't remember anything," he said. "But when Shannon took me out for a drive, we drove down Main Street and this was the only building I remembered, and I'm, like, 'Shannon, pull over! I have to see these people.' And she said, 'Honey, you've only met them one time. They are not going to remember you.' Then I said, 'I know, but I think I remember them.'"[36]

Bill and Shannon knocked on the door, and Nona graciously invited them in. After hearing about the couple's ordeal, the Bogatches offered Bill a scroll saw, which is used for cutting decorative spiral lines or patterns. The Bogatches also gave Bill a room in the Victorian Rose's basement to use as a workshop.

Bill began to build angels in the Victorian Rose's basement, often staying late in the evenings while Nona baked cookies in the kitchen. Although Bill never saw his angel inside the building, he did experience the paranormal. On more than one late evening when the building was unoccupied, he and Nona heard the sounds of running feet and the occasional slamming door upstairs in the main sanctuary. One late evening when Bill was alone in his workshop, he received a phone call from Shannon to let her in the back door. When he returned to his workshop, he discovered his screwdriver had been bent in half and the metal was still warm.

The Jeralds sometimes spent the night in one of the guest rooms. On one of those occasions, Shannon detected the strong scent of something resembling orange spice cologne in the sanctuary, and that this scent followed her back to her room before disappearing. Later that same night, the couple witnessed an oft-reported phenomenon associated with that room. Shannon recalled, "It was so dark we couldn't even see our hands in front of our face, so we turned on the bathroom light. And I'm lying there, I'm about to fall asleep, my eyes closed, and I feel a hand caressing my hair. I say, 'Honey, thank you so much, that felt so good.' Then Bill says, 'I'm not doing it, but I'm watching it.'"[37] The incident had spooked them enough to spend the rest of the night with all of the lights on.

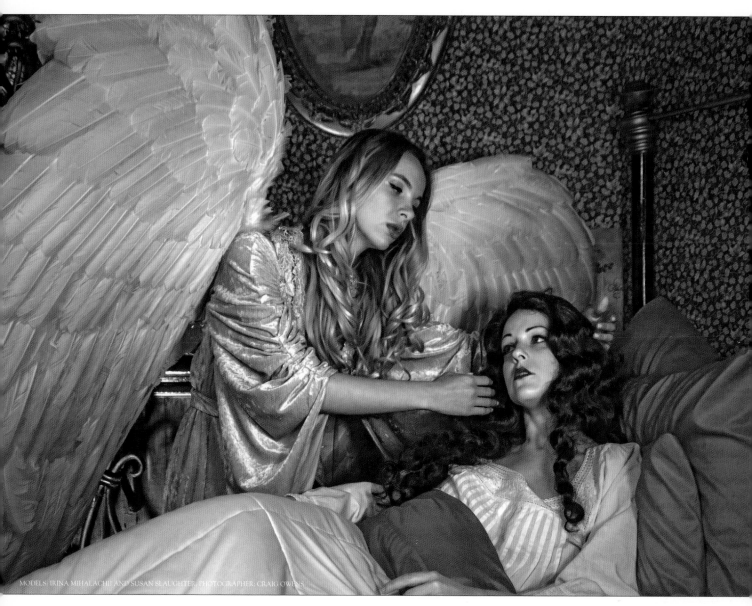

MODELS: IRINA MIHALACHII AND SUSAN SLAUGHTER. PHOTOGRAPHER: CRAIG OWENS

This photo is based on numerous accounts of people's hair being softly stroked by an unseen presence in a few of the guest rooms.

In 2009, after the Victorian Rose had closed and the Bogatches had moved all of their furniture out of the building, Shannon and Bill were staining the floor and listening to music on an alternative rock station when Shannon heard a sound that Bill apparently did not hear. "All of a sudden I hear this Gregorian chant," she recalled. "It was a single voice, and it was just beautiful. I'll never forget it." Immediately after hearing the voice, she searched the building for anything that could have made that sound, but could find no source.[38]

For Bill and Shannon Jeralds, their times at the Victorian Rose between 2007 and 2009 were some of the best times of their lives. Bill's wooden angels were praised for their beauty and craftsmanship, and in 2009, one of his angels was accepted by the Vatican. The Victorian Rose "is such a magical building for me," he said. "I really believe that had I not been given the opportunity to work here, I would have been discouraged. There's something special about this place."[39]

After the Victorian Rose became A Place of Peace, the ghost stories were downplayed and the building was described as a happy, tranquil place where any perceived ghostly energy had been cleansed away through meditation, candle and incense burning, and prayer.[40] This was likely not the case. After the Bogatches retook possession of the property and reopened the Victorian Rose, guests again reported that they were experiencing many of the same, odd, ghostly activities as before. Guests began to comment that their hair had been gently stroked by an invisible hand in the Fleur de Lis Room. Another guest said he had witnessed a newly rewired table lamp turn on by itself.[41] In more recent years, a few guests had heard a mysterious voice calling out their names or the name of a loved one from somewhere inside the building.

While ghost stories continue to fascinate, most overnight guests never experience anything paranormal. In fact, since the Bogatches stopped allowing paranormal investigations, the number of ghostly claims has dropped. Nevertheless, while the Bogatches quietly acknowledge that the unexplainable still occurs from time to time, they also feel that whatever may be lingering is a positive, benevolent energy that means no harm. "People came here during the most devotional times of their lives to worship, to get married, for funerals," Nona said. "I think those emotions, that energy, stayed in the building."[42]

MODELS: NIKKI KVITKY, MARC LIVINGOOD, AND ANDA HAMACHER. · PHOTOGRAPHER: CRAIG OWENS

Three on a light.

Our Shoots

When I first sought permission from Nona to include the Victorian Rose in this book, she was a little hesitant to talk about the ghosts. In fact, she avoided using the word "ghost" altogether, preferring to describe the bed and breakfast as having "guardian angels" who watch over the building and its guests. After I explained the concept behind this book and showed her examples of my photos, she and her husband, Richard, agreed to have us come out.

I reserved all five rooms for a three-day shoot in January of 2012. I then tried to think of different visual themes that might trigger paranormal activity. Rather than go for a spiritual tone, I wanted models to convey passion in subtle and not-so-subtle ways. I also wanted the shoot to be romantic in a way that complemented the decor. For the cast, I chose Anda Hamacher, Chris Jorie, Nikki Kvitky, Marc Livingood, and Renee Paulette. I also brought along Johanna Serrano for hair and makeup.

Left: The spiral staircase and Juliet Balcony.

PHOTOGRAPHER: CRAIG OWENS

The sanctuary's dining table. It was here that model Anda Hamacher (pictured) thought she heard a mystery voice whispering her husband's first name behind her.

Most of the cast stayed at the Pierpont Inn (also in Ventura). However, I asked Renee to stay in the Timeless Treasures Room, while I stayed in the Emperor's Room, so we could keep an eye out for any unusual activity. On our first night's shoot at the B&B, Anda thought she heard a mystery voice whispering her husband's first name as she stood at the dining table in the sanctuary. When I asked Anda if the voice sounded male or female, she replied that she couldn't tell because it sounded like a young teenager. The phenomenon did not happen again, and the shoot continued. However, Chris began to feel increasingly uneasy about portraying a Catholic priest in a former church building, especially a church that never was Catholic. By the end of the second day, I could tell he wanted to leave earlier than planned.

I never felt a strong desire to look for ghosts during this shoot. This is unusual for me. Still, I decided that I should at least conduct one EVP session before the shoot ended, just to see if there was any subtle paranormal activity occurring under the surface. But even that plan never came to pass. On our final evening, I unexpectedly

A cello lesson.

felt chilled and became nauseous, so I decided to set up a couple of audio recorders in the sanctuary and in my room before dragging myself to bed.

As I slept, the audio recorders in the Emperor's Room picked up an occasional male voice that was buried deep in the white noise, or audio hiss, of the recorders. The voice was too faint for me to understand what it was saying or confirm that it was really an EVP. The recorders in the sanctuary captured the sounds of a door opening and movement inside the large room. At another point during the evening, there was a brief series of rhythmic pops, but otherwise, the noises in the sanctuary were nothing more than the creaks and groans of an old wooden building.

The next morning, I awoke with a fever and could barely move. Nona was concerned about my well-being, and Marc, Johanna, and Renee helped me pack my gear into the car. After I said my goodbyes, I drove home. By the time I arrived, I had a 104-degree fever and immediately took a fever reducer and went to bed. Eight hours later, I awoke feeling completely fine, as if the fever had never happened. It was a strange illness, but then again, the entire shoot had been strange.

MODELS: RENEE PAULETTE AND MARC LIVINGOOD. PHOTOGRAPHER: CRAIG OWENS

Months later, I stayed at the B&B while doing historic research on the property. There were no signs of ghosts during these visits, nor did I feel ill. Over time, I grew to love the place for its tranquility and atmospheric charm, but I had also grown increasingly skeptical of its ghostly claims. Then I began interviewing the Bogatches and the Jeralds, who told me their ghost stories at the Victorian Rose. Based on their stories, I found myself wanting to conduct a second photo shoot, this time with a Victorian-angel theme to see if that might draw out the building's alleged ghosts.

In April of 2016, I got my chance. For the second shoot, I asked Jerry Baldonado, Herman Poppe, and Irina Mihalachii to model. I was also fortunate to have Susan Slaughter, a former television cast member of the reality series *Ghost Hunters International* and *Ghost Hunters Academy*, agree to model. Johanna Serrano handled hair and makeup, and cinematographer Peter Borosh assisted with the lights.

On the evening of April 11, Susan, Jerry, Herman, and I recreated a few of the ghost legends in the Fleur de Lis Room, where guests occasionally felt a ghostly hand stroking their hair and/or playing with their feet as they lay in bed. After the shoot

Left: A costume party.

87

PHOTOGRAPHER: CRAIG OWENS

Susan Slaughter lounging inside the Emperor's Room.

ended, we retired to our separate rooms for the rest of the night. The next morning, Susan, who slept in her Victorian nightgown in the Fleur de Lis Room, said that she thought she had felt something pull her toe a couple of times around 7:45 a.m., but that she'd shrugged it off and gone back to sleep.

We resumed our shoot later that morning. Irina spent most of the day dressed as an angel, while Susan wore a red devil suit, and Jerry and Herman dressed as pastors. Once again, there were no obvious signs of paranormal activity.

That night, after we had wrapped and Susan had left for Los Angeles, Herman, Johanna, and I conducted an EVP session in the Fleur de Lis Room. We found no signs of paranormal activity in the room. I then monitored the room noise in the Emperor's Room, where I had earlier photographed Susan wearing vintage lingerie. As I slept in the Emperor's Room, the recorders captured soft voices speaking in the distance, but there was no outstanding proof that these soft voices were paranormal. There was, however, one incident where a mysterious male voice seemed to say, "Watch the man," seconds after I had coughed in my sleep.

While doing research on the property, I could find no positive identification for the phantom minister or the elderly looking female singer. In fact, the majority of the traveling ministers stationed at the church had been young or middle-aged men who went on to live full lives after leaving Ventura. I therefore began to wonder if the older male and female ghosts (assuming that such ghosts existed) might have been former caretakers, possibly a husband and wife or brother and sister team. I also began to wonder if one of the ghosts was that of a child or teenager, who played with guests' feet and, perhaps, was responsible for other, more juvenile, antics like the sound of running feet across the sanctuary. But my guess as to who or what is really haunting the B&B is only as good as the next person's. I have not experienced anything paranormal during my stays there. Still, the believer in me wants to one day hear the singing ghost's Gregorian chant, even if the skeptic in me doubts that I ever will.

MODELS: JERRY BALDONADO AND SUSAN SLAUGHTER. PHOTOGRAPHER: CRAIG OWENS

MODEL: SUSAN SLAUGHTER. PHOTOGRAPHER: CRAIG OWENS

JERRY BALDONADO & IRINA MIHALACHII. PHOTOGRAPHER: CRAIG OWENS

Top left and above: Taken in the sanctuary.
Bottom left: The Fleur de Lis Room.

The Julian Gold Rush Hotel.

3

THE JULIAN GOLD RUSH HOTEL

2032 Main Street, P.O. Box 1856, Julian, CA 92036

The town of Julian, nestled in the Cuyamaca Mountains 60 miles east of San Diego, is best known today for its famous Julian apple pies and its wildflower festival. However, what makes it unique is that it was once a 19th-century gold-rush town.

According to local legend, an African American cattle herder named Fred Coleman discovered traces of a shiny mineral in a creek while riding his horse in the mountains in early 1870. Using a skillet to pan the stream, Coleman discovered that the shiny metal was gold. He then filed a claim and formed the Coleman District, which immediately attracted other prospectors, who panned in what is now known as Coleman's Creek.[1]

In November of 1869, two families, the Baileys and Julians, both originally from Georgia, homesteaded approximately 160 acres of land in a meadow outside the Coleman District. They built log cabins and sowed fields of barley on land that later became the

town of Julian. Their leader was Drury Bailey, a former Confederate soldier who had turned to gold speculating after the end of the Civil War. By February of 1870, Bailey had discovered a quartz ledge, which he named Warrior's Rest. Within days of his discovery, another prospector named H.C. Bickers and his partner, J.T. Gower, found another lode nearby. Because Bickers' discovery took place on a Sunday, he had to wait a day to file his claim, so he named his stake the George Washington Mine in honor of his filing date, which fell on George Washington's birthday.[2]

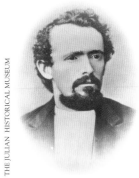

THE JULIAN HISTORICAL MUSEUM

Drury Bailey

Bailey quickly filed paperwork to protect his interests, and on February 15, 1870, the Julian Mining District, named after his cousin Mike Julian, the recorder of the mining camp, was officially established. John L. McIntyre of San Diego was then hired to map the town site, known then as Julian City. During its first year of existence, a saw mill, general stores, a bank, a livery stable, saloons, and a grammar school were constructed, replacing many of the tents that had sprouted up after gold was discovered.

The peak years of the Julian Mining District were between 1874 and 1876, when nearly a hundred mines operating under various names were bringing millions of dollars in gold ore down from the hills. While the miners spent their days tunneling for gold, their women worked in town, teaching, cooking, cleaning, and managing businesses. The Pioneer Hotel opened as the first boarding house in Julian City, followed by the original Julian Hotel, which was owned and operated by George and Katherine Hoskings. (Note: The original Julian Hotel burned down in 1900. It was not the present-day Julian Gold Rush Hotel.)

Though Julian City was a rough, hard-drinking town, there were few gunfights in the streets and just one fatal shooting outside of town. There were, however, fist fights, occasional deaths by mine cave-ins, at least one stagecoach robbery, and an incident in which a Native American was found murdered outside the Julian City jail after he had pled guilty to stealing a mule.[3]

Black settlers of historical importance settled near Julian City in the 1870s. One of them was America Newton, a freed slave woman from Independence, Missouri, who became the town's laundress and made daily trips to and from the mines in a horse drawn buggy. Another Julian City settler was Albert Robinson, also believed to be a freed slave from Missouri, who arrived on April 15, 1872, to work as a farmer.[4] In 1875, Robinson homesteaded land near Eagle's Peak outside of town. Historians believe that he worked a number of odd jobs in the area to supplement his income.

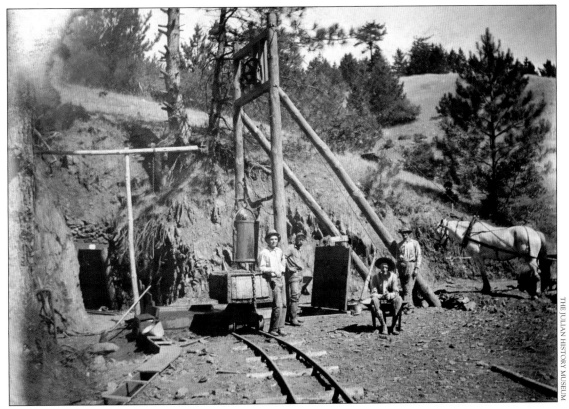

The Washington Mine after Julian's gold rush lost its momentum.

This is partly based on an 1880 U.S. Census that lists Robinson as living in Julian City with a white saloon keeper named Thomas Bundy.

Sometime during the 1870s, a black woman named Susan Tull moved from Temecula, California, to Julian City with her daughter, Margaret "Maggie" Tull Boyd, and a young granddaughter, Martha Boyd. Little is known about their lives before their arrival, except that Susan was the widow of a Temecula farmer named Jesse Tull, the "first colored man ever summoned as a juror in San Diego County"[5] and that Margaret had divorced a man by the name of John Boyd around 1885. U.S. Census records also consistently state that Margaret was born in Missouri.

In the late 1870s, as Julian's gold rush began to wane, the population dropped from an estimated 800 people to around 200. Drury Bailey and a number of other early settlers soon transitioned into agriculture, especially after a farmer named James Madison discovered that the soil around Julian City was excellent for growing apples. By the end of the 1880s, with only a few gold mines still in operation, Julian City became the quiet farming community of Julian.

Albert Robinson and Margaret Tull Boyd married on May 9, 1886. Julian pioneer Alice Barnes, who knew both of them, claimed that Albert was around 40 years old and Margaret was about 26, but U.S. Census records indicate that her age was closer to 33.

Albert tended his farm, where he raised horses, cattle, and possibly chickens, and grew fruit and vegetables. In 1887, the *San Diego Union* reported that he had lost a horse to pink eye[6] and had either owned or leased property on Julian's Main Street, where he had planted peach trees.[7] But surviving historical records only provide

Julian sometime before 1896.

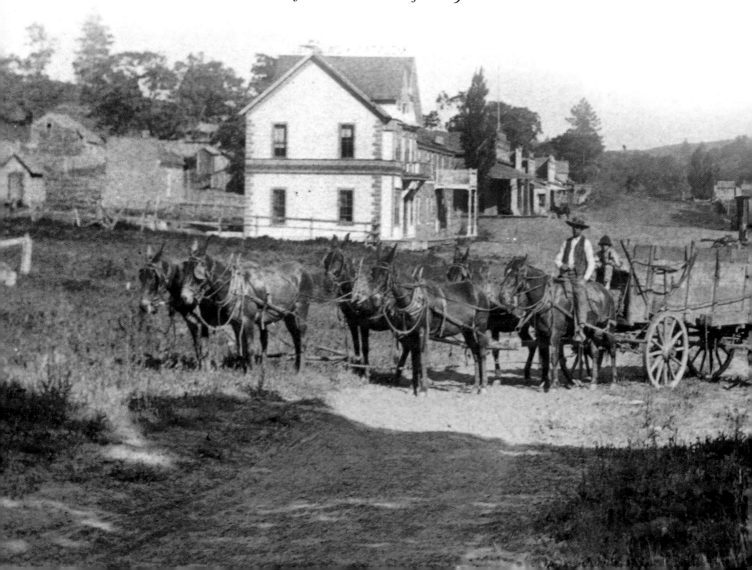

clues as to what the Robinsons actually did in the 1880s and 1890s. In 1894, Margaret Robinson began to buy lots in Julian from her mother, Susan Tull,[8] and Albert and Margaret Robinson purchased a lot on Main Street for $225, a price that suggests that they had bought a building in a prime location.[9]

In 1900, there were two deaths in the Robinson family: Margaret's 19-year-old daughter, Martha, and her mother, Susan Tull. Nothing is known about how they died, but it is generally assumed that both passed away from illnesses at different times of the year.

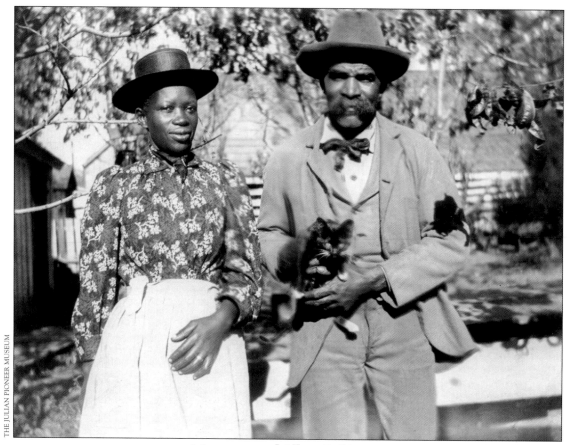

THE JULIAN PIONEER MUSEUM

Margaret and Albert Robinson

While historians have for years believed that the Robinsons operated a bakery/restaurant in 1886 that was torn down and replaced by the Robinson Hotel in 1897, these dates are likely incorrect. In 1899, the San Diego City Directory listed Albert Robinson as the owner of a restaurant, not a hotel. Then in 1900, a fire destroyed the original Julian Hotel, leaving the town with only the Hotel Washington. That same year, the U.S. Census listed Albert Robinson as the proprietor of a boarding house. This distinction was made again in April of 1902, when the *San Diego Union* noted that Julian had one hotel, the Hotel Washington, and two boarding houses, one owned by Albert Robinson, the other by J.H. McCain.[10] However, a little over a month later, on June 9, the San Diego *Evening Tribune* reported that a "new two-story hotel being erected at Julian by Albert Robinson is nearing completion, and is expected to be ready for occupancy by the first of next month."[11] During the time of the construction, Robinson had expanded his land holdings on Main Street by

*Margaret and Albert Robinson pose with friends outside their restaurant and bakery
which is said to have existed on the same site of the Julian Gold Rush Hotel.
The photo was likely taken in the 1890s.*

purchasing three adjoining plots from Drury Bailey for $125.[12] This suggests that the
Robinson Hotel was built in 1902, not 1897. However, it is also possible the new hotel
could have been constructed piecemeal over a period of five years.

The two-story Robinson Hotel, said to have been built by local residents,
C.R. Wellington and F.L. Blanc, offered ten small rooms with double beds, two shared
baths, and a dining room, plus a kitchen, lobby, and parlor. Because the new hotel
had no indoor plumbing, the men's outhouse was located in a barn behind the hotel
and the women's was located a short distance away. Water for bathing, cleaning, and
cooking came from a well located near the outhouses.[13]

Robinson planted cedar and locust trees around the property and added peach
trees taken from cuttings. Later, visitors from back east planted lilacs in front of the

PHOTO: SAN DIEGO HISTORICAL SOCIETY.

The Julian Gold Rush Hotel when it was known as the Hotel Robinson in the early 1900s.

hotel as a gift. The new hotel immediately became a popular establishment in the community, and many of the townspeople visited the hotel every day for their meals.

Margaret, who did most, if not all, of the cooking, was remembered for chicken dinners and her apple pie served with cheese. Louis Juch, who was born in Julian around 1900, told the *San Diego Union* newspaper in 1980 that he remembered Margaret as a "little bit spunky" and recalled a story about her temper. "She had a character rooming here once, a stagecoach driver," he said. "This particular time he came into the hotel kind of cantankerous like. He was mad because his supper wasn't ready and she came out and threatened to beat him with a mop handle. She literally ran him out, she was so mad. He ended up sleeping next to a stable in a pile of warm manure with a canvas cover over him. And then Margaret got conscious-stricken [*sic.*] and invited him back after, I think, three nights and he graciously accepted."[14]

Juch also remembered Albert Robinson as having a kind disposition toward children. "He'd see some kid, maybe he looked like he was hungry, and he would bring him in to eat."[15]

According to county records, Albert stood about 5' 6", and had as an identifying mark a crooked second finger on his left hand,[16] while old-timers remembered him walking with a stoop from an old back injury that they speculated he might have gotten from lifting bales of cotton while he was a slave. One former resident, Keith Ritchie, recalled how Albert used to pick him up (despite Albert's bad back) and carry him into the hotel on his shoulders every time the family visited the hotel for dinner.[17]

The Robinsons never had children, but they took care of a "nephew" named Fernando Dailey, who worked as a waiter in the restaurant. *(Note: Dailey is thought to belong to Margaret's side of the family.[18])*

By this time, Julian had become a quiet, sleepy town, and its citizens were a close-knit bunch who gathered at stores and hotels to play cards, drink socially, smoke, and play occasional practical jokes on one another. Julian's town hall and stagecoach station were located across the street from the Hotel Robinson, and once a month, the community held a dance at the city hall followed by a midnight supper at the hotel.

Albert Robinson in his final years at the Robinson Hotel.

JULIAN PIONEER MUSEUM

101

In 1906, the Robinsons began to advertise their hotel in the *San Diego Union*: "Excellent accommodations for tourists," said one ad. "Automobile parties specially catered to. Table of the finest. Water purist [*sic*]. Scenery grandest. ALBERT ROBINSON, Proprietor."[19] Historians also believe that the hotel had been a stopping place for prominent San Diego citizens, including Lady Bronston, members of La Jolla's Scripps family, Ulysses S. Grant Jr., and a few state politicians. When Albert was asked about the secret of his success, he replied, "I was raised in the South, sah [*sic*]. I knows white folks and how to treat 'em." Juch also recalled Albert working odd jobs around the area to bring in additional income.[20]

In 1906, the hotel offered its guests buggy tours to Lake Cuyamaca and other points of interest.[21] In April of that year, Margaret made a one-dollar contribution to Julian's relief fund to provide aid to San Francisco residents in the aftermath of the great earthquake of 1906.[22] But the summer of 1906 was a lean one for the Robinsons. When a high school student named Olin Blanc shot one of Robinson's cows, Albert pressed charges, asking for the maximum penalty, but this led only to a hung jury and a financial loss.[23]

In October of 1909, Julian held its first Apple Festival across the street from the hotel, and, according to Louis Juch, the event was nearly ruined when a large tent collapsed and forced the hundreds of attendees to move the event into the city hall. Juch credits the Robinsons for rescuing the festival that day by opening their hotel and working around the clock to feed 500 customers. "It was kind of awkward," Juch remembered[24], but the Apple Festival turned out to be a success that attracted an estimated 2,000 visitors.

In 1914, the Robinsons upgraded their hotel by adding imported bathtubs to the shared bathrooms. By this time, Albert's health had begun to fail, and at the age of 69, he became ill and was confined to bed. Dr. Hildreth was called, but Albert's illness grew worse. In shaky handwriting, Margaret was believed to have written in a ledger, "Albert Robinson, Dide [*sic*] June 10, 1915."[25]

With Albert gone, Margaret was faced with the burden of operating the hotel. While she received help from her nephew, Fernando Dailey, the black population in Julian was dwindling. America Newton passed away in 1917, and in 1918, during the First World War, Dailey entered the armed forces and then moved to San Diego following his war service. By the end of the decade, Margaret was thought to be one of the few black settlers still living in Julian. In 1917, she sold the land she had bought from her mother, and in May 1920, also sold the hotel property and a half interest for $1500 to Martin Jacobs,[26] the town's butcher, and his wife, Mary, a schoolteacher. The

Jacobs, who had lived in Julian since the 1880s, were friends of the Robinsons, and earlier real estate transfers suggest that the Jacobs may have helped them financially in the past as a favor.[27]

It is not clear what happened to Margaret following the sale of her hotel. Alice Barnes, the daughter of Martin Jacobs, recalled that "Mrs. Robinson stayed and taught us how to run the hotel for a year, and it was a very nice arrangement because we all got along well and she could stand all of us children. Then after that year was up she went to San Diego and we sort of lost track of her."[28] In 1921, Margaret's deceased mother was still listed as a Julian property tax payer[29] but not in 1922, which suggests that Margaret settled her mother's estate and moved away after her year was up. Margaret's disappearance has long frustrated local historian David Lewis, who has not been able to find out what happened to Margaret after she left Julian.

Shortly after purchasing the Robinson Hotel, the Jacobs renamed it the Julian Hotel.[30] Rather than modernize the structure, the new owners decided to keep it as an old-fashioned memento of an earlier time. Bowls and pitchers of water were placed in every room for washing, and the hotel operated the only restaurant in town. In 1923, the Reverend Roy Campbell, a visitor to the hotel, wrote, "The fact is every man and woman pushing in that doorway with the nervous city haste which the brief ride has

Julian in the 1920s, after the Jacobs had purchased the Robinson Hotel.
The hotel can be seen in the center of the photo.

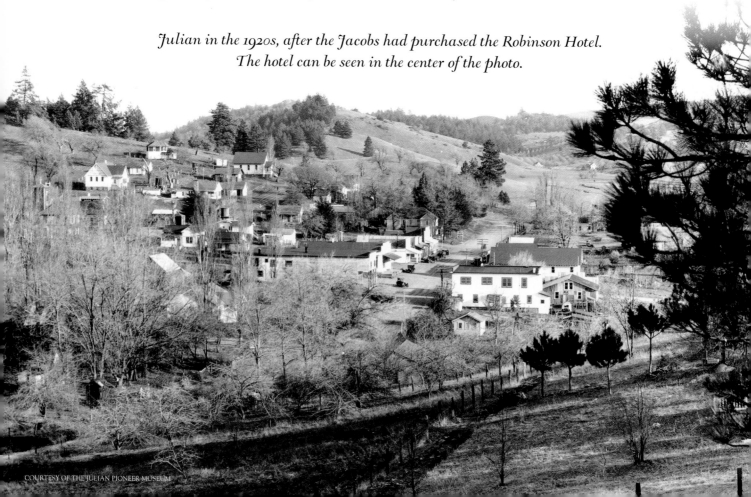

not worn away, ought to be compelled to present references before signing the dingy register. They should give proof that they possess the capacity to appreciate deeply that they are permitted to share an old-fashioned home for which the 'moderate rates' can never, never pay."[31] According to Alice Barnes, the "hotel was the only place to eat in Julian for much of the time. All the news from the city was exchanged there."[32] She also recalled that a number of local women waited tables, cooked, and cleaned when large crowds arrived at the hotel.

By 1929, new roads made it easier for tourists and sportsmen to visit Julian and other nearby points of interest. The annual Apple Festival continued to attract large crowds, and there was briefly a plan to build a modern, three-story hotel along Main Street. But the stock market crash of '29, followed by the Great Depression, turned Julian's promising real estate boom into a bust.

The Julian Hotel, circa 1940s

In January 1930, an unusually heavy snowfall collapsed a couple of barns and knocked out phone service for most of the town. The Julian Hotel also suffered damage when snow accumulation collapsed the roof over the front porch and a small section of the main building while 25 people were enjoying a Sunday turkey dinner.[33] After repairs were made, the Jacobs refurbished the hotel, and by 1935, the dining room/parlor displayed a selection of oil paintings, mostly landscapes by Southern California artists. Indoor plumbing was also added to the building, though it still had shared baths.

In June of 1937, the Jacobs, both in their 70s, turned the hotel over to their son, Raymond, a real estate man, who added a honeymoon cottage behind the hotel. In 1941, Raymond added two new suites on the lower level of the hotel. By this time,

the hotel's history had begun to change. In 1937, for instance, the *Union* newspaper mentioned that the Jacobs had owned the hotel for 17 years,[34] a claim that was repeated in 1938[35] and in 1940.[36] In 1946, the *Union* muddled its history even more by announcing that the hotel was 60 years old and that the Jacobs had owned it for 27 years.[37]

World War II brought fewer visitors to town, resulting in the discontinuation of the Apple Days Festival. The Julian Hotel's restaurant closed in 1945, and in 1946, Gra Donna's Coffee Shop briefly opened in its place, serving full-course meals from 12 noon to 7 p.m.[38] Julian's economy remained sluggish until 1949, when the Julian Chamber of Commerce introduced a new Apple Days Festival, with a large parade, dancing, and tourist events along Main Street. Hollywood character actor Gwinn "Big Boy" Williams led the first parade that year and was made honorary mayor. A reenactment of a stage coach robbery took place in front of the Julian Hotel, and the two-day festival attracted tens of thousands of people.

Despite the growing success of the Apple Festivals throughout the 1950s and 60s, the outdated Julian Hotel went into decline, and in December of 1967, it was sold to Mr. and Mrs. John Nelson of Los Angeles. The Nelson family redecorated the hotel with Victorian wallpaper and furnishings, including velvet covered sofas and chairs, lace curtains, and four-poster beds. The dining room reopened as a country store and gift shop, decorated with washboards, wagon wheels, handmade saws, chandeliers, bookcases, and other antiques.[39]

Although the parade was discontinued for safety reasons in 1971, the Apple Days Festival continued to draw crowds of up to 40,000 visitors each year. Another popular event was Julian's Wildflower Festival, which attracted an additional 10,000 visitors annually. Although the town's success relied on its history and sense of nostalgia, Julian began to lose its old buildings. Concerned citizens banded together to save their town from excessive modernization and in the 1970s, the Nelsons, aided by the Julian Historical Society and a savings and loan company, rescued the Hoskings house, built around 1903-1904, by moving it from its original location on Main and A Streets to a plot next to the Julian Hotel.

In 1975, Jimmie Leach briefly managed the hotel. A year later, the Nelsons sold the Julian Hotel to Steve and Gig Ballinger of Los Angeles, who restored it with a more authentic décor. "A lot of furniture in it when we bought it was not indicative of the period of time," Ballinger told the *San Diego Tribune* in 1978. "It took us awhile to finally furnish it the way we wanted it."[40] The Ballingers opted not to install telephones and televisions in the guest rooms. The main entrance was kept locked, and a small

sign outside read, "For Hotel guests and for people and persons wanting a room."[41] The Ballingers lived in the first floor apartments for nine years, while their two daughters occasionally slept in an upstairs guest room. The dining room and parlor were converted into private family rooms, and the hotel closed every Tuesday so that the family could spend time together and entertain friends.

In 1978, the Julian Hotel was added to the National Registry of Historic Places. Its name also changed to the Julian Gold Rush Hotel. After the Ballingers moved out of the hotel in 1985, walls were knocked down in the original

Louis Juch and Julian Gold Rush Hotel owner Steve Ballinger in the late 1970s.

guest rooms so that private baths could be installed. During the renovation, the Ballingers also expanded the size of their hotel by adding additional guest rooms, and the downstairs kitchen was remodeled so that the original dining room could serve breakfast to hotel guests in the mornings and afternoon tea at 5:00 p.m. Around 2013, a few of the original Hotel Robinson light fixtures were found in a barn. After restoration, the fixtures were installed in the hotel's lobby.

Under the Ballingers' ownership, the hotel remains a time traveler's delight. Each room is furnished with antiques, and has a "secret drawer journal" in which past guests have left comments. A quick glance through these journals reveals comments on Julian's history, apple pies, the hotel's coziness…and the occasional mention of a ghost or two.

The Hauntings

While the Julian Gold Rush Hotel isn't the only location rumored to be haunted in Julian, it is the best known, primarily because it is thought to be haunted by the ghost of Albert Robinson. No one knows for sure when these stories started, but according to historian David Lewis, they were being told as far back as the 1960s, maybe even earlier. These ghost stories were largely spread through word of mouth until the mid-1970s, when *San Diego Union* reporter Craig MacDonald wrote, "Current proprietor Jimmie Leach said that occasionally Albert Robinson's ghost returns to play tricks, like turning out lights, leaving imprints on the beds or closing an open door." MacDonald also wrote that Leach believed that the ghost was friendly and added to the building's "historical charm."[42]

Steve and Gig Ballinger had heard the ghost stories when they purchased the hotel in 1976. Although they did not wish to promote their hotel as being haunted, the press did. In 1978, Mark Briant wrote an article for the *Union* reporting that "a number of longtime residents of Julian...are convinced that Albert Robinson has never left." The reporter identified Room 8

Moni Akiwowo and Clifford Jones as Margaret and Albert Robinson.

PHOTOGRAPHER: CRAIG OWENS

In the dining room.

as the haunted room, though he admitted that "the building transmits every bump, footstep and rattled door, and an inconsiderate guest can wake the entire floor by slamming a single door, as happened to me."[43]

As the ghost stories began to spread, Paula Parker of the *Los Angeles Times* wrote in 1980 that Albert Robinson, because of his race, had not been allowed to be buried in Julian's only cemetery and that his body was buried in an unmarked grave in an unknown location. The article eventually turned into a ghost story in which a hotel housekeeper and caretaker named Dee Baker claimed that she felt that the hotel was haunted by both Albert and Margaret Robinson, whom she described as friendly ghosts. Baker then told the *Times* that she had occasionally smelled fresh-baked bread and cigar smoke in the hotel and had sometimes discovered "fanny prints" on a bed after she had straightened the room.[44] In 1981, Kathryn Phillips of the *San Diego Union* wrote that the ghost of Albert Robinson "occasionally roams the building and occupies Rooms 8, 4 and 5," and that "the current owners, Gig and Steve Ballinger, acknowledge the presence of a friendly ghost."[45]

In 1992, San Diego historian Richard L. Carrico further exaggerated the hotel's ghost legends in his book *San Diego's Spirits: Ghosts and Hauntings*. In a chapter titled "The Julian Hotel: a Ghost of Bigotry," Carrico claimed that back when Albert was alive, "many citizens of Julian carried embers of hatred and racism in their hearts," but that Albert "proved to be an asset to the community and, in spite of his color, gained the respect of all but the most bigoted citizens." Carrico also wrote, "In life, Robinson was tolerated, but in death, he received his final brush with a special prejudice – he was denied burial in the all-white Julian Community Cemetery. (Note: The correct name is Julian Pioneer Cemetery, aka Haven of Rest.) After only a brief community debate on the subject, Robinson's family was told to load the body in a wagon and take it to San Diego for burial 'with your own kind.'" Carrico added to the legend by writing that Albert's grave was located 45 miles west of Julian, and that ever since that time, Albert's "tormented soul never moved out of Room 10 of the hotel," where he allegedly died.[46]

For his book, Carrico interviewed the Ballingers, who were "reluctant to discuss the rumors of hauntings at their hotel," although the family admitted that "unattended windows seem to open and close, unexplained noises emit from empty rooms (especially Room 10), and cold spots suddenly appear in otherwise warm rooms."[47]

Carrico then told a ghost story that he had heard from a couple named Richard and Lynne. As the story goes, one evening when the hotel was closed and the burglar alarms were turned on, the Ballingers and another couple (not Richard and Lynne)

MODELS: ALICE L. WALKER, RENEE PAULETTE, JAMISON TUCKER, AND CLIFFORD JONES. PHOTOGRAPHER: CRAIG OWENS

were playing cards in the dining room when they were interrupted by the sound of footsteps walking down the main stairway. "Looking through the stained glass window that separated the stairs from the dining area," Carrico wrote, "the silent spectators saw a shadow interrupt the colorful light." After seeing the shadow, all four of them searched the empty hotel, but were unable to find any signs of an intruder, which left them baffled.[48]

Carrico also wrote that prior to the Ballingers' ownership, the hotel once had a "malicious" entity haunting the premises, and that "glass mirrors were known to shatter, furniture flew across empty rooms, and fireballs danced in the upstairs windows." Carrico added that the paranormal activity became so disturbing that the owners (perhaps the Nelsons) held an exorcism of the hotel. The poltergeist activity then stopped, leaving Albert Robinson's ghost to wander in peace.[49]

Following publication of Carrico's book, paranormal author Gail White repeated—and distorted—many of Carrico's claims in her book, *Haunted San Diego: A Historic Guide to San Diego's Favorite Haunts.* Instead of fireballs dancing in the windows, White described them as "great balls of fire" shooting through the rooms.[50] She also wrote, "We know from history that [Room 10] is the room Albert

Robinson occupied when he was alive, and many people feel that he has never left."[51] White went on to explain that Albert's ghost didn't like his room to be changed, and was in the habit of moving furniture, hiding items, and slamming doors.

White appears to have altered another ghost story for her book. Instead of housekeeper Dee Baker *smelling* cigar smoke in one of the rooms, White reported that an unnamed maid had *seen* pipe smoke reflected in a mirror. She also claimed that a guest had seen a hazy apparition that looked vaguely human appear for about two minutes. Both of these claims were exaggerated even further by Dennis William Hauck in his book, *The National Directory: Haunted Places*, when he wrote that a housekeeper had seen Albert Robinson's ghost "with a pipe in his mouth, in a mirror reflection in one of the rooms."[52]

White then introduced a new ghost story about an unnamed couple who had experienced the paranormal while walking around the hotel property after dark. "Peering in the window," she wrote, "they saw a menu being studied in anticipation for dinner. They were startled to discover that no one was holding the menu. They walked by later to notice the lacy curtains being pulled apart as if someon [sic.] was looking out. No doubt that was Room 10, and Albert looking over the grounds of his old hotel."[53]

Second floor hallway.

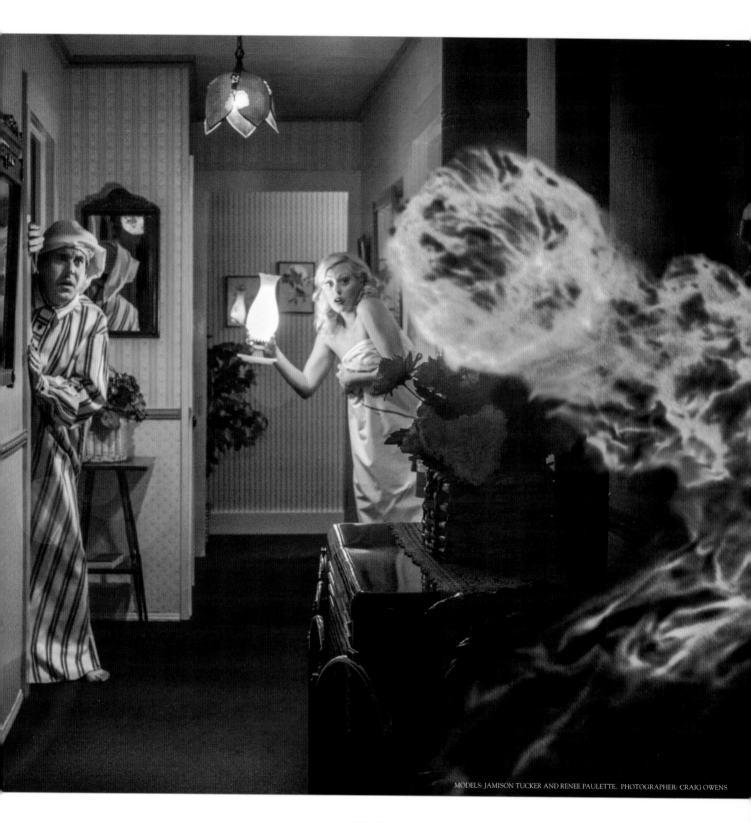

MODELS: JAMISON TUCKER AND RENEE PAULETTE. PHOTOGRAPHER: CRAIG OWENS

The notion that Albert Robinson's ghost haunted his former hotel because of racial discrimination was discredited on January 16, 2005, when historian David Lewis made an important discovery in the "all-white" Julian Pioneer Cemetery, aka Haven of Rest. When I interviewed Lewis about his discovery, he replied, "Almost daily, I would walk the cemetery grounds looking for clues. One morning, I happened to look over my shoulder at an old concrete grave marker and something caught my eye. The sun had just come up and the low angle of the light created shadows on the face of the headstone. Clearly, I could see the name A. Newton [America Newton] with the number 38 in the upper left hand corner of the headstone."[54] Two weeks after Newton's grave was located, Lewis discovered a faded marker with Albert Robinson's name barely legible on it. Excited by his discovery, Lewis searched around the immediate area and soon discovered the markers of black pioneers Susan Tull, Margaret's mother, and Martha Boyd, Margaret's 19-year-old daughter. But there was no sign of Margaret Robinson herself. "The amazing thing about these headstones was that they were 'hiding' in plain sight," Lewis said. "They were never discovered because no one had looked hard enough!"[55] The discovery led to controversy because it rewrote history, and dispelled a commonly held belief. But it also made the Ballingers, the Julian Historic Society, the Julian Cemetery Association, the Julian Merchants Association, and the Casa Del Rey Moro African American Museum extremely happy, and together, they arranged for new headstones and bronze plaques to be placed next to the originals.[56]

When I interviewed members of the Ballinger family and David Lewis about some of the other claims made by Richard Carrico and Gail White, I was told that Room 10 was never Albert Robinson's room, but that he had lived and died in Room 22 on the first floor. When I asked the Ballingers if they had seen a strange figure walking down the stairs while the hotel was closed, Steve admitted that it had happened as described. As for the alleged violent entity and the exorcism, the Ballingers and David Lewis insist that nothing of the sort had ever taken place. The Ballingers are also at a loss to explain Gail White's story about a levitating dinner menu. The dining room never had menus, nor did it serve dinner, and the only menus kept at the B&B are the paper ones provided by local restaurants, which are kept on a table near the base of the lobby stairs. It is thus doubtful that anyone peeking through a window would identify single sheets of photocopied paper as dinner menus.

Even though most of the Julian Gold Rush Hotel's ghost legends, especially the ones about a malevolent entity, appear to be false, the Ballingers still believe that

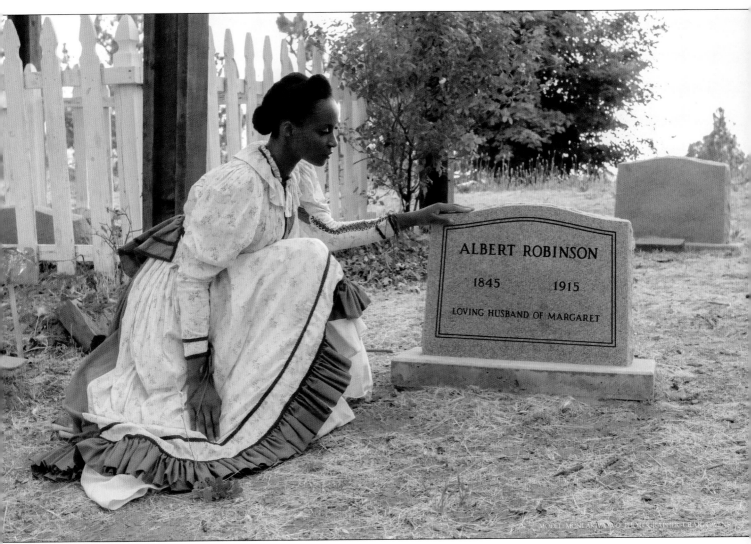

Albert Robinson's grave at the Julian Pioneer Cemetery, aka Haven of Rest.

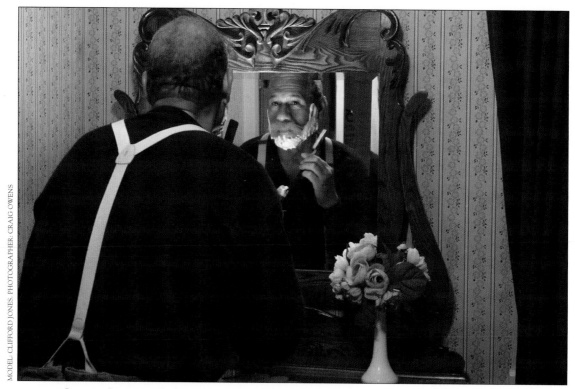

MODEL: CLIFFORD JONES. PHOTOGRAPHER: CRAIG OWENS

Photo taken inside Room 10, where past guests have reported paranormal activity.

Albert's friendly spirit occasionally visits the hotel. The family does not permit paranormal investigations, but they are aware that some of their guests still claim to feel cold spots and unexpected breezes. They also have the sensation of being touched from time to time and see doors suddenly springing open. Several "secret journals" however mention another ghost—a female named Lola—haunting the Julian Gold Rush Hotel. While the name Lola mystifies the Ballingers, it bears a striking resemblance to the name Lula...as in Lula Juch, the very first Apple Days Queen (in 1909) who wore the crown a second time in 1954. Lula was also the mother of Louis Juch, who is quoted earlier in this chapter.[57] But there is another similar sounding name loosely connected to the hotel, that of Lulo Barnes, the mother-in-law of Alice Barnes, the daughter of former owners, Martin and Mary Jacobs. As if that name isn't coincidental enough, I was recently told by a hotel employee that in 2015 a guest spoke about having a psychic impression of a woman named "Alice," connected to the hotel. Alice Barnes passed away in 1996.

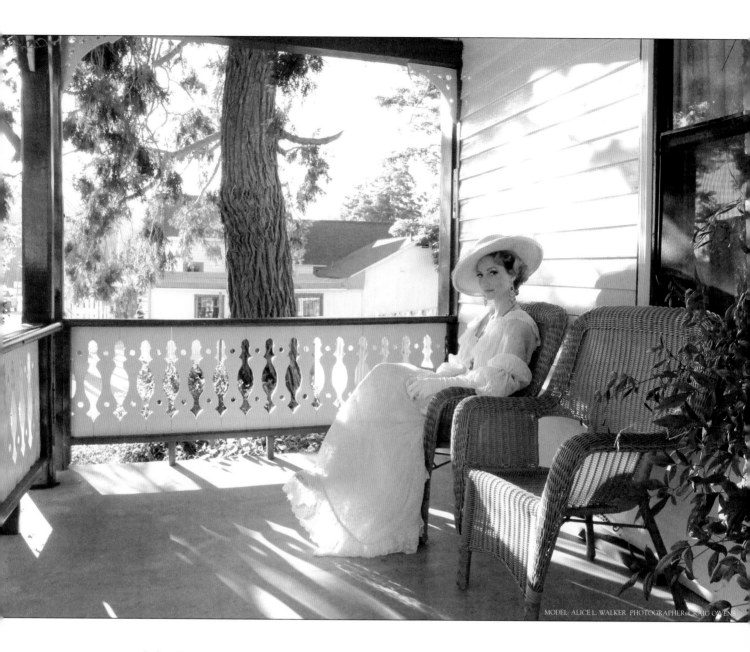

MODEL: ALICE L. WALKER PHOTOGRAPHER: CRAIG OWENS

While the Ballinger family remains tight-lipped about their hotel's ghost legends, they are fine with visitors who feel that these legends add a sense of mystery and adventure to their overnight stays. The Ballingers want visitors to connect with local history and leave the hotel with a sense of how important the Robinsons, gold, and apples are to their community.

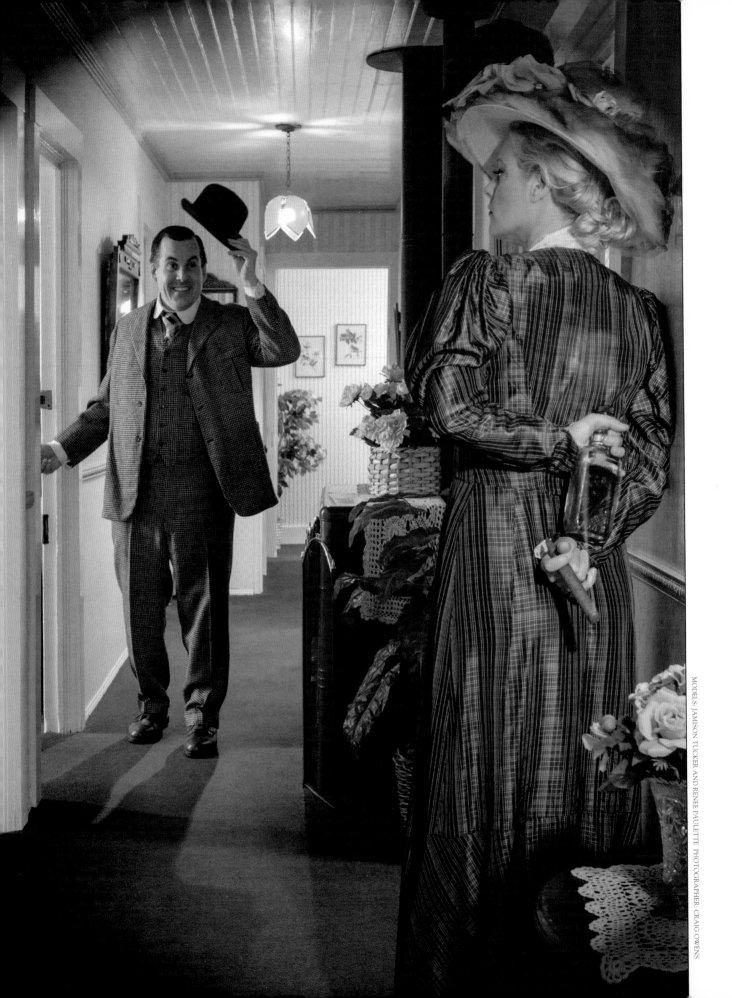

Our Shoot

When I first stayed at the Julian Gold Rush Hotel as a guest, I was immediately taken by its old-fashioned décor and comfort. I also met historian David Lewis, who dropped by the hotel to speak to guests about the hotel's history. He was very gracious about answering my questions. I then approached Steve Ballinger about including the Julian Hotel in this book. He was not at all interested in talking about the ghosts and said that the legends were exaggerated. He also said that he regularly turns down invitations from paranormal investigators and has even declined requests from television news and magazines that have wanted to feature the "haunted Julian Gold Rush Hotel" as part of their Halloween season coverage. Steve and I spoke about how the antique hotel, which is built of wood, creaks and pops with changes in the weather and how the contracting and expanding wood often makes open windows slide closed. We also discussed how cross breezes occasionally opened and slammed doors.

Steve was intrigued by my photos from other hotels, however, and once he understood my eagerness to conduct a photo shoot based on the Robinsons, he allowed

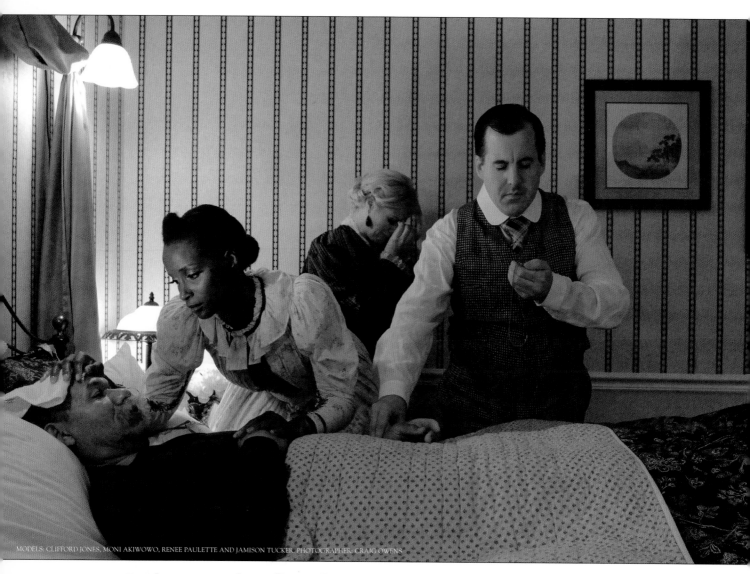

MODELS: CLIFFORD JONES, MONI AKIWOWO, RENEE PAULETTE AND JAMISON TUCKER. PHOTOGRAPHER: CRAIG OWENS

Inside Room 22 where Albert Robinson died. After taking this photo, I was informed by historian David Lewis that in real life, Albert's death was witnessed by Margaret, a doctor, and a female friend, which makes this photo even more compelling, since I was unaware of this fact when I staged this photo.

MODELS: RENEE PAULETTE, JAMISON TUCKER.

Inside Rooms 6 and 7.

me to shoot and gave me the rare opportunity to run a few small paranormal tests...
so long as they did not disrupt business. He also insisted that I would not publish
any paranormal claims without first allowing him to see and hear the data.

I decided to conduct a photo shoot in June of 2012, when the hotel had few guests
and business was slow. I assembled a small, but wonderful cast, including Clifford
Jones as Albert and Moni Akiwowo as Margaret. Renee Paulette, Jamison Tucker,
and Alice L. Walker also came to help, and Johanna Serrano did hair and makeup.

The shoot was small and cozy, and we all stayed in our own separate rooms.
Mine was Room 10, where I had stayed previously. For the most part, we had the
hotel to ourselves and spent the first two days shooting a tribute to the Robinsons,
including a reenactment of Albert's death in Room 22. The staging was a moving
experience for everyone involved, and the cast members began to feel a sense of
sadness and mourning. But there were no signs of paranormal activity during our
EVP session there.

David Lewis came by during our second day and he, Moni, and I walked from the hotel to the cemetery to see Albert Robinson's grave and take a few photos. It was another emotional experience to actually see the grave that was once believed to have never existed. While David is not a believer in ghosts, his passion for history is contagious, and we spent the evening talking about Julian's past.

We ran EVP tests throughout our stay, and for the most part, the results were negative. Just as the Ballingers had warned, the hotel made "old building" sounds at night as the outside temperature grew colder. Floorboards began to pop and creak, many of them sounding like footsteps.

Although we ultimately concluded that these noises weren't paranormal, some hard-to-explain sounds were captured when I planted an audio device in a vase of artificial flowers on a reception table at the foot of the stairs and left it overnight. On two separate occasions, it sounded as though the flowers had moved, but what made the sounds especially odd were the intermittent pops outside the vase shortly before the sound of flowers moving. These intermittent pops sounded like crackling energy.

Throughout the shoot, Jamison and I were hampered by equipment failures. A few programs on our laptop became

Right: Checking in.

124

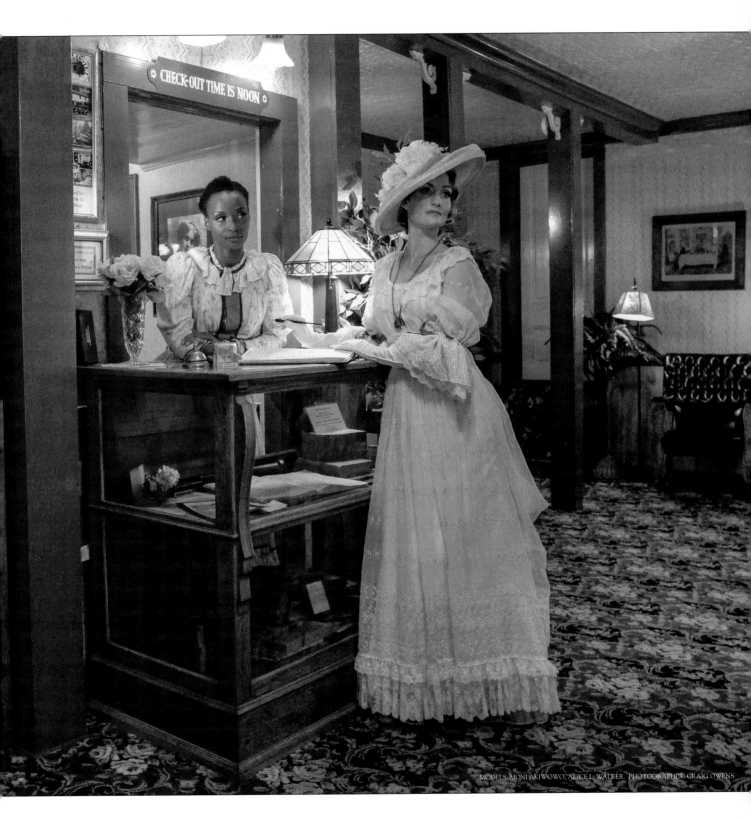

MODELS: MONI AKIWOWO, ALICE L. WALKER. PHOTOGRAPHER: CRAIG OWENS

corrupted, one of my camera disks went bad, and two of our high-end audio recorders malfunctioned, which presented challenges. We had never had this happen at our other haunted photo shoots.

On our final night, after one of the Ballinger daughters mentioned that the honeymoon cottage used to scare her when she was a kid, Renee and I decided to shoot and investigate there. Around 2:30 a.m., as I was carrying audio recorders through the lobby toward the front door, I thought I heard a female voice call out a greeting to me from a corner near the dining room. None of the recorders were running at the time, and I froze in my tracks and looked around the empty lobby. The room was silent, so I retraced my steps to see if a squeaky floorboard could have caused the sound, but I could not reproduce it.

In the honeymoon cottage, Renee and I heard a couple of pops and bangs. One was fairly loud, as if a tree branch had banged against the building. Following the bang, two recorders captured noises that sounded a little like footsteps running away on a wood floor. I went outside and looked around. There were no trees near the building to cause the bang and the air was still. Likewise, the ground wasn't hard enough to have produced the sound of footsteps outside the cottage. Still, the brief series of noises did not fully convince me that we had encountered the paranormal.

Though I walked away with no conclusive proof that the Julian Gold Rush Hotel is haunted, I was thrilled with the photo results. I also came to really enjoy the company of the Ballingers and David Lewis and wished that I could visit with them more often. As for the hotel itself, one doesn't need to look for ghosts to enjoy its vintage appeal or to connect with Julian's history. It's already there.

MODEL: RENEE PAULETTE · PHOTOGRAPHER: CRAIG OWENS

The lobby late at night.

127

The Garden of the B...
Glenwood Mission In...
Riverside - Californ...

4

THE MISSION INN
3649 Mission Inn Avenue, Riverside, CA 92501

The City of Riverside, located about 55 miles east of Los Angeles and about 99 miles north of San Diego, was once a semi-barren strip of land near the Santa Ana River. It had no Native American or Spanish history to speak of, and under Mexican rule, it became a part of the Jurupa Rancho before a section of the land was sold to Louis Rubidoux. In 1869, more than 8,000 acres of former Jurupa and Rubidoux ranchlands became a part of the California Silk Center Association, a business that quickly failed after one of its main owners died.

In 1870, a party of settlers led by abolitionists Judge John Wesley North and Dr. James Greves visited the California Silk Center Association's 8,735 acres of land to see if the site would make a suitable location for an agriculture-based town. After determining that the soil was good for growing citrus crops, wealthy California backer C.N. Felton helped the abolitionists purchase the land on September 15, 1870. The new settlers quickly formed the Southern California Colony Association to oversee the construction of a crude irrigation system and to plan a new townsite. On December 14, 1870, the Association held a special meeting to choose a name for their new town. According to legend, the name Joppa was briefly considered until Felton used his influence to name their new town Riverside.[1]

The new Riverside colony attracted a few undesirable characters who wanted land but didn't want to pay for it. One of them was an abolitionist named Luther C. Tibbets, who squatted on a piece of land outside of town in late 1870 and proceeded to dig his own canal to siphon water from the Association. In 1874, he was joined by his fiancée and future wife, Eliza Lowell, a former Washington, D.C., civil rights reformer who fancied herself a Queen Victoria look-alike and psychic medium.

While the Tibbets were Riverside's most notorious oddballs, they were also responsible for starting the city's citrus boom. Before Eliza left Washington, D.C., she

had persuaded one of her contacts, Bureau of Agriculture Superintendent William Saunders, to ship three Brazilian navel orange trees to Riverside to see if they could produce fruit there. In early 1875, three seedlings arrived and were planted in the

Tibbets' garden. Eliza watered them with dishwater. Unfortunately, one of them was trampled by a cow. The two surviving seedlings were moved to a neighboring property owned by Samuel McCoy and Cyrus Cover, who grafted one of the buds, and planted it in their orchard. The grafted seedling took root, thus producing the United States' first Washington Navel oranges.[2]

In 1884, Christopher Columbus (C.C.) Miller from Tomah, Washington, a former captain in the Union Army, arrived in Riverside to work as a civil engineer/surveyor. After the Southern California Colony Association hired him to expand and improve its irrigation system, CC sent for his wife and their four children, Emma, Frank, Alice, and Edward, who arrived in October of 1884. The family was then joined by a family friend

Riverside's Washington Navel Oranges.

Gustavus Newman another civic engineer, who eventually married Miller's oldest daughter, Emma.

Miller and Newman pooled their money and bought a choice piece of property in downtown Riverside for $250 cash.[3] They then proceeded to build a 12-room, New England-style boarding house made of brick and wood, which they named the Glenwood Cottage. Their first paying guest was Riverside pioneer Albert S. White, a wealthy New Yorker who checked into the boarding house on November 22, 1876.[4] Although the Glenwood Cottage became a popular place to stay, it was too small to accommodate all the visitors coming to Riverside, forcing many prominent guests

to sleep on cots in the barn loft. In 1878, the Millers and Newman expanded the Glenwood Cottage by adding "a spacious dining-room, office, kitchen, row of chambers and cellar,"[5] but the boarding house still couldn't keep up with rising demand.

At that time, the Glenwood property was managed by Mary Ann Miller, who worked as both hostess and housekeeper while her daughter Alice cooked and her son Ed went to school. Their oldest son, Frank Augustus Miller, struck out on his own, operating a mule cart for the nearby Temescal Tin Mine, as well as doing small surveying jobs for his father. Frank saved his money and eventually bought 20 acres of farmland. Then, in 1879, he started his own business, the Blue Front Grocery Store, on Main Street in the heart of Riverside's emerging business area.

Frank Miller, circa 1912.

Newman and C.C. Miller eventually grew tired of the boarding house business, and in August of 1879, C.C. bought Newman's stake in the Cottage for $3,280.[6] When C.C. announced that he, too, wanted to sell out, Frank, who was barely 23 years old, bought the Glenwood property from his father on February 8, 1880, for $5,000, with $2,500 cash down and a note for the balance. Frank then sold his 20-acre farm for $7,300[7] and married his girlfriend of three years, a Riverside school teacher named Isabella ("Bell") Hardenberg, who had lived off and on as a boarder in the Glenwood Cottage while teaching at the local school.

Frank continued to manage his successful grocery store, while his sister Alice managed the day-to-day duties of the hotel. Frank's parents continued to live on the property, and his other sister, Emma, lived with her husband outside of town. Frank's younger brother Ed eventually joined the business, overseeing the Glenwood stables and shuttling guests by wagon to and from the railroad station at Colton, California, approximately 12 miles away.

The Glenwood Cottage continued to attract well-known and influential people, such as future U.S. President William McKinley (then a congressman from Ohio) and Southern Pacific Railroad baron Collis Huntington. In 1882, the Millers spent an additional $10,000 to expand their property, adding 30 more rooms, a living room,

a kitchen, an office, and a parlor. Because the boarding house had increased in size, Frank began to refer to it as the Glenwood Hotel, or the Glenwood Tavern, names that were often interchangeable in ads for his business.

In 1882, Isabella Miller gave birth to a baby girl named Aliss (the name was spelled this way to avoid confusion with Frank's sister Alice). The birth of Frank's only child precipitated other changes to the Miller fortune. By January 1883, Frank had sold his grocery store[8] and in the following year, he built a roller rink, an indoor bowling alley, and an archery range adjacent to his hotel. To supplement his income, he began offering his managerial services to other hotels, and in the spring of 1884, he was hired to refurbish and manage a hotel in Long Beach for the summer season.

In 1885, developers and local politicians, including Riverside trustee Albert S. White, felt that Riverside needed a prestigious hotel that catered to the wealthy, so they began raising money to build a luxury resort near Mt. Rubidoux, about three quarters of a mile from the Millers' property.[9] Frank Miller, who was not involved in the new project, decided to place the Glenwood on the market and announced that he wished to "retire from the hotel business."[10] He then accepted a job managing the Hotel Polmeros in Pomona, where he divided his time between managing his new hotel and working on real estate prospects near Claremont, California. During his absence, his sister Alice married her boyfriend, Frank Richardson. The Richardsons then co-managed the Glenwood in Miller's absence.

But the Glenwood never sold, and a real estate bust in 1888 forced the Rubidoux Hotel project into bankruptcy before it could be completed. Frank Miller came back to Riverside with a renewed determination not to allow another resort hotel project threaten his business. He partnered with Albert S. White to form a real estate company, a move that gave Miller considerable leverage in local politics. His early business dealings, however, sparked anger among Riverside locals, who viewed his actions as being self-serving. For instance, in 1888, after Miller had donated undeveloped land next to his hotel for the construction of a YMCA on condition that he retain the property title, Frank leased the YMCA's top floor to his mother and sister's Christian Science church. In 1889, months after local citizens had voted to make Riverside a dry city, Miller and White persuaded city trustees to pass an ordinance allowing his hotel to serve wine and beer with meals. Facing a potential backlash, Miller refused to stop selling wine and beer at his hotel. He did, however, evict the Christian Science church, preferring to face his mother's and sister's anger over that of the community, which did not view Christian Scientists favorably.[11]

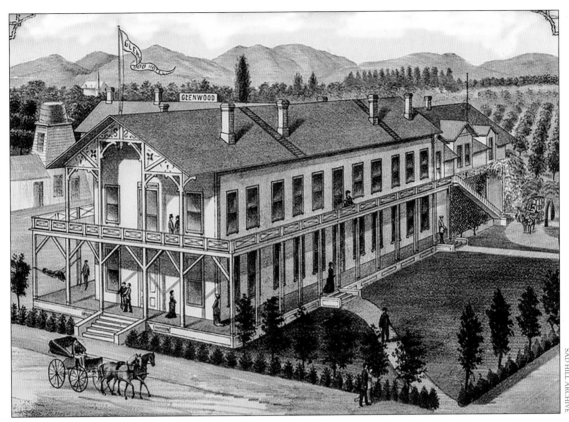

SAD HILL ARCHIVE

The Glenwood Hotel, as depicted in the 1883 book,
History of San Bernardino and San Diego Counties California
with Illustrations by Wallace W. Elliot.

By this time, Miller was fast becoming a political boss, a rise aided by the fact that his hotel still attracted the wealthiest people visiting Riverside. After one of his hotel guests, Charles B. Loring, a millionaire philanthropist from Minneapolis, wrote a scathing letter to Riverside's *Press-Horticulturist* calling the city "very backward,"[12] Miller, White, and Loring introduced a business proposal to Riverside trustees calling for the construction of the Loring Building and Opera House, a mixed-use space for a theater, a city hall, a fire department, a court room, a library, office space, and a basement jail. After the city approved the proposal, the Loring Building was constructed, and upon its completion, Miller and White moved their real estate business into one of its office spaces. Miller also profited from being the opera house's director and booking manager.[13]

In 1891, Miller became a stockholder in the Orange Growers Bank and joined the board of directors of the prestigious Rubidoux Club, further elevating his social

standing. When U.S. President Benjamin Harrison arrived in Riverside for an official visit in 1891, he was met at the Glenwood by nine-year-old Aliss Miller, who offered him a basket of flowers.[14] By this time, Miller promoted himself as a flag-waving Republican who had grown resentful of the City of San Bernardino's Democratic voting block. In 1891, he joined a local delegation sent to Sacramento to introduce a bill calling for Riverside's secession from San Bernardino County. Even though the bill failed on the state Senate floor, Miller became a local hero after word spread that he had engaged in a fistfight with a San Bernardino attorney while in Sacramento.

Politics between the two cities grew nastier. Albert White, who also served as San Bernardino's Third District supervisor, continued to undermine the county by promoting secession.[15] Miller engaged in his own dirty politics by obstructing San Bernardino's criminal investigation of the Southern Pacific Railroad over alleged improprieties. Following Miller's intervention, railroad executives Collis and Henry Huntington made it clear that they owed him a favor. In 1883, Miller returned to Sacramento to ask for secession, this time with the backing of the Southern Pacific Railroad. The state Senate accepted his proposal and Riverside was given its own county. Following Miller's success, the Huntingtons expressed their desire to have full rail access to the new county. Riverside's trustees accepted the railroad's terms, thus forging a longstanding friendship between Frank Miller and railroad executive Henry Huntington.[16]

Following his political victory, Frank, Isabella, and Aliss attended the 1893 Chicago World's Fair, which paid tribute to California's Spanish history and sparked a revival of Mission architecture. In 1894, Miller decided to incorporate the Glenwood Hotel Company so that he could raise enough capital to build a five-story, world-class, Mission-style, luxury resort in Riverside. Riverside taxpayers, however, were reluctant to support his idea, saying there were too many city improvements, such as paved streets and electricity, not being addressed. So Miller partnered with other civic-minded leaders in 1896 to present bids to the city trustees for the paving and electrification of Main Street. After a deal was struck, Miller made sure that all streets, sidewalks, and driveways leading to his hotel were professionally laid and that the Glenwood was electrified with 130 new lights, making it one of the first Riverside buildings to benefit from the new technology.

By the end of 1896, Miller had completed a renovation of his Glenwood property by hanging new Elizabethan-themed tapestries on the walls and installing a glass roof over one of the outdoor verandas to make a new winter sun parlor.[17] Miller then tried once again to win community support for his new resort project by financing

a $5,000 bond and offering to build a wing of the hotel for new county offices. The county supervisors approved the proposal, which led to meetings with Los Angeles architects Theodore Eisen and Sumner P. Hunt, but the project stalled again when Miller failed to raise the necessary $100,000 to start construction. At the end of 1897, Frank Miller and Frank Richardson surprised local residents by accepting an offer from the Pacific Improvement Company, a subsidiary of the Southern Pacific Railroad, to operate the Arcadia Hotel in Santa Monica.

During his two-year tenure in Santa Monica, Miller still dreamed of building a Mission Revival hotel in Riverside. He held a contest to pick a name for his new resort, announcing that his favorite name was Casa La Solana, which means House of Sunshine.[18] He also returned to Riverside in May of 1899 to participate in the electrification of the Riverside and Arlington Railroad, which gave the city its first electric trolleys. After his contract in Santa Monica ended, Miller made Tavern-influenced renovations to the Glenwood by carving arches in the main corridor and adding more plate-glass panels to make the building cheerful and bright.[19] But he nearly lost the Glenwood in January 1900, when a kitchen fire in the north wing destroyed 14 rooms and a portion of the roof, causing several thousand dollars' worth of damage that had to be repaired.[20]

Part of Frank Miller's problem in selling his Mission hotel idea had to do with the fact that Riverside was a new city that had no authentic Spanish or Native American history to attract tourists. Then he got the inspiration he needed after hearing that the federal Indian Affairs Commission wanted to relocate Native American children from a reservation school in Perris, California. He partnered with local politicians and other people of prominence to convince the Commission that Riverside was an ideal location for the new Native American school, thanks to the city's dry laws and employment opportunities in the citrus industry. Although Riverside's proposal was initially opposed, representatives of the Commission changed their minds in 1900 and accepted Miller's offer of a large land tract on the corner of Magnolia and Jackson Streets for the purpose of building the Native American school that later became the Sherman Institute.

Miller immediately converted 23 acres next to the school's site into a new tourist attraction called Chemawa Park, which would later include a polo field, a small zoo, and a racetrack. He also electrified the streetcar tracks running to the site of the new school in time for the Sherman Institute's cornerstone ceremony in July of 1901.[21] Around this time, Miller met with Arthur C. Benton, a Los Angeles architect who had built a new Mission-style building for the First Church of Christ, Scientist

in downtown Riverside. As Miller's passion for the California Mission Revival intensified, he began looking for new thematic ways to link his Glenwood property to the Sherman Institute and Chemawa Park. For instance, after purchasing animals for the park's zoo in 1901, the Millers also bought a South American macaw from a sailor in San Diego and named it Joseph.[22] Joseph the Macaw was then kept on the Glenwood property as a family pet. In February 1902, the Millers purchased five

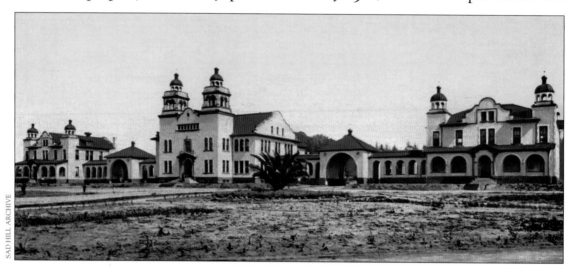

SAD HILL ARCHIVE

The Sherman Institute.

church bells from San Francisco to hang in a Mission-style archway they planned to build either at the Glenwood or in Chemawa Park.[23]

Frank Miller's plans changed, however, after George Reynolds, a member of his Glenwood Investment Company's board of directors, purchased the Casa Palma Hotel, an older building that had formerly been called the Rowell Hotel. Reynolds then paid a secret visit to Henry Huntington in Pasadena to solicit financial help in converting his property into a luxury hotel resort. When Huntington informed Miller of Reynolds' plan, Miller took action, and in late March 1902, Riverside's newspapers ran dual announcements from Reynolds and Miller introducing competing proposals for luxury hotels. Reynolds asked the citizens of Riverside for a bonus of $20,000 to renovate the Casa Palma, while Miller announced that he needed $25,000 to start a brand new $150,000 hotel project that would be completed in time for tourist season.[24]

Miller then paid a visit to Huntington to show him Arthur Benton's new design for a Mission Revival hotel. Huntington was a little hesitant to invest, saying he needed to travel to San Francisco on business to see what kind of monetary

arrangements could be made. A few days later, Miller triumphantly returned to Riverside with a penciled note on a Palace Hotel envelope that read, *Mr. Frank Miller: You can go ahead with your Hotel project as outlined by you. H.E. Huntington.*[25] Upon hearing the news, Reynolds retracted his proposal.

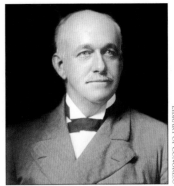

Henry E. Huntington

Construction of the Mission Inn began in the summer of 1902. Arthur Benton' design required most of the Glenwood property to be razed, but not everything was destroyed. The YMCA building remained, and the Millers converted the original Glenwood Cottage into a Mission Revival building called the Old Adobe, which later offered billiard tables, smoking parlors, conference rooms, and (still later) a ladies' tea room. In the meantime, Frank and Isabella Miller traveled for six weeks to eastern parts of the U.S. in search of furnishings and architectural ideas. When the couple returned to Riverside, Miller and Benton made significant changes to the new hotel's design to get an even more authentic California Mission look. But these modifications caused their hotel project to exceed its $150,000 budget, forcing Miller to sign over all of his personal holdings (except his life insurance policies) to Henry Huntington to cover the overages.[26]

On January 22, 1903, the hotel's chimes tower played "America" as the new Glenwood Mission Inn opened its doors. Louis James became the first person to sign the register.[27] Once completed, the four-story hotel, which cost nearly $400,000 to build, offered more than 200 rooms and 100 fireplaces.[28]

In its large courtyard were palm trees, flower gardens, grapevines, and swings. Near the front entrance, and close to Frank and Isabella's living quarters, was the Court of the Birds, where Joseph the Macaw lived. The dining hall had a connecting banquet space called the Refectory (the word traditionally used for dining rooms in monasteries), and the chimes tower played songs like "Last Rose of Summer," "Annie Laurie," "Home Sweet Home," "Nearer My God to Thee," and "Sweet Hour of Prayer" during the evening meal. Although the guest rooms had electric lighting, steam heating, and telephones, they were designed to make guests feel as if they had stepped into history. Miller also strove for homeliness by setting bowls of fresh oranges in every guest room.

Frank Miller struggled to find the best name for his new hotel, alternating between the New Glenwood and the Glenwood Mission Inn, until the end of the 1910s, when the hotel officially became the Mission Inn. He had less trouble choosing

137

St. Francis as the hotel's patron saint, and Benton helped Miller design a Native American rain cross and bell-trapezoid symbol as a marketing brand that was later given to the City of Riverside in 1910 for use as its official symbol.

The opening of the Mission Inn took place a couple of months before the official opening of the new Sherman Institute in March of 1903.[29] The timing was deliberate, and while Miller was proud of his role in bringing the reservation school to Riverside, a few historians have asserted that he did this to exploit the children for personal gain. According to Clifford E. Trafzer, co-editor of *The Indian School on Magnolia Avenue*, "Miller wanted to be associated with Indian students so they could work at the inn and be a part of his pseudo-mission—just like in Old California."[30]

Not surprisingly, the Mission Inn soon became the biggest roadside attraction in Riverside and the town's social hub. While Miller was happy with Benton's work, he still worried about warped boards, paint that washed away after the first rainfall, backed-up toilets and sinks, and electrical shorts. One embarrassing incident was said to have occurred on May 7, 1903, when Theodore Roosevelt became the first U.S. president to spend the night in the Mission Inn's finest suite, which was adjacent to the lobby. According to local legend, a power failure occurred after Roosevelt retired for the night, and when the electricity was restored, hotel employees found the president lying on the floor surrounded by Secret Service agents holding weapons.[31]

Right: The Mission Inn in its early years.

138

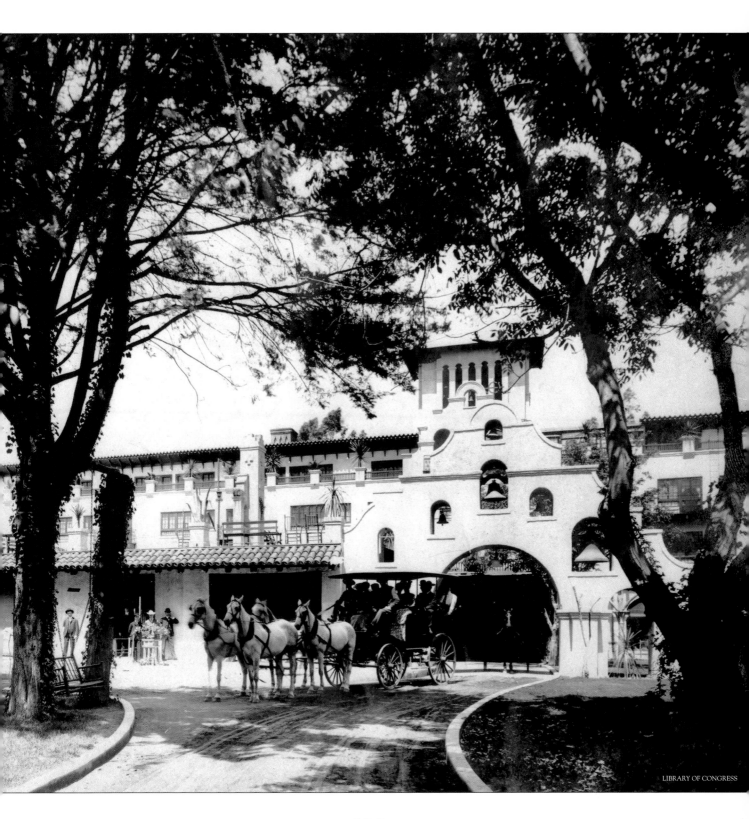

139

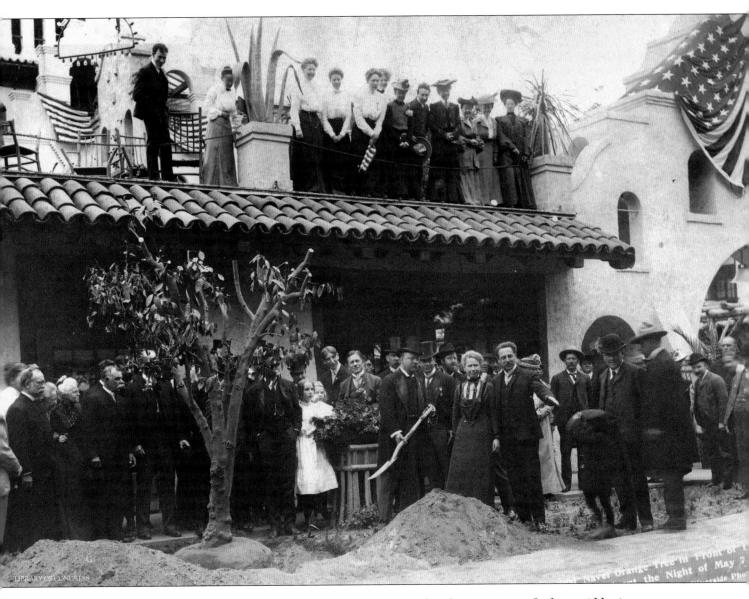

U.S. President Theodore Roosevelt ceremoniously planting one of Eliza Tibbet's Washington navel trees on the grounds of the Mission Inn. Isabella and Frank Miller stand to the right of him.

If the legend is true, Miller refused to let the power failure darken his enthusiasm. The next morning, the president ceremonially replanted one of Eliza Tibbet's original orange trees on the hotel property and a throng of children from the Sherman Institute greeted him. Following Roosevelt's visit, Miller rechristened the president's accommodations the Roosevelt Suite before later renaming it the Presidential Suite.

Although the Mission Inn was an immediate success, Riverside's sweltering summer heat often kept guests—as well as the Millers themselves—from spending the summer months at the hotel. In June of 1904, Frank Miller opened the Lake Tahoe Tavern, a modest Northern California hotel managed by Alice and Frank Richardson during the summer months, while brother Edward managed the Mission Inn. Although Frank Miller also used the summers to scout national parks for potential hotel locations to build his next great hotel, all his plans to build a chain of Mission-themed resorts failed to gain traction.

The Mission Inn continued to undergo modifications. In 1905, the Millers added a separate building behind the hotel to house a new electric plant, a steam laundry facility, and quarters for the female staff. In 1906, the family added an elaborate, Spanish-style garage (managed by Frank's brother Edward) to accommodate ten Stearns automobiles.

Personal tragedy struck the Millers in September of 1906 when Frank Richardson passed away after suffering a series of heart attacks. He was quietly buried in Evergreen Cemetery, and his widow, Alice, took a leave of absence, leaving Edward to handle her late husband's estate and manage the Mission Inn until her return.

During this time, Frank Miller kept busy persuading Henry Huntington to develop Mt. Rubidoux into a tourist destination with the idea of selling it back to the City of Riverside. Together, Miller and Huntington formed the Huntington Park Association and purchased the mountain from S.C. Evans. After Miller failed to get city trustees to pay for the development of a park road, he persuaded Huntington to pay U.S. Army Engineer Colonel Hiram M. Chittenden, who had designed scenic roadways through Yellowstone Park, to build a scenic route. Fifty thousand dollars later, the Huntington Association opened a new, four-mile roadway from the base of Mt. Rubidoux to its summit, which was briefly named Camp Chittenden and furnished with a few antique cannons.

In February of 1907, Miller invited Danish writer Jacob Riis to the Mission Inn to speak at the new road's dedication ceremony. During his speech, Riis suggested that a large cross be planted on Mt. Rubidoux as a fitting tribute to Father Junípero

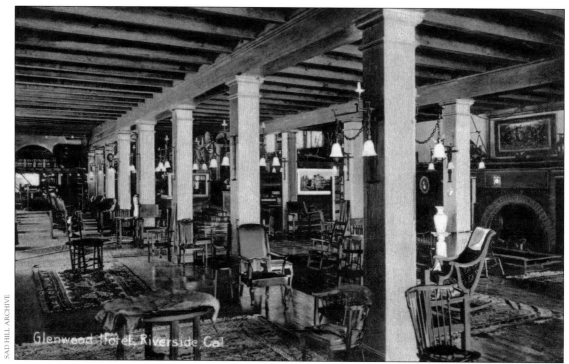

The lobby, circa 1908.

A guest room with a fireplace at the Mission Inn.

Serra, the Franciscan priest who had founded California's missions. Miller loved the idea, and by April a cross was added to the summit, followed by a new dedication ceremony attended by Henry Huntington, Harry Chandler of the *Los Angeles Times*, and Charles Loring. Miller then began charging hotel guests one dollar for an auto trip up and down the mountain during the daytime, plus a small extra fee for picnic and moonlight excursions.

While Miller worked tirelessly to promote his new hotel and Mt. Roubideaux, there was at least one newsworthy incident at the Mission Inn that he could not control. In April of 1907, a fire at the Sels-Foto Circus grounds caused an elephant named Snider to break free of his chains and rampage through downtown Riverside, where he accidentally killed a local woman in front of her home. The frightened elephant then charged toward the Mission Inn and tried to enter the hotel "by

way of the narrow court which leads up to the alcove room outside of the parlor." After smashing his head through a window, Snider rounded a corner and entered the court, knocking over an employee. A circus employee then ran onto the property with a pistol and shot Snider several times in the head, but the superficial wounds only made the elephant angrier. Snider then crashed through the barber shop (close to where the museum now exists), and ran out the front door and onto Main Street, where the elephant was peacefully apprehended, and treated for his wounds.[32]

In the summer of 1907, Frank and Isabella made their first trip to Europe, where they collected a variety of Spanish, Japanese, and Chinese artifacts to exhibit at the inn. Frank Miller was a shrewd negotiator and often got antiquities at cheap prices. After the Millers' return from Europe, several antique bells arrived at the hotel, except for one, the oldest known bell in Christendom, dating back to 1247, which an English antique dealer had mistakenly sold to the Millers for £5. Once the seller realized his error, he tried to give the bell to the British Museum, which prompted Miller to

SAD HILL ARCHIVE

The Miller's two famous macaws,
Joseph and Napoleon.

contact U.S. Ambassador Whitelaw Reid, who advised him to let the museum have it. Infuriated, Miller then solicited the help of his old friend, Wilson Crewdson, a retired director of Oriental exhibits at the British Museum (and a former hotel guest at the Glenwood Cottage in the late 1880s), who convinced the museum to let Miller have it, thus avoiding further trouble.[33] It was perhaps no coincidence that Frank received a second macaw named Napoleon as a gift later that year.

Isabella quietly spent her time making stylistic decisions and tutoring Frank on religious iconography, often accomplishing this by reading to him at night. She never called attention to herself, nor did she feel it necessary to have personal assistants, though she suffered from poor health. After a brief illness, she passed away in July 1908 at the Mission Inn. While the Millers traditionally preferred to have private services, Isabella's funeral was open to the public. Services were conducted at 5 p.m. in the hotel, with Frank, Edward, and Quong Quong (a Mission Inn cook) serving as pallbearers. Riverside closed its businesses out of respect for Isabella's passing, the first honor ever bestowed upon a Riverside woman.[34]

During the weeks immediately following his wife's death, Frank quietly planned new hotel alterations, and in August 1908, he again hired Arthur Benton to construct a row of Mission-style arches along Main Street. His daughter Aliss became romantically involved with a hotel guest named DeWitt Hutchings, a recent Princeton University graduate who had come from New York City for the 1908 winter season.

In February of 1909, Miller announced that the Mission Inn would again expand, this time with the addition of a new Monastery Wing, which later became known

as the Cloister Wing, an annex designed to honor California's missions. At the same time, Miller began courting well-known authors to write flattering descriptions of his hotel and Mt. Rubidoux. In early April of 1909, on their second visit to the inn, Jacob Riis and his wife suggested that the Millers organize a special event, the Early Morning Easter Service, to be held on the summit of Mt. Rubidoux. Days later, a hundred of Miller's friends and hotel guests dutifully gathered at the top of the mountain, and as the sun rose over Riverside, Aliss played "The Holy City" and other hymns and patriotic songs on a portable organ. Miller quickly realized that the Early Morning Easter Service was a highly marketable idea and began to promote religious pilgrimages in Riverside.

Visitors at the summit of Mt. Rubidoux around 1910.

A month after the first Easter service, popular songwriter Carrie Jacobs Bond arrived at the Mission Inn, and after witnessing a stunning sunset from the top of Mt. Rubidoux, she was inspired to write a poem, "A Perfect Day," which was later set to

music. Years after it became a popular song, she dedicated it to Frank Miller, who then promoted it as the Mission Inn's official theme song.

Other visiting authors included Elbert Hubbard, who coined Frank Miller's new official title, "Master of the Inn," and California historian and poet John Steven McGroarty, who was persuaded by Miller in 1909 to write his most famous work, *The Mission Play*, an epic, costume melodrama that retold the early history of Father Serra and the establishment of the California Missions.[35]

The year 1909 held other surprises for the Millers. Frank's long-time friend and former business partner, Albert S. White, passed away in his room at the inn after multiple operations to treat cancer. On September 13, 1909, Aliss Miller and DeWitt Hutchings married. Although Frank attended the small wedding held at the inn, he and the hotel staff were frantically busy making elaborate plans for the arrival of another U.S. President.

When President William Howard Taft visited Riverside on October 12, 1909, Miller arranged for him to be chauffeured to the top of Mt. Rubidoux in the late afternoon to unveil a plaque dedicated to Father Serra. Following the ceremony and a tour of the Sherman Institute, Taft arrived at the Mission Inn for a special banquet held in his honor.

In preparing for Taft's visit, Miller had ordered a custom-made, extra large chair built specifically to accommodate the President's famous 360-pound girth. The oft-repeated story is that the huge chair offended Taft, who forbade any photographs to be taken of him during the banquet. Nevertheless, the president gave a spirited speech about the need to restore and honor California's missions before leaving the inn to attend a military ball in Claremont. After Taft's departure, Miller proudly displayed the presidential "throne" in the lobby.

Frank's romantic life turned a page on December 5, 1910, when he quietly traveled to New York City to marry his long-time secretary, Marion Clark. Marion, who had been employed by the Miller family since 1906, was younger than Aliss, but she was college educated, which no doubt pleased Frank. Marion always referred to her husband as Mr. Miller. Later, Frank attempted to honor his new wife by hiring architect Arthur Benton to build the Mariona, a special house in Laguna Beach named after her.

In 1911, the newly completed Cloister Wing, featuring a large music room with multi-tiered seating for concerts, dances, plays, pageants, banquets, lectures, weddings, and other forms of entertainment, opened to the public. As part of the décor, Miller commissioned three stained glass windows dedicated to the memory of

PHOTOGRAPHER: CRAIG OWENS

The St. Cecilia Windows in the Cloister Music Room depict Frank Miller's late wife, Isabella, and her pet macaw Joseph. The other windows depict orange trees and the Old Adobe.

his late wife, which were set in the wall behind the main stage. The middle window depicted Isabella dressed as St. Cecilia, the patron saint of music, with Joseph the Macaw perched on her shoulder, while the other two windows depicted orange trees and the Old Adobe.

Below the Cloister Music Room's stage was another room, dubbed the Refectorio, which was used for private social gatherings. Connecting the Cloister Music Room to the Refectorio was the Cloister Walk, later known as the Catacombs, which consisted of several underground passageways that showcased Miller's treasures, including his homages to various California missions and Father Serra.

The Cloister Art Shop, located on the main floor of the new wing, sold postcards, books, and antiquities collected by the Miller family. The upper floors offered 45 new guest chambers. On the roof above the Cloister Art Shop was the Garden of Bells, next to the beautiful Ramona Dome, with its series of stained glass windows depicting scenes from Helen Hunt Jackson's novel, *Ramona*. Living quarters and a courtyard for the Miller family were also added to the Cloister Wing's top floor, which also featured the hotel's largest suite at the time, the Alhambra Mirador.

SAD HILL ARCHIVE

The Cloister Walk.

On Sunday evenings, guests were treated to a program of religious music. Anyone who wanted to sing along could purchase a Mission Inn Hymn Book in the Cloister Art Shop. For large banquets, Native American children from the Sherman Institute were brought in to serve punch or perform in their school band. On holidays and other special occasions, Frank Miller, with Napoleon the Macaw perched on his shoulder, wandered through the hotel dressed as Father Serra, though locals playfully greeted him as Father Frank.[36] While Miller's use of commonly accepted religious themes allowed him to attract religious leaders from all faiths, his true religious affiliation remained ambiguous until later in life, when he began referring to himself as the son of a Quaker.[37]

By 1910, Frank Miller had become a politician without an elected office, a religious leader without a church, and a scholar without a degree. When he invited the rich and famous to Riverside, they were welcomed, usually with a complimentary (or discounted) suite, a banquet held in their honor, and a personalized guided tour of Mt. Rubidoux, Chemawa Park, and the Sherman Institute. Through the years, the hotel welcomed Andrew Carnegie, William Jennings Bryan, Helen Keller, William Randolph Hearst, Booker T. Washington, Harvey Firestone, and Henry Ford. The hotel also catered to top entertainers who performed at the Loring Opera House, including Madame Helena Modjeska, Sarah Bernhardt, Lillian Russell, W.C. Fields, Alla Nazimova, Dustin Farnum, Ethel Barrymore, and Mae Robson.

Miller continued to adopt the favorite causes of many of his wealthy friends, particularly if they benefited his hotel. In 1911, a year after Andrew Carnegie created the Endowment for International Peace, David Starr Jordan, president emeritus of Stanford, convinced Miller to hold a Conference for Peace and Arbitration at the Mission Inn. The event catered to scholars, clergymen, politicians, students, and military officers interested in discussing contemporary world conflicts and the

SAD HILL ARCHIVE

A 1913 advertisement for Thieves and the Cross,
the first known movie shot at the Mission Inn.

challenges of bringing and/or restoring peace to war-torn countries. As an added attraction, Miller purchased a large pipe organ and installed it in the Cloister Music Room to accompany hymns and showcase classical music.

Hoping to attract tourists who would be coming to San Diego's 1915 Panama-Pacific International Exposition, Miller hired Pasadena architect Myron Hunt in the spring of 1913 to construct a new L-shaped Spanish Wing based on the Moorish, Gothic, and Spanish Colonial designs of a few medieval landmarks that Frank Miller had admired during his travels. One of the outstanding features of the Spanish Wing was the addition of a large replica of a clock Miller had seen in Nuremberg, Germany. The new wing also featured an outdoor Spanish Patio and a large Spanish Art Gallery built to display Miller's finest art treasures as well as temporary exhibits.

Los Angeles filmmakers began to arrive during construction of the Spanish Wing. The first known motion picture to film at the Mission Inn was *Thieves and the Cross*

149

(1913), an action-suspense short written, directed by, and starring evangelist turned filmmaker Lois Weber and her husband, Phillips Smalley. When filming commenced in October of 1913, Miller agreed to play himself in a brief scene, but he withdrew at the last minute, saying that he had to leave town on business.[38]

The Mission Inn soon became a favorite stopover for other film professionals like Mary Pickford, Douglas Fairbanks, Max Linder, Edith Storey, Hobart Bosworth, Carl Laemmle, Geraldine Farrar, Mary Miles Minter, Cecil B. DeMille, Sir Herbert Beerbohm Tree, Charles Ray, DeWolf Hopper, and Clara Kimball Young. Charles Chaplin also spent a Sunday at the hotel in 1917, enjoying the hotel's museums and grounds before returning to Los Angeles for work the next day.[39]

One of the first films shot in the Cloister Music Room was a serial called *The Trey O' Hearts* (1914) starring Cleo Madison, whose character was married in the room.[40] During the production of *A Woman's Awakening* (1917), starring Seena Owen and Alma Rubens, a full film crew and 40 extras staged a party scene in the Spanish Patio.[41] Other films of note that shot at the Mission Inn during the silent era include *Boots* (1919) with Dorothy Gish and Richard Barthelmess,[42] and *The Challenge of Chance* (1919) starring world heavyweight champion Jess Willard.[43]

Not surprisingly, the hotel became a popular setting for weddings. Cleo Madison returned in 1916 to marry in the Cloister Music Room, and in 1918, cowboy star Tom Mix married his fourth wife, Victoria Forde, in the St. Cecilia Oratory.

While Alice Richardson continued to manage the hotel, Frank's daughter and son-in-law, Aliss and DeWitt, managed the gift shop and were often charged with organizing the Early Morning Easter Service and other social functions when not traveling abroad. Aliss gave birth to three children at the Mission Inn: Frank Miller Hutchings (1913), Isabella Hutchings (1915), and Helen Hutchings (1918). After the births of his grandchildren, Frank Miller began to show an interest in children's organizations like the Boy Scouts of America. He also began collecting Japanese dolls to display at the hotel, which further bolstered his civic position as a benevolent pacifist and upstanding family man.

While Miller maintained his association with the Sherman Institute, he no doubt raised a few eyebrows in 1915 when he tried to purchase a San Francisco Panama-Pacific International Exposition Indian village, along with its real-life inhabitants, for the purpose of exhibiting them as a tourist attraction in Chemawa Park. A few scholars contend that even though Miller may have thought he was helping Native Americans, he had a "tendency...to regard Indians as living museum exhibits, rather than residents of the modern world."[44]

Dorothy Gish at the Mission Inn for the filming of Boots *(1919).*

151

*Boots (1919), a lost silent film starring Dorothy Gish utilized the
Cloister Music Room as one of its locations.*

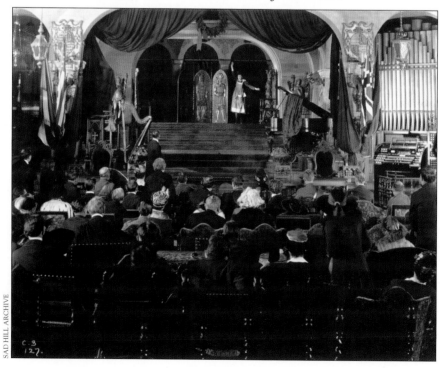

In 1917, as the United States prepared to enter World War I, Miller and other civic-minded local leaders lobbied to establish the Alessandro Flying Training Field, later renamed March Field, in Riverside to train American cadets for aerial combat. Servicemen and pilots of national renown soon became regular visitors to the Mission Inn and following the war's end, Miller instituted an annual Armistice Day sermon on Mt. Rubidoux to honor veterans and promote peace.

Following the end of World War I, John Steven McGroarty wrote a nativity play for the Mission Inn's Cloister Music Room that was performed during the Christmas holidays by key staff members, including Frank Miller as Father Serra and Alice Richardson as a Native American maiden. Children from the Sherman Institute also took part in the pageantry, performing Native American dances for the hotel's wealthy patrons.

Miller continued to collect religious objects, and in the early 1920s, he purchased, sight unseen, a large, early-16th-century, gold-leaf altar from the chapel of the Marquis de Rayas in Guanajuato, Mexico. Miller had it dismantled, packed in straw, and shipped across the U.S. border. But when the altar was painstakingly reassembled at the inn, it did not fit in the space Miller had in mind, so it was displayed instead in the Spanish Art Gallery until he could secure enough money to build a suitable wedding chapel.

The year 1922 was one of losses for the Miller family. Frank's brother Edward passed away after a four-year illness at the age of 58. This was followed by the death of Miller's longtime friend Charles Loring, who died at his home in Minneapolis. A third casualty was Eliza Hewitt's orange tree, which had been replanted by Teddy Roosevelt in 1903.

Overall, the Roaring Twenties was a bustling, booming decade for the Mission Inn. Motion picture stars like Gloria Swanson, Will Rogers, Jack Holt, Hoot Gibson, and Edith Roberts stayed at the hotel, and the Cloister Music Room hosted a number of Hollywood weddings, including Richard Arlen's marriage to Jobyna Ralston, Edna Murphy's marriage to director Mervyn LeRoy, and Marion Nixon's marriage to boxer Joe Benjamin. The hotel also played a small role in a Hollywood tragedy when rising star Charles Emmett Mack, during a break from *The Last Auto*, was killed in a car accident on March 18, 1927, immediately after he had left the Mission Inn to return to work.[45]

In May of 1925, Frank and Marion Miller, accompanied by Alice Richardson, embarked on a tour of Hawaii, Japan, China, and the Philippines. During their absence, prominent friends from all over the country raised money for the construction of a medieval-looking testimonial Peace Tower and Bridge to be built on top of Mt. Rubidoux as a tribute to Miller.

SAD HILL ARCHIVE

A winter visitor to the Mission Inn in the 1920s.

In 1926, Frank Miller co-founded the Institute of World Affairs, which invited scholars and clergymen to speak about the ills of the war to end all wars and the challenges involved in maintaining world peace. He also extended invitations to royalty around the world to visit his hotel, and in July of 1926, Sweden's Crown Prince Gustavus Adolphus and Princess Louise paid a celebratory visit. That same year, Miller expanded his Japanese garden and converted part of the Spanish Wing into the Fuji Kan Room so he could display his Oriental treasures. By this time, he began wearing kimonos and other exotic Oriental attire instead of his Father Serra costume.

Miller's growing preoccupation with Asian cultures no doubt confused many citizens of Riverside. A frugal boss, he had always hired a diverse hotel staff, partly because minority people were cheap labor. But over time, he had also grown to appreciate their cultural differences and world experiences, even though the employees themselves were seldom, if ever, promoted into managerial positions.

Although Miller was revered in most of Riverside's social circles as a man of peace and compassion, he was also a man with more than a few enemies who saw him as a shameless panderer to the wealthy and a political boss who continued to use his influence to get the city to pay for the Mission Inn's publicity. In December 1928, a local newspaper, the *Riverside News*, published a brutally satirical piece that

attacked Miller's alleged practices, both past and present:

The chief attraction and most conspicuous land mark in Graftin, the city beautiful, was the Tiddle-Dee-Winks Inn. This was run by Frankie Buller, who was also the big Boss and political advisor of the Old Gang. Frankie got his start in life as a 'highway-man.' By that we mean he ran a highway road house. It was as a highway man, that Frankie learned the hotel business. The Tiddle-Dee-Winks Inn was the pride of Frankie's heart. He was continually having it repaired and building new additions, which never showed when he got his tax bill each year.

It was rumored by some of the Suckers that you could get anything you wanted at the Tiddle-Dee-Winks Inn: wine, women, or song. Of course, you understand, for a price. Everything at the Tiddle-Dee-Winks

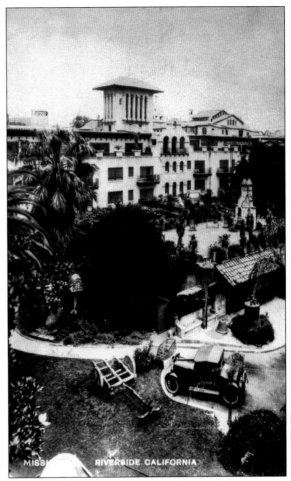

The Mission Inn, circa 1920s.

Inn was for a price. Frankie was strong on that end of the game. Everything always ran smooth at the Tiddle-Dee-Winks except when a bunch of fool Federal officers came around and took Frankie down to the big city, and asked him a lot of questions about his favorite bootlegger.[46]

Miller's political friends were outraged by the political attack, so they shut down the fledgling paper and arrested publishers C.C. Pitts and D.B. Barhart on charges of criminal libel, and any other improprieties that the District Attorney's office could find. After months of intimidation, Pitts and Barhart finally broke down, naming the guilty author. They were also coerced to publicly acknowledge that the article's contents were libelous, and apologized in exchange for their charges being dismissed.[47]

The Carrie Jacobs Bond Room originally served as a club room when it was completed in 1929. Today, it is guest suite 417.

While Miller publicly stayed above the fracas, he more than likely played a role in shutting the paper down. At the time, the *Riverside Daily Press* hinted that the character assassination had been instigated by one of Miller's enemies, Mayor E.M. Dighton,[48] a staunch prohibitionist who had bitterly accused Riverside of being operated by a "Boys' Club." Not surprisingly, the "Boys' Club" retaliated. Soon Mayor Dighton's police chief was arrested for intoxication in nearby Colton. Other scandals followed, which led to the recall of the mayor in 1929 after less than one year in office.

In the summer of 1928, architect G. Stanley Wilson, who had worked under Myron Hunt on the Spanish Wing, was hired to construct six Gothic rooms on the roof of the Spanish Wing, an area then dubbed Authors Row. The corner room, dedicated on February 25, 1929, was named in honor of Carrie Jacobs Bond and used as a club room for women guests, bridge parties, and the occasional wedding. On March 27, 1929, it was also the setting where Japanese prince Tsunenori Kaya, first cousin to Emperor Hirohito, along with the Japanese consul of Los Angeles awarded Frank Miller the Fourth Degree of Merit of Meiji with the Small Order of the Rising Sun on behalf of the emperor.

Months after Miller had received his great honor, the old YMCA building was torn down to make room for the family's last major addition to the Mission Inn, a $500,000 mixed-use, five-floor pergola tower (later dubbed the Rotunda Wing) designed by architect Wilson. Accompanying the pergola tower were a Court of the Orient, a Hall of the Gods, the Ho-o-Kan Room, 15 rooftop bungalows, water fountains, and the St. Francis Chapel and Atrio.

The construction of the new wing couldn't have come at a worse time. The Stock Market Crash of 1929 led to the Great Depression, creating nationwide unemployment and forcing companies out of business. Despite Riverside's economic hardships, however, construction of the new wing continued, and at a stockholders meeting in 1931, the Millers were advised to eliminate all bonuses and borrow the necessary money to complete the chapel. Frank liquidated many of his real estate holdings to help cover the building costs. By late spring of 1931, after the St. Francis Chapel was completed, the Marquis de Rayas altar was moved from the Spanish Art Gallery to its new home. Though the chapel was not sanctified by any religious denomination, Miller had taken great pains to make his sanctuary one of the most ornate wedding venues in Southern California. He even installed nine stained-glass Tiffany windows that had been in the Madison Square Presbyterian Church in Manhattan before that church's demolition. Soon after the chapel opened, an obviously pregnant film star named Gladys McConnell became the first known celebrity to marry there in September of 1931.[49]

Noted guests continued to visit the Mission Inn during the Great Depression. In 1930, the Grand Duke Alexander Mikhailovich, brother-in-law of Russia's last czar, stayed in the Alhambra Mirador Suite, and in the following year, President Herbert Hoover stopped by to present Miller with a bell from the U.S.S. *Sylph*. Other famous guests included evangelist Aimee Semple McPherson, Loretta Young, Vivian Duncan of the Duncan Sisters, and Albert Einstein. Greta Garbo used the hotel as a romantic getaway on at least two occasions, first in 1929 with film star Nils Asther and then in 1931, with a mystery woman named Mademoiselle Jean De Costo (possibly her lover Mercedes de Acosta).[50] The hotel was also frequently used to house stars who were filming in the area. These stars included Richard Arlen, Mary Brian, Tully Marshall, Al Jolson, Clive Brook, Frances Dee, Lila Lee, Gene Lockhart, Mary Boland, Gary Cooper, Howard Hawks, Robert Young, Lionel Barrymore, and Janet Gaynor, the latter two eating their Thanksgiving meal at the inn while filming *Carolina* (1934).

In 1934, Aliss Hutching created a Famous Fliers' Wall in the St. Francis Atrio near the chapel as a fitting shrine to honor the pilots who frequented the hotel. Lieutenant Commander H.V. Wiley was among the first aviators to affix his

St. Francis Atrio
Mission Inn, Riverside, California

*The St. Francis Atrio taken from the
doorway of the chapel.*

autographed copper wing to the wall, which would later honor other distinguished pilots and hotel guests, including Amelia Earhart and Captain Eddie Rickenbacker.

By now, Frank Miller's health was beginning to fail. Although he was still showered with gifts, he rarely attended functions, preferring to send either Marion or Alice in his place. Around midnight on June 15, 1935, he died in his upstairs quarters from cancer, just a few days shy of his 77th birthday. His body rested in state in the St. Francis Chapel, where a private service was held. Although few members of the public were allowed to see Miller's open casket, hotel employees were allowed to pay their last respects. Flags throughout the city were flown at half-staff and businesses were closed in his honor. Hundreds of telegrams and bouquets offering heartfelt condolences to the Miller family arrived from around the world, and eulogies were conducted on Mt. Rubidoux and at March Air Force Field.

Frank Miller left an estate valued at around half a million dollars in 1935. In his will, he requested that "the operation of the inn should be carried on by the family so that the spiritual as well as the material needs of the guests may be served." However, he also called for the appointment of seven trustees to operate the hotel following his guidelines.[51] If the hotel remained in the Hutchings family through 1941, the Mission Inn would become the property of his daughter Aliss, assuming

she was still alive. Otherwise, ownership would fall to Alice Richardson and then to Marion Miller, who was guaranteed a suite, a salary, and possession of the Mariona beach house in Laguna Beach. The listed trustees were Aliss Hutchings, Marion Miller, Alice Richardson, and Frank's three grandchildren, Frank, Helen, and Isabella Hutchings, while the board included *Los Angeles Times* publisher Harry Chandler, printer M.J. Westerfield, former bellboy W.J. (Billy) Herbert, and W.G. Irving.[52] Noticeably excluded from his will was Frank's son-in-law, DeWitt Hutchings.

In late 1935, the Hutchings family, known for their love for air travel, embarked on a world tour. Following their return in May of 1936, the trustees and directors held their first formal meeting, during which Marion Miller was elected president of the directors and Chandler was elected chairman to oversee all business operations governing the Mission Inn. Records suggest that there was early disagreement over policies. When Aliss's children secured liquor licenses to open a cocktail bar, the board immediately voted that hard liquor would not be served to hotel guests and that the inn would continue its traditional practice of serving light wines and beers during meals.[53] Other traditions that were maintained included the Early Morning Easter Service, the weekly Saturday night dance, hotel tours, museum exhibits, and the Institute of World Affairs.

By September of 1936, Alice Richardson had retired as hotel manager and was replaced by E.H. Messereau, who oversaw many refurbishments of the hotel. A new golf course was added at the base of Mt. Rubidoux and the Hutchings softened the religious themes in the Mission Inn's publicity. The mezzanine overlooking the lobby was removed, and the registration desk was reduced in length by half. On Christmas Day 1937, the Mission Inn opened its first cocktail bar, the El Mundo Lounge, which became an immediate success. Seven months after the bar opened, Messereau resigned, followed by Chandler, who stepped down as the chairman of the board and was replaced by DeWitt Hutchings.

Alice spent her final years occasionally playing the role of hostess and being honored by various organizations for her years of friendship and community service. Her health began to decline, however, and in July of 1938, she fell and broke her shoulder. A month later, on August 22, 1938, she suffered a heart attack and passed away at the age of 79 in her quarters at the Mission Inn.[54]

Other changes occurred in 1938. Joseph the Macaw died, and the Hutchings' youngest child, Helen, married at the inn and moved away. In December of 1939, as American sentiment turned against Japan, Isabel and her brother Frank converted

159

part of their grandfather's Oriental Court and the nearby Ho-o-Kan Room into the Lea Lea Room, a South Seas Island supper club.

The hotel still continued to draw an impressive list of famous people, including Hollywood stars Dolores del Rio, Reginald Owen, Norma Talmadge, George Jessell, and June Lang. The Lea Lea Room was said to be a popular drinking spot for Robert Taylor and Bob Hope, who allegedly once soaked his feet in the Lea Lea's koi pond. In 1938, Richard Arlen and Johnny Weissmuller appeared at a golf invitational, and Clark Gable, Myrna Loy, and Spencer Tracy stayed at the hotel during the filming of *Test Pilot*. Richard and Pat Nixon were married in the Presidential Suite in 1940, the same year that a young Stanford student named John F. Kennedy attended the Institute of World Affairs convention in December. In 1942, a large war bond rally brought Mary Astor, Eddie Cantor, and Dale Evans to the inn, followed by a brief visit by Judy Garland and David Rose on their way to Palm Springs for their honeymoon. The St. Francis Chapel also continued to host celebrity weddings, including those of Robert Cummings, Bette Davis, Constance Bennett, Gladys George, and Ken Murray.

The 1940s also saw the beginning of the Mission Inn's decline as Marion Miller sold the Mariona house in 1941, and Frank Hutchings was drafted into the Army Corps of Engineers in 1942. In December of 1943, faulty wiring started a fire that

The St. Francis Atrio and the Fliers' Wall, circa 1940s.

destroyed the Chimes Tower and damaged four guest rooms, a billiard table, and an elevator shaft. While no one was hurt, the damage amounted to $75,000.[55] The Hutchings spent a considerable amount of money rebuilding the tower in 1944, which put a strain on the family's financial resources.

Following his return from military service in 1945, Frank Hutchings became the hotel's vice president. But business at the hotel had changed. Riverside's famous orange groves were being replaced by new housing developments, and the Mission Inn's architecture was deemed passé. In 1948, to attract a younger generation, the Hutchings tore down the Old Adobe to make room for a large Olympic-sized pool, dubbed El Agua Azul. They also modernized the lobby and added a new entrance on Orange Street.

The Mission Inn was used as a movie location in 1950 for *The First Legion*, starring Charles Boyer. By this time, the family's interest in the hotel had waned. Isabel Hutchings had moved out by 1950, followed by her brother Frank. According to Riverside historian Tom Patterson, Aliss remained active, but puttered around the hotel in a house dress, occasionally grumbling that "she had never intended to be a hotel keeper."[56] Because the elder Hutchins needed help running the inn, the family hired a management company to take over. As their last hurrahs, Aliss and DeWitt paid for the installation of revolving, historical California figures in the large replica German clock in the Spanish Wing and the addition of a new bust of Abraham Lincoln for the rotunda. But Aliss and DeWitt's health soon failed, and in the fall of 1952 Aliss Hutchings passed away, followed four months later by DeWitt.

Even though Ronald Reagan and Nancy Davis spent their honeymoon at the Mission Inn in 1952, business declined. In 1953, leading *San Francisco Chronicle* sports writer Bob Stevens dismissively wrote that the famous hotel was now "an art museum with a cocktail lounge."[57] As the family's finances dwindled, Frank, Isabel, Helen, and Marion Miller decided to turn Mt. Rubidoux over to the City of Riverside in 1955. Then on May 18, 1956, newspapers announced that the family had sold the hotel and its treasures to Benjamin Swig, owner of San Francisco's Fairmount Hotel, for an undisclosed price.[58] Two months following the sale of the Mission Inn, Frank Miller's favorite macaw, Napoleon, died of a heart attack in the hotel's dormitory.[59] In late August 1956, a mysterious fire nearly destroyed the Mariona beach house.[60]

New owner Swig paid for an extensive modernization of the Mission Inn that included new carpets, furniture, light fixtures, and a new air conditioning system in the public areas. In 1957, he converted the Presidential Suite into a cocktail bar

called the Presidential Lounge, followed two years later by the opening of a new restaurant called the Squire Arms Grill.

Celebrity sightings became few and far between. In February 1957, film star Linda Darnell was married in the St. Francis Chapel, and Paul Newman was said to have rented the Amistad Suite on the fourth floor during the Riverside International Raceway's largest annual event. One amusing story told through the years is that during one of his stays, Newman had requested the Amistad Suite but was told that it was unavailable because of plumbing problems. Because he liked the Amistad so much, he rented it anyway, along with the suite next to it, so he could use its bathroom for taking showers. As the story goes, word began to spread that Newman was seen wearing only a bath towel as he crossed from one suite to the next, and as the rumor spread, women in the area began to loiter around the fourth floor, hoping to catch a glimpse of the half-naked star.[61]

Swig's attempt to turn business around did not succeed, and so in 1967, he sold the hotel to Goldco and Mission Inn, Inc., a company that went bankrupt in 1969. After Swig repossessed the mortgage, the hotel doors were temporarily padlocked until court-appointed receivers reopened the hotel, restaurant, and art gallery. Even though the Mission Inn wasn't officially listed as being for sale, Swig stated that he would sell his mortgage for $2 million, maybe less, if the deal was approved by the bankruptcy court.[62] When no buyers came forward, rumors circulated that the hotel would be razed, and its treasures sold at auction. These fears were temporarily allayed in October of 1969 when the University of California at Riverside struck a deal with Swig to use the Mission Wing as a temporary dormitory for about 130 students.[63]

There was a glimmer of hope in mid-1971 when the Urban Housing Company, a San Francisco-based company, bought the Mission Inn and embarked on a $2.2 million restoration. By 1973, the hotel had resumed its tours and a handful of rooms were converted into one- and two-bedroom apartments. Later, Urban Housing opened a restaurant and bar, and leased a few retail spaces in the Rotunda Wing.[64] During this time, the hotel became a filming location for *The Wild Party* (1974), starring Raquel Welch, James Coco, and Perry King.

But the Mission Inn was not profitable, which led to employee lay-offs. In an attempt to repay its loans, Urban Housing tried to sell the inn to a group of private investors, who would then lease the property back to Urban Housing. The Riverside Redevelopment Agency nixed this deal, saying that it violated the terms of their $350,000 loan to Urban Housing.[65] When Urban Housing went bankrupt,

A postcard from 1962.

the Connecticut General Life Insurance Company foreclosed on the property in March of 1976.

As rumors surfaced again that the hotel might be torn down, the City of Riverside, at the urging of Friends of the Mission Inn and other grassroots preservationists, purchased it for $2 million and created a new foundation to oversee its operation until a buyer could be found. Exploring every inch of the hotel, volunteers discovered that water seepage in the Cloister Walk had ruined many of Frank Miller's treasures. Water damage and pigeon infestations in the upper floors of the Cloister Wing had also damaged works of art and some of the hotel's original Stickley furniture. Some of these treasures were rescued and restored, while others were sold at auction to help the city recoup its expenses.

During this time, the Mission Inn primarily functioned as affordable apartment housing, a wedding venue, and a restaurant. But it was also a political hot potato, fraught with lawsuits and allegations of embezzlement.[66] In 1985, the Riverside Redevelopment Agency finally sold the Mission Inn to the Carley Capital Group for approximately $3 million. Carley Capital then closed the hotel for an intended two-year, $28 million renovation, and secured a $27.3 million loan from Chemical Bank of New York.[67] Unfortunately, repairs became far more costly than originally

163

budgeted. Earthquake and water damage and erosion of the foundation kept it closed for a total of eight years. The 1909 Mission arches were torn down and replaced by exact replicas. Meanwhile, Authors Row had fallen into such dangerous disrepair that meetings were held to decide whether the original structure should be saved or replaced. In 1987, after a major termite infestation was discovered, the Mission Inn made the Guinness Book of World Records for being the largest building in the world to be tented for fumigation.

By the end of 1988, Carley Capital Group had spent over $40 million repairing the Mission Inn. However, not everyone was happy with the new look. After the company painted the hotel an adobe tan, local residents began to complain that their landmark looked like a really big Taco Bell.[68] The Mission Inn, despite its new look, did not reopen as scheduled. In November, Chemical Bank refused to lend Carley Capital an additional $3 million to complete their restoration.[69] Faced with unpaid loans, the company folded, and Chemical Bank turned the Mission Inn over to one of its subsidiaries, the Henzin Holding Corp., which completed the restoration in July of 1990. By this time, the overall cost of restoring the Mission Inn was around $45 million. Chemical Bank then decided that the hotel would remain closed until a new buyer could be found.

In 1992, the Riverside Redevelopment Agency contacted local venture capitalist Duane R. Roberts and asked if he would be interested in purchasing the Mission Inn. Roberts, a Riverside native who had made a fortune in the 1960s by developing the first frozen burrito, made an offer to Chemical Bank, which agreed to sell the hotel to him for $15.6 million. At 4:45 a.m. on Christmas Eve 1992, the deal closed and Roberts drove from his Century City office in Los Angeles to Riverside to see his new purchase. The Mission Inn's security guards, however, had not been informed of the sale. "No one would let me in," Roberts later recalled. "The hotel looked so beautiful with the sun coming up. I just walked all the way around the place and absorbed that it was mine."[70]

With the help of the Mission Inn Foundation, Roberts opened the hotel a week later, on December 30, 1992, offering approximately 50 rooms (with no room service), one buffet-style restaurant, and the Presidential Lounge, which served non-alcoholic beverages until a liquor license could be obtained. Roberts next paid for cosmetic alterations and furnishings as the hotel returned to full operation. The grand reopening was promoted as a new renaissance for Riverside, and Roberts received accolades as the new Keeper of the Inn. "It can be hard to describe to people who haven't lived in the area," Roberts once said, "but the Mission Inn is just not a building; it's not just bricks and mortar. This place is a living thing and people love it."[71]

PHOTOGRAPHER: CRAIG OWENS

The Ramona Dome in recent years.

Roberts then hired the Windsor Hotel Company to manage the hotel, and soon the Mission Inn began offering Sunday champagne brunches with live jazz and a newly reopened patio restaurant. Although Roberts once said, "There were times when I was writing a check every month that I began to second-guess my decision,"[72] he felt that rebuilding the Mission Inn's business was his way of giving back to the community.

For the 1993 holiday season, Roberts inaugurated the Festival of Lights, which illuminated the entire Mission Inn with 250,000 red, green, and white Christmas lights and 50 animated characters. The following year, he opened Duane's Prime Steaks and Seafood Restaurant, winner of the AAA Four Diamond award. And in 1995, Roberts personally led one of the first walking tours of the Catacombs. Finally, after six years of operation, the Mission Inn showed its first profit.

Because weddings were a major source of income for the hotel, Duane's wife, Kelly Roberts, a businesswoman with a law degree, opened Kelly's Spa at the Mission Inn in 2002, offering personalized European and American-style beauty treatments

aimed at pampering its clientele, as well as a line of botanical beauty products called Kelly's Fountain of Youth Collections.

Beginning in 1999, the Mission Inn began hosting Republican fundraisers for local, state, and national candidates, and in 2003, Roberts introduced a refurbished, modernized, 1,700-square-foot Keeper of the Inn suite located on the top floor of the Rotunda Wing. Although he had originally intended for the new suite to be used by President George W. Bush, the first guests to stay in the suite were Barbra Streisand and her husband, James Brolin. In 2006, bestselling author Anne Rice checked into the Amistad Suite, on the top floor of the Rotunda Wing. Inspired by the location, she wrote her 2009 novel, *Angel Time*, in which Rice describes the Mission Inn in great detail.

The Roberts family continued to make news in 2011, when Kelly Roberts's daughter, Casey Reinhardt, a reality television star from the second season of *Laguna Beach: The Real Orange County*, opened a shop called Casey's Cupcakes at the hotel after she won the "Walk of Fame" contest on another reality television show, *Cupcake Wars*, on the Food Network.

Today, the Mission Inn Hotel and Spa, as it is now called, remains a popular tourist attraction. Libations are offered at the Presidential Lounge and the 54° at Duane's, and High Tea on the Spanish Patio is served daily from 2:00 to 4:00 p.m. The hotel's museum, managed by the Mission Inn Foundation, hosts tours that allow guests to see parts of the hotel that are not accessible to the general public. But the biggest event held at the Mission Inn is its annual Festival of Lights during the Christmas season. This festival has grown over the years and now features an estimated 4 million lights, fireworks, dance performances, horse drawn carriages, and more than 400 animated characters.

PHOTOGRAPHER: CRAIG OWENS

The 16th-century gold-leaf altar inside the Mission Inn's St. Francis Chapel.

167

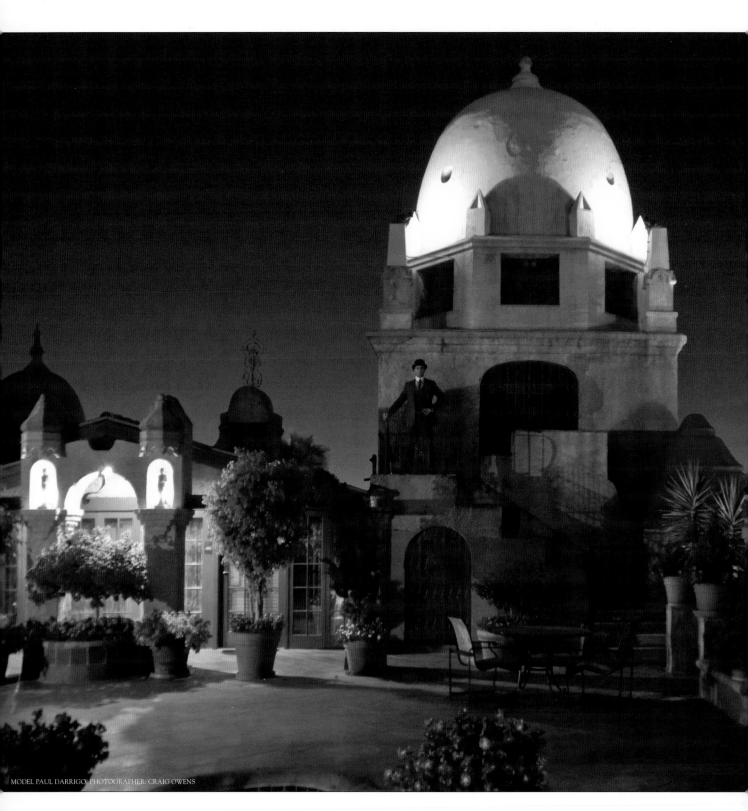

MODEL PAUL DARRIGO. PHOTOGRAPHER: CRAIG OWENS

The Hauntings

Since all of the old California missions are rumored to be haunted, it should come as no surprise that a hotel designed to look like one should have its rumored ghosts, too. And why not? Not only does the architecture stir the imagination, but the hotel property had a fairly high mortality rate.

In the late 19th century, the original Glenwood's confirmable deaths included Frank Miller's father, C.C. Miller, who died in 1889; Jane Vincent in 1894;[73] Frank's mother, Mary Ann Miller, in 1895; and Captain Henry Leslie Blundell and Frank B. Stone, both in 1896.[74] The first death inside the newly constructed Mission Inn occurred in February 1905, when John Leary, a multimillionaire from Seattle, died of heart failure in his sleep.[75]

The Mission Inn's first unusual death occurred in May of 1906, when Alexis Bjornsen, an assistant to Frank Miller, committed suicide in his room by swallowing a lethal dose of morphine.[76] *The San Diego Union* and *Riverside Enterprise* both described him as an extremely charming man

Left: The Mission Inn's fourth floor.

of 47 who had a mysterious past, was fluent in nine languages, and had an extensive knowledge of U.S. geography. Bjornsen used to tell people that he was born in Finland but raised in Poland as an orphan. He also claimed that he was university educated and had contemplated entering the Roman Catholic priesthood before changing his mind and leaving his elderly priest-mentor. Bjornsen said he had traveled around the world twice before relocating to Riverside "after being burned out of his temporary home in Old Mexico."[77] Impressed by Bjornsen's life experiences, Frank Miller gave him a room at the Glenwood Mission Inn, where he (Bjornsen) served as a hotel greeter, congenial host, and occasional travel companion to Miller. During the summer seasons, Bjornsen peddled his courtly charms at the Hotel del Coronado near San Diego, where he was also well liked by hotel staff and guests. *The Riverside Independent Enterprise* once wrote, "It is probable that he enjoyed the acquaintance of more great men than any other resident of California."[78]

Although newspapers speculated that Bjornsen might have suffered from ill health, he acted jovially and was making arrangements to spend the summer of 1906 working at a hotel in Yosemite. A bellboy, most likely Billy Herbert, found his body lying on the bed in his room in late May. Bjornsen left behind a letter addressed to Herbert that read as follows:

> *Dear Billy: There is no one in this world who cares for me. Should anything happen to me I desire that you should have all my effects as a token of gratitude for your kindness to me during the last years of my life. Alexis Bjornsen.*[79]

The coroner ruled that Bjornsen had ended his life by drinking poison. Afterward, Frank Miller arranged for Bjornsen's funeral to be held in the Mission Inn before his body was shipped to Los Angeles for cremation. Bjornsen had always wanted his ashes to be buried in a shallow grave in the Mission Inn's courtyard, but the *Riverside Independent Enterprise* suggested that Miller buried Bjornsen's ashes in the Miller family plot at the Evergreen Cemetery. Herbert then took possession of the dead man's belongings, which apparently included pet birds, potted ferns, $300 cash, and $250 of Mission Inn stock.

The Mission Inn's first reported paranormal activity occurred on July 19, 1908, (the year following Bjornsen's suicide) when Charlotte Foster, a 35-year-old invalid from a wealthy family in Portland, Maine, complained to a night clerk that she had "seen ghosts inside her room."[80] Although the night clerk tried to calm her, he failed to convince her that her room was not haunted. It appears as though her story must have stirred local gossip because a month later, the *Riverside Daily Press* and the

PHOTOGRAPHER: CRAIG OWENS

Model: Patrick Cronen poses by one of the hotel's many antiques on display.

Riverside Enterprise haughtily dismissed Foster's ghost claim by accusing her of being "mentally deranged" after they had learned that she had later leapt out of a third floor window of the Angeles Hotel in Los Angeles.[81]

But if these local newspapers were attempting to quash any gossip of ghosts haunting the Mission Inn, the timing was bad. Eleven days following the publication of both articles, Isabella Miller passed away at the hotel.

The Mission Inn's ghost stories persisted, and on November 21, 1909, the *Riverside Independent Enterprise* printed the following:

> *It is becoming a favorite amusement of the younger guests at the Glenwood Mission Inn to go through the addition in search of the Glenwood Ghost, which is supposed to have already gone in residence in*

the subterranean passages which lies under the cloister floor with ram-
ifications extending the distant points under the various buildings.[82]

By 1911, the Millers had already embraced their hotel's haunted reputation. On New Year's Eve 1911, guests at the Old Adobe, "exchanged ghost stories and tales reminiscent of other New Year's eves."[83] Two years later, in 1913, Frank Miller's son-in-law, DeWitt Hutchings, told "spine-shivering ghost stories" to 30 guests sitting around a campfire on Mt. Rubidoux before leading them back to the hotel.[84] DeWitt also played up the ghost theme later that same year at a party for hotel employees. "Late in the evening," the *Daily Press* reported, "when delicious refreshments of coffee, doughnuts and Bryan cocktails had been served, a weird, white-robed spook appeared and drove [the partygoers] all away. The spook who thus so rudely broke up the party was DeWitt Hutchings."[85] Even Frank Miller got into the act, booking a spiritualist named Dr. Eddy to conduct a séance in the Loring Opera House.[86] Alice Richardson was also thought to have participated in séances at the hotel.[87]

On October 2, 1913, the Mission Inn had another death when Raymond C. McMurtry, a laborer, died from "hemorrhage of the pleura" caused by a cave-in while he was operating a jackhammer during an excavation under the Spanish Wing. Although few details were released about the accident, McMurtry was apparently beneath the hotel at the time, which may indicate that he died in the Catacombs.[88]

Another suicide took place in May of 1929, when a hotel guest named C.E. Van Wormer of Hillsdale, Michigan, apparently fired a .38 caliber Savage revolver into his temple while sitting in the seat of his car at a city park. In the backseat was his hat with a photo of a boy around 12 years old in it. Wormer, who was single at the time, left nearly $1,000 in cash in the dresser drawer of his hotel room, but no suicide note.[89]

Then came the deaths of two of the Mission Inn's most famous personalities, Frank Miller in 1935, followed a few years later by his sister, Alice Richardson. Following Alice's death, a new ghost legend started, possibly by longtime Mission Inn docent May Spiller. In 1939 (the year Spiller began working at the hotel), an older gentleman was given the Alhambra Suite on the fourth floor. As the story goes, the next morning, when an employee asked if the guest was happy with his room, the man stated that he had enjoyed a wonderful night's rest and had especially enjoyed the beautiful singing coming from the adjoining suite...which happened to be the unoccupied former living quarters of Alice Richardson, who had passed away there in 1938.

172

Wax figures of Pope Pius X and his Pontifical Court.

By the 1950s, with the hotel's haunted reputation fairly well established, children used to occasionally sneak into the dank, musty Cloister Walk to look for ghosts and marvel at the macabre furnishings and the deteriorating, lifelike, wax figures of Pope Pius X and his Pontifical Court, which Frank Miller had first put on display in 1918.

The Mission Inn's ghost stories took a different slant, however, during the hotel's worst years of decline, when a saying went around Riverside that "the only thing holding that building up was the ghost of Frank Miller."[90] In 1985, *Los Angeles Times* reporter Louis Sahugan interviewed hotel employees who believed that their crumbling landmark was indeed haunted by members of the Miller family. "In any conversation with hotel staff," Sahugan wrote, "the topic inevitably turned to ghosts, specifically the spirit of Frank Miller, who…is said to pace in Room 413, where he died in 1935." Sahugan quotes an electrician named Lori Larsen, who stated that she thought she had seen a face staring out of Suite 413. Larsen told the *Times*, "I won't go in there alone." Other oddities reported included "cabinet doors found open in locked rooms and light bulbs missing from sockets hard to reach

173

MODEL: PAUL DARRIGO PHOTOGRAPHER: CRAIG OWENS

A fourth floor water fountain.

without a ladder." Sahugan also wrote that a female security guard had quit her job "after hearing footsteps echo eerily behind her in a tiled corridor around the corner from suite 413."[91]

In 1988, Sahugan returned to the Mission Inn after an expensive restoration for a follow-up story for the *Los Angeles Times*. In interviews of the staff, the ghost of Frank Miller was again mentioned. "But Miller's ghost," he wrote, "is anything but a laughing matter for Omni officials, who downplay suggestions that the hotel is haunted." Sahugan asked Vicki A. Derlachter, the hotel's director of marketing and sales, to comment on the Mission Inn's paranormal activity. "Ghosts have a negative connotation," Derlachter replied. "It is not a positive marketing tool."[92]

After Duane Roberts purchased the hotel in 1992, new ghost stories emerged, only this time, they were largely spread through word of mouth. One of the oft-repeated stories involved a desk clerk who resigned in 1992 after witnessing an apparition dressed in early 20th-century clothing walking across the lobby late at night.

Another paranormal incident was said to have occurred in 1993, when a couple on their honeymoon checked out of Suite 402 in the middle of the night after an

MODELS: CHANTEL PARADIS AND NICOLE LORETTA IN THE LOBBY. PHOTOGRAPHER: CRAIG OWENS

The lobby.

invisible force had tried to push one or both of them down the suite's metal spiral staircase. This story has been retold numerous times since then, and many people assume that Suite 402 is the hotel's honeymoon suite, which it isn't. (The Amistad is.) Nevertheless, to this day, Suite 402 is said to have the most late-night check-outs of any suite or room in the hotel.

In 1998, Richard Senate, author of *The Ghost Stalkers Guide to Southern California*, became one of the few paranormal authors to write about the Mission Inn's ghosts. In his book, Senate claimed that a hotel employee had told him that she had seen men and women wearing old-fashioned clothing congregating near the fireplace and stairs of the lobby before mysteriously vanishing. The men were said to have worn hats and coats and had mustaches, and the women wore long dresses. The employee then told Senate that she had heard mysterious squawking of exotic birds near the swimming pool, which she then incorrectly identified as the location of the Court of Birds. Senate also mentioned other apparitions seen at the hotel, one of them being the ghost of an older man dressed in a cutaway coat and tie who looked confused as he watched the

PHOTOGRAPHER: CRAIG OWENS

Paul Darrigo poses in a haunted section on the fourth floor of the Mission Inn.

lobby from the stairs. Senate retold a story given to him by a waitress who had once seen four 1920s-era ghosts socializing around a table in the restaurant before vanishing into thin air. "The women were all in dark blue and the men in striped coats," she said.

Senate also wrote about poltergeist-like activity at the hotel. Not only had guests seen drinking glasses levitating from a tray in the main dining room, but according to Senate, the hotel management had once temporarily closed a guest room after receiving too many complaints about phantom party noises, erratic light flickering, and a television set that changed channels on its own. A white ghost dog was also said to roam the property.[93]

In recent years, different ghost stories have popped up on the Internet. A number of these new claims appear to center around the fourth floor suites known as Authors Row, now often referred to as the Presidential Suites. One of the more notorious of these suites is 401, named for "Aunt Alice" and believed to be where Alice Richardson lived and died. One couple who booked the room claimed they had felt uneasy when they entered, and after venturing up the stairs to the bedroom, they discovered the bedding ripped off the mattress and thrown on the floor. Afterwards, the couple called the front desk and were moved to another suite, leading the reader

to interpret that their experience had been paranormal.[94]

Guests staying in other fourth-floor suites (including 402 and 405) have also occasionally reported hearing the sounds of anxious footsteps pacing back and forth, creaking floorboards, or bangs, all coming from the roof, usually between midnight and 5:00 a.m.[95] An occasional apparition has been seen along Authors Row, as well as other locations on the fourth floor, including an open-mouthed brick hallway connecting Suites 401 and 402.[96] Meanwhile, Suite 413, where Frank Miller is thought to have died, is still closed to the public and its number has been removed from the door, which leads to further speculation that it is haunted.

There are occasional reports of paranormal activity on the other floors as well. These ghostly claims include the sensation of being touched by an invisible force, cold spots in the heat of summer, glowing spheres of blue light, and smoky mists. Over the years, people have seen a costumed woman, or a cowled figure, standing in the balcony of the Cloister Music Room or have heard the sound of a piano playing a few notes on its own. Many witnesses have speculated that the Cloister Music Room ghost is Alice Richardson, who is also said to haunt her former home (Suite 401) on the fourth floor.

Although the Rotunda Wing has the fewest reports of paranormal activity, there has been at least one claim of a translucent man seen near the round stairwell. The apocryphal story behind this ghost is that in the early 1990s a hotel guest slipped on the stairs on a rainy night and fell five floors to his death, but there doesn't appear to be any documentation to prove that such a death occurred.

Perhaps the most ballyhooed haunted area of the Mission Inn is the Catacombs In 2009, before the Catacombs were deemed unsafe, the teen paranormal show, *The Othersiders*, was granted permission to investigate the underground corridors. During their investigation, the show's cast members claimed to have recorded EVPs of a snarl followed later by a mystery voice asking, "Who's there?" Another popular legend maintains that Frank Miller's ghost, wearing his Father Serra cowl, wanders the Catacomb's dark corridors.

There are plenty of people, of course, who have never experienced anything paranormal at the Mission Inn, and the hotel has a policy not to openly discuss its haunted reputation. But those who have encountered the unexplainable at the Mission Inn leave the hotel absolutely convinced that it is haunted.

I'm one of them.

Our Shoot

I first shot at the Mission Inn for another vintage photo project not associated with this book. Because I needed a beautiful location with 1920s charm, the Mission Inn was a natural choice, so in August of 2009, I made reservations and hired a model named Rina, who agreed to participate in a vintage themed photo shoot there.

I had reserved the Carrie Jacobs Bond Suite (417) on the top floor for myself and Room 371, located directly below, for Rina. While I was aware that the hotel had haunted rooms, I didn't rent any of them. However, it didn't take long for odd things to happen in the rooms that we did occupy.

On our first night at the hotel, we shot inside the Carrie Jacobs Bond Suite until around 3:30 a.m. Then Rina returned to her room and I fell asleep on the bed of Suite 417. Later that morning, I ran errands before the day's shoot began. Shortly after noon, I opened the door to the Carrie Jacobs Bond Suite, and immediately heard the sounds of someone moving toiletry items in the bathroom. Thinking it was the housekeeper, I called out, "Hello!" only to discover seconds later that there was no one there. Shrugging off the incident, I got on my computer to check my email. All was quiet for the next ten to 15 minutes, until I began hearing strange sounds coming from the upstairs loft that overlooked the bed. The noises sounded like four separate coins being dropped one by one on a wooden table. I tried to ignore the sounds until I could finish my email, but I was interrupted again, this time by the sounds of a woman's heeled shoes walking from the loft to the top of the stairs behind me. I ended my last email with, "I think I have a ghost in my room. Must go. More later."

I tried unsuccessfully to find the cause of the strange noises. Even though the hotel was well below occupancy, I made sure all of the doors and windows were closed, and with the air conditioner on, I conducted a ten-minute EVP session with an audio recorder I had brought. At the time, I heard nothing except my own voice.

Left: Pierrot and the Maiden outside the Carrie Jacobs Bond Suite (417).

Listening to the recording later, however, I heard a faint, unfamiliar female voice in the upstairs loft area that appeared to answer one of my questions. I had asked whatever it was that might be haunting Suite 417 to come closer and talk to me. Much to my surprise, a female voice had immediately answered, "Sure, I would love that," followed by something unintelligible. Then the same female voice said, in a very faint but clear voice, "I want to go home."

I was intrigued, and a little disturbed, by this. About an hour later, Rina called me to say that she was now awake and ready for a late breakfast. After telling her what had happened to me, she asked if I had moved furniture in my suite around 5:00 a.m. because she had been awakened by the sound of something heavy being dragged overhead. I was surprised to hear this, as I was fast asleep at the time. In fact, I was so tired from the late night shoot that I immediately fell asleep, without even bothering to undress or climb under the covers.

Later that afternoon, I told the desk clerk about our experiences. The night clerk was especially intrigued to hear of Rina's experience. The clerk replied, "You know, you're the fifth person to tell me that story since I've been working nights. It's always the same report coming from that room [371]." She then flatly asked if I had moved furniture at that hour. When I told her that I hadn't, she replied, "That's good to know. I always hesitated to call the Carrie Jacobs Bond Suite because I was afraid I might wake up the guests and they'd get mad at me." She then confided that because it had happened on different occasions with different guests, she thought the noise was probably "something else," meaning paranormal.

The desk clerk wasn't the only employee to hint that the Mission Inn was haunted. Around 2:30 a.m., while I was taking photos of Rina near the St. Francis Chapel, a young security guard with his walkie talkie sprinted around a corner and nearly collided with me. After I showed him our key cards, he chuckled and admitted that he thought Rina might have been a ghost and he was about to report it to headquarters. I then asked if he had ever seen ghosts while on the job. The guard shook his head and said that he hadn't, but he had heard enough stories from the other officers to make him think that one day he would see one.

On our last full day at the Mission Inn, August 6, 2009, I moved out of the Carrie Jacobs Bond Suite (417) and into the Alhambra Suite (403) for one final night of shooting. The suite immediately made me feel uneasy, which I thought was odd. After all, the Alhambra was a very popular, not to mention expensive, suite. Why should I be apprehensive? I soon got my answer.

Left: The door to St. Francis Chapel.

Inside the Alhambra Suite.

Late that afternoon, as I was setting up my computer in a small writing nook in the bedroom, Rina and I both heard a single, loud bang in the main room. Rina turned and saw water swishing around in a drinking glass sitting on a table across the room. Next to the drinking glass stood a plastic bottle in which the water was undisturbed.

That night, my uneasiness turned to dread, as if something frightening was going to happen. I hated being alone in the suite during Rina's wardrobe changes. Her being in the suite didn't help much either. As the evening progressed, I struggled to take good photos, and my whole body tensed up every time I heard a noise. Several times I stepped outside to the patio to look around. I also tried to convince myself that there was nothing wrong with the suite. Rina was unfazed by the room's atmosphere and tried to cheer me up by ordering room service. But I couldn't enjoy the meal. I felt as if I were in a nightmare where nothing was going smoothly. Then around 11:30 p.m., my cell phone rang, and I stepped into the Alhambra Courtyard to answer it. After the call ended, I was walking back across the courtyard when I thought I saw a movement coming from inside a short, open-mouthed hallway to my left.

Uncertain as to why my attention was drawn there, I began to look for something unusual, and after a few seconds, I began to notice a short, inky black, two-dimensional

shadow that vaguely resembled a cowled head and upper torso peeking around the corner of an alcove. At the time, my brain interpreted it as a motionless shadow, until it suddenly darted behind the corner of the alcove and disappeared. Momentarily dumbstruck, I entered the hallway where the shadow had disappeared and found that it had two doors, one to Suite 402, the other to Suite 403, which opened to my bedroom in the Alhambra Suite.

I was shaken by what I had seen, but the nightmare was far from over. As we resumed shooting, Rina and I heard half a dozen floorboards squeaking and a few bangs that seemed to be coming from the second floor of Suite 402, which was located above the Alhambra Suite's bedroom. Adding to the mystery were the additional bangs and footsteps on the Spanish-tiled roof over our heads, where there was not a second floor. Thinking that someone was playing a practical joke on us by throwing something on our roof, I went outside to check. Not only was the courtyard deserted, but there weren't any bricks or rocks large enough to throw. Rina laughed when I suggested that a very large bird might have caused the footsteps, but I had no answer, unless the noises were caused by old pipes. I then set up audio recorders near the Alhambra's inoperable fireplace to see if I could capture the noises, but the bangs and creaks had gone silent.

Finally, around 4:30 a.m., I completely lost all focus and called an end to the shoot. Rina went back to her room and I lay down on the bed, too exhausted to worry about what had happened earlier. But my sleep was not peaceful. I awoke at 7:30 a.m., startled by the very loud slam of a door in either Suite 401 or 402. I rolled out of bed, checked the hallway, and immediately began packing my gear. Later that morning, as I dropped off the key cards, the desk clerk thanked me for visiting the hotel and asked if I had enjoyed my stay. I replied that everything was fine. Then I asked if anyone had been staying in Suites 401 and 402. The clerk checked the computer and said I was the only tenant on the entire fourth floor. I then asked if housekeeping or any other hotel employee might have been in Suites 401 and 402 around 7:30 a.m. The clerk checked the computer again and replied that no hotel employees had been in those rooms at that early hour.

Upon my return home, I slept with the light on for the next ten days or so. The shadow figure had frightened me, and it took time for me to fully process what I had seen. However, I knew I needed to one day return to the Mission Inn for a photo shoot specifically for this book…and to revisit the places that I had experienced paranormal activity.

PHOTOGRAPHER: CRAIG OWENS.

Nicole Loretta and Chantel Paradis inside the gloomy upstairs room in Suite 402.

185

The balcony to Suite 402.

In early August of 2011, I notified the hotel in advance of my intentions, and rented several rooms, including Aunt Alice's Suite (401), the Carrie Jacobs Bond Suite (417), the Alhambra Suite (403), and Suite 402, which is the two-level suite with the metal spiral stairway. Not all of the rooms were available at the same time, but since we were staying three nights, we were able to secure each of these suites for at least one night.

The models who agreed to participate in the photo shoot were Carmen Conte, Patrick Cronen, Paul Darrigo, Lauren Fray, Nicole Loretta, and Chantel Paradis. Johanna Serrano was the hair and makeup person, and Jamison Tucker and Adam Johnson came along to assist me.

The shoot was ambitious. Not only did I want to reshoot some of the photos that I had taken in 2009, but I also wanted to add new photos that were ethereal and dreamlike.

On our first night, we took photos and conducted EVP sessions inside Suite 402, but could find no signs of paranormal activity. The atmosphere seemed gloomy, though, and the downstairs room smelled musty and had cobwebs in it. The spiral stairway shook when I went up and down the stairs, and the suite's two main rooms had many odd angles with furniture that didn't quite fit the allowed space.

I returned to the hallway where I had seen my apparition, only this time, I had Adam Johnson and Jamison Tucker pose as silly, Old Hollywood style shadow people where I had seen my shadow person.

MODELS: ADAM JOHNSON, CHANTEL PARADIS, NICOLE LORETTA, JAMISON TUCKER. PHOTOGRAPHER: CRAIG OWENS

Outside the Alhambra Suite's bedroom door.

Although the real shadow person failed to show up, we had a few strange encounters during our shoot that would have gone unnoticed if not for our audio recorders. For instance, around noon on Monday, August 8, Jamison and Adam were about to begin an EVP session on the top floor of Aunt Alice's bedroom (Suite 401) when two of the audio recorders picked up a mysterious male voice saying, "Get... out!" coming from the office area adjacent to the bedroom.

That same night, we shot extensively inside and outside the Carrie Jacobs Bond Suite (417). Afterwards, Jamison stayed behind to conduct an EVP session. During his question and answer period, he heard a male voice saying something like "Monday" near a recorder by the stairs. If the interpretation is correct, the voice was a delayed response to an earlier question, "Do you know what day this is?"

During the shoot, Nicole and Chantel posed as Pierrot and the Maiden, Paul Durrigo dressed as Frank Miller, and Lauren wandered the upper floors in a vintage wedding dress. All of these themes were designed to capture the dreamlike qualities of the Mission Inn.

188

MODELS: PATRICK CRONEN, ADAM JOHNSON, AND LAUREN FRAY. PHOTOGRAPHER: CRAIG OWENS

Inside the Alhambra Suite.

For the most part, everyone had a good time—even if the ghostly activity was practically non-existent. During lulls in the shooting schedule, Nicole and Chantel practiced their Ouija board skills in Suite 402 and the Alhambra Suite, but their "supernatural" messages dealt with someone's desire to be loved, a man named Calvin, and a murder that supposedly occurred on a wedding night, none of which made sense.

That last night, I excused myself from the dinner table around 9:30 to conduct a walk-through of the lobby to see how busy the hotel was at that hour. I saw five people engaged in an animated conversation in the center of the main room, two people sitting on the sofas in front of the registration desk, and several others socializing in the Presidential Lounge. When I looked in the direction of the cordoned-off doorway leading to the stairs to the Music Room, I thought I saw a pale, monochromatic woman gliding past the doorway on the other side of the velvet rope. She was wearing an old-fashioned, floor-length dress with a high, stiff collar. Her hair was parted in

189

PHOTOGRAPHER: CRAIG OWENS

Models Chantel Paradis, Nicole Loretta in Suite 403.

the middle and pulled back into a bun. She held her hands together in a calm, almost regal, pose.

Wondering if there was a costumed event going on in the Cloister Music Room, I crossed to the cordoned-off area and looked at the landing and the stairs. I saw no signs of anyone downstairs. Turning back to face the lobby, I looked around to see if anyone else might have seen the mystery woman, but no one seemed to have

190

MODEL: LAUREN FRAY. PHOTOGRAPHER: CRAIG OWENS

The Mission Inn at 2:00 a.m.

noticed her, or me, for that matter. Now, I'm a person that never sees ghosts…I mean, never. But there I was again, thinking I had just seen one at the Mission Inn. After pondering the situation for a few seconds, I probably did what most people would do in my situation…I walked away and tried to convince myself that I had imagined the whole thing.

Photo taken in a hotel room facing the Ramona Dome.

Stairs across from the St. Francis chapel.

MODEL: LAUREN FRAY. PHOTOGRAPHER: CRAIG OWENS

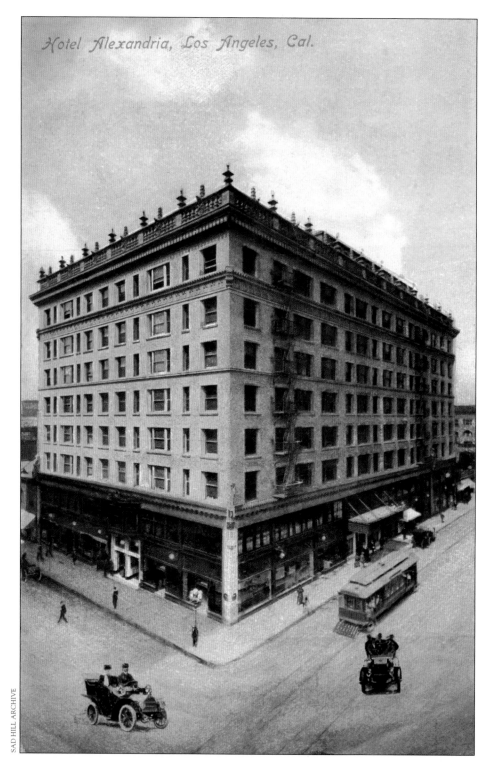

Hotel Alexandria, Los Angeles, Cal.

The Alexandria Hotel before 1910

5

THE ALEXANDRIA HOTEL
501 South Spring Street, Los Angeles, CA 90013

When California became a state in 1850, the population of Los Angeles was under 5,000. However, a land boom was underway. Thanks to the California Gold Rush of 1849, the completion of the Transcontinental Railroad in 1876, and the discovery of oil in 1892, the city's population rapidly grew to 100,000 by 1900.[1]

Hotels built during the boom could not keep up with the population explosion, and by the turn of the 20th century, as the financial district began to move further east from the city's original Mexican plaza, real estate developers Robert Alfred Rowan and Albert C. Bilicke hired architect John Parkinson of Parkinson Bergstrom to design a world-class luxury hotel. The site chosen was the southwestern corner of Fifth and Spring Streets, owned by businessman Harry L. Alexander, and appraised at $400,000.[2] Bilicke and Rowan did not buy the parcel. Instead, their business, the Bilicke-Rowan Fire Company, entered into a 50-year lease with Alexander while the A.C. Bilicke Hotel Company signed a lease for an additional 20 years.

Construction of the eight-story Alexandria Hotel began in 1905 with the removal of a pepper tree and the planting of the first brick. By the time construction was completed in early 1906, the new Beaux-Arts hotel, located in the new financial district, cost just under a million dollars to construct and close to another million dollars in furnishings. It was touted as the finest hotel west of the Mississippi and the only one in Los Angeles offering consistent hot water thanks to the large boilers and steam heating systems located in its basement. The *Los Angeles Times* described the

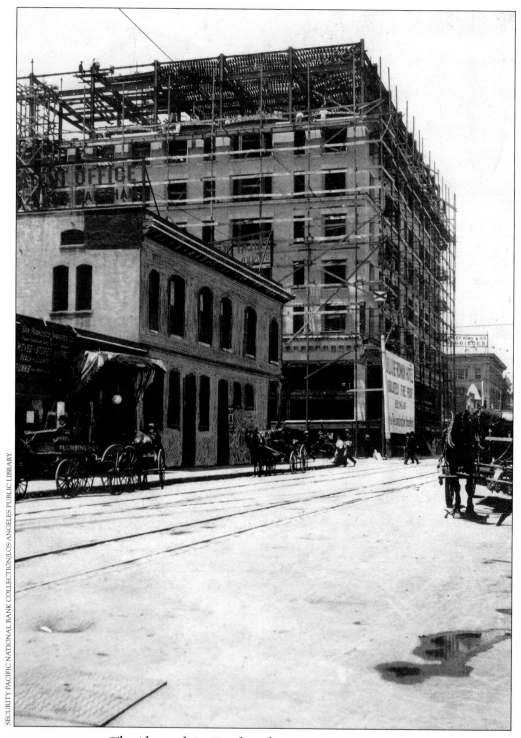

The Alexandria Hotel under construction in 1905.

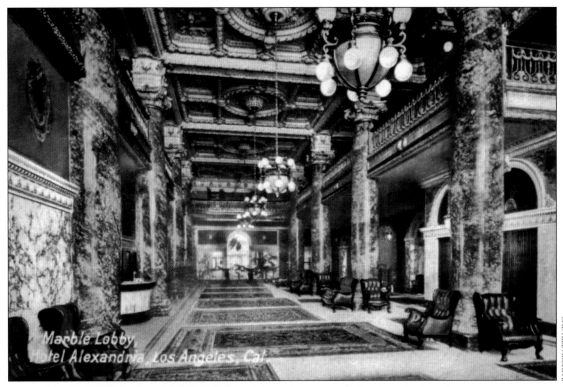

The grand lobby of the Alexandria Hotel during its heyday.

Alexandria as "a gem set in tile, steel and marble," and by all accounts, the hotel lived up to its lofty expectations. Its lobby contained majestic pillars made of brown-hued, polished Italian and Egyptian marble, a mosaic floor, and a ceiling decorated in ivory, gold, and green. Above the lobby stood a rotunda that housed banquet rooms also decorated in ivory and gold, plus a brown and green promenade balcony that allowed visitors to peer down into the lobby. The hotel's main restaurant, often referred to as its dining room, was located on the ground floor. It, too, was furnished with fumed oak and Italian and Egyptian marble, dark green tapestries, 30-foot ceilings, cut-glass chandeliers, and an Italian mosaic floor. Below the lobby, the Alexandria's basement featured a barbershop and other small retail and service shops as well as a second eatery located near the grand staircase called the Mission Indian Café, or the Indian Grill.

The new hotel offered 360 rooms, each with its own private bath. The *Times* described these guest rooms as being decorated in shades of green, blue, tan, and mahogany, with furnishings modeled after the "colonial, Louis XV, Louis XVI and

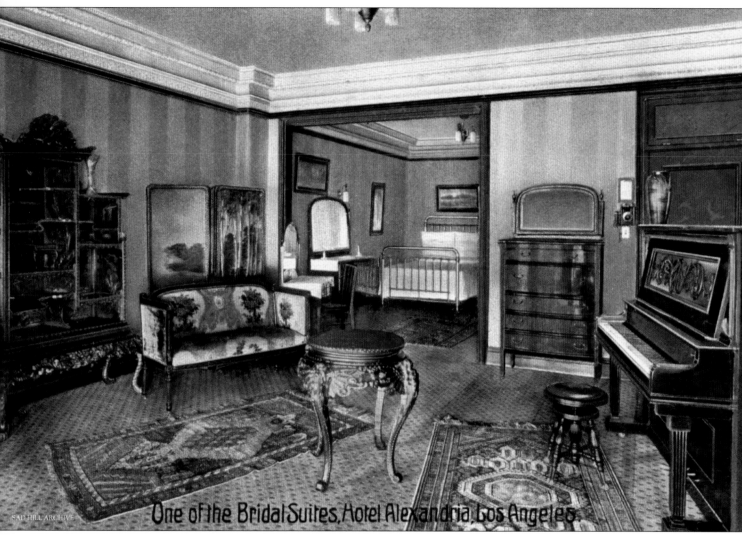

The Bridal Suite, pre-1910.

Empire periods."[3] Even the doorknobs were high end and said to be "noiseless" when turned.[4] The Alexandria Hotel officially opened its doors to the public on February 10, 1906, with a live orchestra playing from 8:00 to 10:00 p.m. in the promenade. It quickly sold out as both wealthy tourists and Angelenos wanted to bask in its luxury. It also became a major haven for lobby loiterers and reporters who thrilled at the continual parade of well-known millionaires, politicians, and theatrical stars checking into their rooms.

The hotel's instant notoriety also attracted more than its share of grifters, imposters, and jewel thieves. One of the more colorful con artists to grace the Alexandria was a man who passed himself off in 1907 as one Major de la Poer Beresford,

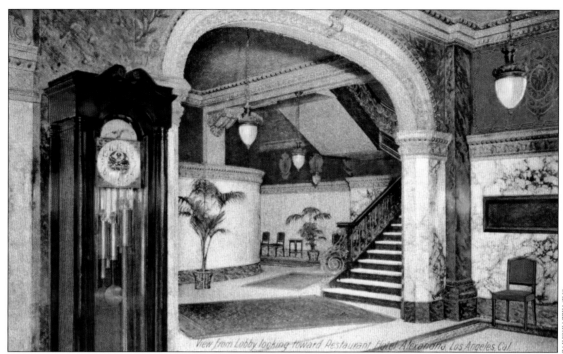

Postcard reads: "A View from Lobby looking toward Restaurant
[the hotel's main dining room]."

The Alexandria's dining room on the lobby level.

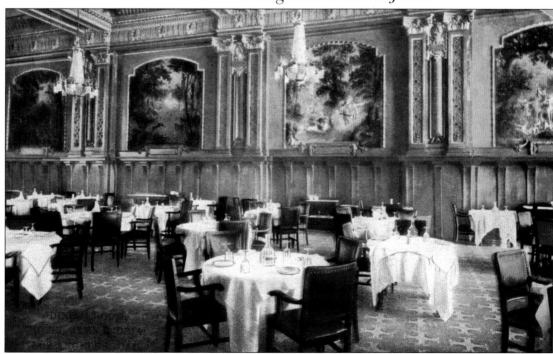

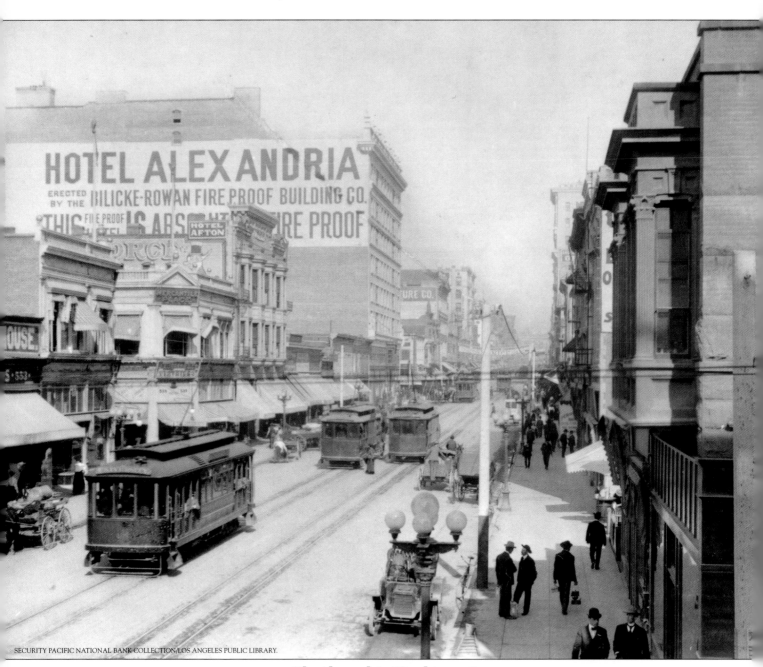

The Alexandria Hotel in 1906.

a bored British nobleman who had recently departed Hong Kong for California. Arriving with leather suitcases, canvas bags, and fancy walking canes, the dapper gentleman freely spent money in the bar before cashing in notes from a Vancouver bank that turned out to be worthless.

At first, the *Times* reported that Beresford turned a blind eye to the "handsome ladies" at the hotel and rebuffed the newspaper's request for an interview by saying in a theatrically phony accent, "To hell with you reporters! You are too fresh!" Before long, however, journalists began to suspect him of working with a female accomplice. This was corroborated when a female guest mysteriously left the hotel after conducting suspicious business transactions on the mining exchange. Beresford, too, had beat a hasty exit, telling the hotel staff that he intended to spend the day at Catalina Island, "don'tcher know," before abandoning his luggage and disappearing from sight. Both grifters were later arrested at the Planter's Hotel in St. Louis while trying to cash fake notes under the name Colonel Edmund Burke.[5]

In November 1909, Bilicke and Rowan began planning an annex building while also lobbying the Los Angeles city council to pass an ordinance that would allow taller buildings (up to 180 feet) to be constructed downtown. Once the new ordinance passed, the two men immediately leased adjacent properties along Spring Street from landowners Nelson Story, Abbey R. Thompson, Mary E. Richards, and the Maier Brewing Company.[6] The architectural firm of Parkinson Bergstrom was hired again, this time to construct a 12-floor annex to the Alexandria that would add more than 300 additional rooms to the overall property. The cost for this expansion was budgeted for an additional $2 million, and exploratory trips were made to the finest hotels on the East Coast and Europe to find inspirations for the annex building's design and furnishings.

Significant changes were then made to the main Alexandria building. The Indian Grill, located in the basement, was doubled in size, and the original ballroom was reconfigured into

The Gentlemen's Grill in the early 1910s.

201

separate lounges, conference rooms, and a smaller Gentlemen's Grill. Construction also began on a new dancing venue called the Rose Ballroom on the mezzanine floor with its ceiling raised to the third floor, where a special balcony was built for the orchestra.[7]

The Alexandria remained open during construction, and in January 1910, members of the Biograph Company, including D.W. Griffith, Mack Sennett, Mary Pickford, and her younger brother Jack, checked into the hotel for the winter to make motion pictures under the warmer Southern California sun before returning to the East Coast. Later that year, the hotel became entangled in a labor dispute that played a supporting role in a national debate over job safety and long hours. On June 1, 1910, after the wood-framed buildings along Spring Street were razed in preparation for the new annex, the metal trade unions called a nationwide strike, demanding union recognition and the implementation of an eight-hour workday. After iron and other metal union workers gathered in front of the worksite, the Los Angeles city council passed an ordinance outlawing picketing. The ordinance was largely ignored, and in August, a 14-foot fence was built around the annex to keep union workers from taunting the non-union laborers hired to construct the building.[8]

On September 2, 1910, a non-union ironworker named Louis Jeffries, a nephew of boxing great Jim Jeffries, was killed when a hoisting derrick collapsed and fell on him. When Jeffries' corpse was carried off the premises by the non-union workers, enraged union members attacked them with fists and bottles. The *Los Angeles Times*, in its fiercely anti-union crusade, called the union picketers "blackguards," "loafers," and "ruffians" who ran away like cowards when police arrived.[9] The next day, another non-union iron-worker Martin Burkwitz died when a defective hoisting derrick caused him to fall off a second-story girder and into the basement of the annex.[10]

As labor tensions escalated, so did the intrigue. Around the time of the two deaths, a bag of dynamite was found at the annex site. The bag belonged to a former miner named Albert Kennedy, who told police that it had been placed there by a friend as a practical joke. The police accepted Kennedy's explanation and the matter was dismissed.[11] Days later, another explosive device was found at the Los Angeles Hall of Records construction site, and on October 1, 1910, just after 1:00 a.m., a suitcase containing 16 sticks of dynamite detonated in an alley outside the *Los Angeles Times* building located at First Street and Broadway. The explosion caused considerable damage and the deaths of 21 newspaper employees. The *Times* called the bombing of their building "the Crime of the Century," and the City of Los Angeles hired "the American Sherlock Holmes," William J. Burns of New York City, to bring the dynamiters to justice.[12]

SAD HILL ARCHIVE

The Franco-Italian Dining Room (now the Palm Court) in the 1910s.

Burns traveled to Los Angeles and registered as a guest at the Alexandria. According to Alexandria bellboy Harry Posner, a longtime employee at the hotel, "Many a time you would find him at the bellboys' bench, telling us some of his thrilling experiences, giving us some of the details and clews [clues] he had concerning his latest cases and asking for opinions. He listened very seriously to any ideas we would have, and I am sure some of the 'slants' and hunches we had helped him solve some of his problems."[13]

Construction of the annex continued, and by August of 1911, a large, world-class kitchen was near completion in the new basement as well as a new power plant in a sub-basement. Other new features at the annex included an electric water fountain in the lobby, and a new ladies' entrance with a granite staircase on Spring Street.

The most impressive room was the Franco-Italian Dining Room on the lobby level, which was decorated with mahogany woodwork, two-toned DuBarry pink satin draperies, crystal chandeliers, and stained-glass Tiffany skylights.[14]

The new dining room had its formal opening in October of 1911 with a banquet honoring U.S. President William Howard Taft. However, the presidential visit almost didn't happen. In the wee hours of the morning on October 16, as the president's train sped toward Los Angeles, a railroad security guard had thwarted dynamiters from blowing up the railroad tracks on a bridge outside of Santa Barbara.

Plans were then changed to better protect the president. Instead of having Taft enter the Alexandria through the Fifth Street entrance as planned, the president and his staff dodged the throng of enthusiastic greeters and a band playing "Hail to the Chief" by quietly sneaking in through the new women's entrance on Spring Street and taking a nearby elevator to the Imperial Suite on the eighth floor.[15]

The plot to dynamite the president's train was thought to have been provoked by the upcoming McNamara trial, which proved to be a highly emotional event filled with unexpected twists and turns. That November, Detective Burns, a guest at the Alexandria, began feuding with the McNamara brothers' defense attorneys, led by Clarence Darrow. As the trial wore on, Darrow attempted to negotiate a plea bargain behind closed doors, but his plan backfired, resulting in criminal charges being filed against him for tampering with the jury. The McNamara brothers, perhaps unaware that they had the sympathy of the American public, felt they had lost their case, and in early December, they stunned the nation (and their defense team) by changing their plea from innocent to guilty. Because the Los Angeles court could not bring itself to sentence the two brothers to death, one brother received a life sentence and the other was sentenced to 15 years in prison. Burns was livid at the court's leniency, while Darrow unhappily awaited his own trial.

The court case was still the talk of the country when D.W. Griffith returned to the Alexandria during the winter of 1911 to shoot more films. Howard Blum's book *American Lightning: Terror, Mystery, the Birth of Hollywood, and the Crime of the Century* describes how Burns, Darrow, and Griffith unexpectedly crossed paths in the Alexandria lobby in January of 1912. As the story goes, Griffith was sitting in the lobby and enjoying a cigar when he saw Burns, an acquaintance from New York, walking toward the dining room. Calling out to him, Griffith rose from his chair, and as the men approached each other, Darrow, on his way to the bar, nearly collided with Griffith. The three men awkwardly exchanged good-humored pleasantries for about a minute, then each man walked off in a different direction.[16]

Life at the Alexandria was filled with famous people and humorous events. One anecdote tells how famed politician William Jennings Bryan once invited reporters into his suite for an interview. He was wearing nothing but his underwear because "his baggage had been delayed and he had sent his only available suit to the tailors to be pressed for the banquet held in his honor that night."[17] Posner recalled guests complaining about the music coming from the world-renowned concert pianist Ignacy Jan Paderewski's suite when he stayed at the hotel. "People paid a five-dollar top to hear him play the piano at the theater," Posner said. "But when he played in his

A drawing room at the Alexandria Hotel in the 1910s.

The Indian Grill.

SAD HILL ARCHIVE

The mezzanine level.

room, people phoned down to the manager about the 'noise.' We would never think of disturbing the great pianist by telling him to 'cut the racket.' Instead, we moved the unappreciative guests to rooms out of range."[18]

An amusing incident occurred on March 13, 1913, when millionaire Armin W. Brand held an elaborate party in which the second-floor Rose Ballroom was transformed into "an immense barnyard," complete with live horses, mules, pigs, cows, and free-roaming ducks, turkeys, guinea hens, and geese. In keeping with the theme, guests were encouraged to wear farm clothing.

When a society woman arrived wearing a flaming red gingham dress, a Jersey heifer lost control and chased the terrified lady in red out of the ballroom and along the mezzanine, knocking over furniture along the way. After the heifer was wrestled to the ground in the library, the cornered woman was found hiding behind a green velvet settee.[19]

The Alexandria's greatest contribution to Los Angeles' history, of course, was its central role in the birth of the city's motion picture industry. By 1912, new production companies like Keystone and Nestor were moving to the outskirts of Los Angeles, often

SAD HILL ARCHIVE

The Alexandria Hotel library room on the mezzanine level, circa 1908.

occupying old farmhouses or storage buildings to make their films. In December of 1913, Cecil B. DeMille and actor Dustin Farnum briefly checked into the Alexandria while scouting locations for their next picture, *The Squaw Man* (1914).[20] That same month, Charles Chaplin, another new arrival to Los Angeles, began working for Mack Sennett in Edendale, a neighborhood near Hollywood. Many of these personalities patronized the Alexandria's bar and other nearby social hangouts like Levy's Tavern and the Los Angeles Athletic Club. Sennett claimed that he and members of his company often showed up at the hotel for a ten-cent slice of turkey or ham or to down scotch-and-sodas between 5 and 6 p.m.[21] Posner recalled a day in 1914 when Chaplin jubilantly entered the Alexandria lobby, did a comedic jig, and slapped the bellboy on the back, exclaiming, "I'm chief comicker with Mack Sennett now! I get $175 a week!"[22]

D.W. Griffith, who returned in 1914, was living beyond his means in a corner suite of the Alexandria. During production of his most successful film, *The Birth of a Nation* (1914), bellboys arrived every morning to prepare his morning bath filled with ice cubes, and to deliver a chilled bottle of champagne[23] before a chauffeured limousine picked him up at 7:30 a.m. to take him to the set.

Also returning to the Alexandria that year was Mary Pickford, who had recently negotiated a $50,000-a-year contract with the movie and distribution company, Famous

FROM TOP TO BOTTOM:
D.W. Griffith
Mary Pickford
Jack Pickford

Players-Lasky. Writer Rufus Steele recalled seeing a "much-awed reporter" interviewing the star in the hotel's crowded lobby. "You could not have learned by consulting the register that one of the most beautiful and expensive suites of the sumptuous Alexandria was occupied by the little star who is best loved in rags," wrote Steele, "for the only Pickford entry on the register was that of her sister Lottie. Yet Mary's name was on the line above."[24] Posner recalled that Pickford stayed on the eighth floor. "I remember me telling [Pickford] one day," he wrote, "'there's a schoolgirl downstairs who wants to meet you. She's been pestering around here for some time although she admits she hasn't ever met you and hasn't any appointment with you. What'll I say to get rid of her?' Mary said, 'Oh, don't send her away, by all means. I'll be right down and see her.'"[25]

By 1915, new motion picture studios like Universal City and Famous Players-Lasky began hosting events at the hotel that were designed to bring positive attention to the movie industry and to court Broadway personalities interested in breaking into motion pictures. Meanwhile, a handful of top movie directors formed the Directors Association of America, organizing banquets and formal balls at the Rose Ballroom, charging stars $5 apiece to attend.[26] Filmmakers like Thomas Ince, D.W. Griffith, and Mack Sennett used the hotel to court local politicians and discuss topical issues like censorship. The Alexandria was also used as a shooting location for films like *The High Hand* (1915), directed by William Desmond Taylor; *Pretty Mrs. Smith* (1915), directed by Hobart Bosworth; *Hands Up* (1917), directed by Tod Browning and Wilfred Lucas; *A Midnight Romance* (1919), starring Anita Stewart and Jack Holt; and *The Spite Bride* (1919), directed by Lois Weber and

starring Olive Thomas and Jack Mulhall. The publicity generated by the film industry attracted people from all over the country to the already famous hotel. As author Budd Schulberg, whose father worked as a film studio executive back then, wrote in his book, *Moving Pictures: Memories of a Hollywood Prince*:

> *The lobby was...full of unknown girls showing off their faces and figures in hopes of being discovered on the spot. Along with Geraldine Farrar and Mary Garden from grand opera there were a host of hopefuls from all the little towns across the country, waiting for Mack Sennett to put them into fetching one-piece bathing suits. The doors of the Alexandria lobby were not marked Ladies and Gentleman but Obscurity and Fame. And along with all of those names and would-be names, there were the sight-seers, the rubes, the hicks, the marks rubbernecking around the lobby to catch sight of a famous face.*[27]

Many of the stories told about the Alexandria from 1916 to 1921 suggest that the early film stars brought a carnival-like energy to the hotel, where anything could happen at any time. Posner, for example, recalled Chaplin at the Alexandria as "usually so dignified and solemn in public" yet "doing funny falls and turning handsprings all over the floor and the furniture the minute he got into the privacy of his room."[28] *Times* reporter Eric Malnic wrote about an alleged incident in 1916, when Universal Western star Harry Carey and a "bunch of cowhands ... rode up the steps and into the lobby of the elegant Alexandria Hotel."[29] In more recent years, the story changed to say that Tom Mix along with his bride, had ridden a horse into the lobby,[30] but that story

FROM TOP:

Charles Chaplin
Mack Sennett

PHOTOGRAPHER: HOMER PEYTON, STRAUSS-PEYTON

SAD HILL ARCHIVE

209

FROM TOP:

Norman Kerry
Rudolph Valentino

may be apocryphal, as Mix's 1918 wedding to Victoria Forde took place at the Mission Inn in Riverside.[31]

In 1917, one Rodolpho d'Antonguolla, soon to be better known as Rudolph Valentino, arrived from San Francisco after his friend Norman Kerry, a working actor, invited him to stay, rent free, in his Alexandria room. Samuel Goldwyn, known back then as Samuel Goldfish, recalled seeing Valentino in 1918 (after Valentino had moved to a nearby address), trying to stand out from the other lobby loungers. "Even when he leaned up against a cigar case," Goldwyn said, "you felt that the column of some ruined temple overlooking the Mediterranean would have been more appropriate." Goldwyn went on to say that Valentino often asked producers and directors about upcoming casting sessions. "He always looked so eager when he put the question," said Goldwyn, "and so disappointed when he got the answer."[32]

Another actor looking for a break in the late 1910s was Jose Ramón Gil Samaniego, later becoming Ramon Novarro, who worked as a busboy and singing waiter at the Indian Grill. Novarro was said to have bribed a chambermaid to give him Griffith's room number before introducing himself. "He always said he discovered me," Novarro later said of Griffith. "Actually, I discovered him."[33]

By 1917, the Turkish rug in the middle of the Alexandria Hotel's lobby was humorously nicknamed the "million-dollar carpet," thanks, in part, to the number of small-time producers and directors who mingled with the legitimate ones to boast about their epic-size budgets and

Room rates for the Alexandria in 1914.

industry-changing business propositions. While many of these "quidnuncs and quasi-promoters,"[34] as Chaplin called them, came and went, a few legitimate deals were said to have been initiated on that carpet. For instance, after San Francisco showman Sid Grauman checked into the Alexandria in 1917, he was able to secure financing for his first Los Angeles movie theater, which probably inspired him to name his new motion picture palace the Million Dollar Theatre. Another producer said to have gotten his start on the carpet was Louis B. Mayer, who went from junk dealer to movie producer.

According to legend, a great deal of hedonistic behavior took place behind closed doors at the Alexandria. Mitchell Rheine, a longtime professional gambler, said that he had personally witnessed Roscoe "Fatty" Arbuckle lose $25,000 on a single roll of the dice. Arbuckle then shrugged, walked out of the hotel, and returned later with a brand new, $40,000 Cadillac.[35]

Budd Schulberg recalled that "the whole damn industry was there together in one big hotel. You could get laid, you could become a star, you could start a new movie company, and you could go broke, all in that same place the same afternoon."[36]

Schulberg also mentioned a prostitution racket called the "Alexandria Game" that existed sometime between 1917 and 1920. According to legend, a sharper would approach a tourist in the bar and casually strike up a conversation, asking which young, beautiful celebrity the sightseer had seen in the lobby. If the tourist gave a name, the sharper would pretend to be a production employee, usually an assistant director or producer, who "knew" the starlet personally. The sharper would then start telling lurid stories about the starlet's nymphomania and how she enjoyed sexual encounters with strangers. Once the potential customer had become excited at the thought of sleeping with a famous star, money exchanged hands, and the sharper would take the tourist to a hotel room where a prostitute who vaguely resembled the star waited in a negligee. Schulberg said the Alexandria Game became such a lucrative racket that a similar version of the game was created in Hollywood in the 1930s.[37]

The hotel became the site of intrigue during the January 1919 convention of the First National Exhibitor's Circuit, when rumors surfaced that filmdom's most powerful rivals, Paramount and First National, were quietly planning to consolidate. Worried that a merger would affect their salaries and artistic freedom, Charles Chaplin, Mary Pickford, and Douglas Fairbanks hired an attractive female to canvass the Alexandria during the convention to see if the rumors were true. Three days later, the woman reported that a $40 million secret merger was in the works and that it was designed "to put the industry on a proper business basis, instead of having it run by a bunch of crazy actors getting astronomical salaries."[38]

Within days, a new rumor surfaced that the film industry's top stars were hatching their own company to block Paramount and First National's potential merger. Paramount's chief executive, Adolph Zukor, heard it and cornered Fairbanks at the hotel to persuade him not to leave Famous Players-Lasky. The air was thick with wheeling and dealing, and backroom betrayals, leading columnist Harry Carr to write, "You have to make an appointment to bathe your hands before lunch, because every washroom is occupied by film magnates in secret whispered conferences which are to decide the fate of the picture business."[39] On January 15, Charles Chaplin, Douglas Fairbanks, Mary Pickford, D.W. Griffith, and Western star William S. Hart held a press conference in the Franco-Italian Dining Room to announce their intention of forming United Artists, a new entity that would produce and distribute the stars' films. Although Zukor and Jesse Lasky managed to lure Hart away from the combine with a lucrative contract, Chaplin, Griffith, Pickford, and Fairbanks moved forward and signed United Artists into existence on February 5, 1919, at Griffith's movie studio on Sunset Boulevard.

SAD HILL ARCHIVE

D.W. Griffith, Mary Pickford, Charles Chaplin, and Douglas Fairbanks signing United Artists into existence after first announcing their plans to form a combine at the Alexandria Hotel in January of 1919.

In April of 1919, the Alexandria lobby's "million dollar carpet," well-worn by this time, mysteriously disappeared. An assistant manager told the *Los Angeles Times* that he thought the prankster was Sid Grauman, owner of the Million Dollar Theatre. "Sid done it at midnight on Friday," the assistant manager said, adding that Grauman had orchestrated an elaborate theft that involved paying off porters, calling a false alarm on the top floor of the annex, and distracting the night clerk and cashier long enough for him and his cohorts to roll up the carpet and exit out the Fifth Street doorway.[40]

Although Grauman denied the story, his knowledge of the rug's weight and dimensions indicated that he knew what had happened. Years later, Hollywood columnist Jimmy Fidler told a different story. He said the thieves had been Buster Keaton and Roscoe "Fatty" Arbuckle, who had made a $500 wager with an unnamed person during a New Year's party that they could steal the carpet without getting

213

*Harry and Bess Houdini celebrating their wedding anniversary inside the Rose
Ballroom on the mezzanine floor.*

caught. Once the wager was made, a hired stooge yelled "FIRE!" from one of the
adjacent rooms, and as hotel employees scrambled to find the blaze, Keaton and
Arbuckle strolled into the lobby, rolled up the famous rug, took it out the front door,
and collected their money.[41]

The hotel was visited by numerous celebrities in 1919. In late June, Harry Houdini
and his wife, Bess, celebrated their wedding anniversary with a large banquet in the
Rose Ballroom. That same year, Gloria Swanson and Herbert K. Somborn, founder
of the Brown Derby restaurant, met, married, and spent their honeymoon at the
Alexandria; Jackie Coogan first met Chaplin on the new "million dollar carpet" to
discuss an acting role in *The Kid*; and D.W. Griffith temporarily offered his Imperial

214

Suite to U.S. President Woodrow Wilson, who visited Los Angeles less than a month before suffering a near fatal stroke.[42]

In the waning months of 1919, musician and aspiring bandleader Paul Whiteman got his first big break playing at tea dances in the Rose Ballroom and evening jazz in the Indian Grill. Music and booze were an important part of the Alexandria's nightlife. As Prohibition was about to take effect, Hollywood columnist Grace Kingsley attended a Thanksgiving Ball thrown by the Directors Association, which she described as a formal event that offered "near-temperance punch, served in the ante-room, the ante being quite low." Kingsley gushed over stars like Mary Miles Minter, who arrived at midnight in "high spirits and a tall blue limousine"; Alla Nazimova, wearing a "beautiful slinky silk gown and her shredded wheat hair"; Wanda Hawley, who "looked sweet in a little dress that commenced late and finished early"; and Ruth Roland, who wore a "pink-and-blue frock to match her car." Charles Chaplin reportedly "peeped rather gloomily in, but he saw so many vulgar, curious newspaper people about that he hastily withdrew."[43]

As the 1910s came to a close, the Alexandria Hotel operated smoothly, despite changes in its ownership. On May 7, 1915, Alexandria co-owner A.C. Bilicke perished on the *Lusitania* when the luxury liner was sunk by a German torpedo off the coast of Ireland, leaving his partner Robert A. Rowan in charge of the hotel. After Rowan died in Pasadena in July of 1918, many months of negotiations followed and all of the Bilicke-Rowan holdings were sold to the Linnard Company in April 1919[44] (the same month that the "million dollar carpet" was allegedly stolen and replaced). Linnard had wanted to construct a large luxury resort in the heart of the new Wilshire business district west of downtown Los Angeles, but the company's plans fell through. By the end of 1919, Linnard had sold the Alexandria and its new hotel project to the S.W. Straus Company of New York and Chicago, the company that had originally bonded Linnard's deal.[45] The Straus Company then set up a company called the Wilshire Boulevard Hotel Company and proceeded to construct the Ambassador Hotel on Wilshire, using the Alexandria as its construction headquarters.

In 1920, the Strauss Company paid for a $100,000 renovation of the Alexandria. Lobby walls were torn down to make way for new restrooms and a new grand entrance to the dining room. Because of Prohibition laws banning alcohol, the *Times* reported, the Indian Grill was to be closed and converted into a writing room. Other changes included a new ladies' hair parlor, a ladies' restroom, and a large telephone exchange on the mezzanine level.[46] What was not reported was a possible speakeasy that may have existed in the hotel's basements.

In April of 1920, the lobby became the scene of a famous post-dinner fist fight between Charles Chaplin and Louis B. Mayer. Chaplin was engaged in a much-publicized separation from his wife, Mildred Davis, and had become upset with Mayer after the producer started billing his star as Mildred Harris Chaplin instead of Mildred Harris. On the evening of April 8, Chaplin was dining at the Alexandria with Marshall Neilan, Jack Pickford, and Agnes Ayres. Several tables over Mayer sat with film star Anita Stewart and several other clients. According to the *Times*, Chaplin received an insulting note from Mayer and the two men later squared off in the hotel lobby. According to one version of the story, Chaplin had challenged Mayer to step outside to settle their differences, but Meyer only glared at him. Chaplin then said, "Take off your glasses," to which Mayer replied, "Do you mean it?" At that point, Chaplin threw a wild punch and Mayer countered with one of his own. Although neither punch connected solidly, Mayer's blow landed hard enough to throw Chaplin off balance, causing him to slip and hit his head on a nearby chair. Another version of the fight, related by onlooker Robert Rubin, maintains that Chaplin had confronted Mayer near the lobby restrooms and had raised his voice at Mayer, saying, "You can't use my name in your pictures!" Mayer then yelled back, "What are you going to do about it?" As Chaplin lunged, Mayer stuck out his fist and knocked Chaplin down. The *Times* reported that Chaplin, after falling to the floor, began kicking Mayer, who grabbed the star by the nose and tweaked it, leaving marks. The fight was quickly broken up, and Chaplin caught a ride home in Jack Pickford's limo while Mayer returned to his dinner party and a round of applause.

While Chaplin biographer David Robinson suspects that Mayer's note to Chaplin may have been penned by Jack Pickford as a prank,[47] Budd Schulberg surmised that the note and subsequent fight were desperate moves by Mayer, who was struggling to protect what little credibility he had in the industry. "The Alexandria days were desperate times," Schulberg wrote. "Those were the days from hunger, when you lacked the credentials and assets you made up in bluff and chutzpah."[48]

The hotel continued to thrive into 1920, when waiters were said to "make only one appearance each evening," and "Los Angeles society turn[ed] out in practically full force every evening."[49] But all of this was about to change after January 1, 1921, when the Alexandria's sister, the Ambassador Hotel, opened. At first, the stars divided their time between the two hotels, but by the end of the year, both older and younger generations of film stars began to spend more time at the Ambassador and the newer entertainment venues that had opened up in Hollywood. When *Motion Picture Magazine* writer Herbert Howe visited the hotel in 1922, he reported, "I fully expected to behold its

Opposite: The Commercial Artists Ball inside the Rose Ballroom in 1922.

lobby filled with familiar faces, but the only screen favorite that I recognized was the Potted Palm."[50] Douglas Fairbanks Jr., who moved from New York to Los Angeles to live with his famous father in 1923, later said, "When I first came out, they were saying it was a shame that the movie people didn't meet anymore at the Alexandria Hotel in Los Angeles. Everyone had moved out to Hollywood and some had gone as far as Beverly Hills, where the bean fields were. Each new generation in Hollywood makes its own changes. You can't live in a state of constant regret."[51]

The next bad news for the Alexandria came on October 1923 with the opening of the $10 million Biltmore Hotel across from Pershing Square, a few blocks away. As the *Times* reported, "The exodus of the Associated Cofraternity of Lobby Loungers of Los Angeles was completed yesterday from the Hotel Alexandria to the new Hotel Biltmore.... Among the émigrés from the Alexandria are the gentleman who always has his pockets stuffed with diamonds and rubies, which he always has just inherited from a rich uncle; the old prospector in the Polk collar who has a lost mine in every pocket, and the several dapper persons who have no apparent cause for membership except that they press their own trousers, live in furnished rooms over cross-street places of business, eat in cafeterias but always pick their teeth in the lobby of the big hotels."[52]

The Straus Company continued to operate the Alexandria even as the hotel's clientele changed. One guest was Mad Josephina, a deranged stalker from Mexico City who was eventually arrested for breaking into Chaplin's Hollywood Hills home and waiting for him in his bed.[53] Another guest was former heavyweight champ Jess Willard, who in 1924 was low on cash after losing his last fight to Luis Ángel Firpo.

As the Alexandria declined, many longtime employees and key managers transferred to the Ambassador, and in 1927, the Strauss Company sold the Alexandria to San Francisco businessman William C. Crittendon. He immediately leased the property for 25 years and sold the furnishings to hotel chain owners Eugene C. Eppley and Charles B. Hamilton in an overall transaction costing $8,500,000.[54] Crittenden then formed the Alexandria Hotel Realty Corporation to oversee the hotel's business interests. The hotel continued to struggle, and following the Stock Market Crash of 1929, Crittendon sold his interest for $3 million to Charles C. Chapman and his son, Stanley, owners of the Santa Ysabel Land Company.[55]

Prices at the Alexandria were slashed and by 1930, the Indian Grill had become a cafeteria, and the hotel's tea room had become a coffee shop. After the Alexandria Hotel Realty Corporation went bankrupt in 1932, the leaseholders organized a new company called Spring Street Properties to try and sell over a million dollars in bonds to pay property owners.[56]

While the hotel struggled to stay solvent, a few sports stars stayed there. One of them was Johnny "Blood" McNally, a Hall of Fame halfback for the Green Bay Packers. During his stay, Blood was said to have climbed onto a ledge on the eighth floor and leapt five feet to the ledge across the way in order to enter Packer Coach Curly Lambeau's room and ask for a cash advance so he could go drinking.[57] Another sports legend was future heavyweight champion Primo Carnera, who told the Alexandria bellboys that "he was lonesome and asked if someone couldn't get him a sweetie."[58]

In 1933, the Security First National Bank brought a lawsuit against the Chapman family, Spring Street Properties, and the Alexandria Hotel Realty Company, asking for $1,144,500. The suit also claimed that these companies had defaulted on ground rentals and the principal.[59] On January 31, 1934, hotel guests and tenants were given notice that the hotel would close on February 9.[60] The management held a farewell banquet for its employees, who walked the halls along with longtime residents, gazing at the empty marble floor where the "million dollar carpet" had once lain and reminisced about past guests like Jack Dempsey, Jess Willard, and the famous movie stars who used to play there. "It's funny," said Posner.

> *You get set in a place doing the same thing day after day—you see people who are nobodies go to be somebodies—you see them go from palookas to world champs—and then later you see them again, drifting down or forgotten. And somehow you get to feeling that you are something like a god—if you understand what I mean—because you are always looking at a sort of parade that is passing by; everybody changing; going up, later down; becoming has-beens—while you stay the same. Then [all] of a sudden something happens and it hits you…that Father Time hasn't forgotten you either…you're changing like the others.* [61]

Hotel guests Barry Gray and Walter Masters were the last to check out,[62] and then the doors closed and many of the hotel's finest furnishings and fixtures—including the lobby rugs, marble, and the gold leaf covering of the mezzanine lobby—were removed and sold. An unusual item was found by auditors in one of the hotel's vaults. In an envelope marked *D.W. Griffith—personal*, they found $26,000 in cash that had apparently been forgotten by the director.[63]

Because Bilicke and Rowan had never bought the land the Alexandria and the annex were built on, the ownership of most of the original building fell into possession of Mrs. Elsie K. Alexander, widow of original property owner John Alexander, while a small wing of the building along Fifth Street belonged to William Chick. The annex

fell into the possession of several landowners, including Mrs. Alexander, the family of Nelson P. Story, Mrs. John E. Wheeler, Mrs. Abbie R. Thompson, and the heirs of Mary E. Richards, and G.H. Pinney.[64] Elsie Alexander sold her entire stake, including her partial ownership of the annex, in 1937 for approximately $300,000 to Phil Goldstone, a motion picture producer who dabbled in real estate. Goldstone then announced that he would reopen the Alexandria Hotel after a $500,000 refurbishment.[65]

In June of 1938, John E. Wheeler bought out the remaining annex property owners for $250,000 and announced that he would spend an additional $300,000 to refurbish it as a separate building.[66] His plans never materialized, however, and the annex ended up in the possession of Goldstone. Meanwhile, Lee M. Roddie, daughter of William Chick, refused to sell her small wing of the main building at 218 West Fifth Street, which consisted of a number of guest rooms, and a couple of store fronts. As the story goes, Goldstone became furious with her when one of his retail tenants relocated to her property after Goldstone raised retail rents. Because Roddie would not raise her rent, Goldstone angrily bricked all hallway access to her property, rendering her guest rooms useless as her wing had no elevator or stairway access.[67]

The reopening of the Alexandria Hotel in 1938 stirred up curiosity and sentimentality among those who had loved the old building. But Goldstone's version of the hotel, minus its marble columns, gold leaf detail, and other nostalgic furnishings, never reclaimed its former glory. Instead, it operated as a nice, middle-class hotel that catered to businessmen and downtown civic groups.

During World War II, when mandatory blackouts were enforced throughout the city, all of the Alexandria's skylights, including those in the Franco-Italian Dining Room, were painted black. The hotel also occasionally housed military personnel and emergency volunteers during the war.

In 1946, Goldstone sold the Alexandria to Julius Epstein and Maxwell Abell. Eight years later, in 1954, the Alexandria lobby underwent another major renovation. The mezzanine that had once overlooked the lobby was filled in so the Pacific Coast Merchandise Mart could occupy the entire floor, along with three additional floors. With the ceiling space now lowered, the lobby was given a Mid-Century Modern, French Provincial look, featuring square pillars, custom-made furniture, and planters.[68] By this time, part of the basement level had already been gutted to make room for a small underground parking garage.

In 1957, Maxwell Abell and Associates sold the Alexandria for $2 million to manager George H. Karlin, and his brother, Phillip, who formed the Karlin-Alexandria Hotel Corporation. Although the Karlins planned to add televisions to the rooms and air conditioning to the common areas, money became an issue.[69]

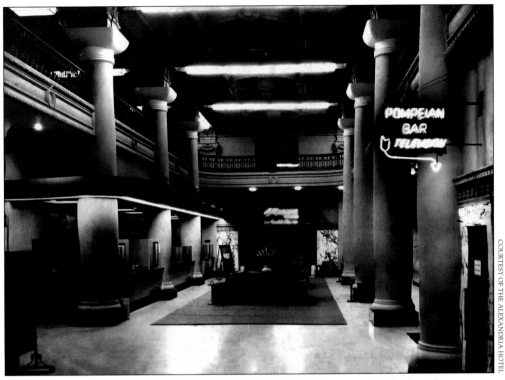

*The lobby in the mid to late 1940s, after Goldstone sold the hotel to
Julius Epstein and Maxwell Abel.*

The lobby after it was modified in 1954.

In 1958, the Franco-Italian Dining Room and the Rose Ballroom were leased by famous boxing promoter George Parnassus, who installed a training ring for Mexican featherweight boxer Pajarito Moreno, who was preparing for a world title bout at Wrigley Field. Despite Moreno's loss, the Franco-Italian Dining Room, now called the Palm Court, became a popular venue for press conferences and sports banquets. Parnassus, who maintained his headquarters at the Alexandria, brought business to the hotel by offering rooms to boxing fans coming to see his fighters. At first, the novelty of training camps at the hotel attracted crowds. "You enter the Alexandria Hotel and find the lobby liberally sprinkled with knots of people, most of them Latin," *Times* reporter Al Wolf wrote in 1960. "They lounge lazily and converse in low tones. But when the door marked Palm Room is thrown open, the scene suddenly becomes animated. Everybody surges toward that door, including women with babies in their arms or toddlers at their sides. ... The admission charge is $1, and bills rain down on the man at the little desk, though some don't appear to be that affluent."[70]

But by 1968 the novelty had worn off and *Times* reporter Dwight Chapin wrote, "Downstairs, the old men with hard eyes, their cigars gone dead between their teeth, sit slouched on couches. Some read, some chat, some just stare. As you walk upstairs, through the semi-darkness, you think that this Alexandria Hotel once must have been some kind of place. But now its opulence, its era of greatness is gone."[71]

The Alexandria eventually sold again, this time to S. Jon Kreedman, a real estate developer who initially planned to tear down the hotel and build an office building. Then the City of Los Angeles mounted a campaign in 1969 to rejuvenate its downtown business district and set aside funds for the restoration of historic buildings. Kreedman learned of the Alexandria's importance from a prospective tenant, who suggested that he try and save the hotel rather than tear it down. Two actresses, Nancy Malone and Lisa Mitchell, were contracted to research and supervise the restoration of the "Alex," and in 1971, the Palm Court was recognized as a local historic landmark, though the rest of the building was not.

Under Malone and Mitchell's direction, suites were refurbished with Victorian furnishings, and renamed in honor of the A-list celebrities who were said to have visited the Alexandria. A plaque of names and room numbers was also mounted on a lobby wall, though much of the information was invented to enhance publicity. The resurrection of the Alexandria brought cheers from Old Hollywood enthusiasts, the vintage crowd, conservationists, and former tenants. When a suite was officially

The Alexandria Hotel, furnished with Victorian wallpaper
and reproductions, in the early 1970s.

named in honor of a celebrity, surviving silent film players like Betty Bronson, Vivian Duncan of the Duncan Sisters, Minta Durfee, and Claire Windsor were present at the event, telling stories about their days and nights at the hotel. Some of them even arrived wearing vintage clothing.[72]

But the nostalgia didn't last. Kreedman sold the Alexandria in 1975 to La Alexandria Corp., headed by Manuel Vazquez, for $4 million.[73] By this time, the hotel had 460 guest rooms, three restaurants, and a garage for 250 cars. La Alexandria Corp. failed to make the hotel profitable, however, and by the late 1970s, the hotel was again promoting boxing matches.

In 1979, Martin Yacoobian, who owned properties in the downtown Skid Row section of Los Angeles, bought the Alexandria for around $5 million. By this time, the hotel was nearly empty, so Yacoobian brought in 250 permanent residents and asked the city's Community Redevelopment Commission for help in acquiring the Alexandria's sealed-off wing, which still had two longtime retail tenants, Broadway Florist and a bar named Trochy's. But Lee Roddie, who still owned that part of the

building, refused all offers, telling the *Times* in 1980, "No! No! No! I'll never sell! If they threaten me with condemnation, I'll threaten them!"[74] Condemnation never happened, and after Roddie's death later that year, the "ghost wing" continued to rot.

Yacoobian's plan to spend approximately $3 million to restore the Alexandria into an affordable hotel for low-income individuals was not successful. In fact, under his ownership, the hotel sank to a new low as Spring Street became the city's illicit drug center and the old hotel its "supermarket." According to the *Times*, from the beginning of 1987 through April of 1988, close to 600 drug and prostitution arrests were made in the hotel by Los Angeles Police Department officers, who found crack cocaine labs on the eighth and 12th floors and prostitutes loitering around the lobby.

Mayor Tom Bradley called the Alexandria "a magnet for parasites in this society,"[75] and the City of Los Angeles filed a complaint against the Yacoobian family, charging them with violating the city's prostitution and drug laws. While the Yacoobian family argued that the LAPD was exaggerating its claims, Police Officer John Emmett Smith, who regularly patrolled the Alexandria, told the *Times*, "I have made arrests on every floor of the Alexandria Hotel, including the barroom, roof and lower-level parking lot…. There is no place inside the hotel that you cannot find evidence of narcotics use."[76] The fight to rid the hotel of its drug traffickers became an ongoing battle waged by police and the Yacoobian family, who had hired security guards to monitor the lobby and hallways.

Mayor Bradley calls for a crackdown on the drugs, and prostitution at the Alexandria.

By 2005, a real estate boom had brought a new kind of interest to the Alexandria as developers began to toy with the idea of turning the building's old guest rooms into micro-lofts. Martin Yacoobian Jr. scoffed at the idea, arguing that, thanks to rent control and the legal problems that would arise from evicting the poor, the hotel would always be low-income housing for the downtrodden. "It is what it is," he told the *Times*. "There's only so much you can get out of a building like that."[77]

But the Amerland Group, a for-profit company controlled by Ruben Islas, Jules Arthur, and Paul Buxbaum, thought differently. The partners purchased the Alexandria in 2006, and with the help of city leaders and access to millions of dollars in tax-exempt public bonds, they began converting rooms into affordable micro-loft apartments for people living below a certain income level.

Amerland's tenure was not without its controversy. In 2007, a lawsuit was filed against the hotel owners and the City of Los Angeles claiming that a handful of tenants had been illegally displaced. The lawsuit further alleged that during renovations, Amerland shut off heaters, water, and elevators without sufficient notice to its elderly and disabled tenants. Adding to Amerland's woes was the city attorney's filing of 36 criminal counts related to fire code violations for both the Alexandria and the Rosslyn, another old hotel purchased by the company for low-income housing. Amerland pleaded no contest, paid the fines, and updated the fire sprinkler systems. In early 2009, the other lawsuit was settled, whereby ten tenants, including four who had been unlawfully evicted, were paid close to $1 million in damages.[78]

The "ghost wing" was finally sold in late 2012 to developer Nick Hadim, who announced his intention to convert the long-abandoned section of the Alexandria into the Chelsea Apartments; however, as of late 2016, no work had been done on the sealed off section of the building. The Alex, meanwhile, still had problems with occasional outbreaks of crime, as evidenced by a stabbing that took place in the lobby in January 2013.[79] A glimmer of hope began to shine in 2014 when developer Izek Shomof purchased the Alexandria, telling the press that he would continue to restore it without damaging its historic appeal.[80] Since that time, the lobby, Palm Court, and second floor ballroom, have been converted into upscale wedding and party venues. The micro-loft units have also improved, and it appears as though the Alexandria may enjoy another kind of renaissance in the near future.

The Alexandria Hotel's "Ghost Wing" in 2016.

PHOTOGRAPHER: CRAIG OWENS

225

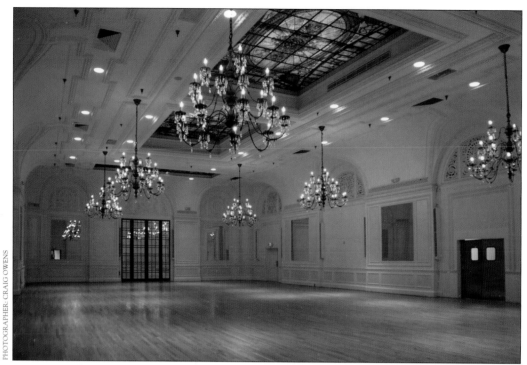

PHOTOGRAPHER: CRAIG OWENS

The Franco-Italian Dining Room (now the Palm Court) in 2016.

Part of the lobby is now a rental facility for weddings and private receptions.

PHOTOGRAPHER: CRAIG OWENS

The Alexandria's lobby.

SAD HILL ARCHIVE

KING EDWARD DID NOT SLEEP HERE!

Did you know that the Alexandria Hotel's second floor ballroom is called the King Edward Ballroom—despite the fact that King Edward never set foot inside the hotel?

The legend started in 1969, when boxing promoter George Parnassus told the *Los Angeles Times* that the heir to the British throne once visited the hotel to attend a secret meeting with famed pianist and Polish politician Ignacy Jan Paderewski. The secret meeting, however, never happened nor did the *Times* bother to fact check Parnassus' claim.

The haunted Valentino Suite (Rooms 1202-03).
The door seen in this picture slammed shut on its own
during our shoot, startling all of us.

The Hauntings

The Alexandria Hotel has long been rumored to be haunted, and its ghost stories are based on legends of suicides, accidents, murders, heartbreak, and wild parties. It is true that the hotel, despite its bright and glorious history, had a surprisingly high mortality rate from 1913 to 1922. Still, it is hard to pinpoint exactly when the ghost stories first began, although there are indications that the ghost stories go back many decades. [*See end of chapter for more details.*]

When the hotel faced closure in 1934, the *Los Angeles Times* published an article titled "Ghosts of Hostelrie's Past Grace Farewell Gathering of Staff." In the article, the *Times* used the supernatural to romanticize the hotel's history by writing, "The ghosts of Woodrow Wilson, William Howard Taft, Theodore Roosevelt, William Jennings Bryan, Enrico Caruso, Sarah Bernhardt and scores of others who have been toasted by the world stalked through the corridors of the Alexandria last night, corridors in which a weight of memories flitted behind a mantle of regret." It further stated that "Shades of departed Presidents and royalty haunted the famous Imperial suite on the seventh floor [sic]."[81]

When the Alexandria reopened in the late 1930s, there was no talk of ghosts, at least, not publicly. There were no reported deaths, either, until December 13, 1961, when 34-year-old Irving Moses, a former mental patient, leaped to his death from a fire escape at the hotel and landed on two pedestrians who survived, though one of them sustained a broken back.[82]

However, by this time, ghost stories at the Alexandria definitely existed. These claims centered around a female apparition that was thought to be connected to the sealed off wing. In fact, one of the first public mentions of a haunting occurred in 1969, when *Times* reporter Turnley Walker wrote, "Thirty rooms were sealed off by an heiress of great fortune who lived on and on there, ghost-fashion."[83]

Nancy Malone had also heard that the Alexandria was haunted when she started working there in the early 1970s. She didn't think much about it until she

MODEL: RUBY MAE COLLINS. PHOTOGRAPHER: CRAIG OWENS

An Alexandria Hotel hallway.

encountered a ghost while she was hanging pictures in an upstairs hallway. She claimed that around two o'clock on a September morning, she saw a semi-solid woman in her 30s or 40s wearing a black, high-necked, early 20th-century dress with something resembling a bustle and a wide, veiled, black hat. The ghostly woman walked about eight feet down the hallway before disappearing.[84]

In 1997, the International Society for Paranormal Research (ISPR), headed by Larry Montz (who claimed that he had a Ph.D. at the time[85]) and Daena Smoller (a medium and publicist), arrived in Hollywood from New Orleans to establish Ghost Expeditions, a Los Angeles-based commercial ghost-hunting tour. The Alexandria

became one of ISPR's haunted destinations as customers paid $45 each for the opportunity to investigate the so-called Valentino and Chaplin Suites, the Palm Court, and part of the basement. During one of their 1997 investigations, ISPR's Maria Saganis and Chris Kelley told their customers "of mirrors falling off the wall, lights turning themselves off and unexplained music in the deserted ball room." The team also claimed that the Chaplin Suite (Rooms 1102-03) had a closet whose door would slam shut and whose light would turn off. At one point during the investigation, Saganis, who claimed to be clairvoyant, told *San Bernardino Sun* columnist Janet Zimmerman that she could see "a handsome '30s socialite named Tom, who had curly blond hair, a double-breasted suit and chiseled features" who had "died from a gunshot to the head."[86] A year later, Smoller told the *Times* that Rudolph Valentino haunted the 12th floor suite named after him and that "Every single time we have done an investigation there, someone in the group ends up having a channeling experience. And it's always in the bedroom." The ISPR team also claimed that the hotel's cleaning staff had seen an apparition of a well-dressed man in the bedroom and that people, especially women, experienced the sensation of being touched by invisible hands.[87]

Smoller then claimed that the ghost of an angry teenage male haunted the Charlie Chaplin Suite, that the Palm Court had unexplained cold spots, and that the Alexandria's basement, described as a "maze of three tunnels," was haunted by the ghosts of "Larry and Gus, both Mafioso and very communicative." As Smoller told the *Times*, "We get the impression that Gus was a hit man from the old Ciro's nightclub days on Sunset, which is now the Comedy Store, also one of Gus' favorite haunts."[88] Of course, the Comedy Store also happened to be one of ISPR's other haunts.

In 2001, after Montz and Smoller failed to sell their paranormal television show concept to a cable television network, they moved ISPR back to New Orleans, declaring that their successful field "research" had reached a satisfying conclusion. However, ISPR's field research was far from scientific, and they left behind a number of false ghost stories about many allegedly haunted locations, including the Alexandria. When Montz was questioned about the integrity of ISPR's paranormal conclusions, he replied, "But we've had so much validation already [from psychics], it's a moot point to have a researcher go back through newspapers or whatever."[89]

Even after ISPR left, new ghost stories emerged at the Alexandria as tenants continued to report unusual banging sounds, bursts of air blowing through their rooms, doors opening and closing on their own, and other alleged paranormal phenomena.

MODEL: RUBY MAE COLLINS . PHOTOGRAPHER: CRAIG OWE

The mezzanine level.

The building continued to have a number of deaths. In 2009, a faulty fire escape railing on the ninth floor broke, sending an 87-year-old man to his death. Another death occurred in 2013, when a 24-year-old man plummeted from the fourth floor.[90]

One of the most haunted areas in the Alexandria is the second-floor ballroom (formerly called the Rose Ballroom). Not only has the "lady in black" been seen near its entrance, but there has also been at least one eyewitness account of a spectral 1910s formal dance taking place in the room. In the second floor ladies' restroom, located nearby, people have seen faucets turning on by themselves. In 2012, security guard Johnny Rayo claimed that while he was monitoring the building's security cameras, he had noticed the lights in one of the ballrooms flickering, as if someone

232

were rapidly turning the lights on and off. When he went to investigate, he discovered that all the entrances to the ballroom were locked.[91]

Another apparition commonly reported near the second floor ballroom is a shy young girl wearing a white dress who is occasionally seen peeking through the doorway before turning and running away. She's described as being eight to 12 years old, with long, dark hair. Employees have also seen a male apparition wearing an overcoat and fedora walking through walls in the hotel's parking garage. More recently, a new legend emerged that the "lady in black" ghost is a shape shifter that can take the form of a black cat.

Former tenant Alexis Justman heard about the hotel ghosts when she worked as a hostess for the Gorbals Restaurant next to the main lobby. Apparently, in 2009, Gorbals used the Franco-Italian Dining Room's former kitchen as a storage room. On several occasions, Grobals' wait staff saw vintage looking servers "wearing fancy black and white period suits" enter from the empty banquet room to grab invisible supplies before leaving. "They never acknowledged us and minded their own business," Justman recalled. "But they looked like real people, not apparitions or ghosts."[92]

The old elevators are also thought to be haunted because they have the tendency to stop on different floors. The prevailing legend is that a six-year-old girl (possibly the daughter of one of the hotel's architects) opened one of the elevator cages while the hotel was under construction and fell down the shaft to her death. Historically, however, none of the architects ever lost any family members at the hotel, nor are the current elevators original to the building. That said, there were real accidents connected with an elevator at the Alexandria, but none of them resulted in death. In late January of 1916, for instance, an elevator door unexpectedly closed on the leg of its operator, Joe Brousett. When the elevator took off, his trapped leg was badly mangled and he fainted. An ambulance was called, Brousett was driven home, and another elevator operator took his place. Three hours later, Doc Bassett, superintendent of services, stepped into the elevator and "thought he saw a ghost" when he found Brousett back on the job. "You see," Brousett explained, "that was a cork leg that got smashed. … The accident brought back so vividly my original accident that I fainted and only came to by the time I reached home. Then I put on my reserve leg and came back to work."[93]

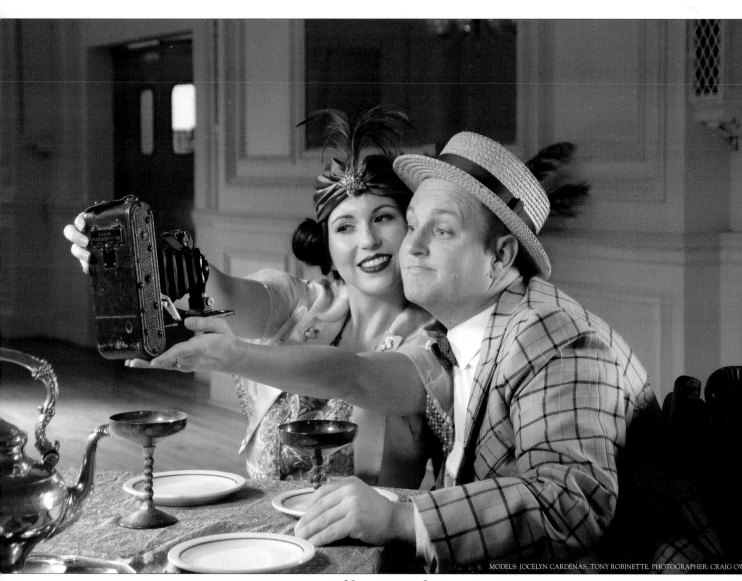

MODELS: JOCELYN CARDENAS, TONY ROBINETTE. PHOTOGRAPHER: CRAIG OW

Selfies, 1916 style.

Our Shoots

In early 2012, I met with an Alexandria leasing agent named Javier, who agreed to let me conduct a small shoot in the Valentino Suite (Rooms 1202-03). Having seen that space in 1997, I was excited to shoot there, but I was also shocked to see how badly it had deteriorated. The once red carpet was now a sun-bleached neon pink and was badly stained. Many of the furnishings were either broken or had long since been removed, including Valentino's portrait, which had hung on the bedroom wall. All that remained were a headboard, a Victorian loveseat reproduction (now falling apart), a broken chair, and a chaise whose fabric was ripped.

When I asked Javier about the suite's ghost story, he told me that a woman, perhaps one of Valentino's wives or a girlfriend, had committed suicide after hearing about the star's death in 1926. This story was baseless, since neither of Valentino's two ex-wives, Jean Acker and Natacha Rambova, committed suicide. Javier also told me that during a previous photo shoot in the suite, one of the doors connecting the front room to the bedroom had slammed shut on its own with tremendous force, startling the photographer. Javier also said that people walking past the room occasionally heard strange bangs and angry voices coming from inside the suite, which was thought to be empty at the time.

With Javier's stories in mind, I organized my shoot and spent a couple weeks searching for period furniture, bedding, and hand props. I hired Carly Carpenter and Adam Johnson to be the models and Johanna Serrano as the hair-and-makeup artist. My brother Jamison joined us as we made numerous trips up and down the elevator, hauling furniture and equipment up to the Alexandria's top floor. Meanwhile, Johanna and Carly used a micro-loft on the 11th floor for hair and makeup.

With Adam's help, Jamison and I spent a couple hours decorating the Valentino Suite and made multiple trips to local stores to buy fake flowers, batteries, bottled water, coffee, paper towels, and insect spray. In the suite's front room, there was

an oversized open window that could not be closed, which allowed thick clouds of swirling fruit flies to invade the suite. The window had no screen and was too wide for a person to catch himself if he should trip and fall. When I caught Johanna standing near the window, I pulled her back, moved a chaise in front of it, and told everyone that it was off-limits. It was too easy to imagine how a simple clumsy movement could result in a fatal, 12-floor plunge to the pavement below.

Because of the flies, we had to fumigate the room a few times, which meant that we had to leave for about a half hour each time. During one of those breaks, I decided to go outside and have a cigarette. As I left the Valentino Suite and absent-mindedly ambled down one flight of stairs, it dawned on me that walking down 11 flights of stairs to the lobby was ridiculous. I then pressed the elevator button on the 11th floor and decided to wait, and as I stood there, my peripheral vision caught a short, squat, elderly woman wearing a dark, wide-brimmed hat and a dark dress hobbling up the hallway towards me. She carried a walking cane with one hand and a large bag with the other. Because there are all kinds of eccentric people living at the former hotel, I chose not to stare and simply minded my own business. But I was aware that the woman had stopped behind me and did not continue down the hallway. In fact, I remember hearing her breathing and the crackling sounds made by her bag.

When the elevator finally arrived and the doors opened, I turned and gestured for the woman to enter the elevator first. The only problem was…the woman was no longer there! Puzzled (and a little embarrassed), I took the elevator down alone.

As the afternoon shoot began, Carly and Adam took turns in front of the camera, Jamison stood near the lights, and Johanna crouched by the wall with her makeup kit. By 9:30, the suite had turned gloomy. Carly, Adam, Joanna, Jamison, and I were working in the bedroom while Javier, who had joined us after work, stood alone in the front room, aiming a hand-held spotlight at Carly. As I fired off a couple of test shots and made adjustments to the camera's aperture, Javier said he was "getting spooked" and wanted me to hurry up and get my shot so he could leave the front room. We were all kind of joking around, trying to make light of the gloom, when suddenly the bathroom door in the front room slammed shut with such force that we all felt its impact and heard the windows rattle throughout the suite. Javier, who was standing about six feet from the door, let out a cry of alarm and the beam from his handheld spotlight began to quiver. We were all saucer-eyed, but I managed to convince everyone to remain calm a little longer as I fired off a few more shots.

We all knew the slamming door was not caused by a cross breeze because there was no significant wind that day. Furthermore, when I investigated the windowless

236

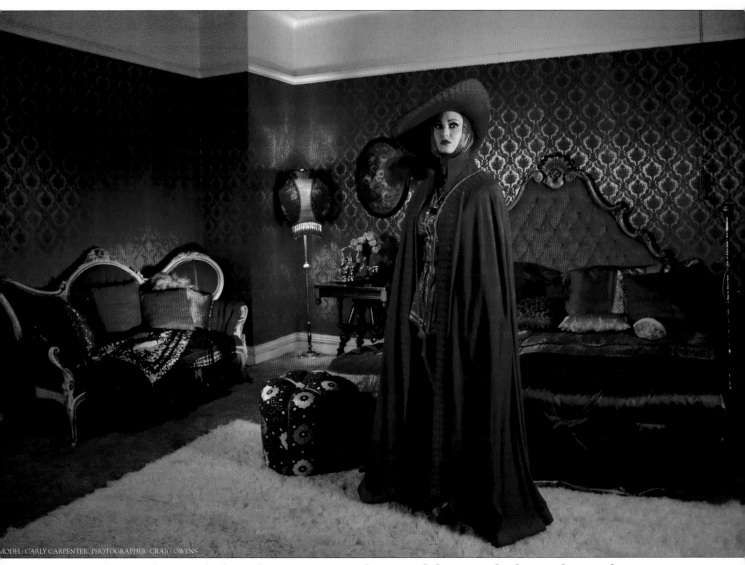

MODEL: CARLY CARPENTER, PHOTOGRAPHER: CRAIG OWENS

Photo taken inside the Valentino Suite, right around the time a bathroom door in the next room slammed shut by itself.

bathroom, I discovered that the floor tiles were so uneven that the door had to have been wedged in an open position. As I tried to recreate the force required to make the door slam hard enough to make the window glass rattle, I determined that it took over three-quarters of my arm strength just to free the door from the uneven tiles.

Around 1:45 a.m., we packed our gear and left the Alexandria. Though we had tried conducting EVP sessions with our digital audio recorders, the downtown noise was too loud. Still, we all were certain that we had witnessed a definite paranormal encounter inside that room.

We returned for the second part of the shoot the following Sunday and spent the first half the day shooting in the Valentino Suite. We attempted to run a few paranormal tests, but there were no signs of a ghost. Still, it was hard for us to leave the room at the appointed time as we had grown quite accustomed to the space.

That night, we moved to the Rose Ballroom on the second floor. While there, we saw a number of people coming and going from a performance in the City of Angels Theater, which was located near the original upstairs orchestra balcony.

During our shoot, Javier had a new story to tell about the ballroom. A few days before our arrival, a grip and a member of the electric crew for a film shoot arrived at the Alexandria around 5:00 a.m. and began hauling lights and cables into the ballroom. One man left to pick up more gear, while the other stayed behind with the cables and equipment. Alone in the room, the crew member suddenly began feeling uncomfortable. When he looked into one of the large mirrors near the fireplace, he saw the "girl in white" standing directly behind him. He dropped his gear and immediately left the room. After hearing Javier's story, I had privately hoped that I, too, might see the "girl in white," but, alas, it didn't happen.

In 2016, I returned to the hotel for a second shoot. This time I brought along models Jerry Baldonado, Jocelyn Cardenas, Bonnie Dias, Laine Hunkeler, and Tony Robinette. Ginger Pauley, Peter Borosh, and Johanna Serrano were the crew.

For this second shoot, we were given access to the Palm Court, the lobby, the mezzanine level, a hallway, and the Valentino Suite. Because the shoot was a short one, we unfortunately had no time to ghost hunt…not that we would have been able to find anything paranormal, anyway. The first and second floors were bustling with workers as hotel employees routinely gave tours to prospective customers looking to book their next event.

In preparing for the shoot, I heard a couple of new ghost stories relating to the mezzanine floor and the Little Easy restaurant and bar on the ground floor. Apparently, a manager of the Little Easy was walking along a hallway on the mezzanine level

when he suddenly felt something invisible tugging at the receipts he was carrying. Wondering what was going on, the employee tightened his hold on the papers, and then the pulling sensation suddenly stopped, leaving him baffled as to what had just happened. On another occasion, Little Easy employees working the late shift witnessed a number of candles on tables in the back dining area blow out by themselves.

While I never experienced any paranormal activity during our 2016 shoot at the Alex, it was still a great thrill for me to be there. I love this building. I always find myself imagining what life must have been like a hundred years ago when the hotel dominated Los Angeles' social scene. And after researching all of its famous guests, its grifters, its wild parties, and its hard times, (not to mention my own paranormal experiences at the hotel in 2011), I can't help but conclude that if the Alex isn't haunted by its own history…it should be. It has earned that right.

A small section of the Alexandria's ground floor that has still retained much of its original character.

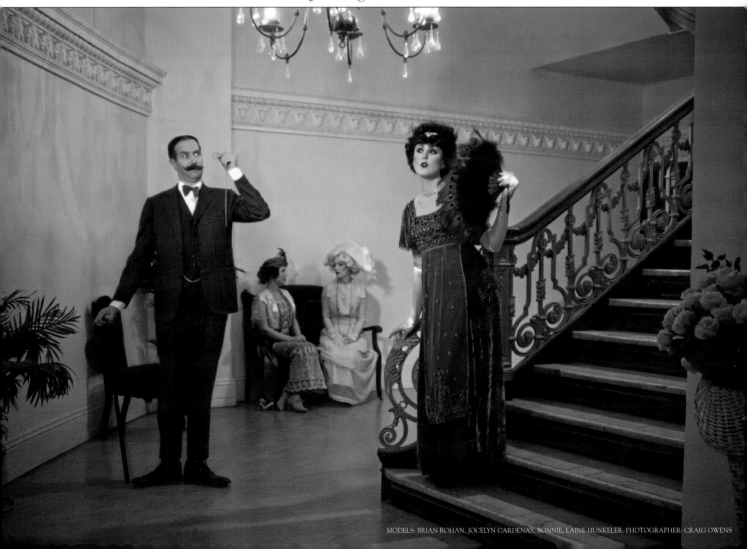

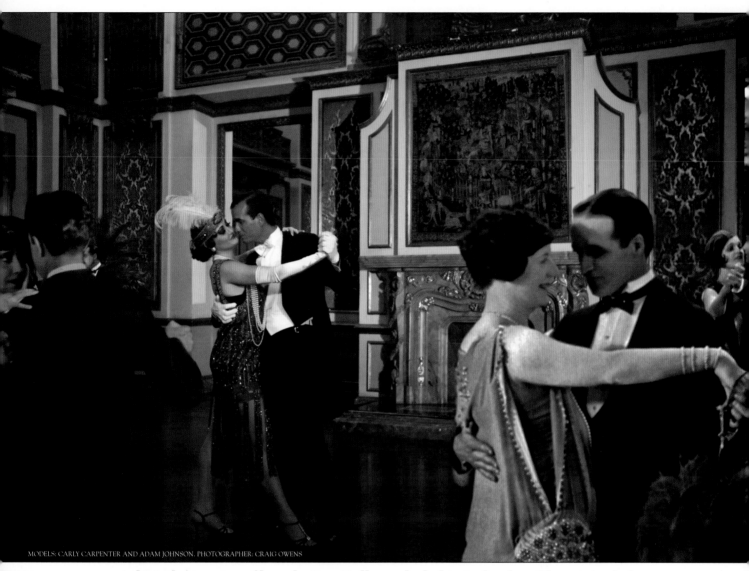

MODELS: CARLY CARPENTER AND ADAM JOHNSON. PHOTOGRAPHER: CRAIG OWENS

A digital recreation of how the Rose Ballroom looked in its heyday. The original photo was shot inside the room in 2011.

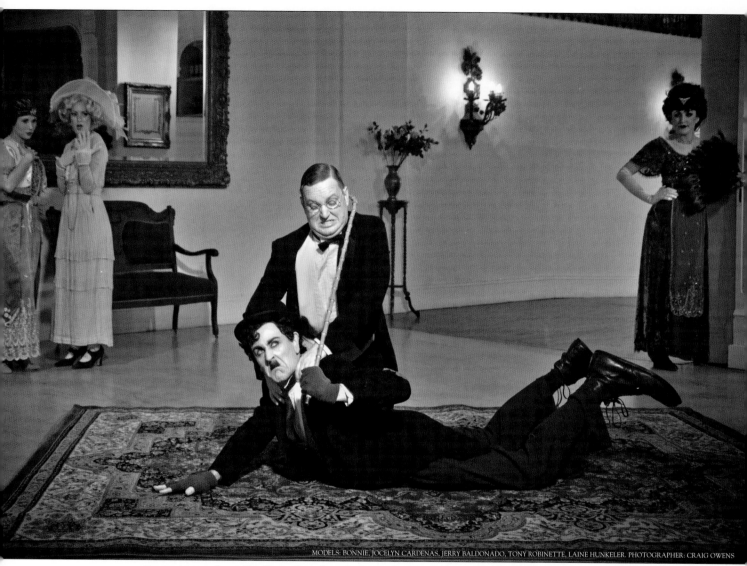

MODELS: BONNIE, JOCELYN CARDENAS, JERRY BALDONADO, TONY ROBINETTE, LAINE HUNKELER. PHOTOGRAPHER: CRAIG OWENS

Restaging the Charles Chaplin fight with Louis B. Mayer in the lobby.

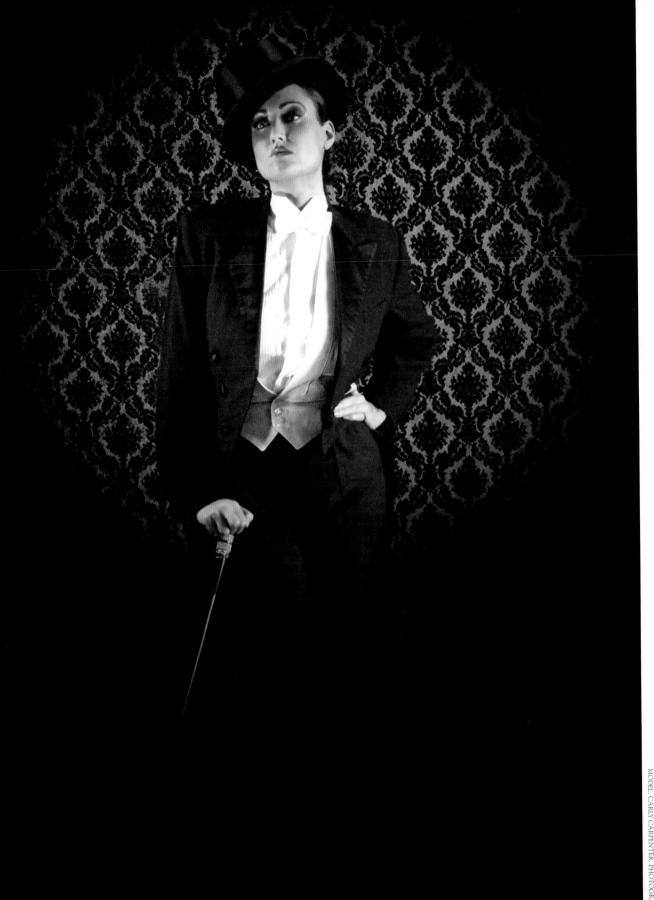

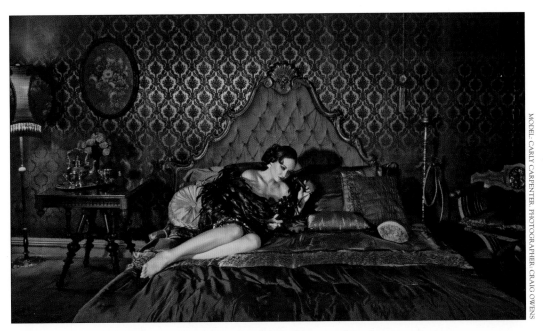

MODEL: CARLY CARPENTER. PHOTOGRAPHER: CRAIG OWENS

Left, above, and below: Inside the haunted Valentino Suite.

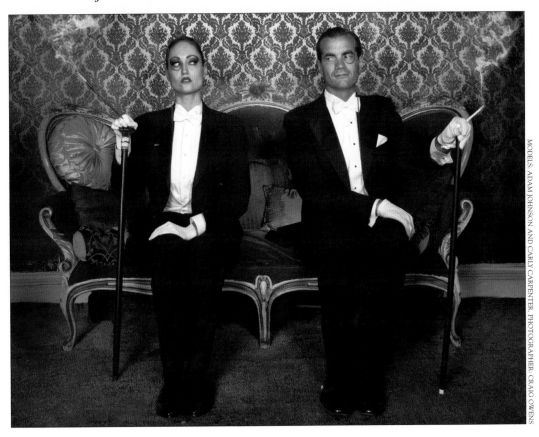

MODELS: ADAM JOHNSON AND CARLY CARPENTER. PHOTOGRAPHER: CRAIG OWENS

TONY ROBINETTE AND LAINE HUNKELER. PHOTOGRAPHER: CRAIG OWENS

Two photos depicting the Alexandria Game prostitution racket
(see page 212).

Strange Deaths at the Alexandria Hotel (1913-1922)

Despite the Alexandria's reputation for being the place to be seen in Los Angeles, it had its share of bizarre deaths, too.

On March 19, 1913, the *Los Angeles Times* mentioned three hotel deaths in three weeks. The first was a 60-year-old woman named Mrs. Meckle L. Lee, who was described as eccentric, a dabbler in real estate and worth half a million dollars, who had died of heart failure in her sleep. Next came G.W. Clark, a vice president at the Homer Laughlin China Pottery Company of East Liverpool, Ohio, who died of cerebral hemorrhage, also in his sleep. The third death occurred on March 18, when 21-year-old Marjorie Sullivan was discovered by her mother and sister at 5:30 a.m. dead from heart failure induced by phthisis, a medical term synonymous at the time with tuberculosis.

The Alexandria's manager at the time, S. J. Whitmore, gave a very odd interview to the *Times* in which he said that these deaths fulfilled a "mystic

Mrs. Adele Fairchild Suicide
Takes Poison in Los Angeles

Mrs. Adele Fairchild, of this city, who ended her life in Los Angeles yesterday, after several years of unusual domestic infelicity.

Husband Says She Loved Man He Once
Sued for $250,000 Damages

Adele Fairchild, alias Adele Frisbee, was the first reported suicide at the Alexandria. But was her death really a suicide…or murder?

cycle of three" and that further deaths were no longer a concern:

> *When I was notified this morning of the passing away of Miss Sullivan, all of my suspense was at an end,"* Whitmore said. *"I was able to relax and stop wondering who would be the third. In an establishment of this size, where there are more than a thousand persons a day making their home, to say nothing of the hundreds of employees, there is always a certainty of the appearance of death…. It is statistically impossible for a hotel to avoid such things and the traveling public no more thinks of death, ghosts and other phenomena of this character in a superstitious light.*[94]

Though there are no records of other triple deaths at the hotel, the deaths grew increasingly strange.

On May 27, 1915, Anna "Adele" Elizabeth Fairchild, a 25-year-old woman from San Francisco, checked into a spacious suite late at night using the alias Adele Frisbee. The next day, a chambermaid heard the sound of a woman groaning, which prompted her to enter Fairchild's bedroom, where she found the woman in agony. A physician was sent for, but nothing could be done to save her. Fairchild's last words were, "I have taken poison. I want to die. I want to die so much…so much," at which point she drifted out of consciousness and out of life.[95]

Detectives concluded that Adele Fairchild had bought the poison the night before at a nearby drugstore and had ingested it with water shortly before going to bed. They had also found a worn letter that indicated an unhappy marriage. Police then contacted Adele's husband, Leon Fairchild, a druggist in San Francisco, who

told them that his wife had recently had an adulterous affair with his "old friend" and former employer, Walter P. Shaw, a wealthy Los Angeles businessman who worked as a western representative for a Kentucky distillery. As the story goes, Leon had worked for Shaw as a salesman in the San Francisco area while the Fairchilds lived in Los Angeles. In December of 1914, after Leon had returned home from a "temporary absence," he found that his wife had an unusually large sum of money. An argument broke out and after she admitted her infidelity, Leon filed a lawsuit against Shaw in superior court in January 2015, asking for $250,000 for "criminal conversation." Then the Fairchilds moved to San Francisco. While there, Adele had repeatedly told Leon that she did not love him and was said to have threatened to poison him. Then one day she packed her belongings and left home, and Leon spent the remainder of the day looking for her in San Francisco. Los Angeles police then inquired as to Shaw's whereabouts and learned that, days before Adele's arrival in Los Angeles, he, too, had left home, and that his housekeeper didn't seem to know his whereabouts.[96] Leon Fairchild then told the *San Francisco Chronicle*, "There is no doubt but that Mrs. Fairchild went to Los Angeles to be with Shaw, as she had told me many times that would be the ending. It is evident that Shaw did not welcome her, and her suicide does not surprise me."[97]

But the tragic love triangle had a few surprises that went unnoticed by the *Times* and the Los Angeles Police Department. Three days after Mrs. Fairchild's death, Leon claimed to have received a letter mailed by his wife before she had left for Los Angeles. In the letter, she declared Leon's innocence and blamed herself and Shaw for all of their marital troubles. The letter made a vague reference to suicide, but the wording was awkward: "I have been a set back from the start for you and I want you, if I live, and I realize that is impossible."[98]

Leon told San Francisco police that he had just learned that his wife had worked as a prostitute at a San Francisco "bath and massage parlor" and it was there that she had first met Shaw, who later sent for her to come to Los Angeles.[99] He later altered his story to say that she had left him twice for Shaw, only to return to San Francisco both times, asking for forgiveness. Leon said that being the good husband, he had taken her back the first time, but not the second time. Leon also claimed that his rejection had led to her suicide at the Alexandria. San Francisco police responded to Fairchild's accusation by arresting the massage parlor's proprietor, Jean Burr, and her maid, Juliet Schaler, but could find no indications that their business had ever engaged in white slave trafficking. However, it also appears that the women refused to talk and that their business was never reopened.

When Leon Fairchild's lawsuit went to court in June 1915, his story fell apart. Under cross-examination, he admitted that he had deliberately faked a letter suggesting that he and Shaw were old friends. Then Mrs. Anna (or Annie) S. Fleming, a friend of the Fairchilds, destroyed Leon's credibility by telling jurors that both of the Fairchilds were grifters and that Adele Fairchild had told her on New Year's Eve 1914 "that a 'plot' had been arranged between [Adele] and her husband whereby she was to entice Shaw into her room and then to have her husband discover them under compromising circumstances. Leon was then going to place a revolver to Shaw's head and threaten to kill him if he did not give him $10,000."[100]

Upon hearing this testimony, Leon Fairchild's attorneys immediately "submitted their case without argument," i.e., they gave up, and the jury quickly found Shaw not guilty. The circumstances leading to Adele Fairchild's death, however, raised new questions that were never answered. Was her death really a suicide? Or was she given a poisonous "sleeping aid" by her husband after the blackmail plan had begun to unravel? Perhaps Adele Fairchild's final words, "I have taken poison. I want to die. I want to die so much…so much," was an exclamation made under intense pain, and not a suicide confession. She had, after all, ingested a slow acting poison.

The next two hotel deaths were not as dramatic as Fairchild's demise. Both were from heart attacks. One occurred on February 4, 1916, to E.S. Moulton, president of the First National Bank of Riverside, and the other occurred on March 8, 1918, to Isidore G. Fleishman, a member of the wholesale produce firm of Loeb, Fleishman and Co. of Los Angeles.[101]

The next suicide took place on July 30, 1918, when Mrs. Ethel Ferry, 27 years old and described as "beautiful," left her Los Angeles home and arrived at the hotel around 1:00 p.m. and asked for a quiet room. Around 8:00 p.m., a floor maid entered to discover blood stains on the bedcover and Mrs. Ferry's body lying on the floor beside a chest of drawers. Near her body was a pistol. Police surmised that Mrs. Ferry had been lying on the bed when she fired a bullet into her chest, which they believed did not kill her. She then rose to her feet, stood before the mirror, and fired two more shots into her chest. On a nearby writing desk lay the following suicide note, dated 2:30 p.m.:

> *Dear Hubby:*
> *I am tired of life, try and forgive me if you can. I have thought it out and decided to end it all. I don't know what waits on the other side. I have been somewhat of a failure here. I bought the gun at a loan shop on Main street*

($4.) and thought a hotel as a place as any. I can't think of anything to write, and yet there is so much to say. You have been awfully good to me, and I was happy when we were alone. I just can't write anymore, don't know how long I have been at this.

Good-bye,
Ethel

After Mr. Ferry, an insurance salesman, was notified of his wife's suicide, he rushed to the hotel, and fainted when they gave him the details. He then told police that he was unaware that his wife was unhappy. He did say, however, that she had been in a train wreck in Illinois when she was 19 years old and hadn't been the same since. He also stated that he did not understand what his wife meant in her suicide note about being "happy when we were alone," since they were alone most of the time.[102]

In late 1919, 45-year-old Albee Smith Jr., a former newspaper man and publicity manager for the Chicago Liberty Loan office, rented several rooms on the sixth floor of the Alexandria while working as an "advance agent for an industrial concern about to establish here." Several days later, on December 12, he called the city editor of the *Los Angeles Times* to say that he had a "big story" for them, but before a *Times* reporter could arrive, Albee had already jumped or fallen out of a sixth-floor window and landed on a second-floor skylight above a writing room next to the lobby. Still alive but apparently unable to speak, he was rushed to the hospital, where he later died.[103] Smith's intentions remained unclear; however, another newspaper covering his death claimed that Smith had been drinking heavily for several days, and may have wanted the reporter to witness his suicide.

The next Alexandria Hotel death occurred on December 18, 1920, when 30-year-old Lieutenant Pat O'Brien committed suicide by shooting himself in the head in his room. O'Brien had been an American pilot who had achieved fame as an aviation hero with the British Royal Flying Corps. During World War I, he had flown a number of missions before crashing "several thousand feet behind the German lines with a bullet in his throat after a battle with a German flyer." He was then captured and his

Lieutenant Pat O'Brien

wounds were treated. On his way to a prisoner of war camp, he made a daring escape from a moving train and wandered around the Belgian countryside for 72 days until he reached the Dutch border, where he dug under an electrified fence using his bare hands and a piece of wood. His heroic exploits earned him both official recognition and an hour-long visit with King George V at Buckingham Palace. He also wrote a book called *Outwitting the Hun* and gave speeches on the lecture circuit.[104]

In May of 1920, O'Brien married Virginia Elizabeth Allen, a news reporter in Washington, D.C. The couple then moved to Los Angeles to work in motion pictures, O'Brien as a Hollywood barnstormer, and Mrs. O'Brien as an actress. The marriage didn't last, and after a few months, Mrs. O'Brien checked into the Alexandria. O'Brien followed, and after failing to reconcile with her over the phone, he left behind a suicide note that read:

> *Only a coward would do what I am doing. But I guess I am one. With all my war record, I am just like the rest of the people in this world – a little bit of clay.*
>
> *And to you, my sweet little wife, I go, thinking of you and my dear, sweet mother, my sisters and brothers. And may the just God that answered my prayers in those two days I spent in making my escape from Germany, once more answer them.*
>
> *And bring trouble, sickness, disgrace and more bad luck than anyone in this world has ever had and forever that awful woman that has broken our home and has taken you from me.*
>
> *She caused this life of mine, that just a few minutes ago was so happy, to go on that sweet adventure of death.*
>
> *Please send what you find back to my dear mother in Momence, Ill.*
>
> *To the five armies I have been in, the birds, the animals I loved so well, to my friends, to all the world and to adventure, I say good-bye.*
>
> *Pat O'Brien*[105]

The "awful woman" mentioned in the note was Sarah Ottis of Springfield, Illinois, who had moved into the Alexandria to stay with Mrs. O'Brien during the breakup. Mrs. Ottis told reporters that Mrs. O'Brien had suspected her husband of having mental problems and had feared that he might murder her. Mrs. O'Brien, in turn, defended her friend, by saying, "Mrs. Ottis has been more of a mother to me than anything else. Last Tuesday, after Mr. O'Brien had given way in a fit of temper,

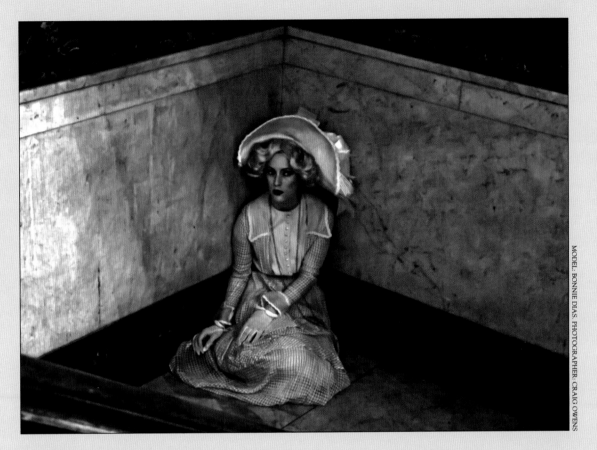

in which he broke my finger, I left our home and engaged a room at a hotel. Mrs. Ottis joined me at my request. She had nothing to do with my leaving home. I simply decided I could no longer live with my husband."

Pat O'Brien's relatives and friends refused to believe that his death had been a suicide. They suspected murder and pressured the Los Angeles Coroner's Office to conduct a second investigation. The District Attorney's Office closed the case by stating that the "aviator-hero was shot through the mouth, the bullet passing out and piercing the wall near the ceiling.... The angle at which the bullet struck the wall...is proof conclusive that no one but O'Brien himself could have fired the shot."[106]

The next suicide occurred on June 6, 1922, when 60-year-old Mrs. H.L. Boyden died from an apparent overdose of opium tablets. The hotel management arranged for her corpse to be quietly transported to an undertaking establishment without police notification. After being admonished for trying to hide the death, hotel staff told detectives that Mrs. Boyden had checked into the hotel on June 10, had made several phone calls from her room, and had been looking for employment. When a

housekeeper had entered her room, she found Boyden in bed with an unsigned poem next to her.

> One other bitter drop of drink and then—
> No more –
> One little pause upon the brink, and then –
> On o'er.
> One pang, and I shall end the
> thrall
> Where, grief abides, and generous
> deat [sic] will show me all
> That now he hides.
> One moment, al, and then I shall
> Discover,
> What all the sages of the earth
> have tried to learn.
> One plunge and the stream is
> crossed.
> So dark, so deep –
> And I shall triumph, or be lost in
> endless sleep.
> Then onward, whatso'er my
> Fate,
> I shall not care,
> For sin nor sorrow, love nor hate
> Can touch me there.[107]

Perhaps the strangest death at the Alexandria occurred several months later, on November 27, 1922. At 9:00 a.m., 22-year-old Vaden Elwynne Boge, the son of a wealthy Oregon rancher, registered at the front desk as "Mr. and Mrs. Boge" and took a room for two people on the fourth floor. Boge, who was wearing a leather aviator's coat, told the front desk that his wife would arrive later in the day with their luggage. Around 1:00 p.m., he ordered a room service lunch consisting of two chicken sandwiches, one rice salad, two cups of coffee, cranberry sauce, and two slices of pie. According to waiter J. Lohry, Boge was alone when he opened the door and beckoned Lohry in with the food

tray. An hour later, however, a hotel houseman heard the sounds of screaming coming from inside his room. Suddenly the door crashed open and Boge ran into the hallway, yelling, "I believe I have been poisoned!" Then he collapsed and was carried back into his room, where he died.

SAD HILL ARCHIVE

Vaden Boge

Homicide detectives investigating the death scene were baffled. The two chicken sandwiches had been eaten, as had the two pieces of pie and some of the rice salad. One of the coffee cups was half empty. The other contained remnants of cyanide of potassium, which the city chemist deduced had been added to the coffee while the cup was half full. There was no indication that a woman had ever been present in the room with Boge, nor were there any eyewitness accounts of one being seen with him. The *Los Angeles Herald* and *Santa Ana Register* began claiming that police were searching for a "ghost woman."

In piecing together the puzzle, detectives learned that Boge was unmarried and had expressed no interest in women. He had served in the military during World War I, had been enrolled as a student at the Portland Wiring School, was a member of the American Legion, and worked for the Western Electric Company. Police suspected him of being a loner whose family members knew very little about his personal life, although a distant relative thought he had once overheard someone claim that Boge was engaged. Police also learned that prior to Boge's arrival at the hotel, he had stayed with a distant cousin, Mrs. Ida Lingenfelter, and her attractive teenage daughter, Nadine, in a house in Los Angeles. Mrs. Lingenfelter stated that Boge was depressed and had seldom left the house during his brief visit. The *Oregon Daily Journal*, meanwhile, reported that Boge's mother had received a letter from her son before his death that had expressed "more than passing interest" in Nadine.[108] Detectives now suspected suicide, which became more apparent after they located a pharmacist on Main Street who presented Boge's signature on a sales slip for the purchase of cyanide on the day of his death. Although the brown wrapper containing the poison was never found in Boge's hotel room, the police concluded that the young man had tried to hide his suicide by making it appear that he had been murdered by a woman.[109]

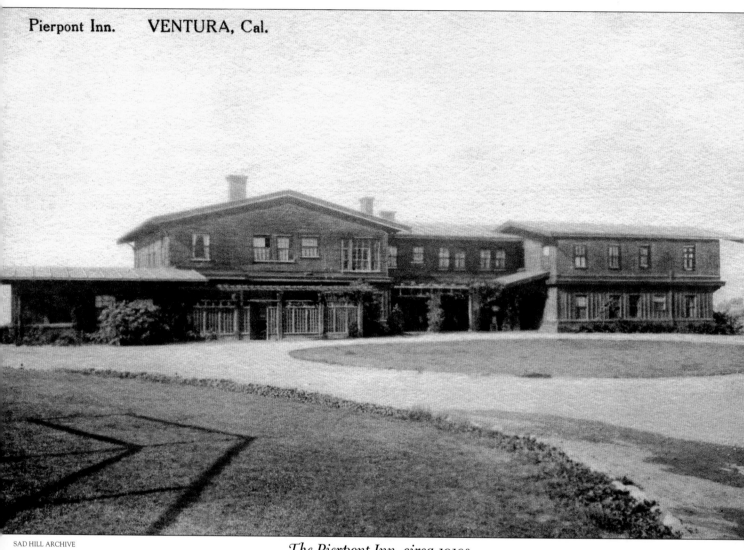

Pierpont Inn. VENTURA, Cal.

The Pierpont Inn, circa 1910s.

6

THE WYNDHAM GARDEN VENTURA PIERPONT INN
550 Sanjon Road, Ventura, CA 93001

When the Pierpont Inn first opened in 1910, it quickly became a favorite stopping place for early motorists, thanks to its stunning ocean views, fine dining, and lovely gardens. Its history unofficially began around 1890, when Dr. Ernest Pierpont, his wife, Josephine, and their two-year-old son, Philip, left Illinois to start a new life in Southern California. Dr. Pierpont had been diagnosed with tuberculosis, and he and his family hoped the sunny California climate would heal his lungs. The family first settled in Los Angeles, where Josephine gave birth to their second son, Austen, in 1890. After the doctor's health improved, the family moved to Ventura County and bought a 40-acre ranch in a settlement called Nordhoff, which later became the City of Ojai. Their neighbor was the Thatcher School, an expensive boarding school for boys. Not only did the Pierponts become close friends with Sherman Thatcher, who owned the boarding school, they also built a number of Craftsman-style rental cottages on their property for parents visiting their children at the Thatcher School. When the cottages opened in 1892, the Pierponts called them The Overlook, but changed the name in 1900 to the Pierpont Cottages.[1]

After Ernest Pierpont died in 1904, Josephine married a San Francisco publisher named Frederick Ginn. Hoping to expand her real estate holdings in Ventura County, she began to look at beachfront property near the City of Ventura, and in 1908, she purchased a coastal former bean field from A.C. Gates of the Title Guarantee Company. She then hired Los Angeles architect Sumner P. Hunt to construct a $30,000, two-story, Craftsman hotel and restaurant on a 40-foot-high bluff overlooking the ocean. The new hotel location was close to Thompson Road (later Thompson Boulevard), a new route for motorists traveling from Los Angeles to Santa Barbara. At first, she named her new hotel the Wayside Inn, but shortly after construction began in April 1910, she changed the name to the Pierpont Inn.[2]

257

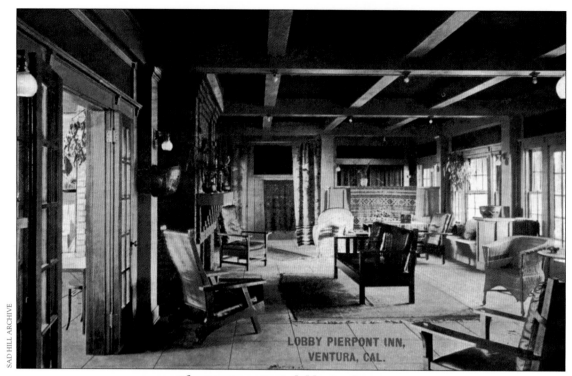

The Pierpont Inn's lobby in the 1910s.

When the new hotel opened on September 6, 1910, it offered 14 rooms with seven baths, a dining room, social parlors, billiard rooms, and a restaurant. Austen Pierpont, who had left Stanford University following a painful hemorrhage in his eye, co-managed the hotel with his mother during its first year of operation while his older brother, Phillip, ran the Pierpont Cottages in Ojai.

Even though the Pierpont Inn was well liked, automobile travel along Thompson Road was light and business was slow, leading Austen Pierpont to become dissatisfied as an innkeeper. After his mother sold the hotel's lease to Walter Hempel in 1915, mother and son moved to San Francisco. A year later, Hempel announced his plan to add a golf course to the property, and in 1917 he incorporated the Pierpont Inn for $25,000.[3] The golf course was never built, however, and Hempel closed the Pierpont Inn in 1918 and moved to San Diego to run other hotels. Josephine Pierpont, who had married a third time and was now Josephine Steinburger, reacquired the hotel.

In 1919, she sold the inn to William X. Roach,[4] who moved into the hotel with his wife, Janie, and their two children. After the Roaches spent the next three months refurbishing the main building for a new opening, financial problems and marital discord led to filing for divorce in January of 1920.[5] This was quickly followed by a lien for more

than $1600 placed on the hotel by the Ingle Manufacturing Company, a San Diego company that specialized in heating and ventilation.[6] A few days after the lien was filed, the *Oxnard Daily Courier* announced that Janie Belle Roach had become the hotel's sole owner after her husband, William, retired "from all connection with the Pierpont."[7] However, William refused to sign over the deed to the property, and the divorce dragged on for years.

Betty Compson.

Under Janie Roach's management, the Pierpont Inn hosted numerous large banquets for the citizens of Ventura and its neighboring city, Oxnard. The Pierpont Inn's romantic setting and opportunities for grunion fishing also contributed to the hotel's growing popularity among tourists. It also benefited from its close proximity to Hueneme Beach, near Oxnard, which had become a popular filming location for motion pictures. One of the early stars to rent the entire Pierpont property was Betty Compson, who spent August of 1920 there with her film company, many of them sleeping in cots during production.[8] Other stars who visited the Pierpont in the early 1920s include Bebe Daniels and Norma Talmadge.[9]

Another well-known person connected to the Pierpont Inn was mystery author Earle Stanley Gardner of Perry Mason fame, who met his longtime assistant and future wife, Agnes Jeanne Bethell, at the Pierpont. Bethell worked at the hotel when they first met, and was said to have been the inspiration for Perry Mason's hardboiled secretary, Della Street,[10] though she later insisted the character was actually a mixture of several different people.

Because the Pierpont could no longer accommodate all the visitors wanting to stay there, Janie Roach began looking for ways to add more rooms. In May of 1921, the *Oxnard Daily Courier* reported that she had sold the Pierpont for an estimated $50,000 to Ojai resident, M. Fiender.[11] However, this doesn't appear to be the case because in 1923, Roach announced plans to spend $50,000 to build a separate structure (or structures) that would offer 20 additional rooms with individual baths, plus a parking garage.[12] It may have been Austen Pierpont who oversaw these additions. Austen had returned to Ojai in 1921 to pursue a career in architecture and had, in fact, built a handful of cottages on the property in the 1920s.

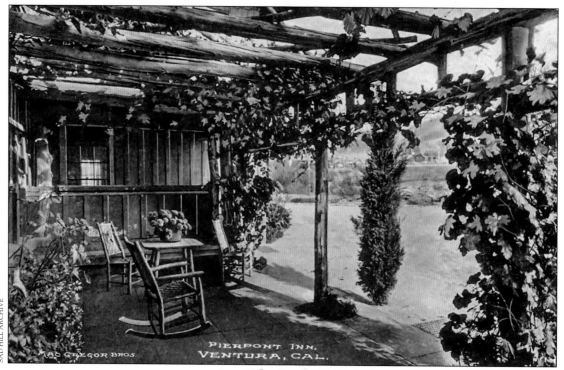

The porch.

Janie's divorce was finalized at the end of 1923, and her ex-husband officially forfeited the deed.[13] Shortly after that, Janie remarried, changing her last name to McKelvey.

In 1925, Ventura boomed as the Los Angeles real estate firm headed by Frank Meline began selling beachfront property known as Pierpont Bay. Three local businessmen approached Janie McKelvey with an $80,000 offer to buy the Pierpont Inn and its surrounding acreage for use as an exclusive country club.[14] She accepted their offer, and the directors incorporated the Pierpont Beach and Country Club.

The Pierpont Inn building closed for renovations on January 1, 1926, and reopened as a country club on April 10, offering more dining, dancing and game room space.[15] During the next two years, the new country club was the site of parties, banquets, and monthly dances featuring its own five-piece band, the Pierpont Country Club Pirates. Hoping to boost membership, the owners added a private plunge in May of 1926.[16] Although Austen Pierpont, Sherman Thatcher, and other wealthy citizens were members of the elite club, the venture was not a success, and by 1928 the directors had voted to reopen the clubhouse's top floor as a hotel and rent banquet space to nonmembers.

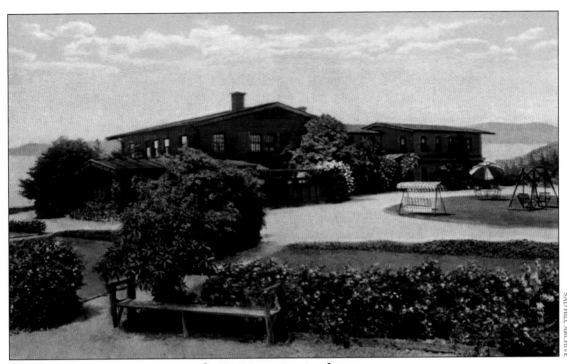

The Pierpont Inn in the 1920s.

That same summer, the board, now headed by Austen, received notice that it owed $50,000 in delinquent mortgage payments to Janie McKelvey.[17] The directors had the property appraised and were disappointed to learn that despite their additions, the overall property was worth less than when they bought it in 1926.[18] In February of 1929, Janie McKelvey filed a foreclosure lawsuit against the club,[19] and a month later, the directors voted to dissolve the country club, form the Pierpont Inn Corporation to buy the property, and then settle the lawsuit with her.[20] After accomplishing this, the company looked for a new buyer. Gus Gleichmann, a former professional baseball player turned hotel manager, wanted to purchase the property, so he turned to his wife, Mattie Vickers Gleichmann, who asked her wealthy father, Ashby Vickers, for financial help. Ashby, a prominent Santa Paula farmer, agreed to loan $80,000 to his daughter and son-in-law and in October of 1929, the Gleichmann's purchased the hotel and surrounding property.[21]

The Pierpont Inn became a family-run business with Gus and Mattie Gleichmann living at the hotel with their two children, Ted, age five, and Nancy, age three. Also living on the property was Gus's 61-year-old, German-born mother, Bertha, who helped care for the children.

261

As the 1930s progressed, Gus and his brother began constructing small cottages next to the hotel to provide additional rooms with baths for visitors. The Gleichmann's also built themselves a new, two-story, Spanish Colonial home, known today as the Vickers, or Vickers' Estate, next to their hotel in 1935. The family then converted their old family quarters in the Pierpont's main building into a banquet space.

According to *Photoplay Magazine*, the Pierpont Inn remained a popular getaway for film players, thanks to its Persian tea and meandering pathways from its cottages to the beach. However, tragedy struck the Gleichmann family in November of 1938 when an automobile accident near Ojai killed Gus and injured his mother. Now widowed, Mattie took charge of the hotel, and after Bertha moved off the property, Mattie's parents, Ashby and Addie Vickers, moved in and lived there until Ashby's death in 1940.[22]

During World War II, the U.S. military stationed troops at the Pierpont Inn, and many of the other hotels along the California coast. According to Ventura historian Glenda J. Jackson, "Fortifications were established at the bluff with guns and cannons, and searchlights were set up on the grounds. Many naval officers and enlisted personnel stayed at the inn, with rank determining sleeping quarters—officers were assigned rooms while enlisted men slept in makeshift quarters in the garage."[23] However, this may have been a temporary arrangement since the Pierpont continued to operate as a civilian hotel with Mattie in charge.

Mattie's son, Ted Gleichmann, served in the Air Corps from 1942 until 1945. Upon his return home, he became the Pierpont's general manager. Ted married Jane Chinn in 1947, and they had two children, Vic (born in 1948) and Alisa (born in 1952). By this time, Mattie was disinclined to handle the day-to-day business affairs of the hotel, preferring to spend her time outdoors tending the hotel gardens, spending time at the beach, and playing hostess.

The Pierpont remained a social hub in Ventura. One of its famous guests is said to have been an oil drill-bit salesman, George H.W. Bush, who temporarily lived in one of the cottages in 1949 with his wife, Barbara, and their son George W. Bush.

Despite the hotel's success, Ted Gleichman felt that the property needed to stay current with changing tastes. Over the next 20 years, the old 1930s cottages were torn down or moved off the property to make room for a Mid-Century Modern East Wing building,[24] followed later by a West Wing building designed by renown architect Robert R. Jones. In the 1950s, two houses were also added to the property.

PHOTOGRAPHER: CRAIG OWENS

The back of the Pierpont Inn, circa 2012.

One was an office/model home built next to the Vickers Estate; the second was a new home for Mattie called the Bluff House, known as the 50s Flat.[25]

By 1951, the family had donated the beachfront acreage behind their hotel to the California State Parks Commission under the condition that the state would build only park roads for travelers visiting the beach. The plan backfired, however, and according to public records, in 1959 "the Director of Natural Resources executed a deed granting an easement to its Department of Public Works and authorizing the construction of [a new] freeway."[26] The construction of the Ventura Freeway (U.S. Route 101) between the Pierpont Inn and the Pacific Ocean created unwanted noise and obstructed the once-heralded scenic view, which had been one of the Pierpont Inn's selling points. The Gleichmanns sued the State Parks Commission for breach of promise, asking for more than $388,000 in damages. Once the lawsuit was over, the family was awarded a little more than $225,000 in reparations in 1966.[27]

An avid golfer, Ted often spent his time playing in statewide tournaments and occasionally, socializing with Bing Crosby and Fred MacMurray. When he was in town, he participated in many civic organizations and sat on several boards. However,

Mattie Gleichmann's former house. Today, it is the Pierpont Inn's Spa.

on November 24, 1975, Ted died from a brain tumor at the age of 52, while living at the Vickers Estate.[28] Following his death, Ted's adult son and daughter, Vic and Alisa, took over operations at the Pierpont Inn, and in the following year, Mattie's grandnephews, Spencer and Scott Garrett, leased part of the hotel property and built the Pierpont Racquet Club. Few renovations were made to the property over the next 15 years, and by 1990 the Pierpont Inn had fallen into disrepair, prompting the Gleichmann family to try and sell it. After a potential buyer pulled out of a deal three days before escrow was finalized, the hotel was taken off the market. Vic and Alisa resigned from their duties, leaving Rod Houck, Alisa's husband at the time, as the Pierpont's general manager.

In 1991, *Los Angeles Times* critic David B. Goldman gave the Pierpont Inn a dismal review, complaining about the freeway noise coming from "six lanes of howling traffic," and writing that the dining room was "so drab it is almost indescribably boring."[29] Following the *Times'* review, the Gleichmann family spent $750,000 repainting the hotel, restoring its two remaining cottages (both built by Austen Pierpont), and

adding a gazebo for weddings, and a new staircase in the main building. In 1993, the Pierpont Inn was designated Ventura County Landmark No. 80.

In her final years, Mattie lived in the home built by a lumber company and tended her gardens, passing away in her home at the age of 100. Following her death in 1996, the family kept the hotel two more years before again putting it on the market. "Now is the time to bring in serious capital," Rod Houck told the *Los Angeles Times* in 1998. "We are looking at a couple of million dollars easily, and the family decided not to take the risk. We need larger bathrooms, the noise of the freeway is an issue, the banquet rooms are dated and need to be redone. What we've done here is all through service. While the product is charming and historical, it isn't exactly a four-star resort."[30]

Spencer and Scott Garrett, who were still operating the Pierpont Racquet Club, decided to buy the hotel property and restore it. In 2001, one of the larger upstairs rooms of the original building reopened as the Austen Suite. The following year, the Pierpont Inn became a member of the Historic Hotels of America, and the Garrets paid for the construction of a pavilion attached to the unoccupied Vickers Estate.[31]

In 2005, the Garrets sold the Pierpont for $10.4 million to Central Coast Management, a company owned by the Panchal and Patel families, but the new owners had no intention of keeping the property for long. "Basically, it was for sale from day one since we bought it," Pravin Patel told the *Ventura County Star*. "It's like Donald Trump. If you get a good price, you sell it. There are investment opportunities elsewhere if you market it right."[32]

In 2008, the Panchal and Patel families allowed a prospective buyer to take over the property before the sale was finalized. However, the sale collapsed during the Great Recession, and employee morale plummeted, resulting in the owners deciding to close the Pierpont's restaurant until a new buyer could be found.

In the spring of 2009, the La Cañada-based Pierpont Group LLC, with Grace S. Ahn as the managing partner, purchased the troubled hotel for $11.5 million. Grace's son, Harry Ahn, the new chief executive officer, told the *Ventura County Star*, "My mother saw it not only as a good investment opportunity but also as a good way to strengthen the mother-son bond."[33]

The Ahn family brought in new staff and reopened Austen's Restaurant with a new menu. Renovations were soon underway, including air conditioning in the rooms, flat-screen televisions, renovated bathrooms, and a whirlpool spa. The Ahns added stonework to the exterior of the East Wing, along with new fountains, and replanted gardens. The pavilion banquet room was redone with maple flooring, and a high-definition projection system was added for weddings and other ceremonies.

PHOTOGRAPHER: CRAIG OWENS

The Pierpont Inn lobby in 2012.

But despite these changes, the Pierpont still lost money, and in 2011, Grace Ahn filed for Chapter 11 bankruptcy. Among the creditors listed in the bankruptcy filing were the Garrets, who held a second-priority lien against the Pierpont for about $2 million. According to the *Ventura County Star*, the Ahns also owed $6 million to Community West Bank in Goleta, and they had run up $173,079 in charges on 13 credit cards.[34]

Even after the property went into receivership, the Pierpont Inn still struggled to attract guests and was sharply criticized in consumer reviews on Internet sites for its poor customer service. On September 14, 2012, the property was purchased at auction for $6.5 million by Irvine-based Brighton Management, a hotel and commercial real estate development and management firm.[35] Brighton rebranded the hotel as the Wyndham Garden Ventura Pierpont Inn. In 2015, DKN Hotels, Brighton Management's parent company, sold Brighton, then purchased the Pierpont Inn, keeping the Wyndham Garden brand name in place.

More troubles soon followed. In February 2016, the City of Ventura discovered that DKN had hired a contractor who had gutted the historic lobby, restaurant, and

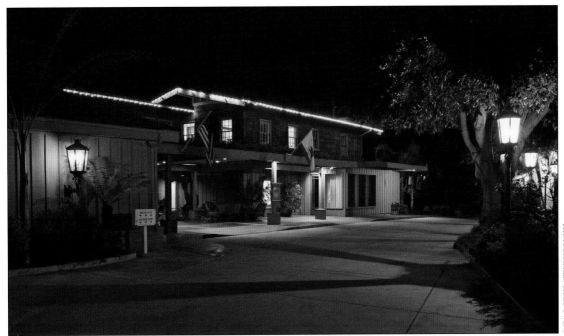

PHOTOGRAPHER: CRAIG OWENS

The Pierpont Inn at night.

banquet rooms after discovering dry rot in many of the wood beams. Because these changes to the historic property were done without permits, the city "red-tagged" these areas as structurally unsafe and demanded that DKN make amends or face closure.[36] As of 2017, DKN is still working on restoring the main building back to its former self, and the corporation remains hopeful that these repairs will be completed before the end of the year.

Near the wedding pavilion by the cottages.

The Hauntings

Prior to 2000, stories about ghosts at the Pierpont Inn were largely unknown to the public. In fact, Gleichmann/Vickers family members contend that their hotel was not haunted. Their argument appears to have some credence. For instance, when paranormal investigator Richard Senate first published his book, *Haunted Ventura*, in 1998, he made no mention of the Pierpont's ghosts. Nor did Rob Wlodarski in his 2001 book, *Dinner and Spirits: A Guide to America's Most Haunted Restaurants, Taverns, and Inns*. But according to longtime Ventura residents, the Pierpont Inn did, indeed, have a haunted reputation, and that rumors dated back to the 1950s, if not earlier. The Pierpont's former marketing director, Cynthia Thompson had also heard the rumors, and after she was told by the Historic Hotels of America that "ghosts were good for business," she began collecting stories from hotel employees for marketing purposes.[37]

Around 2002, a bumper crop of paranormal claims began to gain media attention. Both Senate and Wlodarski jumped on the publicity bandwagon by suddenly telling their own Pierpont ghost stories, which led to their being interviewed for an episode of *Mysterious Journeys* for the Travel Channel. Wlodarski then published a new book, *California Hauntspitality* (2002), now claiming to have experienced significant paranormal activity dating back to the mid-1970s. For instance, Wlodarski wrote that he once saw a semi-transparent male apparition wearing a broad-brimmed hat, and floating along a short hallway in the Rose Cottage (built by Austen Pierpont). He also claimed he had heard the sound of furniture being rearranged in the cottage's den, only to discover the room was undisturbed. Wlodarski recalled an episode in the inn's cocktail bar in the mid-1970s, when he saw a "strange-looking man wearing a rumpled brown suit, wearing horn-rimmed glasses," whom he later identified as the ghost of former owner Gus Gleichmann.[38] For his *Mysterious Journeys* interview, Wlodraski claimed to have seen the hotel's swimming pool (built in 1957) disappear, then reappear, and that during this vanishing act, he had seen images of Gus, Mattie, Bertha (Gus's mother), Ted, and Nancy Gleichmann in what he described in his book as "a strange time-warp tale."[39]

Senate began to claim that in 1986 he had interviewed a night auditor who told him that she and another employee had seen the ghost of Ted Gleichmann, wearing

MODEL: ERIC GABLE. PHOTOGRAPHER: CRAIG OWENS

Inside the Vickers Estate.

a dark suit. The ghost entered the accounting office (Room 6) on the second floor and sat in a chair before vanishing. Senate also said that guests had been disturbed by loud talking, party horns, and noisemakers coming from an empty room next door, though Senate (nor Wlodarski, who repeats the story) never specified in *what* part of the property this was said to have occurred.[40]

Most of the paranormal activity centers on the 1910 building. For instance, employees saw the ghost of a man wearing a tailored suit and tie, and a hat before he disappeared. Others saw a ghostly man in either a downstairs hallway or the kitchen.[41] Kirk Bentiz, who was the Pierpont's banquet manager for many years, said that while he was working in the upstairs office area, he briefly saw the mystery man staring at him from a reflection in the glass window in the door.[42]

Another ghostly presence haunting the main building is a female. In November of 1999, a graphic designer named Alexis Rachel was working alone in an upstairs office when she suddenly heard the swish of stiff taffeta and felt a cool breeze pass behind her, which she could not explain.[43] On a late evening in the fall of 2000, a

270

A tree on the Pierpont Inn's property.

kitchen employee named Sean saw the apparition of a woman from the 1910s, wearing a satin gown, long white gloves, a feathered hat, and carrying an umbrella. He said the ghost woman sat at a restaurant table before vanishing. Patty Torres, a former bar manager, also thought she saw a ghostly woman running in the upstairs hallway near the copy machine. When she followed the woman around a corner, she found an empty hallway that led to an exit to the roof.[44]

Employees also began claiming to have seen male and female ghosts in the banquet rooms. According to one oft-repeated story, an unnamed employee was sitting alone in a banquet room when he saw a transparent man and woman appear, cross to his table, and sit down next to him. This appearance frightened the employee so much he left the room. On another occasion, the same employee claimed to have entered the Santa Rosa meeting room to find it filled with ghostly people and food. He recognized the same male and female apparitions, who beckoned him to join them. And then, suddenly, the entire party vanished, leaving behind an empty room.[45] The former banquet manager, Bentiz, had a similar story. He claimed that one day he was carrying linens down a first

floor hallway when he heard female voices engaged in a jovial conversation. Passing a closed banquet room, he looked through the door's glass window and thought he saw several women wearing large hats moving around in the room. But when he opened the door, the women had disappeared and the chattering stopped.[46]

In addition to adult ghosts, there are infrequent reports of a female child ghost wandering the property. One person claiming to have seen her was Phil Goossens, owner of the Pemko Manufacturing Co. of Memphis, Tennessee. He described the ghost child as being a "young girl, probably somewhere between 8 and 10, with curly locks, either red or brown hair," who pulled the covers off his bed during the night.[47]

Bentiz also claimed that during his years of working at the hotel he had heard the disembodied laughter of children in the garden area near the cottages.[48] In 2001, catering manager Kathy Farrell-Gordon claimed that she was standing at the upstairs copy machine early one morning when she looked up and saw a male coworker walking toward the general manager's office accompanied by a three-year-old girl, who was giggling loudly as she entered the office with him. When Farrell-Gordon asked who the little girl was, the puzzled employee walked out of his office and said there was no child with him.[49] Years later, Senate retold this story, claiming that Farrell-Gordon had "identified the child from an old photograph" as the "daughter of the former owner... taken in the 1930s!"[50] The problem with Senate's claim is that the daughter in question, Nancy Gleichmann Hensen, was still alive in 2001.

According to Thompson, employees and visitors occasionally blamed the Pierpont Inn's ghosts for accidents, odd noises, and other strange occurrences that randomly happened for no apparent reason. For instance, a kitchen employee named Rafael claimed that while he was standing in the dishwashing area, he saw a box on an overhead shelf scoot forward under its own power and plunge to the floor, shattering every glass inside it.[51]

In 2001, Ventura resident Bruce Barrios and his friend Patrick Ward were sitting at the bar late one night when Barrios saw something move out of the corner of his eye. Turning to look, he saw what looked like ribbons of vapor hovering above an empty table against the wall in a corner of the room. "It was like fog or steam—some kind of haze," he later told the *Ventura County Star*. Shrugging it off, Barrios and Ward continued drinking, and the whole incident would probably have been forgotten had something else not happened. After the bar closed, the men went to Barrios's van. As they opened the door, they were hit by the overwhelming scent of flowers in the vehicle. "I smelled strong, strong lavender," Ward said. "I have allergies, so I know."[52]

PHOTOGRAPHER: CRAIG OWENS

Austen's Restaurant in 2012.

According to the *Ventura County Star,* John Mork, a former night auditor, recounted an incident that happened in 2005 during his first week at the Pierpont. Mork heard the bell at the front desk ring around midnight while he was in a back storeroom. Thinking he had not properly secured the front door, which he had locked at 11:00 p.m., he walked back to the desk, only to find an old-fashioned glass filled with chilled champagne sitting on the counter. Mork admitted to drinking the champagne so as not to appear rude. Then he set the empty glass, which has "gold filigree designs at the base," in the kitchen next to the other glasses. The next day, the glass was missing and no one ever came forward to ask about the drink.[53]

While researching old photos of the hotel at the Ventura County Library, Thompson discovered an historic photo of a 29-year-old woman named Eliza "Emma" Darling in a black dress and hat, standing on the beach with the Pierpont Inn looming in the distance. The photo, taken in 1911, had an eerie quality to it, so she used it to promote the Pierpont's legends, and soon, Emma Darling became one of the hotel's most seen apparitions. In 2008, the Pierpont Inn's spokesperson, Denise Bean-White, who replaced Thompson, told the *Ventura County Star* that guests and

employees had seen Darling's ghost wandering the grounds. One employee who saw the apparition in the hotel parking lot, described her as being a slightly transparent female that was seen "dancing, waving her hands and jumping high into the air without a care in the world."[54]

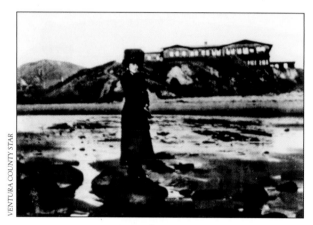

Emma Darling, circa 1911.
The Pierpont Inn is in the background.

Historic Hotels of America promoted Darling's ghost on its website, stating that Darling "died in 1997" shortly before "her spirit began appearing at the hotel," and that her ghost "has been seen in massage rooms, dancing in the parking lot or leaving wet footprints on the lobby floor for the cleaning crew."[55] Other variations on the story claim that Darling was also responsible for the ghostly scent of flowers. All of these claims, however, are either doubtful or attributed to the wrong person. Emma Darling died in 1982, not 1997, and had lived a full life away from Ventura.

Mattie Gleichmann, on the other hand, was 100 years old when she died in 1996 in her home, which is now the Pierpont Spa. She also loved to walk along the beach and had a lifelong passion for flowers. It therefore comes as little surprise that following her death, employees began to suspect that Mattie's ghost now haunts the inn, along with Gus and Ted Gleichmann, and possibly Mattie's father, Ashby Vickers, who also died on the property in 1940.

In the summer of 2000, a hotel employee named Miguel was sent to a dark, unrestored former guest room on the second floor to fetch kitchen supplies. Standing in the darkness, he tugged on the string attached to the original light fixture, only to discover that the light didn't work. Frustrated by the electrical failure, he called out, "Come on! I am trying to help your family!" when suddenly the light turned on.[56] Former desk clerk Mork also alluded that Mattie's ghost may still be playing hostess at the hotel. In his interview with the *Ventura County Star*, he recalled one night during his first year at the inn when he left the main building after 3:30 a.m. to check on a broken heater in a guest room. Returning to the front desk about an hour later, Mork remembered that he had forgotten to give a 4:00 a.m. wake-up call to a guest. When he called to apologize, the guest told him, "Oh, don't worry. A woman called

VENTURA COUNTY STAR

PHOTOGRAPHER: CRAIG OWENS

The Vickers Estate in 2016.

us from the front desk and woke us up at four." According to Mork, the guest said the mystery caller had sounded like a nice, elderly woman.[57]

In 2007 while preparing for his California Ghost Hunters Conference at the Pierpont Inn, Richard Senate told the *Ventura County Star*, "Most of the ghosts I've been able to determine are members of the [Gleichmann/Vickers] family who lived and worked there, as opposed to visitors who may have stopped for the night."[58] However, all of these ghost stories did not sit well with members of the Gleichmann/Vickers family. Ex-Pierpont Inn general manager, Rod Houck, who was a former in-law of the Gleichmanns, angrily told the *Ventura County Star*, "I've been in every room, I've been in every inch of the property, and I have never, ever in any way experienced anything but the wind howling." He also said, "I find it somewhat presumptuous, and I find it somewhat disrespectful to the heritage of our family. I find it somewhat disrespectful to the history of the Pierpont Inn."[59]

The Ahn family, however, did not share the Gleichmann/Vickers opinion. Shortly after the family bought the inn in 2009, Harry Ahn told *California Chronicle* reporter Tina Vervoorn, "We welcome the living and dearly departed here at the Pierpont Inn. We are living history here every day and are thrilled to serve as caretakers for this historic property as it nears its 100th year."[60]

Soon after the Ahns began renovating the hotel property, Marcia Santilli, the hotel's director of catering, and Nadine Goodwin, the catering manager, had a shock when their locked, second-floor office door, suddenly flew open and slammed into the wall.[61]

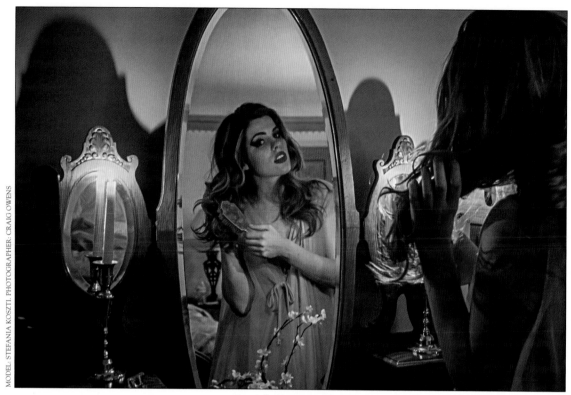

MODEL: STEFANIA KOSZTI. PHOTOGRAPHER: CRAIG OWENS

Inside Room 603.

The paranormal stories changed, however, after the Vickers Estate was renovated, and the Ahns began renting out the estate's former Gleichmann bedrooms (Rooms 601-603). In September 2009, a father and son claiming to be ghost hunting, checked into Room 601. After they failed to check out the next morning, housekeeping staff entered the room and discovered the two men had fled in the middle of the night, and one of them had wet the bed.[62] Richard Senate also claimed that something unseen had once tried to shove his wife, Deborah, off the bed in one of the Vickers Estate rooms. Stories appeared on the Internet claiming that in Room 603, guests had occasionally found their bed made, or a comforter folded when no housekeeping staff had been present.[63]

After the Ahn family lost the Pierpont Inn in 2011, the receivers downplayed the hotel's haunted reputation. But this did not stop the Pierpont's ghost activity. One hotel employee who wished to remain anonymous, told me that in 2012 a woman staying in the Austen Suite had witnessed the bathroom door closing on its own. Curious about what had just happened, she crossed the room to the door and tried to open it. The doorknob turned, but the door behaved as if someone on the other side

was holding it closed. Then, after several attempts, the door suddenly opened without a problem, and the guest saw that no one was on the other side. The woman immediately packed her belongings, demanded a full refund, and admonished the desk clerk for not warning her about the Pierpont's ghosts.

A room in the Austen Pierpont Suite, circa 2012.

Another employee who also wished to be anonymous, told me that around 2012 in the early morning hours of a slow weeknight, a night clerk was standing at the registration desk and talking to a security guard when a tall man wearing a flashy, yellow tuxedo urgently knocked on the front door. The security guard crossed to the entrance and cracked the door open to ask the man what he wanted. The man replied that he had come from a party and needed to use the bathroom. Even though the security guard could see no car in the driveway, he opened the door and gave the man directions to the nearest restroom. The man disappeared around the corner, walking in the right direction. The guard and desk clerk talked about how strange the man looked and behaved. After several minutes had passed, the guard decided to check the bathroom to see what the stranger might be doing. When he entered the men's restroom, it was empty. He then checked the women's restroom, only to find it empty, too. The guard then walked all over the property and checked all the buildings, but he never found the man in the yellow tuxedo.[64]

In more recent years, the number of paranormal claims posted online have quieted down, partly because most of the overnight guests stay in the newer buildings. While the West Wing doesn't appear to be haunted, the East Wing occasionally has rare reports of ghostly behavior in the rooms closest to the Vickers Estate. For instance, in the summer and fall of 2000, there were isolated paranormal incidents, one involving a malfunctioning soda vending machine, which was later found not to be broken, and a window curtain in a guest room that briefly rose into the air as if blown by a heavy wind, though there was no draft in the room.[65] Most visitors, however, are unlikely to encounter a ghost at the Pierpont Inn unless they are willing to spend a quiet night alone in the Vickers Estate...as I did in 2009 and 2012.

PHOTOGRAPHER: CRAIG OWENS

Our Shoots

I first visited the Pierpont Inn on September 29, 2009, to conduct a small, vintage photo shoot for another project. For the occasion, Eric Gable modeled and Melinda Mauskemo handled makeup. Since I wanted access to the older parts of the hotel, I booked the Rose Cottage, Room 603 of the Vickers Estate, and a standard room in East Wing as a guest room for Eric. I brought a few ghost hunting devices with me so I could conduct a paranormal investigation in my spare time.

There were hardly any guests at the hotel, and judging from the cobwebs in the Rose Cottage, it hadn't been occupied for quite some time. Because we were the only guests with access to the Vickers Estate that night, Melinda and I decided to investigate it. After conducting a few EVP tests, I placed an audio recorder on the hearth of the downstairs fireplace around midnight, and warned Melinda to not wander around the building without identifying herself. She went up to her room, and I returned to the cottage.

Approximately ten minutes after I had left, Melinda began hearing odd sounds outside her door. At one point, it sounded as if feet were tramping past her room. She was curious and opened the door to look, but the hallway was dark and quiet. Later, after she had gone to bed, she heard a loud male voice speaking somewhere inside the building, and later still, she thought she heard the sound of an antique telephone buzzing in another part of the estate.

Melinda told me about these sounds the next morning. Fortunately, the downstairs recorder captured many of the strange noises she had heard. While the sound of an old telephone might have been the buzzing of water running through pipes, the sounds of footsteps made by hard-soled shoes roaming the building were unmistakable. At one point, a door opened and closed, and then a male voice called

Left: Inside the Austen Pierpont Suite.

279

MODEL: ERIC GABLE. PHOTOGRAPHER: CRAIG OWENS

Inside the bedroom of the Rose Cottage.

out, "Hello...hello...." Oddly enough, there was never a sound of a person leaving the building. Instead, the sounds of footsteps occurred randomly for a couple hours, and then, after 3:00 a.m. the building quieted down.

After breakfast, I asked the front desk clerk if anyone else had checked into the Vickers Estate the previous night. Because the building was accessible only by keycard, she checked her computer to see if anyone had entered or exited the building, and then told me that Melinda had been the only guest that night, and no one else had entered or exited the building after I left.

Later that morning, we began our photo shoot in the large cottage, then moved to the Vickers Estate, where Eric dressed in a 1930s suit and posed at the Arts and Crafts fireplace in the Camulos Room. At one point during the shoot, he began to feel cold on half of his body. We talked about this, but the cold sensation eventually went away and we continued the shoot.

At lunchtime, we met the Austen's Restaurant's manager, and as we talked about the photo shoot, the conversation turned to ghosts. We told him about Melinda's odd experiences at the Vickers Estate the night before. The manager then began telling us that the original inn's second floor guest rooms had a lot of paranormal activity. He even gave us a private tour of these rooms, which were currently used as the hotel's main offices. He also told us about Room 601 of the Vickers Estate and suggested that since no one had registered to stay the night in the building, I should spend the night there. I was intrigued by the suggestion and decided to do it.

After the shoot ended, Eric left for home, and Melinda and I went into Room 601 around 10:55p.m. and set up several audio recorders and stationed ourselves on the two beds. The room felt gloomy, and the freeway traffic outside was quite noisy. At one point, we both felt a cold breeze, and the temperature in a narrow spot on a blanket on the bed I was sitting on became increasingly cold. I asked Melinda to check the temperature with an infrared digital thermometer. As I was speaking to her, a male voice spoke near the recorder on the nightstand, saying something like, "Changed my mind." Though we didn't hear the mystery voice at that time, Melinda and I were sufficiently spooked by the gloominess of the room and its heavy atmosphere. After we had spent half an hour conducting an EVP session, she retired to Room 603, and I left the recorders running while I stretched out, fully clothed, on one of the beds in 601.

The next morning, the room still felt gloomy, but not as spooky as the night before. Melinda and I hung around till mid-afternoon, then she gave me her key card before she left, so I could investigate her room. That night, when I tried to enter the Vickers Estate around 11:00 p.m., I discovered that none of the key cards worked. Because the main building was locked for the evening, I had no choice but to return to my cottage and call it a night.

At checkout the next day, I told the desk clerk that the key cards had not let me into the Vickers Estate and asked if I would be charged for the night. The clerk looked puzzled and said that Melinda's room hadn't been canceled, so the key cards should have worked. She tested both of them on her machine, and they seemed fine. However, she could see on her computer that no one had entered the building that night, so she apologized and didn't charge me. I then left the Pierpont for home. Later, after hearing all of the strange footsteps and strange voices we had collected on our audio recorders, I was convinced that Melinda and I had encountered the paranormal inside the Vickers Estate.

Three years later, I wanted to return for another shoot, but the hotel had fallen into receivership by then, and the new managers seemed nervous about discussing

MODELS: CONNIE LOVE, RENEE PAULETTE, AND TOM GURNEE. PHOTOGRAPHER: CRAIG OWENS

Inside the Vickers Estate.

its ghosts, or renting the Vickers Estate. I had spoken with the Pierpont Inn's event coordinator, and although I'm not sure if she ever understood exactly what I was hoping to accomplish, she eventually gave me exclusive access to the estate for the photo shoot. I then rented the Rose Cottage, the Austen Pierpont Suite, and a handful of guest rooms in the East Wing.

I based my concept around a Pearl White-inspired silent movie serial theme, rather than the Pierpont's ghost stories. While preparing for the shoot, I asked Adam Johnson to build an early 20th-century robot costume that he could wear. He also helped me assemble a large cast that included Tom Gurnee, Stefania Koszti, Nadia Lanfranconi, Connie Love, Jeremiah McDonald, Glen McDougal, Sean McHugh, Renee Paulette, Michael Ontiveros, and Marshall Watson. Johanna Serrano, as usual, came along for hair and makeup.

We arrived at the Pierpont Inn on Sunday, February 5, 2012, and again I noticed that it had very few guests. Most of the cast stayed in rooms on the East Wing, while Nadia stayed in the Rose Cottage, Stefania in the Austen Suite, and Renee and I took Rooms 603 and 601 in the Vickers Estate. That night, we enjoyed a large meal at

Austen's Restaurant, and after dinner, we broke into small groups and conducted EVP sessions around the Pierpont property, but we found no signs of paranormal activity.

Around 2:30 a.m., Renee retired to Room 603 and I placed several audio recorders around the Vickers Estate before going to bed in Room 601. Shortly before 3:00 a.m., a downstairs recorder captured the sounds of someone wearing hard-soled shoes walking across the floor. Also during the night, the recorder by my nightstand recorded a crackling sound like cellophane or someone rummaging through plastic grocery bags. About a half hour later, the recorder on a chair near the bathroom in my room picked up a male voice that said either "Careful" or "Pitiful."

Around 5:30 the next morning, Stefania was awakened in the Austen Suite by the sounds of footsteps and something being dragged overhead. She later asked the housekeeper if someone had been moving furniture upstairs and was told that there wasn't an upstairs, only the roof.

That Monday, we shot inside the Vickers Estate and in the gazebo near the cottages. The photo theme involved a wedding that was disrupted by a vamp and her gang of thugs.

In the wee hours of the morning, after we had ended the day's shoot, I left all our props and lights in the Camulos Room and set up digital recorders around the Vickers Estate before going to bed. About an hour and a half into the recording, as I slept, one of the recorders in Room 601 once again picked up a crackling sound in my room that sounded like someone or something was again rummaging through plastic bags. Meanwhile, a downstairs audio recorder captured the sound of a door closing around 3:30 a.m., plus a few odd pops that sounded different from the usual settling sounds the Vickers Estate made.

The next morning, I said good-bye to Jeremiah, Marshall, Connie, Sean, and Glen, who headed back to Los Angeles. Because the rest of the crew was tired, I let them sleep in. Nadia, who had stayed in the Rose Cottage, reported that she had twice found the back door to the patio wide open, even though she had made sure it was locked.

After another full day of shooting, I was too exhausted to investigate, so I placed audio recorders around the Vickers Estate and went to bed. In the early morning hours, a recorder in the study captured a male voice, though it was not clear what it was saying. Moments later, the recorder picked up a strange noise that sounded female, followed by a deep male voice. The building then quieted down until a recorder near the top of the stairs caught the sound of a door closing. Some time later, two of the recorders picked up an eerie whipping sound that sounded like someone had whacked

MODELS: RENEE PAULETTE AND STEFANIA KOSZTL. PHOTOGRAPHER: CRAIG OWENS

Battling brides inside Room 603 of the Vickers Estate.

a riding crop or a leather strap three times against a table. Despite these odd sounds, Room 601 remained quiet, except for one fairly loud bang.

The next morning, Adam and I woke up early and decided to drive into Ventura for breakfast. Around 7:30, as I pulled out of the parking lot, my wife, Lena, called from our home in Glendale to say that she had gone into our daughter's bedroom and had found a large framed picture lying face-up on our daughter's bed, two feet from the wall where it usually hung. In the center of the picture stood a small, stuffed giraffe. Because the nail in the wall, the hook, and the wire attached to the back of the picture were all in perfect shape, Lena had awakened our daughter, Katya, to ask her if she knew how the picture got there. Katya, who was seven years old, had no answers. I was not able to explain what had happened, but I began to wonder if it had something to do with our paranormal investigations at the Pierpont, 65 miles away.

After breakfast, I bade farewell to Stefania and Nadia, who left for Los Angeles. Adam and I then went to take a look around the Rose Cottage to make sure everything was in order. While we were there, we inspected the back door that had allegedly

284

A small 1920s cottage.

opened on its own a couple of times, and discovered that if it wasn't secured well enough, it did pop open. Satisfied that at least one mystery had been solved, we locked the door and resumed our photo shoot.

As sunset drew near, I wanted to photograph the small cottage, so I borrowed the key card from the front desk and went inside. The cottage smelled musty and unused, so I turned on all the lights to make it look cheerful before taking a few photos. I then asked Adam and Renee to stay behind and conduct an EVP session in the small cottage before returning the key card to the front desk. Soon after their EVP session began, both recorders captured a mysterious male voice in the room asking, "Who's that girl?" Later in the session, Renee suddenly smelled a very strong scent of flowers. Adam checked the room's air freshener and saw that it was empty. The flower scent faded, then returned a couple minutes later. "Whoa! Flowers!" Renee exclaimed. "That perfume! Like there was a flower being held up to my nose…. Smells very expensive, like roses." And, again, the scent disappeared. After Renee returned to her room at the Vickers Estate, the same thing happened, once again, only this time Johanna smelled it in Room 603.

Over dinner, Renee, Johanna, and Adam told me about the strong floral scent in the small cottage and in Room 603. I was stunned to hear this. Because I didn't believe the story, I had not bothered to mention the phenomenon to the cast and crew. But after hearing about their experiences, I then told them that the smell of flowers was one of the main paranormal claims at the Pierpont Inn.

Later that evening, Johanna, Renee, and I started a new photo shoot in the Vickers Estate's Camulos Room downstairs while Adam investigated other parts of the property. About 2:00 a.m. Renee and I stepped outside to take a break. During our absence Johanna, who was sitting in front of the fireplace, heard footsteps walking across the floor above her, even though she was the only person in the building.

Around 3 a.m., after Johanna and Adam had gone to their quarters, Renee and I conducted one last EVP session in the Camulos Room. The building was quiet and empty, and after not hearing anything unusual, we turned off the recorders around 5:00 a.m. As we were talking near the bottom of the stairs, we suddenly heard the sounds of a woman's heels clicking across the entire length of the second floor, ending near the upstairs restroom. Then the building got quiet again for the rest of the morning.

After a few hours sleep, it was time to check out. Standing at the front desk, I made sure all bills were covered and thanked the hotel staff for allowing us to shoot. The desk manager then asked, "You're not going to write on the Internet that all our best rooms are haunted, are you? We're trying to attract weddings, and we can't have people being scared off because all of our best rooms have ghosts in them."

I assured her that the photos were for a book. "Good," she said, "because I don't believe in ghosts. I'm a Christian." She then began to sermonize that all paranormal activity was the work of angels or demons, and that those who looked for ghosts were doing the devil's work. Wishing to avoid an argument, I thanked her again and left the Pierpont Inn, but I couldn't help chuckling to myself. You see, I had never considered the possibility that all of the best rooms at the Pierpont Inn might be haunted. But you know what? She's probably right.

Inside the Pierpont Inn's dining room.

Inside the Vickers Estate Library.

At the wedding pavilion.

The upstairs foyer of the Vickers Estate.

Inside the Camulos Room.

MODELS: RENEE PAULETTE AND MICHAEL ONTIVEROS. PHOTOGRAPHER: CRAIG OWENS

Inside the Vickers Estate Library.

Catfight in the Austen Pierpont Suite.

MODELS: NADIA LANFRANCONI AND RENEE PAULETTE. PHOTOGRAPHER: CRAIG OWENS

Inside the Rose Cottage.

Happily ever after?

The Banning House Lodge

7

BANNING HOUSE LODGE
1 Banning House Road, Two Harbors, Catalina Island, CA 90704

Santa Catalina Island, just 22 miles southwest of Los Angeles, is the third largest of the eight Channel Islands off the California coast. While the City of Avalon is Catalina's most popular tourist attraction, the village of Two Harbors, built on a half-mile wide strip of land on the island's west side, is arguably more historic.

In its earlier days, before Two Harbors was established, visitors called the narrow strip of land the isthmus (or "Isthmus") because it separated Isthmus Cove from Catalina Harbor. Archaeologists and historians believe that its first inhabitants were the Tongva Indians, who arrived on sturdily crafted plank canoes from the Southern California coast around 5,000 B.C.E. Scholars also believe these first people called themselves Pimugnans. Not only did the Pimugnans live on the island, but they used the isthmus as a spiritual center called the *Sonag-na* for worshipping their god, Chinig-Chinch (or Chinigchinich).[1]

Spanish explorer Juan Rodriguez Cabrillo is thought to have arrived near the isthmus in October of 1542 with his three ships, the *San Salvador*, the *Victoria*, and the *San Miguel*. Original records are murky, but they indicate that he might have christened the island *San Salvador*. Journals kept by his men also recount that Cabrillo had died during an Indian attack on one of the islands after he shattered his lower leg while trying to jump from his rescue boat onto a rock on the beach. For years, it was believed that his death and burial had taken place near the isthmus,[2] but this long held belief is now disputed by scholars who argue that Cabrillo was killed and most likely buried on another of the Channel Islands or some other unknown location along the California coast.

NASA

A satellite image of Santa Catalina Island.

WIKIPEDIA

Thomas Cavendish

SAD HILL ARCHIVE

Sebastián Vizcaíno, the Spanish explorer who gave Santa Catalina Island its name.

English pirates are said to have visited the isthmus after Cabrillo's landing. Famed English privateer Sir Francis Drake's navigational charts suggest that he might have spent the winter of 1579 at Catalina Harbor repairing his ship, the *Golden Hind*. Some scholars believe, however, that Drake exaggerated his exploits and did not sail up the California coast at all.[3] Another pirate thought to have visited the isthmus around 1587 was Thomas Cavendish, who used Drake's published navigational routes to travel up the southern California coast.

The island's official Spanish name remained unclear until explorer Sebastián Vizcaíno arrived at the isthmus on Saint Catherine's Day in November 1602 and christened it Santa Catalina. During his visit, Vizcaíno wrote of seeing a shipwreck off the shore. He believed this was one of Drake's ships, especially after a Native American woman showed him two pieces of badly damaged Chinese silk thought to have been part of a sunken pirate ship's treasures. Vizcaíno also reported seeing several young Native American children that looked "white and blonde."[4]

Other ships followed, and by the early 1800s, European diseases carried by British and Russian sailors had begun to reduce the island's population. To help curtail smuggling and convert the Pimugnans to Christianity, Father Esteban Tápis, president of the Spanish missions in California, was granted permission in 1804 to build a mission on Santa Catalina Island. But his plans never went forward. In a report to his superiors in 1805, Tápis wrote that nearly 200 Pimugnans had perished from measles and that the island did not have adequate land for agriculture and water to sustain a mission.[5] As the Native American population further declined between 1811 and 1820, the Spanish began moving the survivors to the mainland to work on the

grounds of the San Gabriel Mission, located in present day San Gabriel, California. The Spanish changed the name of the survivors from Pimugnans to Gabrielinos.

An American carpenter named Samuel Prentiss (or Prentice) became one of the island's new pioneers in 1824 after the vessel he was traveling on, the *Danube*, wrecked off the Southern California coast near San Pedro. According to legend, Prentiss met Turai, a dying Gabrielino chief living at the San Gabriel Mission, who told him about Spanish gold buried under a tree somewhere on Santa Catalina Island. The chief then either drew a map or had a Spanish map in his possession, which he gave to Prentiss, who then built his own boat and sailed to the island. As the story goes, Prentiss encountered turbulent waters and lost his treasure map and most of his supplies. After landing near the isthmus, he built a cabin close to a coastal area now known as Emerald Bay, where he hunted otters and dug under trees, hoping to find the lost treasure.

Samuel Prentiss' grave marker on Catalina Island. Date Unknown.

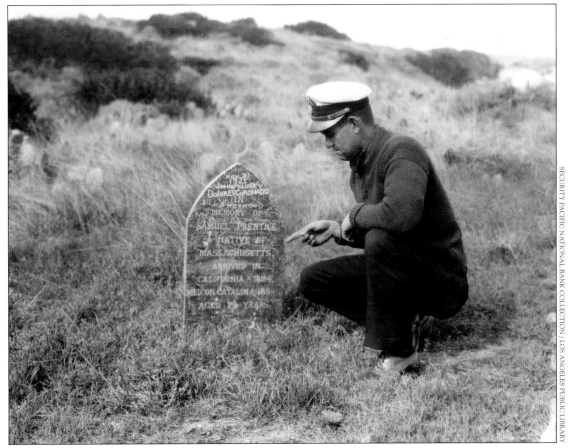

In 1846, just days before the U.S. and Alta California (under Mexican rule) went to war, Alta California Governor Pío Pico deeded Santa Catalina Island (commonly referred to simply as Catalina) to Thomas Robbins, a naturalized Mexican citizen, for sheep grazing. Following California's annexation into the United States in 1850, Robbins filed an ownership claim with the U.S. Land Commission, then sold his property for $10,000 to José Maria Covarrubias, who promptly turned around and began selling parts of the island to land speculators. In 1854, Samuel Prentiss and one of his friends, George C. Yount, began telling prospectors about buried treasure and traces of gold to be found on the island. One prospector who had heard the stories was Santos Louis Bouchette, who claimed in 1860 to have found a vein of gold as well as other valuable minerals on the island. Bouchette then opened the Mineral Hills Mine near Cherry Creek, sparking Santa Catalina's gold rush.

In 1863, during the American Civil War, a wealthy land baron named James Lick began buying up sections of the island for its mineral rights. That same year, the schooner *J.M. Chapman* was seized in San Francisco after authorities discovered that it had been converted into a privateer to be used by Confederates to rob gold shipments leaving California.[6] When Union officials soon became concerned that additional Confederates had infiltrated Santa Catalina, Union military personnel evaluated the island. Major Henry Hancock wrote a letter in late November 1863 to Lieutenant Colonel James F. Curtis recommending that a permanent military base be established at the isthmus to defend the California coast from possible "maritime enemies."[7] After the U.S. approved the creation of a base, General George Wright suggested that the island also be used as a Native American reservation for dissident tribes.

Phineas Banning, a staunch Union supporter based in the port town of Wilmington, California, built living quarters that were later called the Civil War Barracks on a small rise that overlooked Isthmus Cove and Catalina Harbor. In January 1864, Captain R.B. West and his 80-man Fourth California Infantry arrived and set up cannons on the high ground to defend their position. The troops then proceeded to evict all the prospectors on the island. However, once the military determined that the Channel Islands no longer posed a threat, the idea of using the island as a reservation was abandoned, and in December of 1864, after the barracks were completed, Camp Santa Catalina closed and the troops were withdrawn.

In 1867, the U.S. Land Grant office officially deeded Santa Catalina Island to James Lick, who had purchased all of the island's remaining acreage for $80,000. While Lick honored Bouchette's stake at the Mineral Hills Mine and signed a few of the sheep ranchers to lease agreements, he evicted everyone else. No minerals

of substantial value were ever found, however, and so by
1872, Lick wanted to sell the island. He found no buyers,
and following his death in 1876, the island was added to his
considerable estate, which was managed by the University
of California. Two years later, in 1878, Bouchette and his wife
packed their belongings and abandoned their Mineral Hills
mine, never to be seen or heard from again. Their departure
killed the island's gold rush once and for all, and subsequent
legends maintained that Bouchette had been nothing more
than a con artist who used the fake mine to fleece investors.

*George R. Shatto,
former owner and
developer of Santa
Catalina Island.*

By this time, sheep and goat ranchers were squatting on
the island. One of them, Augustus W. Timms, was a former sea
captain turned wealthy San Pedro philanthropist. Around
1883, he began charging tourists $4 each for steamship
passage to his goat farm on the island, which became a
camping and fishing destination known as Timms' Landing. Timms' rival, Phineas
Banning, had also seen the island's potential as a tourist destination, but he died
in 1886 before he could find investors to buy it. A year later, George Shatto, a real
estate speculator from Grand Rapids, Michigan, bought Catalina from the Lick
Trust for $150,000 (some reports claim it was $200,000), which included a partial
payment in cash and "mortgage notes for the remainder."[8] Shatto was primarily
interested in developing Timms' Landing as a resort, but he needed additional
capital. Looking for investors, he solicited financial help from the International
Mining Syndicate (Ltd.) of Great Britain, which agreed to buy the rest of the island
for $400,000.[9]

Timms' Landing was thus transformed into Avalon and got a new wharf, the Hotel
Metropole, and a few small structures. As Avalon's popularity grew, Phineas Banning's
three sons, William, Joseph, and Hancock, proprietors of the Wilmington Transport
Company, began offering steamship travel to the island, with additional daily trips
during the summer season. After the Banning brothers heard rumors in 1889 that the
British mining company had defaulted on its mortgage payments, they expressed their
desire in 1890 to purchase the island. Shatto responded by saying that because the
mining company would soon pay its mortgage, he would sell his stake in Avalon for
$300,000. But the Banning brothers didn't believe Shatto, so they used their influence
to persuade the Lick Trust to demand prompt mortgage payments. The International
Mining Syndicate officially defaulted, and the Bannings purchased Catalina Island for

FROM TOP:
William,
Joseph, and
Hancock Banning

$127,000. Shatto then entered into "friendly negotiations" with the Bannings and transferred all of his equities and ownership properties in Avalon to them for $25,000.[10]

Like their father, the Banning brothers envisioned Catalina as a private resort with free amenities available only to tourists who had bought tickets through the Wilmington Transportation Company. The reasoning behind their plan was simple. The brothers lacked the money to develop and maintain the island unless it made a profit; therefore, they felt a transportation monopoly was necessary to pay for Catalina's upgrades and amenities. In 1894, the brothers created the Santa Catalina Island Company to oversee development and promote its sports fishing, hotel, and mining potential. William, the oldest brother, oversaw the company; Joseph, nicknamed Judge, managed Avalon; and Hancock, the youngest, looked for businesses willing to invest in gold prospecting, sheep ranching, and soapstone mining.

The Bannings improved Avalon's infrastructure by constructing a sea wall, sewage lines, and new roadways. They also added tent cities, restaurants, a golf course, a dance pavilion, a pleasure pier, bathhouses, and glass-bottomed boat rides. Tourists could now travel by stagecoach to remote parts of the island like the Eagles Hunting Lodge. The brothers also opened Camp Banning, a children's summer camp, near the isthmus.

As tourism improved, Joseph and Hancock and their families became active members of Avalon's local community. But the Bannings' monopoly was soon threatened when independently owned boats began offering cheaper fares and vacation packages to Catalina. By the late 1890s, island police had been hired to levy heavy tariffs on these "tramp steamers." Meanwhile, the Bannings ordered Avalon vendors to shun unauthorized visitors, or else they would develop the isthmus into a new seaport, tentatively called Catalina City. In 1899, after a handful of vendors ignored the Bannings' threat, William and Joseph authorized the Santa Catalina Island

ISLAPEDIA.COM

Company to spend $60,000 on a new wharf, water pipes, eucalyptus trees, and graded dirt roads at the isthmus. The Bannings also hired the Olmstead Brothers, an influential landscape company, to design an upscale hotel.

In April of 1900, the Bannings and the vendors signed a truce, whereby development of the isthmus stopped. However, the Bannings' strategy had strained their finances. After negotiating a late mortgage payment to the Lick Trust, the brothers began looking for new investors. In 1901, they convinced one of their friends, a wealthy attorney named George S. Patton (father of the famous general), to join their Santa Catalina Island Company and become a minority owner of the island. With additional money coming in, the company built a new power plant and a Greek amphitheater at Avalon.

Tuna fishing on Catalina Island in 1902.

Family drama soon began to tear the Bannings apart. A key factor was Joseph Banning's alcoholism, which made him unpredictable. In 1897, while he was trying to convert his Avalon summer home into a restaurant and beer garden, he received a letter from his older brother William warning that the presence of shady characters "and particularly women"[11] could bring scandal to the family. William and Hancock were worried that gambling, excessive drinking, and prostitution could hurt Avalon's reputation as a family resort. They also believed that Joseph and his employees were too lax in their management duties.

Unhappy with the way Avalon was being run, the Bannings planned to spend one million dollars to develop a boulevard and other roadways leading to the isthmus so that new homes and businesses could be built in the area.[12] In 1904, after the stagecoach road from Avalon to the Middle Ranch was extended to the isthmus, the area became a popular place for picnics and barbecues among tourists. But the promise of new home construction was not realized.

Frustrated by the constant feuding with Hancock, Joseph resigned from his office in 1903, only to return a year later and complain that his authority had been undermined. By 1905, Joseph and Hancock were no longer on speaking terms and their families avoided one another whenever possible. Soon rumors began circulating that the battling Bannings were secretly trying to sell their island. In 1905, Joseph

299

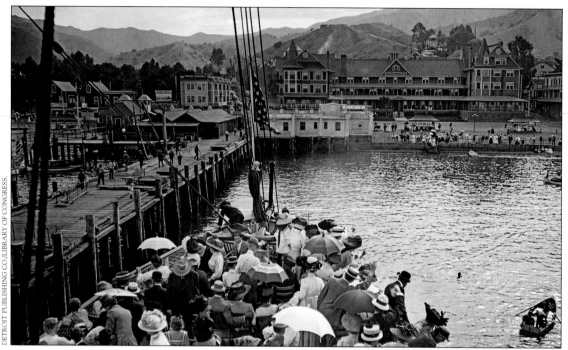

Passengers arriving to Avalon in the early 1900s.
The Metropole Hotel is in the background.

approached Henry Huntington and George Patton to buy his interest, but they turned him down. After missing a couple of company meetings, Joseph was demoted from vice president to traffic manager, while Hancock was given more responsibility.[13]

The year 1907 was a bad one for the Banning brothers. After the Meteor Boat Company was denied docking privileges at Avalon, it successfully sued the Wilmington Transportation Company and broke the Bannings' transportation monopoly. Angered by the court loss, Hancock Banning announced that the Santa Catalina Island Company would spend $18,000 to move Avalon further south along the beach "for the purpose of protecting the island's regular patrons and quiet-loving residents from the influx of crowds brought in by launch excursions of the 'independents.'" The Bannings also announced their intention to build a wall, to be guarded by police, to separate the old Avalon from the new city in order "to sift out undesirable visitors."[14]

But Avalon was never relocated. Instead, the directors met and decided to discontinue many of their side businesses, including the family-owned sheep farm. These cutbacks angered Hancock, who then demanded that Catalina be split into sections, each managed by one of the brothers. The idea was approved by the directors, but was never acted on because Joseph and Hancock could not agree on who got what

300

land. Joseph wanted exclusive managerial control of the isthmus, which he and William had hoped to develop as Catalina's main resort. William hired laborers to plant new trees and to transport lumber to the isthmus, but excessive drinking by employees, property damage caused by a bad storm, and pressure from nervous vendors in Avalon forced him to shut down the new development. By this time, Joseph's drinking had also become so bad that he required emergency treatment for a damaged liver.

In June of 1910, Joseph, who was now recuperating, hired Los Angeles architect Carroll H. Brown to design a new family summer home overlooking the Isthmus Cove and Catalina Harbor.[15] Built for social gatherings, the house had ten dormitory-style guest rooms, known as the "boys' quarters," each room opening to an outdoor patio. This arrangement required guests to have individual keys to their rooms so their comings and goings would not disturb the other guests. An outdoor walkway led from the kitchen and dining room to the main entertainment room, which was furnished in mahogany with a fireplace and an upper deck for board games and cards. Joseph and Katharine's quarters were located under the guest rooms and facing Catalina Harbor.[16]

The new house was completed around the end of May 1911. Among the first guests to stay there were Joseph Banning Jr., who was home from Yale, and his friends, Miss

Joseph Banning's former summer home in the 1920s.
Today, it is the Banning House Lodge.

THE BUNGALOW AT THE ISTHMUS - CATALINA ISLAND, CALIF.

Marie Bobrick, Miss Madeline King, Jack and Paul Bucklin, and the Misses Grace and Katherine Melius.[17] Over time, the Banning house became informally known as the Hacienda and was the "scene of many exclusive house parties when the elite of the southland were entertained as their guests."[18] The amenities available to guests included sailboats in the ocean and horseback riding on the land.

Joseph continued to live wildly, often racing his Packard roadster to and from Avalon along the narrow, twisting and turning stagecoach road through the mountains at speeds up to 14 miles an hour.[19] Although Katharine Banning joined her husband at the house on family occasions during the summers, the couple spent much of their time apart. In 1913, the isthmus only had one registered voter, a man named Charles Wilson,[20] who managed the local tent city for summer campers and acted as a caretaker for the Banning home.

The Bannings had become unpopular with Avalon's citizens and vendors, who felt that they had been bullied and threatened long enough. On November 29, 1915, a mysterious fire burned down half of Avalon's buildings, including six hotels and several clubs. The damage amounted to about $2 million, and even though no one was charged with starting the fire, arson was suspected. For the next couple of years while Avalon was being rebuilt, the number of visitors dropped off. To bolster tourism, a Chinese pirate ship called the *Ning-Po*, built in 1753, was towed from Venice Beach, California, to a location outside Avalon, where tourists could board it and have tea.[21] Prior to its arrival, the ship had been enhanced with a starvation cage and chopping blocks on its decks to promote a gruesome legend that its Chinese crew had beheaded 158 prisoners during a rebellion against the emperor in 1806.[22]

William Wrigley, Jr.

By 1918, the majority of Santa Catalina Island Company's directors wanted to sell out. The answer to their prayers came the following year, when chewing-gum magnate William Wrigley Jr. visited Santa Catalina with his wife Ada and their son, Philip. Wrigley immediately approached the Bannings with an offer to buy both the Santa Catalina Island Company and the Wilmington Transportation Company for a negotiated price of $3 million. The company directors welcomed his offer...except for Hancock, who at first refused to sell. After the papers were signed by William Wrigley and William Banning at Joseph's isthmus house, the Banning family packed up and left the island.

C.43. THE ISTHMUS, CATALINA ISLAND, CALIFORNIA.

SHOWING QUAINT OLD CHINESE PIRATE SHIP "NING PO". 109690

The Ning-Po at Catalina Harbor.

The *Ning-Po* attraction was moved to Catalina Harbor around the same time the isthmus was opened to Hollywood motion picture studios as a desirable filming location. Among the early films shot there were *The Shepherd of the Hills* (1919), *Treasure Island* (1920), and *The Sea Wolf* (1920).

Because the isthmus was largely undeveloped, studios used the Banning house as living quarters for principal cast members, directors, and producers while the Civil War Barracks and a few vacant cottages occasionally housed crew members and extras. Wrigley okayed the construction of a central dining hall and kitchen for cast and crew. Once completed, the new eatery became the Hawaiian Village Café, operated by A.J. Valley and Tom White.[23]

In the spring of 1924, two separate film crews arrived at the isthmus at the same time. One film crew worked on *Captain Blood*, directed by Frank Lloyd, while the other worked on *The Shooting of Dan McGrew*, directed by Clarence Badger. As Enid Bennett, who starred in *Captain Blood*, wrote in a letter to Myrtle Gebhart of *Photo Player Weekly*:

> *I feel like a queen, for I live in the old Banning home on top of a high*
> *hill and from my window I can look upon the horizon of the Pacific in the*

Above: Film extras working on the film Old Ironsides (1926) receive their mail at a post office established at the isthmus.

Below: A staged sea battle for the film Old Ironsides (1926). Two extras lost their lives in the explosion.

304

west, and closer in to shore see Barbara La Marr working in a freakish
old Chinese junk with Mr. Badger directing. And to the east I see beyond
the slope and Camp Lloyd, with its many tents, its funny Algerian slave
market and custom house, the channel and out in the middle of the harbor
I can see Mr. Lloyd in a khaki shirt and brown trousers calling for action
from the naked slaves at the oars of the bright yellow Moorish landscape.[24]

During the filming of *Captain Blood*, the film crew dynamited and sank a real galleon in Catalina Harbor. After they returned to Los Angeles, the isthmus and parts of Santa Cruz Island were converted into Never Never Land for *Peter Pan* (1924), a silent film starring Betty Bronson, Ernest Torrence, Mary Brian, Anna May Wong, and Phillipe DeLacy. In 1925, Milton Sills, Viola Dana, and Ruth Clifford were at the isthmus shooting scenes for *As Man Desires*.

In December of 1924, the Lasky Film Company made arrangements with the Santa Catalina Island Company to bring 14 individually crated North American bison to the isthmus and turn them loose in the wild. Avalon's local newspaper, *The Catalina Islander*, stated that the bison might be used in a possible film project and were there for the winter;[25] but it is more likely that the herd had already been used in the 1923 Lasky film, *The Covered Wagon*, and that the film company had struck a deal with Wrigley to bring their leftover animals to the island, which became their permanent home.

Other filmmaking companies continued to shoot at the isthmus. In January 1925, movie cannibals dropped Pauline Starke into a giant cauldron in *Adventure* (1925), costarring Tom Moore and Wallace Beery.[26] That same year, film crews shot exterior scenes for *The Silver Treasure* with George O'Brien and *Ben-Hur: A Tale of the Christ* with Ramon Novarro. Frank Lloyd, director of *The Sea Hawk*, then returned with a $2.5 million swashbuckling pirate movie *Old Ironsides*, starring Charles Farrell, Wallace Beery, George Bancroft, and Esther Ralston. One of the great spectacles shot for the film was an elaborate battle between two large galleons in Catalina Harbor. During the mock sea battle, an accidental explosion on one of the ships, the old *Llewelyn J. Morse*, which had been reconfigured into the *U.S.S. Constitution*, resulted in the deaths of two extras.

Cecil B. DeMille returned to the island in October of 1926 and transformed part of the isthmus into Galilee for the *King of Kings* by importing camels, goats, chickens, and other animals. Grace Kingsley of the *Los Angeles Times* described a party hosted at the Banning house for Julia Faye, one of DeMille's favorite actresses. Attending the

party were DeMille, H.B. Warner, Joseph Schildkraut and his wife Elise Bartlett, Theodore Kosloff, Jeanie MacPherson, Mitchell Lyson, Edna Mae Cooper, Ernest Torrance, Sam de Grasse, Sally Rand, Josephine Norman, Ann Bauchans, Mason Litson, Bob Edeson, and Grace Gordon.[27]

After *King of Kings* departed, Harold Lloyd and his film crew arrived to shoot *The Kid Brother* for two weeks on board an old beached ship, the *Palmyra*, which was docked in Catalina Harbor. Another film shot in early 1927 was *Blood Ship* starring Hobart Bosworth, Jacqueline Logan, and Richard Arlen.

In April 1927, columnist Inez Wallace visited with Pauline Starke, George Fawcette, Lars Hanson and his wife, Ernest Torrence, and Marcella Day, who were on location for *Captain Salvation*. Wallace wrote, "The Banning house was a desolate looking place on account of the cold. We were chilled though from the wind of the ocean, but there was only one big fireplace and a stove—no other heat in the place. The water pipes had bursted [*sic.*] and none of the crowd had baths for three days."[28]

A scene from King of Kings (1926), partially shot at the isthmus.

Following *Captain Salvation*, a street in Pago Pago was built along Isthmus Cove, and in August of 1927, Gloria Swanson, director Raoul Walsh, Lionel Barrymore, and a crew of 200 workers and extras arrived for the three-week shoot of *Sadie Thompson*. That same year, the isthmus attracted other films, such as *Scarlet Seas* starring Richard Barthelmess, Betty Compson, and Loretta Young, and *The Divine Lady* starring Corinne Griffith and directed by Frank Lloyd.

In 1930, David M. Renton, general manager of the Santa Catalina Island Company, announced the opening of the Banning house as a first-class hotel, proclaiming that it had been completely renovated with new furnishings, an updated kitchen, and a dining room under the supervision of a chef named Clark, who prepared steaks and fish for guests. The hotel operated on the American Plan, meaning that it served three meals a day to guests, whereas the Civil War Barracks offered 32 smaller rooms and served as a lower-end hotel on the European Plan (which offered no meals). Abandoned movie sets near Isthmus Cove were converted into one-room "bungalettes" and a general store. The Santa Catalina Island Company had also graded land for a new park, and an 18-hole miniature golf course. Additional palm trees were also planted near the pier, and the former Hawaiian Villa Café reopened under the management of Rodney Jefferson, master chef of the Catharine Hotel in Avalon. In addition to the new structures, improvements were made to the area's sewage system and the company also installed high-voltage power lines to bring electricity from Avalon to the isthmus. The Santa Catalina Island Company built public bathrooms, refurbished the pavilion, and offered rentals of canoes, horses, and even bathing suits for the tourists. Transportation to the isthmus from Avalon was made possible by boat, limousine, stagecoach, and car rentals.[29]

*Enid Bennett (top),
Julia Faye (middle) and
Pauline Starke (bottom) are among
the many silent film stars who
temporarily lived at the Banning
house while making movies at the
isthmus in the 1920s.*

SAD HILL ARCHIVE

The isthmus around 1930-31. The Banning house (upper left)
overlooks the campground and pier.

However, the Santa Catalina Island Company's plan to offer the Banning house and Civil War Barracks as hotels had a logistical problem. Because film studios kept renting the isthmus for movie productions, lodgings were seldom available to the public. In fact, *The Catalina Islander* reported that in 1930 the Wrigleys earned $200,000 renting the entire isthmus as a film location.[30] In the early 1930s, scenes from *The Sea God* (1930) with Richard Arlen and Fay Wray; *Seas Beneath* (1931) directed by John Ford with George O'Brien; *Island of Lost Souls* (1932) with Charles Laughton, Richard Arlen, Leila Hyams, and Bela Lugosi; *The Painted Woman* (1932) with Spencer Tracy and Peggy Shannon; and *Birds of Paradise* (1932) with Dolores Del Rio and Joel McCrea were all partly shot at the isthmus.

One of the more elaborate productions to shoot there was *Rain* (1932), a remake of *Sadie Thompson.* For this production, United Artists built an entire Pago Pago village, and Joan Crawford, Walter Huston, and a large cast and crew shot the entire film in five weeks, with director Lewis Milestone using the Banning house as a command post. As the *Seattle Sunday Times* wrote:

Like a field marshall coordinating his forces for battle over a wide front, Milestone occupied a vantage point with his staff and made sure that no incongruous note entered into the scheme of things during the actual filming and sound-recording of big scene. ... The bay was first cleared of all craft except those needed in scenes. Then, by means of sirens, a loud-speaker system, and captive balloons for airplanes, semaphores, and signalers aboard speed boats, the Pago Pago atmosphere was assured while cameras and sound-recording equipment were in operation.[31]

In 1935, Metro-Goldwyn-Mayer construction crews for *Mutiny on the Bounty* planted palm trees and constructed a new Tahitian village at Isthmus Cove. On the other side of the isthmus, carpenters built a replica of Britain's Point Smith Harbor. When director Frank Lloyd and his cast arrived, they took up residence in their own cluster of tents and bungalows. Cast members Charles Laughton, Franchot Tone, and Herbert Mundin, were quartered in the Banning house, where a special cook was hired to prepare meals exclusively for them.[42] Because Clark Gable and Laughton did not get along on the set, Gable lived on the top floor of a large bungalow set which doubled as an island bar for the cast and crew. The structure, dubbed Christian's Hut, was named after Gable's character, Fletcher Christian. At times, tensions ran amok, and on at least two occasions MGM executive Irving Thalberg arrived by seaplane to address production problems, and to negotiate peace between Gable and Laughton.

Around mid-summer of 1935, another MGM construction crew arrived and began converting one of the island's summits into Grecian ruins for *I Live My Life,* starring Joan Crawford and Brian Aherne and directed by W.S. Van Dyke. That fall, Gable (minus co-stars Jean Harlow and Wallace Beery) returned to the isthmus to shoot scenes for *China Seas.* Columnist Willa Ocker wrote that "Luggage and personal belongings of the players, Gable's among them, are carried up the steep mountainside to the imposing old Banning house, offering the only modern conveniences within miles. Up the hill behind the luggage trudge the stars."[33]

In 1936, the Santa Catalina Island Company converted the Civil War Barracks into a yacht club, then kicked off the festivities with a costume party enjoyed by Victor McLaglen, Johnny Weissmuller, John Ford, Lewis Stone, and Gloria Stuart. Christian's Hut, now operated by isthmus manager Art La Shelle, lived on as a popular bar.

SAD HILL ARCHIVE

Clark Gable, dressed as Fletcher Christian for the film Mutiny on the Bounty, *poses with Joan Crawford, who arrived at the isthmus to shoot scenes for* I Live My Life *(1935).*

The Catalina Island Company also added new tennis courts, motor gliders, and the Seven Seas Trading Post. Movie stars Warner Baxter, Donald Crisp, Preston Foster, Stan Laurel, Dick Powell, Joan Blondell, John Wayne, and Lupe Vélez were among its visitors. Other films shot there were John Ford's *The Hurricane* (1937) with Jon Hall and John Carradine; *Souls at Sea* (1937) directed by Henry Hathaway and starring Gary Cooper and George Raft; and *Ebb Tide* (1937), with Oskar Homolka, Frances Farmer, and Ray Milland. By this time, however, the movie sets were built to last no longer than a few months.

Around 1937-38, a fire destroyed a couple of old prop ships left behind at Catalina Harbor: the *Llewellyn J. Morse* and the *Charles F. Crocker*. One version of the story is that the fire was accidentally set by men who had used the ships' interiors to smoke goat meat. Another version of the story maintains that the fires were set by an arsonist who believed the ship's fastenings were made of salvageable copper.[34] Some reports claimed that the old *Ning-Po* tourist attraction had also been lost in the same fire, but according to one newspaper account, it "broke up several years ago" and that parts

of her hull "have been preserved as relics and made into glove and handkerchief boxes."[35] The losses of these ships were of little concern to the Santa Catalina Island Company, which by 1938 was toying with the idea of renaming the isthmus Cabrillo.[36] However, the name change never happened, and the isthmus continued to be publicized as the Isthmus Movie Colony and/or the Motion Picture Village. By this time, the old movie sets from *Sadie Thompson* and *Rain* had been converted into a new place to dine or lodge called the Inn of Sadie McKee.[37] The Samoa Theater, originally built as a set for *Painted Woman*, was remodeled into the area's only movie theater. Other new businesses included two restaurants, Wong Lee's and Der Kaiserlicher Rattshoff.

By the end of the 1930s, studio interest in filming at the isthmus began to wane. When Dorothy Lamour, Robert Preston, and Lynne Overman arrived to shoot exterior scenes for *Typhoon* (1940), a Hollywood magazine described the location as being near the "unfashionable Isthmus on Catalina."[38] In her book, *Hollywood's Man Who Worried for the Stars: The Story of Bo Roos*, Carolyn Roos Olsen referred to the isthmus as the "poor man's Hawaiian Islands."[39]

By around 1940, Art LaShelle had closed his popular bar at the isthmus, left the Wrigleys, and opened a new Christian's Hut in Balboa, California. A year later, the Wrigley family decided to refurbish the isthmus. As the *Los Angeles Times* reported, "Hundreds of gigantic palm and olive trees brought across Catalina Channel on barges and hoisted ashore with derricks have been planted on a wide, sandy strand of beach created by thousands of tons of sand brought by barges."[40] The isthmus' main restaurant became the *heiau*, or feasting hall, where exotic drinks were served. Dances and music by string orchestras and *luaus* were held three nights a week.

Rejuvenation of the isthmus came to an abrupt halt, however, after Japan attacked the U.S. Pacific fleet at Pearl Harbor, Hawaii, on December 7, 1941. Santa Catalina Island was closed to tourists, and the U.S. Coast Guard occupied the isthmus. Recruits were housed in the Civil War Barracks while officers were quartered at the Banning house. An obstacle course for military training was erected near the abandoned movie sets.

Following Japan's surrender in 1945, Santa Catalina Island reopened for tourism, and by 1948, operations at the isthmus were supervised by Wilfred F. Olsen, the Santa Catalina Island Company's Director of Hotel Enterprises.[41] Also around this time, the isthmus was renamed Two Harbors, though the village remained unincorporated. In 1951, the Civil War Barracks resumed its earlier function as the Catalina Yacht Club,

and later in the 1950s, Phillip Wrigley ordered Orvall Liddell, an engineer in his employ, to tear down the old movie sets, including Christian's Hut,[42] in order to build a more permanent restaurant and patio bar called Doug's Harbor Reef Restaurant and Saloon.

In 1955, Avalon residents Arnold Eddy and Mrs. Helen Cruickshank struck a deal with the Santa Catalina Island Company to lease the Banning house as the headquarters for the Catalina Island Girls' Camp, which offered rooms and all kinds of amenities for young female campers for eight weeks each summer. In the early 1960s, the name of the Banning house was changed to the Harbor View Inn and it became the island's new hunting lodge during the winter months while still operating as a girls' camp in the summer. After the hunting lodge closed and the girl's camp relocated to another location, the Harbor View Inn reopened in 1970 as a ten-room hotel offering a free continental breakfast and a "single entrée, cook's choice dinner" from Thursday through Sunday.[43] The inn continued to operate under that name until sometime after 1977, when its name was changed to the Banning House Lodge.

Two Harbors remained a sleepy little village until movie star Natalie Wood was found dead in the waters of Isthmus Cove a short distance from the dingy belonging to her yacht, the *Splendour*. Wood had been vacationing with her husband Robert Wagner and fellow actor Christopher Walken during the Thanksgiving holiday. They had been drinking at Doug's Harbor Reef Bar (as it was called at the time) on November 21 before heading back to the *Splendour*. Later that evening, Wood mysteriously fell into the chilly waters and drowned; her body was discovered early the next morning. (Note: In 2011, the Los Angeles Police Department, after reexamining the facts surrounding her death, changed their verdict from "accidental drowning" to "drowning and other undetermined factors."[44])

In 1996, Scott and Kate Panzer managed the Banning House Lodge, which has seen minor repairs and renovations, as a bed and breakfast. When members of the Banning family returned to their ancestral summer home in 2010 for a family reunion, a ceremonial flagpole was dedicated in their honor.[45] In May of the next year, a fire broke out near Catalina Harbor that burned nearly 117 acres before it was extinguished with the help of local citizens and the Los Angeles Fire Department. Fortunately, the lodge survived the blaze, although it came close to being destroyed.

The Panzers left the Lodge in 2012, and even though the old Banning house is still not officially recognized as a historic landmark, it still remains a source of pride to the local community. The Banning House Lodge also continues to operate as the area's only lodging...and is an ideal getaway for anyone wanting to stay overnight at a hotel with a strong Old Hollywood connection.

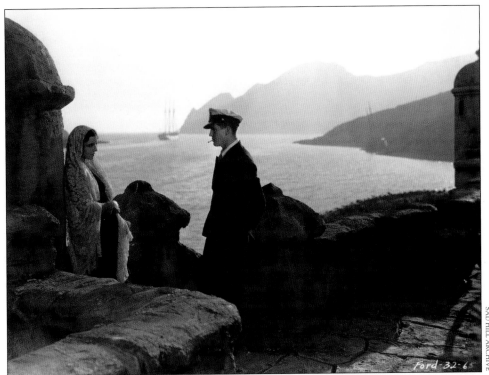

Above photo: The Seas Beneath (1931). Bottom photo: The Banning House Lodge Terrace, c. 2011. Catalina's coastline appears relatively unchanged.

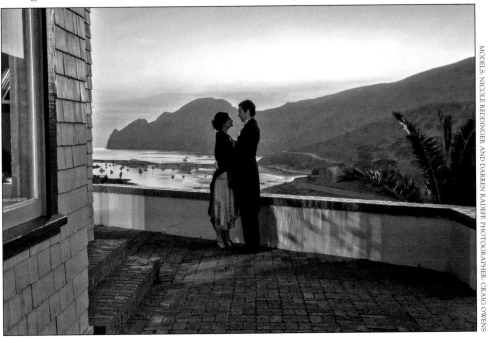

PHOTOGRAPHER: CRAIG OWENS

*A lens flare creates a faux orb in this staged séance photo at the
Banning House Lodge. Models: Darren Radeff, Jennifer McPherson,
Russ Harper, and Nicole Reddinger.*

The Hauntings

The Banning House Lodge's haunted reputation became public knowledge around 2000, thanks to paranormal writer and investigator Robert Wlodarski. In his book, *Dining with Spirits*, he wrote that the lodge had one primary ghost, which he described as "an elderly man…in his 40s-50s wearing an overcoat, hat, sporting a bushy beard, and looking like a fisherman." He also claimed that the fisherman spirit occasionally manifested as a cold spot, or the smell of tobacco and fish, and that the ghost haunted "the stairway leading to a second floor observation point" of the den, where his footsteps could occasionally be heard. Wlodarski then made the vague suggestion that "Some feel that a member or two of the Banning family still returns to their former home,"[46] though he failed to provide any further details.

Two years later, Wlodarski embellished the Banning House Lodge ghost stories in his book *California Hauntspitality*, by claiming that "several people reason that the [fisherman] ghost is one of the Banning brothers," and that the ghost had now been seen walking along the patio walkway as well as staring out the observation window at Catalina Harbor from the upstairs deck of the main den. He also wrote that the lodge had a second ghost, an unseen female spirit who emitted a strong flowery perfume and could occasionally be heard calling out along the walkway and in some of the rooms. "Perhaps the two spirits knew each other in life and are continuing their relationship in the afterlife," he surmised. "Maybe time and a psychic investigation will uncover the identities of these and perhaps other spirits who call this fabulous lodge and unforgettable vacation destination, home."[47]

In 2011, Wlodarski significantly altered his ghost stories in his book *Haunted Catalina II*. This time around, he mentioned that cast and crew members working on a 1987 documentary, *Catalina Island: Treasures of the Past*, had seen the apparition of the fisherman on the observation deck and had heard the ghostly sounds of the fisherman's footsteps walking up the staircase. However, Wlodarski no longer hinted that the fisherman is the ghost of one of the Banning brothers.

He also claimed that past guests had heard the sounds of ghostly guitars and party noises during the night, and that one person reportedly saw the apparition of a woman standing for a few seconds at the foot of a bed, before it abruptly vanished.

Wlodarski next told the story of a couple who were awakened in the early hours of the morning by the sounds of an argument outside their room. As the couple peeked into the courtyard, they saw the apparitions of William and Joseph Banning, both dressed in early 20th-century attire, standing near the stone wall before they, too, disappeared.

In his book, Wlodarski claimed that his group, the International Paranormal Research Organization (IPRO), investigated the Banning House Lodge in 2008, relying on electromagnetic field meters, digital audio recorders, point-and-shoot digital cameras, and séances. Using their field equipment, team members found electromagnetic field spikes in Rooms 6 and 10 and in the fireplace area of the main den. Wlodarski also claimed that IPRO encountered the "impressions of five strong energies, primarily related to the Banning family"[48] attached to the property. Among the Banning "energies" were Joseph, Hancock, and William.

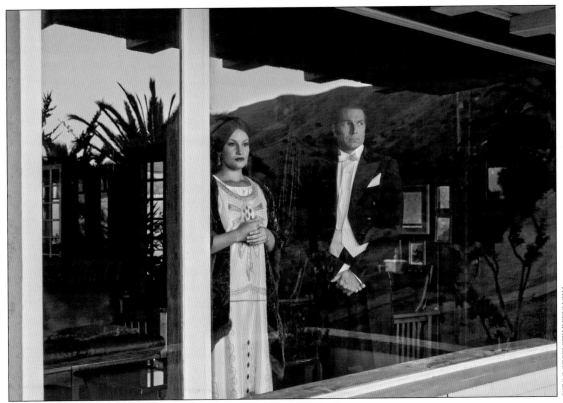

Wlodarski mentioned vague "recent reports" from unnamed psychics who sensed a "possible betrayal or affair" in the Banning family that was somehow linked to a curly-haired woman with a K in her name, whom he identified as Joseph's wife, Katharine Stewart Banning. He also provided a transcript of a séance he conducted in the den in 2008, claiming that he made contact with her spirit. "A click or knock," he wrote, "a whisper and what sounds like Katherine [*sic*.]!"[49] Seance participants also heard a child's voice and a throat-clearing sound. In addition to the possible spirit voices, Wlodarski claimed to have experienced electrical equipment failure, and had witnessed odd behavior from a black cat when it suddenly bolted out of the main room.

The manner in which he described these activities, however, suggests that he is not being transparent about how he got his information. For instance, Wlodarski obscured the fact that he worked as a consultant on the 1987 documentary and was at the Banning House Lodge during production. Furthermore, he did not fully disclose that most (if not all) of the claims were made by friends and psychics who accompanied him to the lodge for the specific purpose of looking for ghosts.

I corresponded with Wlodarski in 2011 and 2012 about a few of his claims, which I thought were inaccurate. Katharine Banning, for instance, was a socialite who

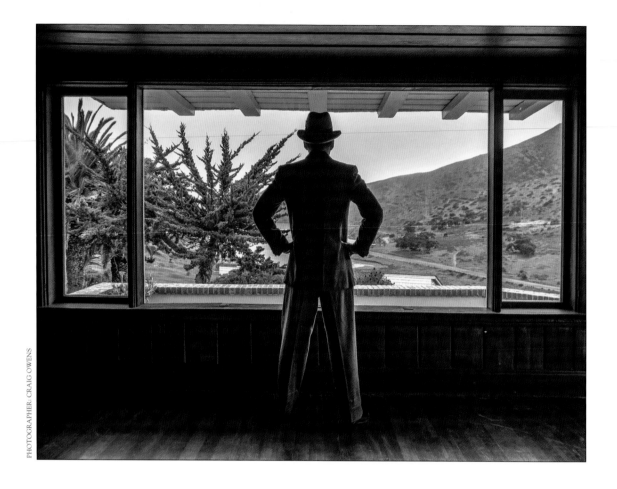

preferred city to country life;[50] therefore, I thought it out of character for her ghost to haunt a remote location like the Banning House Lodge. I also questioned Wlodarski's insistence that Hancock Banning was one of its ghosts. The house was built by Joseph Banning to get away from Hancock, who was probably not welcomed there.

In our correspondence, Wlodarski stood by his latest claims. He also added a few new ones. He said that there were at least six or seven ghosts haunting the Banning House Lodge: Katherine (*sic.*), Joseph, William, and Hancock Banning, a fisherman, an unidentified male, and a child. He also said that he had investigated the hotel 30 times in 30 years, which made him an expert on the subject, and that during a séance, a table had levitated, off and on, for about seven minutes. He also cited other paranormal phenomena, such as doors opening and closing by themselves and eerie indentations appearing on beds, though these were never mentioned in his book. Nor does his website show that he investigated the lodge 30 times. It lists only one investigation at the Banning House Lodge…and that was in 2008.[51]

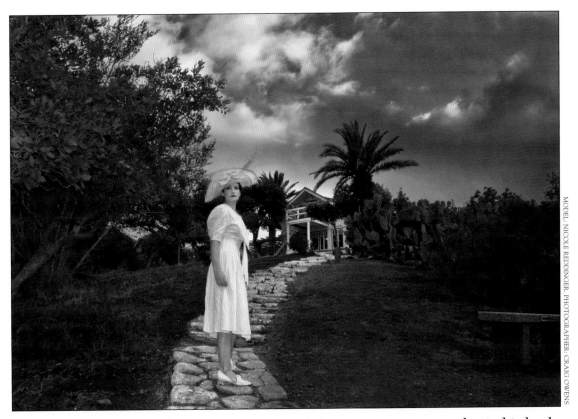

MODEL: NICOLE REDDINGER. PHOTOGRAPHER: CRAIG OWENS

In 2011, author Rich Newman mentioned the Banning House Lodge in his book, *The Ghost Hunter's Field Guide: Over 1,000 Haunted Places You Can Experience.* Instead of writing about the Bannings haunting their old home, he described the apparition of a lady in white that had been seen inside the Lodge's common areas and stairs as well as on the road connecting the Banning House Lodge to the Civil War Barracks.[52]

When I asked long-time Banning House Lodge general manager Kate Panzer about the white lady legend, she replied that she also saw the apparition once. This occurred near the Banning House Lodge in the 1990s. It was daylight, and Panzer was driving her vehicle down the driveway when she looked in her rearview mirror and saw a white mist that looked like a woman wearing a long dress standing behind her vehicle. Panzer stared for a few seconds as the apparition faded and disappeared. When I asked if the white lady was ever seen inside the hotel, Panzer replied that the ghost was mostly seen on the outskirts of the village on the opposite side of Two Harbors, and that the ghost has no connection to the Banning House Lodge.

Panzer did, however, tell me she believes that the Banning House Lodge has at least one real ghost. But although she has heard tales of a ghostly fisherman, or sailor, appearing on the observation deck, she has never seen him. She and other hotel

employees have, on occasion, discovered that certain items like cleaning supplies had disappeared, only to turn up later in odd places. A specific incident occurred in the main den when a bottle of glass cleaner disappeared, only to reappear on another shelf in the room. An employee also told me that she felt uncomfortable going into the basement.

In our conversations, Panzer never claimed that the Banning family haunted their former summer home. She maintained that the lodge was a quiet, restful place occasionally used for weddings, honeymoons, and romantic getaways. She added that on very rare occasions, guests will claim that they felt that the hotel might be haunted, but nothing dramatic has ever happened.

In researching the area's history to see if there were any deaths that could be connected to hauntings at the Banning House Lodge, I came across a few fatalities at the isthmus. For instance, in 1890, a sailor named William O'Neill drowned after the tugboat, the *Alert*, he was on was wrecked during a storm. Another death occurred in 1918, when the isthmus' longtime manager Charles Wilson passed away there from natural causes. Another death was recorded in 1931 when 19-year-old Edwin W. Rogers stumbled while goat hunting and accidentally shot himself with his own rifle.[53]

As for the white lady, I came across a bizarre story that occurred in the summer of 1901 that appears to match this ghost story. According to newspaper accounts, Los Angeles newlyweds, C. Chester and his wife spent their honeymoon camping on the isthmus. One morning, the couple left for a hike but did not take any provisions with them. When they failed to return that night, the tent city manager began to worry. He sent a search party out to look for them, and in time, the searchers found the husband wandering around in the dark and behaving in an emotionally imbalanced manner. Chester told his rescuers that his wife had been killed in a fall while climbing a precipice and that he had stayed with her until she died earlier that evening. He then said that he had gotten lost and didn't know where he was or where his wife had fallen.

After leading the search party all around the western part of the island looking for his dead wife, the party eventually found Mrs. Chester's corpse much closer to the isthmus than they had been told. She was found about a mile west of Catalina Harbor, "propped up against a rock with a handkerchief, her parasol fixed over her, calmly reposed." The search party also determined that Mrs. Chester had not fallen to her death or met with a similar accident. Instead, her arms were riddled with needle marks. After the body was discovered, Chester was once again questioned by authorities. This time, he changed his story to say that she might have overdosed

320

on morphine, which she used to treat her heart trouble.[54] The *Los Angeles Herald* reported that Mr. Chester had also confessed that following his wife's death, he had tried to take his own life with the left over morphine, but there wasn't enough to kill him.

Following the inquest, Mrs. Chester's body was taken from the isthmus and buried in a nearby cemetery in Cherry Valley,[55] close to where the lady in white's apparition is occasionally seen.

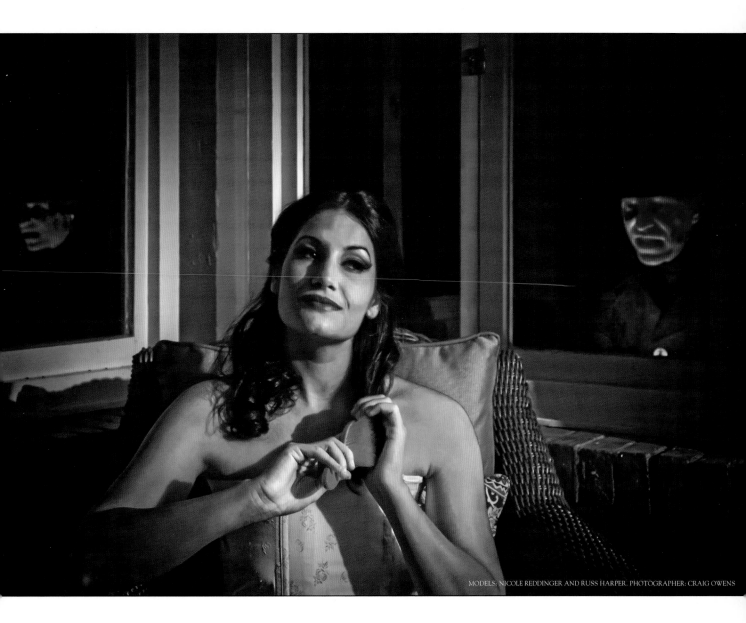

MODELS: NICOLE REDDINGER AND RUSS HARPER. PHOTOGRAPHER: CRAIG OWENS

Our Shoot

Although I felt that the Banning House Lodge's ghost stories sounded weak and unconvincing, I was still happy to receive permission to shoot there during the off-season in 2011, when the hotel was quiet and had few guests. Kate Panzer, the manager at the time, kindly booked our rooms and arranged for our boat travel while I worked to put together a theme loosely based on the Banning family. My goals were to capture jealousy, romance, intrigue, alienation, and mystery and to see if these emotions could somehow stir up paranormal activity.

MODEL: JENNIFER MCPHERSON. PHOTOGRAPHER: CRAIG OWENS

323

A late night toast.

On November 13, Russ Harper, Jen McPherson, Darren Radeff, Nicole Reddinger, Johanna Serrano, and Jamison Tucker met me in Long Beach, and we all took the Catalina Express ship directly to Two Harbors. The Banning House Lodge van was waiting for us at the port, and our costumes, hat boxes, camera equipment, and personal luggage were carried up the summit road to the hotel.

At check-in, I asked Panzer if any of the rooms were considered haunted, and she replied that none of them were known for specific activity. She did, however, recommend that I stay in a room called the Crow's Nest, located above the large den, where a few people had claimed to have felt uneasy. Jen, Nicole, and Jamison took rooms along the main corridor of the original Banning house, and Darren and Russ took rooms in a separate mid-century-modern building down the hill overlooking Catalina Harbor.

At first, our wardrobe room was in a spacious family room, located in a detached building behind the Banning House Lodge. After Johanna and two other models said they felt uncomfortable in that room, something unusual happened...the lock mysteriously stopped working, which forced us to move all the costumes into Johanna's room next door.

MODELS: DARREN RADEFF AND RUSS HARPER. PHOTOGRAPHER: CRAIG OWENS

The Banning House's courtyard.

MODELS: DARREN RADEFF, NICOLE REDDINGER, AND RUSS HARPER. PHOTOGRAPHER: CRAIG OWENS

MODELS: JENNIFER MCPHERSON AND RUSS HARPER. PHOTOGRAPHER: CRAIG OWENS

A wide view of the main den.

After settling in, we went down to the Harbor Reef Bar for a meal and to ask questions about the village's local ghost lore. For instance, in his book, *Haunted Catalina 2*, Rob Wlodarski claimed that the restaurant and bar are haunted by as many as ten ghosts, all from different eras. He also claimed that people had even seen the ghost of Natalie Wood there on occasion. During our meal, I asked our server if these paranormal claims were true. She gave me a blank stare, shook her head, and said she had never heard any ghost stories about the bar or Natalie Wood. She then asked the other employees if they knew of any ghost stories, and everyone shrugged their shoulders, shook their heads, and said no.

After our meal, we returned to the lodge and broke into groups of two or three people to conduct EVP sessions at the hotel. The only other guests that night were a young honeymoon couple staying in a newer, separate structure.

We noticed right away that the lodge has very thin walls, which makes it easy to hear conversations in other rooms, even along the outdoor walkway. Music and conversation from the restaurant and bar below also could be heard quite clearly in the patio area. We also discovered that the rooms had occasional drafts that blew in from

Room 3.

the harbors, which led us to theorize that these breezes were responsible for cold spots. Finally, we discovered that footsteps from the Crow's Nest above the den sounded exactly like someone walking up the stairs from the den to the observation deck.

While our EVP session in the Crow's Nest yielded no paranormal activity, Jamison and Russ captured a possible male voice in Room 3, followed later by a strange, raspy sound like a wheeze or someone clearing their throat. The throat-clearing sound, we discovered, corroborates one of Wlodarski's claims. Later that evening, while Nicole, Johanna, and I were conducting an EVP session in the den, our recorders picked up a similar wheezing sound, although the noise was too brief and distant for us to make a positive EVP identification. Afterward, Darren and Jamison investigated the den. During their EVP session, audio recorders picked up the sound of a male humming two notes, as well as a few knocks and bangs that sounded like the settling of the building.

At the end of the night, after everyone else had gone to their rooms, Jamison set up a video camera in the den, and I set audio recorders around the room and on the observation deck to monitor the room noise.

327

Two views of the den.

The Banning House Lodge's terrace above the basement.

After we had gone to bed (and I had fallen asleep in the Crow's Nest above the den), the recorders below picked up what sounded like footsteps, shuffling and creaking floorboards. These were about an hour into the recording, as if something or someone were moving around inside the den, although no one had entered or left the room. On the other side of the property, Johanna had awakened to the sound strange voices coming from the empty family room next door.

The next morning, we went to the dining room for breakfast and coffee before preparing for our shoot. When the newlyweds arrived a little later, the bride told Johanna that a spirit of a former caretaker for the property had visited her during the night, waking her from sleep to complain that he did not like what our group was doing and wanted us to leave. When I was told about this, I approached the woman and asked about her visitation. Without smiling, she told me that she was clairvoyant, which was why the male spirit had contacted her with his message that he didn't like our being there, didn't like what we were doing, and, more

It was a running joke among cast members how we would resolve the family conflict theme of the shoot. Obviously, there was no murder at the Banning House, but that didn't stop us from concluding our shoot by giving it a Hollywood ending.

330

specifically, didn't like me. After hearing this, I told her the Banning House Lodge did not feel haunted or threatening to me. She replied, "He's avoiding you. He'll be keeping a distance, but he'll be watching."

Our shoot that day was fun and ghost-free. Everyone had an enjoyable time, though several of the models claimed that every time they passed the family room with the broken lock, they still felt spooked. For our meals, we went down to the Harbor Reef. When I asked a different server if the restaurant had any ghost stories attached to it, she replied that while the Banning House Lodge was considered haunted, no one had ever mentioned any ghosts in the restaurant.

The weather was perfect that afternoon, and we were able to get many good exterior shots. Late in the afternoon, Nicole dressed up as the white lady, and we shot along the unpaved road leading to the Banning House Lodge. Before bedtime, Jamison set up a video camera facing the stairs while I placed multiple audio recorders around the den, the upstairs observation deck, and the Crow's Nest. It was windy outside that night, and the recorders captured nothing unusual, only the bangs and knocks of settling wood, water pipes, and the lonely clanging of a rope swinging against a flagpole.

During our last full day at the Banning House Lodge, we concluded our murder mystery theme, which had become a running joke among cast members as to how the jealousies and staged intrigue would be resolved.

That night after dinner, we conducted one last paranormal investigation inside the hotel, including EVP sessions in Room 3 and the den. After Jamison and I placed audio recorders around the den before bedtime, these recorders captured an unusual crash from somewhere inside the room, as if something had been knocked over or moved. Later, a male voice uttered one short word that wasn't clear but sounded like "sit." When I had a chance to listen to all audio recordings, I discovered that we had captured the same word in other EVP sessions.

On the morning of our checkout, I told Panzer that I felt she was right about the Banning House Lodge being more peaceful than haunted. I mentioned that while we hadn't run into any noticeable ghosts, the bride who had checked out a couple of days earlier had told me the property was haunted by a former caretaker who didn't like us.

"It wouldn't surprise me at all if a caretaker haunted this place," Panzer said. "The Wrigleys always made sure someone was here taking care of the house. It was never unoccupied."

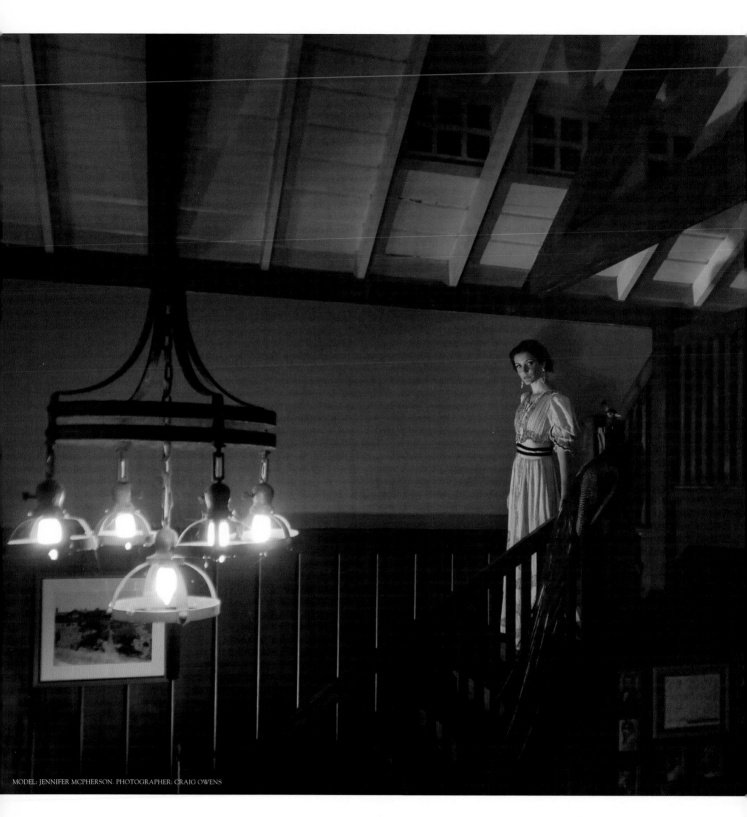

MODEL: JENNIFER MCPHERSON. PHOTOGRAPHER: CRAIG OWENS

Intrigued by her comment, I asked if she knew of any deaths on the property. She shook her head and said if there were any deaths, there probably would not be records of them.

When I asked about the family room, she said that the building was original to the house and that it had been once used for card games and drinking by Joseph Banning and his male friends, but that there had been no reports of paranormal activity.

Although we were able to gather small amounts of data suggesting paranormal activity, the Banning House Lodge isn't as haunted as others have claimed. I do, however, believe that the hotel has at least one ghost watching over the property...one that makes its presence known from time to time.

The Banning House Lodge's haunted stairs.

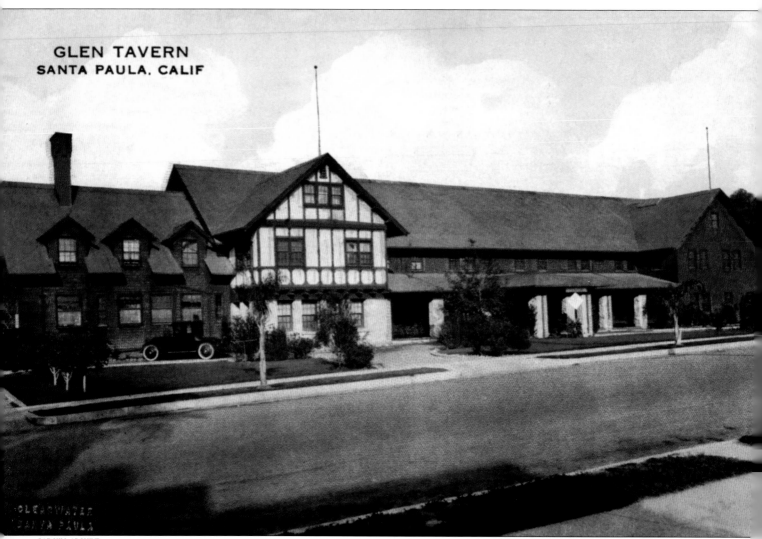

GLEN TAVERN
SANTA PAULA, CALIF

8

THE GLEN TAVERN INN
134 North Mill Street, Santa Paula, CA 93060

The City of Santa Paula is nestled in the Santa Clara Valley near the City of Ventura. It originally got its name in the late 1700s, when Spanish missionaries from the San Buenaventura Mission named the local creek in honor of Saint Paula. In 1843, the governor of Alta California, Mexico, deeded the creek and surrounding acreage to Secretary of State Manuel Jimeno Casarin, who named it the *Rancho Santa Paula y Saticoy*. Because Casarin lived in Northern California, the rancho remained undeveloped, and after California became a part of the United States in 1850, the rancho lands changed owners.

In 1862, George Briggs, an agriculturalist from Marysville, California, purchased 17,700 acres near Santa Paula creek after discovering that the soil was suitable for farming. He planted orchards of soft-skinned fruit trees, hoping to sell his harvest at top prices in San Francisco,[1] but misfortune soon followed. Not only did bad weather ruin his orchards, but Briggs lost his wife to illness. Briggs then hired an agent in 1870 to subdivide and sell his ranch at prices ranging from $10 to $25 per acre.

Two years later, Nathan Weston Blanchard and his wife Elizabeth arrived from Dutch Flats, California, and purchased 2,700 acres from Briggs. Blanchard then founded the township of Santa Paula with the help of his brother and silent partner, Tilton.

335

In 1872, Santa Paula consisted of little more than a house, saloon, and stable situated on a stagecoach road between Saugus (now a part of the City of Santa Clarita) and San Buenaventura.[2] However, within two years, the town had two hotels, two saloons, two stores, a post office, and a flouring mill. Its economy was strictly agricultural until prospectors discovered petroleum in the Santa Paula Canyon. Soon, more prospectors arrived from the east. Chief among them were Pennsylvania oil men Wallace Hardison and Lyman Stewart, who established the Hardison and Stewart Oil Company in Santa Paula in 1883.

The *Santa Paula Chronicle* newspaper went to press in 1886. The following year, the Southern California Railroad arrived. As the town's population boomed, so did its lawlessness. As Frank Taylor and Earle M. Welty, authors of *The Black Bonanza*, wrote:

> *Santa Paula was but a frontier agricultural community into which a number of unwelcome wild west gun-toting characters had moved in the wake of the oil strike. The latter were not only heavy drinkers but quick shooters who terrorized the 200 inhabitants. Santa Paula boasted the dubious distinction of a saloon for every seven families.*[3]

One of these quick shooters was Joseph F. Dye, a crooked ex-lawman from Los Angeles who staked his own oil claims, under threat of violence, near Santa Paula. In 1888, Dye ran afoul of the law after he fatally shot a local Santa Paula shopkeeper on Main Street over a personal dispute. Dye was arrested and charged with murder, but after two trials, a jury found him not guilty. Dye continued to threaten and bully people over Ventura County oil claims until 1892, when he was gunned down in downtown Los Angeles by his own nephew, after Dye had repeatedly threatened to kill him over a soured business deal.

The oil business was a cutthroat industry with many companies vying for dominance in drilling the rich oil deposits near Santa Paula. Wishing to avoid a potential hostile takeover, the Hardison and Stewart Oil Company brought in a third investor, Thomas Bard. The three businessmen then consolidated their holdings, creating the Union Oil Company with Bard as its president. By 1890, the Union Oil Company had become the town's leading oil exporter with its corporate headquarters

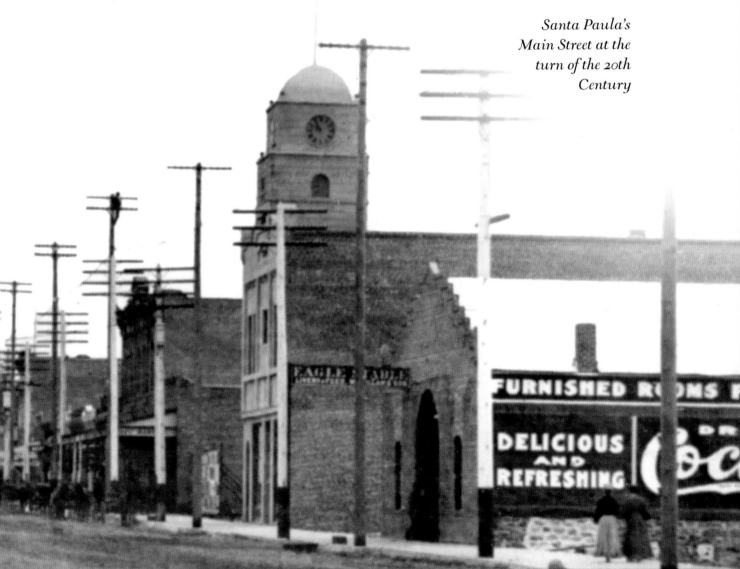

Santa Paula's Main Street at the turn of the 20th Century

on Main Street. Two of its directors, Lyman Stewart and Warren Hardison, then joined Santa Paula founder Nathan Blanchard to try and civilize the town. Stewart, a staunch evangelical, advocated for more churches in Santa Paula, and required all Standard Oil managers to be strong Christians. Hardison, on the other hand, partnered with Blanchard to purchase more than 4,000 acres of citrus farmland, which became the Limoneira Ranch.

By the time Standard Oil Company moved its headquarters to Los Angeles in 1901, Santa Paula had more churches per capita than any other town in the state. The Limoneira Ranch had also become Santa Paula's leading producer of lemons. The ranch's success was largely due to innovations made by its manager, C. C. Teague, a distant relative of Hardison.

In 1903, a fire destroyed Santa Paula's only hotel, the Petrola, forcing guests to stay with local families and boarding houses. At the time, community leaders didn't feel the need for a new hotel on Main Street, so the Petrola was not rebuilt. However, by 1905 the number of visitors began to overrun the town's boarding houses, especially the Casa Ladrillo, located at 119 North Mill Street, near the train depot.

On April 1, 1910, the *Santa Paula Chronicle* announced that the Casa Ladrillo was closing because its proprietor, Widow Clayton, was tired of struggling to accommodate the numbers of guests arriving by railroad. Because the town's population was 2,216 and growing, the directors of the Santa Paula Board of Trade called an emergency meeting to devise a plan to build a new hotel. They decided to establish the Santa Paula Hotel Company with Teague as its president.

After the company raised $25,000, it decided their new hotel, the Glen Tavern, would be located on Mill Street across from the Methodist Church and near the Southern Pacific Railroad Depot. Architects Silas Burns and Sumner Hunt, who had designed the Pierpont Inn in Ventura in 1910, were hired to construct a three story Arts and Crafts-style building with an "Ann[e] Hathaway style of architecture,"[4] which is a reference to the famed English cottage belonging to William Shakespeare's wife. Materials used to build the hotel included Oregon redwood and stone.[5]

While the hotel was under construction, early film pioneer Gaston Méliès, older brother of French filmmaking pioneer Georges Méliès, arrived by train in April of 1911. He had originally wanted to relocate his Star Pictures from San Antonio, Texas, to Santa Barbara, California, so he could continue making Western short films. However, money became an issue. After determining that Santa Barbara's real estate was too expensive, he chose nearby Santa Paula and built a small production studio

338

on the corner of Main and Seventh Streets. Méliès' arrival thus sparked a short-lived motion picture industry in Santa Paula—one that would eventually interweave with the Glen Tavern's history, and cause headaches for local citizens, who did not want to see Santa Paula once again depicted as a shoot-'em-up Western town.

When the Glen Tavern opened on May 16, 1911, it boasted a large lobby for social gatherings, a restaurant, grassy lawns, and a wide driveway for carriages and automobiles. Behind the hotel stood a small house where the hotel employees lived. Next to the house was a wooden barn where employees gathered eggs and milked cows for the hotel restaurant.

The Glen Tavern offered 32 guest rooms and had a third-floor attic that could be configured into additional rooms if needed. A standard room without a bath cost $1 per night, while rooms with a private bath cost $1.50. The restaurant charged 50 cents for a full meal. Santa Paulans were proud of their hotel and nicknamed it the Little Potter, a tongue-in-cheek reference to the huge, lavish, Spanish Colonial Potter Hotel in Santa Barbara, which was considered the finest hotel in the area.

A scene from a Gaston Méliès film shot in Santa Paula, circa 1911-1912.

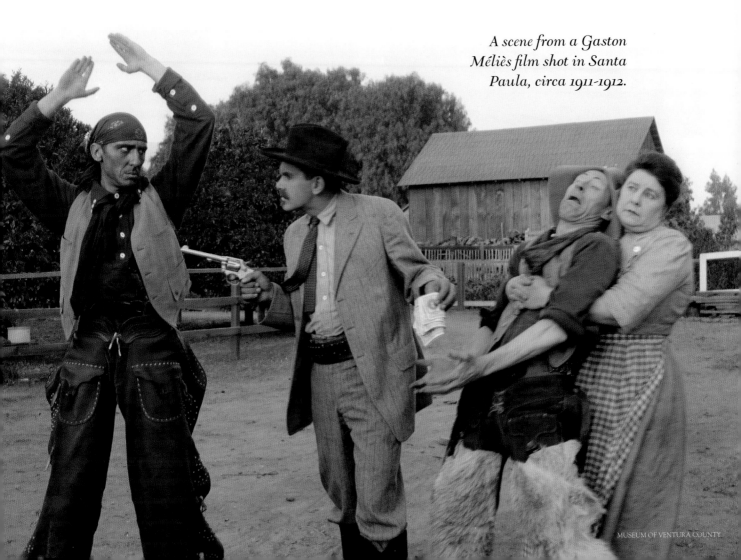

The Glen Tavern's first leaseholder, Smith J. Walling of San Luis Obispo, purchased the hotel's furnishings in Los Angeles and supervised the interior decoration. His tenure as the hotel's first manager, however, was beset by at least two embarrassing incidents. On September 23, 1911, he was arrested by Ventura Sheriff Edmund Guy McMartin on an outstanding warrant in Alabama on charges of embezzling $15,000 from a bank in Albertville, where he had once worked as a clerk.[6] Walling was extradited back to Alabama to face charges before he was acquitted, and returned to Santa Paula.

The second embarrassing incident occurred in April of 1912, when Walling was severely beaten inside the hotel while trying to stop a party in one of the guest rooms. According to the *Santa Paula Chronicle*, Walling entered the room to find five men drinking and playing poker "or some game with cards wherein chips were stacked upon the table." The noisy gamblers were Richard Stanton and Charles Edler, two local film actors with the Gaston Méliès film company; M. Morgan, "a well-known promoter of San Diego," George S. Bates, a piano agent, and B.B. Grinnell, "the local field super intendent [sic.] for the Union Oil Company."

Walling demanded that the men leave. After Grinnell peacefully departed without incident, tensions flared. The *Chronicle* reported, "Mr. Stanton beat up the proprietor of the hotel mercilessly," while Morgan, the promoter, yelled, "'Let me hit him, too.'" When Santa Paula's main physician, Dr. D.W. Mott, arrived at the scene, Morgan threatened to beat him, too. After tempers subsided, Dr. Mott treated Walling's injuries, which consisted of a laceration to his forehead as well as bruises around his eyes, nose, and mouth. The police arrested Stanton and Morgan, and the *Santa Paula Chronicle* admonished the gamblers for using the Glen Tavern as "a resort for their personal convenience in endeavoring to satisfy their own debased appetites and desires...."[7]

Walling stayed with the Glen Tavern until April of 1913, when he traded managerial positions with H.O. Henderson, another hotel director for the Walling Hotel Company. Walling then relocated to the Appleton Hotel in Watsonville, California. A short time later, Henderson and his co-manager Edward Henry Marsh arrived in Santa Paula to take charge of the Glen Tavern.

By 1913, Gaston Méliès had sold his movie company to producer Willis Robards, owner of the St. Louis Motion Picture Company, and then left town. Robards continued producing Western short films in Santa Paula from 1913 to 1917, which were then distributed by Universal Pictures. During these productive years, cast members Lillian Hamilton, Fred Church, Edythe Sterling, and Olga Printzlaugh occasionally stayed at the Glen Tavern and took their meals there.

The Outlaw's Daughter (1914), starring Edythe Sterling.
Shot in Santa Paula.

By 1913, the Glen Tavern's small size had already become a problem. Too many visitors were arriving in Santa Paula for the hotel to accommodate, forcing Henderson and Marsh to contact neighbors to see if they could handle the spillover. In 1914, the *Chronicle* mentioned that the proprietors wanted to convert the Glen Tavern's third floor into guest rooms. However, adding new walls, plumbing, and fire escapes was considered too expensive, not to mention inconvenient for travelers staying in the hotel during construction.[8]

Soon, the Glen Tavern went through a succession of management changes. In March of 1914, Henderson turned management of the Glen Tavern over to his co-manager Marsh and left town. In December, both Henderson and Marsh sold their lease, along with the hotel's original furnishings and fixtures, to Mr. and Mrs. James A. Crane for approximately $4500.[9] The Cranes then moved into the Glen Tavern with their two daughters, Patricia and Eleanor, and lived there until of the end of 1917. On January 1, 1918, E.A. Smith of Omaha, Nebraska, took over the managerial duties at the Glen Tavern.[10] He did not last long, either.

Throughout all these management changes, the Santa Paula Hotel Company still owned the hotel and surrounding property. The company also made sure that the Glen Tavern adhered to the Prohibition laws. As Horace McPhee, editor of the *Chronicle*, wrote in 1919, "Santa Paula is a 'dry' town and the hotel does not openly, nor in any other way, favor any infractions of the local ordinances, which are probably the strictest, in a prohibition way, adopted by any city in California."[11]

The Glen Tavern changed hands again in 1919, when Charles D. Estep, a hotel owner from Indiana, leased it for a year before deciding to buy it from the Santa Paula Hotel Company. Estep completed the conversion of the third floor into ten additional guest rooms. He also landscaped the grounds, hung cages with canaries on the porch and in the lobby, and added a nine-hole putting green on the property.[12]

Notable guests who visited the hotel during the 1910s and early 1920s included William Jennings Bryan and Ignacy Jan Paderewski, the composer, pianist and prime minister of Poland. Local legend also maintains that Warner Bros. canine star Rin-Tin-Tin stayed on the third floor during the production of *The Night Cry* in December of 1925.

Because the Glen Tavern was primarily made of wood, it was constantly under threat of fire and had more than its share of them. However, there were no reported fatalities. The first known fire broke out on October 17, 1922, causing several thousand dollars' worth of damage.[13] In December of 1924, a second fire started in a guest room, followed by a third fire that started in the basement laundry room less than a month

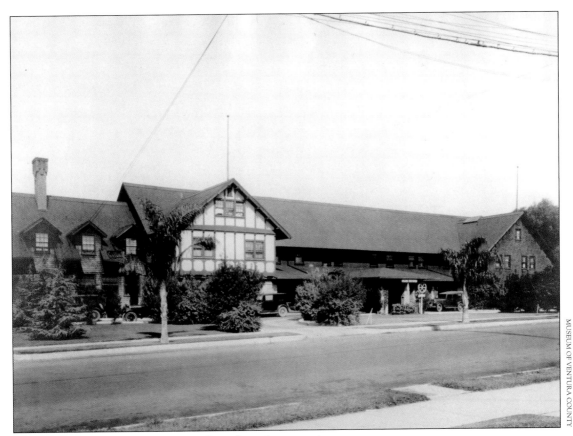

The Glen Tavern, circa 1930s.

later. Fortunately, the local fire department extinguished the latter two blazes with little to no damage.

Santa Paula's serenity was disrupted on March 12, 1928, when the newly constructed St. Francis Dam located approximately 40 miles northwest of Los Angeles, collapsed at about 11:57 p.m. More than 12 billion tons of water roared down a 54-mile path through the San Francisquito Valley toward the ocean. Around 1:30 a.m., Louise Gipe, a Santa Paula telephone operator, overheard the news about the dam's collapse and alerted highway patrolman Thornton Edwards that the flood waters were heading toward Santa Paula. With sirens wailing, Edwards rode his new Indian-4 motorcycle into the low-lying areas of Santa Paula to warn citizens of the impending disaster. He was joined by fellow officer Stanley Baker, who had also been notified.

Around 4:00 a.m., the flood waters roared through the southern half of Santa Paula, leaving behind a gruesome landscape of mud, yellow silt, wrecked buildings, uprooted trees, and dead bodies either floating in the river, or partially buried in

343

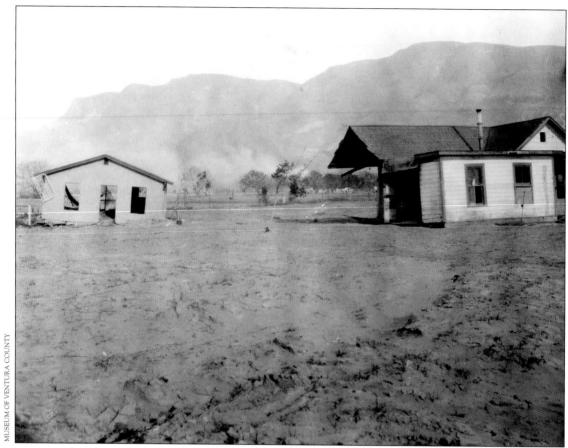

Flood damage in Santa Paula from the St. Francis Dam disaster of 1928.

muck. The dam failure was the second largest disaster in the State of California's history and destroyed a total of 909 homes and ten bridges. It also killed more than 450 people, many of them washed into the ocean and never found.[14]

It is unclear as to what role the Glen Tavern played during the flood's aftermath. Most historians believe that it was not damaged by flood waters due to its safe distance from the disaster area. Immediately after the flood, an army of rescue workers from Los Angeles arrived and set up a Red Cross soup kitchen and emergency hospital at a grammar school on the south side of town. Displaced residents took refuge in the old Citrus Association building, while others lived in temporary tent cities near the flooded area. In an effort to prevent looting, no one was allowed into town without an issued pass card.[15] As embalmers established temporary morgues around the disaster area, French's Mortuary, located two blocks from the Glen Tavern, became Santa Paula's main morgue.

Santa Paulans worked quickly to rebuild their town. By 1930, it had 11 churches, six schools, seven fruit and nut packing warehouses, one lima bean warehouse, multiple automobile dealerships, six smaller independent petroleum companies, one small refinery, and an airfield. Its population had also risen to 7,395 people.[16]

In the early 1940s, the Glen Tavern was again attacked by a series of fires. The first occurred in May of 1942, when children playing with matches in the back of the hotel were blamed for burning down the old, dilapidated barn. Later, lit cigarettes were believed to have started two other small fires at the hotel, one around Thanksgiving of 1942 and the other on February 1, 1943. Both of these fires were quickly extinguished with little to no damage and no loss of life.[17]

Throughout the 1920s and 1930s, the Glen Tavern operated as a "dry" hotel. When Estep applied for a liquor license in 1942, the Methodist Church across the street, led by Reverend Clell C. Gray, organized a protest that forced Estep to withdraw his application. "The Glen Tavern [is] at present a nice hotel, and a credit to Santa Paula," Gray said. "But in my opinion to bring a cocktail bar in would be a detriment to the community."[18]

When Estep and his wife, Madge, divorced in the early 1940s, he kept the hotel. However, in June of 1943, the U.S. Federal Public Housing Authority leased the property from Estep to house bookkeepers and stenographers assigned to Port Hueneme, a naval base located near the City of Ventura. The government agency spent more than $40,000 converting the Glen Tavern into a women's dormitory. The shingled roof was painted green, the exterior received a new outdoor stairwell, old light fixtures and furniture were replaced, and the rooms were reconfigured to house more than 70 women. A ping pong table and a dart board were installed downstairs, and croquet and shuffleboard were added to the back lawn. The restaurant became a cafeteria managed by Alfred Baptista and his wife, while the dormitory itself was managed by Miss Mildred Meek. In 1944, the *Chronicle* published the following guidelines:

> *The girls [sic] are allowed to have guests in the lobby and game rooms until 10:30 week nights and until midnight on Saturday and Sunday nights, but guests, including boy friends, must be invited in advance. Gate crashers are given the bum's rush.*[19]

With little to do, Estep moved to Santa Barbara until after the war. When the government's lease ended in early 1946, he returned to the Glen Tavern, married his second wife in the lobby, and promptly leased the property to Mr. and Mrs. John W. Starks, who managed it for five years under its new name, the Glen Tavern Hotel.

345

Santa Paulans were happy to have their building back, and during the Glen Tavern's conversion into a hotel, it had a 50 percent occupancy. Movie stars came back, too, including Randolph Scott, who was seen dining in the restaurant in 1947.[20]

Estep's niece, Fairy, and her husband, Raymond LeRoy Bannister, assumed management of the hotel in 1951 and added a new lawn, two restrooms, and fresh coats of paint in the kitchen, restaurant, and lobby. In 1953, the Bannisters purchased the hotel from Estep for $60,000[21] and proceeded to further modernize it by adding new apartments, 21 bathrooms, new furniture, and a swimming pool. By 1959, the restaurant became the Gourmet Dining Room, managed by Marvalene Agee and Chef Charles Decker.

Ray Bannister died in 1962, and a year later his wife, Fairy, married Harry McCann, who helped her run the hotel. The Glen Tavern Hotel underwent further alterations in 1964 when a new two-story stucco building was added next to the original building to accommodate a reception room and two units. However, downtown Santa Paula soon fell into a steep economic decline. When the McCanns finally sold the Glen Tavern Hotel in 1972, it had become a low income, residential housing in need of repair and plagued by crime.

The Glen Tavern Hotel in the late 1940s.

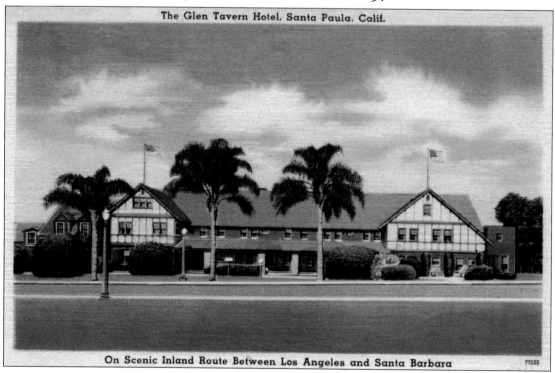

The Glen Tavern Hotel, Santa Paula. Calif.

SAD HILL ARCHIVE

On Scenic Inland Route Between Los Angeles and Santa Barbara 77222

In late 1980, city officials condemned the hotel for fire and safety violations, and soon the IRS went after its newest owner, Ron Smith, for unpaid back taxes. Facing foreclosure, Smith answered a newspaper real estate ad placed by Shirley Butterfield, a businesswoman in Camarillo, California. Butterfield told the *Chronicle* that "Smith wanted to swap the tavern for a mobile home park."[22] Although she refused his offer, Butterfield bought Smith's Glen Tavern Hotel Corp. to stave off foreclosure. She then paid for new fire doors, a sprinkler system, and fire escape ladders. She also repaired the roof and purchased new carpets and drapes.

In April of 1981, Ventura County officially designated the Glen Tavern Hotel a local landmark. However, Butterfield's good fortune was short-lived. In May of 1981, the IRS threatened to attach the hotel's liquor license unless she paid "taxes accumulated under the old corporate structure."[23] Faced with mounting financial problems, the hotel property was scheduled to go to auction that October. Butterfield asked Santa Paulans for help, saying, "I believe in the Glen Tavern Hotel and I believe it has the right to be what it was meant to be, a grand old hotel where friends can meet in traditional surroundings." She then enlisted musical acts, including the Drifters, the Coasters, the Diamonds, and country and western star Tex Williams, to play benefit concerts to help her raise money to save the hotel.

While Butterfield's fight for the Glen Tavern Hotel was heroic, it wasn't enough. In December of 1981, the IRS forced her to surrender the hotel's liquor license.[24] Butterfield then closed the hotel in 1982, and the property went to auction a year later with an initial offering of $434,700.[25]

Mel Cummings, a real estate developer and Santa Paula ranch owner, bought the hotel at auction and renamed it the Glen Tavern Inn. He then hired workers, who spent seven months rewiring the building and upgrading the plumbing. Shortly after the Glen Tavern Inn reopened in 1984,[26] it was added to the National Register of Historic Places. However, the refurbished hotel continued to have problems with criminal activity. In April, a man was arrested at the bar for "battery to a police officer,"[27] and in early May, the front desk was robbed by two men carrying shotguns.

In May of 1986, Senior Health Resorts, Inc., owned by nursing home professionals Kathy Hernandez and Dolores Diehl, signed a 30-year lease to operate the Glen Tavern Inn as an upscale senior living center. Their plans hit a snag, however, when they failed to reach an agreement with Cummings over installing an elevator. The two women then tried operating it as a retirement hotel that offered amenities for mature travelers and senior tour groups. To lure seniors, they installed Jacuzzis in

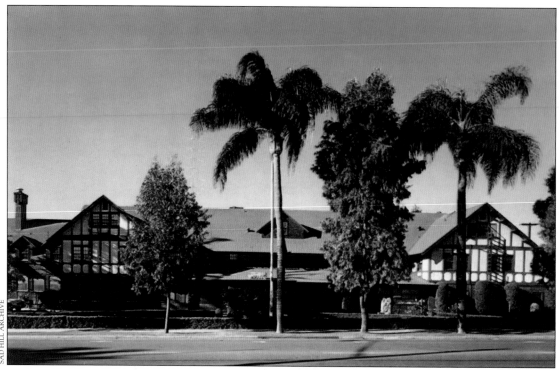

SAD HILL ARCHIVE

The Glen Tavern Hotel, c. 1960.

select rooms and an outdoor gazebo on the side lawn. They also leased lobby space for a new hair salon and a gift store, and opened a bar called the Glen Tavern Pub.

The retirement hotel concept was not successful, forcing Senior Health Resorts to file for bankruptcy in November of 1986. In March of 1987, Hernandez and Diehl issued the following announcement:

> *Since the people of Santa Paula have made it clear that they don't want to give up their hotel, which has been used for years to accommodate tourists and guests, the Glen Tavern is officially once again a full resort hotel, open to the general public the year around.*[28]

Hernandez and Diehl began researching the hotel's history, hoping to find famous guests that had once stayed at the Glen Tavern and whose names they could include in their advertising. As Hernandez told the *Los Angeles Times* in 1986, "Clark Gable and Carole Lombard were guests here.... We're just not certain which room was theirs. We're still researching and we hope to have a sign up in their room as soon as we're sure."[29] The problem with their research, however, was a lack of documentation

348

proving that any famous film personalities stayed there. So Hernandez and Diehl took liberties by designating Room 307 as the Rin-Tin-Tin room, even though there was no conclusive proof that even the celebrity canine stayed there.

In May of 1988, the Santa Paula city council voted to legally pursue the collection of more than $27,000 in unpaid transient occupancy taxes against Senior Health Resorts, Inc. Unable to pay the amount, Hernandez left the partnership, and Diehl was forced to close the restaurant and bar, and lay off 25 employees. After an eviction notice was served in September of 1988, Diehl left the hotel, blaming property owner Mel Cummings, along with the real estate recession and the Writers Guild of America strike for hurting the hotel's business. The strike, she complained, had stopped union film and television production units from coming to Santa Paula to shoot.

After Diehl's departure, Cummings reopened the restaurant and bar until he could find a hotel buyer who could meet his asking price of $2.25 million. Cummings expressed his disappointment with the Glen Tavern Inn's performance by telling the *San Francisco Public Press*, "I hate to think how much money I put into [the hotel]. I'm sorry I ever got into it, to tell you the truth."[30]

On March 31, 1989, Cummings sold the Glen Tavern Inn for $2.1 million to Tokyo International College, which renamed the hotel the Tokyo International College Center for Western Studies. A few hotel guest rooms were converted into classrooms, which were then used for teaching American culture to Japanese students living at the hotel. However, "a disappointing number of students"[31] enrolled in the program kept the school from being profitable. In 1992, a local scandal broke out after the college filed a lawsuit against its business manager for not meeting American accreditation requirements.

The college's problems worsened after the county tax collector's office claimed it owed more than $57,000 in back taxes. The Glen Tavern building closed and was put on the market again, this time for $1.5 million. There were no buyers.

After building inspectors discovered major electrical and plumbing problems inside the Glen Tavern building, the City of Santa Paula ordered its water shut off, and forced Tokyo International College to erect a fence around the property. City officials grew increasingly agitated over the state of the hotel, and before the city could file criminal charges against Tokyo International College, the school spent approximately $50,000 to bring the building back to code. In July of 1993, the college gave it another try, and Japanese students returned to the property. This time, however, their classes were held at Ventura City College.

In 1998, Tokyo International College once again closed the building and placed the property on the market. The Glen Tavern Inn building sold in December of 2001 to Santa Barbara resident Steve Talley for $590,000. "They had wanted $1.3 million, so they basically gave it me," Talley told the *Los Angeles Times*. "I'll probably have to put another $500,000 into it, but I love it."[32]

In March of 2002, the Glen Tavern Inn reopened as an apartment hotel, offering only 17 guest rooms for rent. Local police soon learned that people were living in the basement and that a large dog was freely roaming inside the hotel. The following year, the city temporarily closed the Glen Tavern Inn after the hotel failed a safety inspection.[33] Once repairs were made, the hotel reopened. However, it once again catered to low-income tenants.

In 2004, real estate developers Rosanna and Tom Jennett of Malibu saw the Glen Tavern Inn listed for sale on the Internet, and purchased it on February 2 for $1.4 million. "When we acquired the property it was dilapidated," Tom Jennett told the *Ventura County Star*. "It was an eyesore. It was a sore spot in the city. It was a flop-house. We bought it with the idea of renovating it from top to bottom."[34]

After a major restoration, the Glen Tavern Inn and its new restaurant, Avenue X, opened in early 2006. Then a major fire badly damaged the hotel on April 19 while the Jennetts were on vacation in Kentucky. Although the cause of the blaze is unknown, the Jennetts believed that a restaurant employee accidentally dumped live cigarette butts into a linen bag in an outdoor trashcan. After the linen bag burst into flames, live ash and sparks set the restaurant and hotel roof on fire. Fortunately, the Santa Paula and Ventura fire departments saved the building. However, when the Jennetts reentered their hotel after the fire, they discovered that it was flooded with foam and water. Several third floor rooms, including Room 308, suffered heavy fire damage. Since these rooms were small and oddly shaped, the Jennetts decided not to restore them back to their original configuration. Instead, they hired workers to rebuild the space into a large, modern suite that became the new Room 308.

By the end of summer, the Glen Tavern Inn reopened for business again, this time with a new restaurant called the Grove occupying the original dining room. The Grove, however, closed within two years and was replaced by the Ironhorse, which then closed in 2009. Frustrated by the turnover in restaurants, the Jennetts opened their own eatery in 2010. It was called Enzo's Italian Restaurant, with a menu created by Chef Onsy "Enzo" Mahrous.[35] That same year, the Jennetts tried to sell their hotel for $2.7 million, but Rosanna Jennett had a change of heart and it was taken off the market.

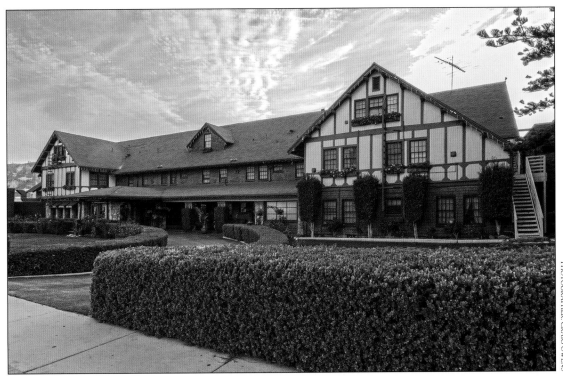

PHOTOGRAPHER: CRAIG OWENS

The Glen Tavern Inn in 2011.

Today, the Glen Tavern Inn is a successful hotel. Not only is it an affordable wedding venue, but it also relies on other events to keep rooms filled. Low budget films like *The Lyons Den* (2012) as well as the hit television show *NCIS* were filmed at the hotel, and stars like Lindsey Lohan, Jeff Bridges, and others have visited it during filming of other productions in the area.

But there is another key marketing strategy that has contributed to the Glen Tavern Inn's success: the promotion of its ghost legends, which has brought scores of ghost enthusiasts to the hotel, hoping to make contact with the hotel's spirits.

First floor hallway.

The Hauntings

According to some locals, the Glen Tavern Inn never really had any ghost lore until the 1980s. As Santa Paula historian, artist, and author John Nichols told the *Ventura County Star* in 2007, "We've lived in Santa Paula 31 years. When we first moved here, it wasn't haunted. And then somebody along the way—one of the former owners, I think—got the idea that a ghost would be a good marketing device. So they went to Central Casting and got a ghost."[36]

Nichols was referring to owners Dolores Diehl and Katherine Hernandez, who first claimed that the Glen Tavern Inn was haunted during the Halloween season of 1986. Before making their big announcement, Hernandez and Diehl had decorated the hotel with black plastic spiders and webs, carved jack-o'-lanterns, and pictures of witches and goblins. They also allowed their employees to dress in costume.[37] Diehl then brought in psychics, one of them being her friend, Cheryl King of Ojai, who claimed to have found two ghosts at the hotel, one haunting Room 218, the other haunting Room 307.

Next, Diehl invited Ventura ghost hunter and paranormal author Richard Senate to see what he could find. Because Senate was teaching a course on "ghosts and haunting" at Ventura City College at the time, he arranged to bring his students to the Glen Tavern on October 15, 1986, for a paranormal investigation and a séance conducted by Senate's wife, Deborah, a psychic medium.

While investigating Room 306, Deborah fell into a trance. As her head dramatically jerked back and forth, she claimed to channel the spirit of a 35-year-old woman named

MODEL: ANGELIQUE HENNESSEY. PHOTOGRAPHER: CRAIG OWENS

Room 305.

Jennifer, who apparently didn't know she was dead. Instead, Jennifer told Deborah that she was still waiting for three friends to arrive for a 1931 Thanksgiving party and that she (the ghost) needed an aspirin for her headache.[38]

The following day, the *Santa Paula Chronicle* published an interview with Diehl, Hernandez, and the Senates, who claimed that there were three ghosts haunting the hotel. In addition to Senate's discovery of Jennifer, Diehl mentioned the two ghosts channeled by Cheryl King. One of them was identified as Wilbur, a man who had died in a gunfight while playing poker in Room 307. The other spirit was named Ellen (her name later became Helen), who had died during childbirth.[39] Richard Senate corroborated King's claim that Room 307 was haunted by telling the *Chronicle* that his students had witnessed a mysterious indentation forming on the bed, as if someone were sitting or lying down on it.

Even though Diehl and Hernandez admitted that they had not seen anything paranormal, they claimed they had sought the help of King and the Senates after

hearing a number of ghostly reports from staff members. Diehl then told the *Chronicle* a hotel bartender quit "when he saw a shadowy figure stirring something at the stove" in the kitchen, and that "a ghost appeared to a housekeeper in Room 307 and told her to get out."[40] Head waitress Johnnie Britton told the newspaper she had seen "items being thrown in the kitchen" and had felt "cold air pass by her as if there were emotions from some being around her"[41] while standing at the foot of the main staircase. Other employees also shared their stories with the *Chronicle*. Employee Pam Decker said she had heard a ghostly voice call her name more than once. Cris Zacher said she had seen Wilbur throw an ice cream scoop across the room on at least six separate occasions.[42] The *Chronicle* listed other paranormal activities said to be going on at the inn. These included cold spots, lights turning off and on in empty guest rooms, and reports of employees being pushed by an unseen presence. At that time, the haunted rooms were said to be 304, 306, 307, 308, and 218.[43]

The Glen Tavern Inn's ghost marketing, however, did not stop after Halloween. On December 21, 1986, Diehl held a press junket at the hotel during which she told the *Camarillo Daily News* that "the second Ghost Hunt is on, specialty of the inn, with Senate offering a lecture, video and séance following a tour of the 'ghostly' sites."[44]

The lobby.

This time around, Cheryl King and Richard Senate were on hand to provide more details about the Glen Tavern Inn's ghosts. King told the *Los Angeles Times* that she had encountered "a wistful woman of 34 named Helen, dressed in a flowery print dress with a white eyelet collar,"[45] (Note: The *Camarillo Daily News* still reported that the ghost's name was Ellen.)[46] King then told reporters she had encountered a ghostly "Buffalo Bill look-alike who was obsessed with what he thought was a cache of gold hidden somewhere in the hotel's rafters." She said that after all these years, the ghost was still looking for his missing green valise with the loot in it. King said she had seen the ghost "once on the television screen and another time across the wall above the brass bed."[47] King described him as wearing a "string tie, shoulder-length hair and handlebar mustache." Diehl, meanwhile, told the *Camarillo Daily News* that the Buffalo Bill look-alike had "white, shaggy hair, a beard and blue eyes," though she later admitted she had never really seen him.[48]

By this time, the ghost named Wilbur was now blamed for being the dining room ghost that "has been known to throw pots to the floor and toss an ice cream scoop from the refrigerator." However, Pam Decker, who also participated in the press junket, cast doubt on the existence of a dining room ghost, telling the *Ojai Valley News* that the ice cream scoop was "not always set back right on the wall and it just keeps falling off the hook."[49]

In January of 1987, Senate claimed that one of his college students, Catherine (another paper spelled it Katherine) Dickerson, had photographed the Buffalo Bill look-alike ghost with her infrared camera inside Room 307. "There's a misty, weird figure with a goatee, and the photo even looks like he might be playing cards,"[50] Senate told the *Times*.

After seeing the photo, Diehl secured signed affidavits that the photo had not been altered by the lab and that Dickerson was alone in the room when she took the photo. On January 17, 1987, Cheryl King returned to Room 307 for a follow up investigation. While there, she came up with two names, "Cal" and "Elaine" (a variant of Ellen and Helen), and the date "August 1917." King also claimed that during a spirit writing session in Room 307, she automatically wrote the words, "murder...gold...rafters."[51]

Diehl invited other psychics to the Glen Tavern Inn to share their impressions. Grace Coveney, a Calabasas psychic and radio personality claimed that the hotel had three ghosts: one was a woman who haunted Room 218, the second was a child on the first floor, and the third was the Buffalo Bill look-alike who laughed at her when she encountered him in the third-floor hallway. Another psychic, Susie Kantell, based in Van Nuys, claimed that the first-floor child was around eight years old and knew

MODEL: ADAM JOHNSON. PHOTOGRAPHER: CRAIG OWENS

The Glen Tavern Inn's main staircase.

about the Buffalo Bill spirit, but did not know about the woman haunting Room 218. Kantrell claimed that the child ghost was not allowed to go upstairs, although she didn't explain why.[52]

On January 28, 1987, Diehl held another press conference to talk about the Glen Tavern Inn's ghosts.[53] Local reporters were shown the ghost photograph, the signed affidavits, and King's spirit writings. One of the attendees was *Ojai Star-Free Press* photographer Ron Silva, who admitted that the ghost photo looked unusual, whereas his young son said the ghost looked like a troll.[54] King, Coveney, and Kantell discussed their impressions at the event. Senate meanwhile, suggested that the Buffalo Bill look-alike could have been an unnamed silent film, Western actor.[55]

Diehl and Hernandez spent 1987 trying to incorporate the ghosts into the hotel's events. In April, psychic Grace Coveney returned to the hotel to tape a short-lived, local, cable talk show in the hotel's pub.[56] On October 2, Diehl and Hernandez

brought in Kenny Kingston, the self-proclaimed Psychic to the Stars, for a press conference. While sitting in the lobby, Kingston told a local reporter he had felt the spirits of Clark Gable and Carole Lombard in the "bright red, heart shaped bathtub," which Diehl and Hernandez had installed, and that the spirit of Charles Laughton had also dropped in for a visit. "There's a reunion of 'Mutiny on the Bounty' going on upstairs," Kingston quipped. He also mentioned that he had brought along his own traveling companion spirits, Clifton Webb and Chief Running Bull, who were present in the Glen Tavern Inn's lobby. As for the inn's other ghosts, Kingston said the hotel rooms "have a marvelous vibration about them—good, clear vibrations. I think that definitely one of them was in the closet in Room 307—one or two."[57]

In November of 1987, Richard and Deborah Senate claimed that during their stay in Room 308, they had witnessed the bathroom door swing open and close several times on its own before it came to a complete stop.[58] Richard Senate then claimed that around midnight, he "glanced up [from the bed] toward the door and, in the dim light that filtered into the third floor room, [he] saw a jet black form. It appeared in the doorway." He then added, "It just stood for a moment, its arms hanging down at its sides. I couldn't see a face on the form. It seemed almost like a shadow. After several seconds it moved to the left and vanished."[59]

Senate's new paranormal claims quickly started a false legend about Harry Houdini's visiting the Glen Tavern. The following month, Diehl installed tin plaques designating Room 307 as the Rin-Tin-Tin Room, and Room 308 as the Harry Houdini Room. According to Senate, "The story is that Houdini was forced to spend the night at the place in the mid-1920s, when the railroad line north was damaged in a rainstorm. At that time, the third floor was mostly attic space. Houdini wanted a place to store his magic props where he could watch over them so no one would discover his secrets."[60]

While Senate admitted that he could not validate the Houdini story, his claim lacked credibility for additional reasons. According to newspaper accounts, Harry Houdini never visited Santa Paula, nor did he travel to Southern California in the mid-1920s. When Houdini did travel with his act, he was always accompanied by a small army of assistants to protect his props. Likewise, the third floor attic of the Glen Tavern had already been converted into guest rooms by 1920. Therefore, the third floor would not have been "mostly attic space" as Senate claimed.

Around the same time that the Houdini legend started, Katherine Hernandez introduced another false legend about the Glen Tavern. In an interview with the *Los Angeles Times*, she claimed the third floor had been a speakeasy during

MODEL: ANGELIQUE HENNESSEY. PHOTOGRAPHER: CRAIG OWENS

The third floor landing.

Prohibition, a story the *Times* described as "a frail but legitimate link to the gold cache ghost story."[61] The speakeasy legend made little sense. If an illegal bar and brothel existed on the third floor, hotel guests on the second floor would have heard thundering noises above them at night. Citizens, including church-goers across the street, would also have seen lights on the third floor late at night. Plus, there was no escape route in the event of a police raid.

Fortunately, not everyone believed the ghost stories about a murdered gambler on the third floor. In a letter published in the *Chronicle* in December of 1987, a hotel guest ended his complimentary letter by writing, "P.S. The kids don't buy the ghost in Room 307."[62]

By 1988, the ghost legends had become even more commercialized. For example, as St. Patrick's Day neared, the *Santa Paula Chronicle* warned that "if a visitor there hears a voice with a thick Irish accent that seemingly comes from nowhere, it probably means the resident Irish spirit is somewhere nearby."[63]

Calvin, a fictional ghost said to haunt the Glen Tavern Inn.

That same year, Senate told paranormal author Dolores Riccio that he had visited the Glen Tavern Inn 50 times since 1986 and decided "to take a ghostly census" of the inn's resident phantoms. "From the information we collected," Senate said, "no less than six phantoms call the place home." [64] However, by September of 1988, Senate increased his ghost count, telling the *Times*, "I thought the *Queen Mary* was haunted, but it's only got five ghosts and this has nine ghosts in a much smaller area. I've never been to a place with more recurrent phenomena."[65]

In discussing his census, Senate told the *Times* that the Buffalo Bill look-alike ghost had once been an actor named Calvin or Wilbur, who had been murdered by more than one person in Room 307 after being caught with five aces in the poker deck he was using. "They realized that the man had been cheating," Senate explained. "Angered about this, they shot and killed him."[66]

Senate's ghost census included Jennifer, who had been channeled by Deborah Senate in Room 306. He also listed the ghost of Ellen/Helen/Elaine, originally identified by psychic Cheryl King in 1986. Only this time, King's ghost no longer wore a flowery dress, nor was she the ghost of a woman who had died in childbirth. Senate now claimed that Ellen/Helen/Elaine was the ghost of a perfume salesperson who emitted a flowery scent on the second floor where she was thought to roam. "She'd knock on the door and climb into bed with people," Senate told the *Times*. "She was supposed to be French."[67] Senate's census also included Houdini's ghost in Room 308.

When the *Times* contacted former Glen Tavern Inn owner Fairy McCann for her opinion on Senate's claims, she declared, "No Houdini. And, of course, there's no ghost. That's just something to talk about…. That's all advertisement." Even Diehl admitted that she had never encountered a ghost in the two years she had operated the hotel. However, she still defended her claims that the hotel was haunted. "All I know," she told the *Times*, "is that my staff saw a lot of things happening that couldn't be explained." Before leaving the Glen Tavern Inn in late 1988, she removed many

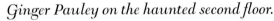

Ginger Pauley on the haunted second floor.

items from the hotel, including the bedding from Room 307 and the ghost photo. "I felt sentimental about it so I took it with me," she explained. "I took the ghost, too."[68]

After the hotel changed hands, media coverage of the Glen Tavern Inn's paranormal activity quieted down. However, in 1994, Richard Senate wrote about the hotel's ghosts in his book, *The Haunted Southland*. In a chapter devoted to the hotel, he downplayed his own contributions to the hotel's ghost lore by blaming Diehl and others for starting the ghost legends. He wrote, "Many of the reports center on Room 307, where she [Diehl] claimed to have spoken to the phantom presence and learned that his name is 'Calvin.'" He further added that "skeptics derided the accounts, saying they were the creation of the former management in an attempt to secure publicity and attract visitors. Though some of the reported ghosts may well have been glamorized, the vast majority of them seem to be real events witnessed by ordinary people."[69]

In his book, Senate also wrote about his own Glen Tavern Inn ghost stores, claiming that his wife had heard the sounds of a ghost child running down the main stairs at 3:00 in the morning. He also mentioned the shadowy figure he had seen in Room 308, and how this apparition was said to be connected to Harry Houdini. Once again, Senate distanced himself from the Houdini legend by writing, "Could it have been the ghost of Harry Houdini? I don't think so, but it was something out of the ordinary."[70]

In 2002, paranormal author Robert Wlodarski mentioned the Glen Tavern Inn in his book, *California Hauntspitality*. He wrote that it was haunted by the ghost of a "young boy who died [in the hotel] and is seen playing on the second floor and in the lobby." Wlodarski also mentioned that the lobby piano occasionally played by itself, and that there were multiple "sightings of a person looking out of the window of Room 23 when it is unoccupied."[71]

When Tom and Rosanna Jennett bought the Glen Tavern Inn in 2004, they had heard about the ghostly Calvin and that the third floor had once been a speakeasy and a brothel. They were also told that Room 307 was haunted by the ghost of an unknown prostitute from an unknown era who had been beheaded in the room's large closet. At first, Tom felt that all of the inn's ghost stories were ridiculous. However, Rosanna and her adult daughter, Monica de la Torre, believed that the Glen Tavern Inn was haunted. In 2005, Monica saw an apparition of a woman in early 20th-century attire disappear through a wall near Room 106.

Workers renovating the hotel found no satchel of gold hidden in the rafters, although they did uncover an old door (possibly an attic door) that had once connected the second and third floors. During the remodeling of the kitchen, workers knocked

MODEL: MICHAEL OWENS. PHOTOGRAPHER: CRAIG OWENS

The third floor.

a hole in the wall where they found a hidden bowler hat (some accounts say it was a Western hat) with two holes in it.

In 2006, Senate once again promoted the Glen Tavern Inn's ghosts. On his ghostvillage.com website, he claimed that Calvin was a ghost who smoked expensive cigars and haunted the entire hotel, including the downstairs ladies' restroom and the main staircase. Senate also wrote that his wife had seen another male ghost walking in the first floor hallway. Senate then mentioned that the hotel's night manager, Susan Pardo (probably Susan Gallagher), had told him that she and her husband Charles had briefly seen a ghostly party in the lobby, complete with music and dancing.[72]

In 2007, a psychic medium and tarot card reader named Heather Woodward organized the South Coast Paranormal Convention at the Glen Tavern Inn, featuring herself, Richard Senate, and a multitude of other paranormal "experts" to give lectures and conduct investigations over the course of a weekend. The cost to attend the convention was $125 per ticket.[73]

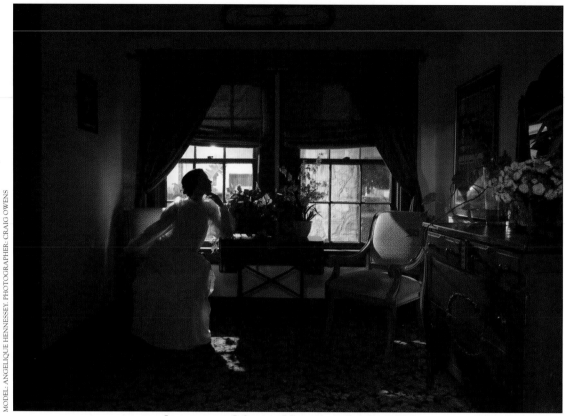

MODEL: ANGELIQUE HENNESSEY. PHOTOGRAPHER: CRAIG OWENS

A lounge used for weddings on the first floor.

To promote her event, Woodward interviewed Glen Tavern Inn night manager Susan Gallagher about her paranormal experiences for a YouTube promotional video. On camera, Gallagher told Woodward that hotel guests in certain rooms had heard mysterious knocks and disembodied voices calling the guest's names. Gallagher also said that guests had seen doors opening by themselves, faucets in a shower turning on, and curtains suddenly falling from windows. When discussing her own paranormal experiences, Gallagher told Woodward that she had seen the third-floor hallway lights surge unexpectedly. Gallagher also said that she had photographed a ghostly lady from the 1930s, wearing a white, full-length nightgown and wandering the first-floor hallway. Gallagher told Woodward that psychics had told her that the ghost's name was Rose, and that Rose had once been involved with a married man who had abandoned her at the hotel. In addition, Gallagher mentioned that other guests had seen Rose, too, and that the ghost was crying.[74]

Senate promoted Woodward's event by telling the *Ventura County Star* that the ghost named Calvin had been a middle-aged movie actor and horse wrangler, who,

364

after serving a stint in Buffalo Bill's Wild West Show, had moved to Santa Paula in the 1920s to find work in second-rate, silent Westerns. Senate also said that after Calvin was murdered, his body was dumped into a crawlspace on the third floor. Woodward added that Calvin also haunts the ladies' powder room on the first floor, the third-floor hallway, and the kitchen, "where, during recent remodeling, a cowboy hat pierced by what appeared to be a bullet hole was found inside a wall."[75]

Woodward told the *Ventura County Reporter* that when she had entered Room 219, she received the "psychic impression" of a "man with light features, an olive complexion and a mustache, wearing a top hat and a black suit and smoking a cigar." She also saw visions of ships, one being the *Titanic*.[76] After discussing her impression with Senate, both concluded that the ghostly presence had to be pioneer filmmaker Gaston Méliès. They maintained that Méliès had loved booze, poker, and prostitutes, and that he was a regular customer at the Glen Tavern.

Woodward told the *Reporter* that during a séance on the first floor, she had contacted another French ghost named Pearl. "She wanted to be a star," Woodward said. "She really liked her money and liked to count her money. She has a very hearty laugh."[77] Though Pearl had never been seen by anyone else, Woodward described her

Inside the lobby.

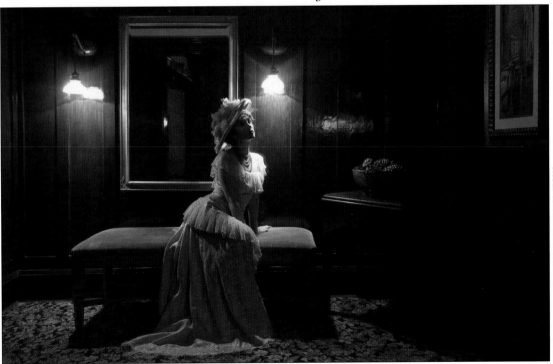

as having a broad nose, red nails, and red lipstick. Woodward also said that Pearl had been strangled by her own pearls (hence the name).

Woodward next described the ghost named Rose as having dark hair in a 1920s bob and an olive complexion. Rose was said to open and close doors and cause the phones to ring with no one on the other end. Woodward then recycled an old 1980s paranormal claim by telling the *Reporter* that during a spirit-writing session, she had contacted a ghostly lady in white who had once been a French perfume saleswoman that had died in the 1930s from complications associated with childbirth.

In 2007, celebrity psychic Lisa Williams visited the Glen Tavern Inn to film a segment for her short-lived Lifetime series, *Living Among the Dead*. While there, she claimed to not know anything about the paranormal activity, even though she immediately began to pick up psychic impressions of two of the hotel's false ghost legends. On camera, she told hotel manager Monica Del Torre that a woman had been horribly murdered in Room 307 and that her corpse was hidden in the closet. Later, in her book, *The Survival of the Soul*, Williams wrote,

> *When the manager, Monica, let me in to Room #307, I almost immediately felt the energy of a woman who was refusing to leave. Monica informed me that an unsolved murder had occurred at the inn some years back. It turns out that I'd encountered the murdered woman's soul, who had remained behind to look for her killer and had been haunting the inn ever since. … Before I knew it, there was someone else who wanted to come in—a man who'd been shot while he'd been gambling in that exact room.*[78]

Despite these two false stories, guests continued reporting paranormal activity in Room 307, as well as in other rooms on the third floor. For instance, a couple staying in Room 307 said that they had placed their luggage in the closet, only to wake up the next morning to find the closet door open and their luggage sitting at the foot of the bed. Other guests found their luggage mysteriously sitting in the halls outside their rooms. Over the years, guests have heard mysterious scratching sounds coming from Room 307's closet, disembodied knocking on doors and walls, and voices coming from the halls and unoccupied rooms. On at least one occasion, a cleaning employee saw a misty white apparition in Room 307 that quickly dissipated into thin air.

The Jennetts admitted that Rooms 306 and 218 were both dead-bolted from the inside on more than one occasion while the rooms were vacant.[79] On another occasion, an elderly couple staying in Room 204 called down to the front desk from the

MODELS: KATYA, MICHAEL, AND LIZA OWENS. PHOTOGRAPHER: CRAIG OWENS

A first floor guest room.

upstairs landing to say that there was a young girl with braids who had accidentally walked into their room and was playing under their bed. Other eyewitnesses claimed to have seen the ghost of a vintage dressed boy bouncing a red ball on the second floor. On a separate occasion, a group of contractors staying at the hotel saw ghost children running in the second-floor hallway and then vanishing into a wall.[80]

In 2011, Richard Senate self-published a 24-page pamphlet titled *The Ghosts of Santa Paula*, in which he claimed that "glowing orbs of energy" were seen inside the hotel and that on one occasion the orbs chased three children. He also said the inn's ghosts included a man wearing overalls and standing on the porch, and a red-headed phantom woman peering from a third-floor window. Senate wrote that a poltergeist-type entity once slid chairs from under tables to block a night employee's path through the restaurant. He noted that other ghosts move items around in guest

Bear fight in the lobby.

rooms. One of them is a male phantom in Room 23 who also stares out the window; and the other one is a "shadow ghost" in Room 103 who engages in whispering. Senate next claimed that a female apparition has been seen in Room 104 raising a glass to make a toast before disappearing. He added that she might be a murdered girlfriend of either a crooked politician or a gangster.

Senate briefly discussed the Glen Tavern Inn's ghost children, claiming that they primarily haunt the first and second floors. One is a female child spirit who is allegedly seen riding an old fashioned tricycle in the dining room, while another is a boy who had either drowned or been murdered in a second-floor bathtub. A third child ghost, according to Senate, roams the main property wearing knickers, suspenders, and a cloth cap.[81]

Naturally, Senate mentioned the ghosts he helped invent, such as Calvin, and the female French perfumer, whom he now said haunted—Rooms 220 and 222. He still

maintained that Gaston Méliès haunts Room 219, and that Harry Houdini haunts Room 308, even though these claims have been disproven.

Senate wrote about a story that clearly contradicts one of his earlier claims. In 2006, he wrote that he had once recorded an EVP of a voice saying, "I'll kill you."[83] However, in 2011, he changed his story by writing:

> *A phantom of an elderly woman walks the second floor hall. She confronted two children long ago and they asked her how old she was. The old woman said 78 then added, 'I will kill you!' [sic] the kids ran and reported the event but there was no one like that staying at the Inn and no one has seen her since, but they report someone knocking on doors on the second floor.*[84]

As if Senate's credibility isn't questionable enough, he also claimed that in 1901 the "bench on the front porch of the inn was once used by President James McKinney [*sic*] to give a speech. This was just before his violent assassination!"[85] Not only did Senate completely botch President William McKinley's first and last names, but he also incorrectly asserted that McKinley had been at the inn—ten years before the Glen Tavern was built.

A mirror on the second floor.

MODEL: ANGELIQUE HENNESSEY PHOTOGRAPHER: CRAIG OWENS

In 2012, the *Ghost Adventures* television show arrived at the Glen Tavern Inn for a taping. During their investigation, the team heard the disembodied voice of a young girl during a séance. The team also interpreted random words generated on an Ovilus word-generating device and sound blips overheard on a spirit box as being paranormal.

Two years later, *The Dead Files* television show conducted their own investigation, drawing the unlikely conclusion that the Glen Tavern Inn was haunted by the late, 18th-century gunman, Joseph Dye. The show then made an unsubstantiated claim that Dye was a serial killer of women. The show also falsely claimed that the Glen Tavern was flooded during the St. Francis dam disaster. One of the show's cast members also told Rosanna Jennett that she might have been a reincarnation of an earlier Santa Paula resident who was attached to the hotel.

Today, paranormal enthusiasts and psychic mediums continue to look for the Glen Tavern Inn's ghosts, even though the majority of its legends can be best described as a series of myths built on top of other myths. Calvin and the beheaded woman never existed. The third floor was never a speakeasy or a bordello. Harry Houdini never visited Santa Paula, and there is no evidence directly linking Gaston Méliès and Joseph Dye to the property.

So if all of these stories are untrue, who or what is haunting the hotel?

There are documented deaths associated with the property. The first known death happened on February 16, 1887, when 85-year-old Asa Morton, a former gold prospector turned wagon builder and farmer, died in bed in his home, which occupied the property before the hotel was built. The second death occurred in 1888, when Morton's daughter, Laura Chiles, was found dead in the garden; however, the cause of her death is unknown.

After the hotel opened in 1911, there were at least two documented deaths from natural causes. One was Charles Estep's mother-in-law, Amanda Heacocks, who passed away at the hotel in 1941. The other was owner Raymond LeRoy Bannister, who was found in his first-floor quarters on June 12, 1962.[86] A death by suicide took place in 2007, when a resident named Henry hanged himself on the second floor in a structure that was attached to the back of the main building. A second suicide occurred in the 1964 building attached to the hotel in 2015.

There have been a couple off-site deaths connected to the hotel. One was the death of 27-year-old Charlotte Wassel, who was killed west of Santa Paula in 1944 when a car she was riding in was struck by a train. Another death was former owner Charles Estep, who died on the Saticoy Country Club's golf course on November 28, 1957. Both resided at the Glen Tavern at the time of their deaths.[87]

A corner of the lobby.

MODEL: GINGER PAULEY. PHOTOGRAPHER: CRAIG OWENS

But none of these documented deaths explain ghost children or ghostly women wearing early 20th century clothing. Could the ghosts be somehow connected to the St. Francis Dam tragedy?

The Glen Tavern Inn's ghost stories first went public in 1986, two years after Mel Cummings bought the old French Mortuary building, which had been converted into the Jackson Hotel, and later, became the Santa Paula Inn. According to local legend, the second floor of the Santa Paula Inn is also supposedly haunted by at least one ghost child.[88]

Is it possible for both properties to be haunted by the same ghosts? Did the ghost stories travel from one location to another during renovations of both properties? There are no good answers to these questions, except to say that the Glen Tavern Inn's hauntings remain a mystery that has, to date, given few clues as to why it has so many ghostly claims.

MODELS: KATYA OWENS, MICHAEL OWENS, CYNTHIA TUCKER, AND LIZA OWENS. PHOTOGRAPHER: CRAIG OWENS

Storybook time.

Our Shoot

I initially visited the Glen Tavern Inn in early 2011 and rented Room 307 for one night just to see what might happen. While there, I met with owner Rosanna Jennett, who told me some of the ghost stories she had heard. Later that evening, I placed digital audio recorders around Room 307 to monitor the room noise. As I slept, the recorder clearly picked up a female voice inside the room saying something that sounded like "Faye." Faye has an indirect relevance to the Glen Tavern's history. The name derives from the word *fairy* – which coincides with the name Fairy Bannister-McCann, a former Glen Tavern owner who passed away in 2004. The problem with this connection, however, is that Fairy never went by the name Faye.

After receiving permission to conduct a vintage photo shoot at the hotel, I reserved a handful of rooms for mid-April 2011. Models Adam Johnson, Angelique Hennesey, and Ginger Pauley agreed to take part, and Melinda Mauskemo handled the hair and makeup for the models. Melinda and I arrived on Sunday, April 13, 2011, the day before the shoot began, and that night at about 11:30, we placed multiple recorders around the lobby to conduct an EVP session. Nothing unusual happened during the 25-minute session, however, as I fumbled to turn off the H4 Zoom recorder on the end table closest to the registration desk, the device captured what sounded like an aristocratic female voice saying, "Don't turn it off."

Not realizing at the time that we had captured a possible EVP, Melinda and I were standing in the lobby discussing the next day's shoot when an unusual noise from the vacant front desk interrupted our conversation. It sounded like a fingernail scratching across one of the propped-up display signs. We then started a second EVP session in the area, but nothing unusual was captured on audio.

Adam and Ginger arrived the next day, April 14, and checked into their rooms on the third floor, while Angelique checked into one of the larger rooms on the first floor.

That afternoon, we began our shoot in Room 213, a second-floor room that we chose because of its wallpaper and two beds. By 11:30 that night, the few guests staying at the inn had gone to bed and the front desk closed, so Melinda and Adam conducted EVP sessions in other parts of the hotel while the rest of us continued to shoot in Room 213. To keep the noise factor down, the door to the room was closed, but not latched, so Melinda and Adam could enter without knocking.

Shortly after midnight as I was adjusting the tripod, I heard the doorknob behind me turn. Looking back at the door, I expected to see Melinda and Adam enter the room. Instead, the door opened before coming to a standstill, and then it closed on its own. Not feeling any cross breeze, I quickly stepped into the hallway to look around. It was quiet and there were no open windows.

About an hour later, another odd thing happened. Ginger, Angelique and I heard the sound of someone or something scampering along the hallway above us. Ginger thought it sounded like a running dog, which would have been unusual, given that we had the entire third floor to ourselves. It wasn't Adam and Melinda, either.

Room 213.

MODELS: GINGER PAULEY AND ANGELIQUE HENNESSEY. PHOTOGRAPHER: CRAIG OWENS

374

The next day, April 15, Melinda told us that while she was in Room 305, she had turned around and nearly collided with a female apparition that quickly disappeared. Melinda described the woman as middle-aged, and wearing a dark blue, Edwardian outfit with a high-collared blouse, and a hat.

Because most ghost hunters believe that ghosts are made up of energy, we tried to use several different types of electro-magnetic field (EMF) devices to monitor the third floor. During our test, we discovered that there was a lot of electrical interference in the atmosphere. We felt that part of the interference was due to a cell phone tower located very close to the hotel. Another source of EMF disturbance was the wireless Internet router located just below Room 307.

Around 9:00 p.m., we moved to the second floor to photograph Ginger in the hallway. Later, Adam, Melinda, and I hid an audio recorder in the second floor hallway and set up a video camera at the end of the hall for surveillance. While the audio recorder captured a few odd, indefinable sounds, the monitoring session captured no signs of paranormal activity.

Rooms 306 and 307.

On April 16, Melinda, Ginger, and Angelique checked out of the inn, leaving Adam and me alone. The atmosphere on the third floor was much gloomier than it had been before. That night, Adam dressed as the ghost Calvin, and we decided to do an EVP session in the middle of the hallway near Room 307. As we both sat against the wall with a Zoom audio recorder in the middle of the corridor, I asked whatever was present to please show itself by knocking the recorder on its face (where the buttons were located). For the next ten to 15 minutes, nothing happened…and then, as we were about to end the EVP session, a sudden gust of air whipped past us, knocking the Zoom recorder on its back. Coinciding with the mysterious gust of wind were a series of loud cracks and bangs throughout the hallway. The incident was over in a second, but it was powerful, and left us confused as to how this could've happened since all of the doors and windows were closed.

We then set up a second recorder on the third floor near a closed window that overlooked the church across Mill Street. While we were shooting in that hallway, I became aware of male and female voices talking nearby, possibly in Room 302, which was unoccupied. At first, I dismissed it as my imagination, or maybe it was a television show coming through a vent (which was never found). The voices, however, were not loud enough for Adam and me to understand what was being said, though they were loud enough to get our attention. Since there were no occupants in the rooms along the third floor hallway, I asked Adam to remain upstairs while I searched the hotel to see if anyone had a television turned up loud, or if someone was talking outside of the building. All was quiet.

I returned to the third floor, and the faint voices continued. After a few minutes, Adam made his own sweep through the hotel. The voices eventually faded away, and we ventured down to the lobby to continue our shoot, leaving the recorder upstairs to monitor the noise.

Adam and I checked out the next day. I couldn't wait to get back home to find out if the faint voices we'd heard on the third floor were loud enough to be caught on the recorder. Fortunately, a few of the words were audible, and I was able to pick up a male voice at one point saying, "Get out of here." At a later point in the recording, a soft voice said, "Glen Tavern." Later still, a voice said, "Leave us." Towards the end of the recording, while Adam and I were in the lobby, there was one loud voice that spoke near the microphone. While it was a deep, raspy, male voice, it did not sound quite human, nor could I understand what it said.

After researching the history of the hotel, I decided to return in 2015 for a small pick-up shoot. This time, I brought my three children and mother, who agreed to model.

376

Wandering the second floor.

For the second shoot, I avoided the most haunted rooms. As a result, nothing paranormal happened during our 24-hour stay. But there was one amusing anecdote. At one point during the photo shoot, my two youngest children Liza and Michael wandered up to the second floor to visit their grandmother. As they scampered down the hallway, a hotel guest opened the door, saw the kids in their vintage costumes, and asked if they were ghosts. Michael and Liza couldn't wait to tell me what had happened.

Overall, I was thrilled to take photos and to experience the paranormal at the Glen Tavern Inn. I truly love this hotel. The food is good and reasonably priced, and the staff is very nice and helpful. As for its ghosts, well, let's just say that they provide a little mystery to a wonderfully charming hotel.

ENDNOTES

CHAPTER 1: HOTEL DEL CORONADO

1. Cecil C. Moyer, "When Cattle Roamed North Island," *San Diego Union*, July 21, 1968.

2. "San Diego. Flattering Development of its Resources," *San Diego Sun*, January 5, 1884.

3. Eileen Jackson, "Golden Jubilee of Hotel Opening Recalls Dream of Pioneers Bored With Retired Life," *San Diego Union*, February 13, 1938.

4. "The San Diego and Coronado Beach Water Company," *San Diego Union*, March 10, 1886. It should be noted that Coronado Beach Company promotional literature occasionally listed other names as its officers, such as John Inglehart and H. Schussler. It appears as though their involvement was temporary.

5. Burke Ormsby, "The Lady Who Lives by the Sea," San Diego Historical Society Quarterly, January 1966, Volume 12, Number 1.

6. Christine Donovan, *Hotel del Coronado: An American Treasure with a Storybook Past*, (Hotel del Coronado Heritage Department, 2006), p. 6.

7. Ibid., p. 12.

8. Donald Langmead, *Icons of American Architecture: From the Alamo to the World Trade Center* (Greenwood Publishing Group, 2009), p. 244.

9. Donovan, p. 10.

10. Ibid.

11. "A Sage Discovery," *San Diego Union*, January 1, 1888.

12. "Suburban Cities," *San Diego Union*, January 25, 1888.

13. Donovan, p. 11.

14. "Suburban Cities," *San Diego Union*, February 4, 1888.

15. Advertisement, *Daily San Diegan*, January 30, 1888.

16. A plaque can still be found inside the Hotel del Coronado.

17. Ross MacTaggart, *Millionaires, Mansions, and Motor Yachts: An Era of Opulence* (W.W. Norton & Co., 2004), p. 81.

18. Richard W. Crawford, *The Way We Were in San Diego* (The History Press, 2011), p. 32.

19. "A Gorgeous Oregon Liar," *San Diego Union*, March 14, 1889.

20. "Half a Million," *San Diego Union*, July 27, 1889.

21. "Coronado Saloon Keeper Keeps City Separate," *Lodi News-Sentinel*, February 7, 1969.

22. "Coronado Beach," *San Diego Union*, January 1, 1894.

23. Lewis Publishing Company, *An Illustrated History of Southern California: Embracing the Counties of San Diego, San Bernardino, Los Angeles and Orange, and the Peninsula of Lower California* (Chicago: Lewis Publishing Company, 1890), pp. 124-125.

24. J.W. Sefton, "One of City's Self Made Men, Is Dead," *San Diego Union*, March 26, 1908.

25. "Mr. Spreckels' Views," *San Diego Union*, January 12, 1896.

26. "Stupid Falsehood Exposed," *San Diego Union,* October 19, 1897.

27. "The Tent City Beside the Pacific," *San Diego Union*, April 19, 1900.

28. Charles F. Lummis, *The Land of Sunshine: A Southern California Magazine*, Vol. 13 (Land of Sunshine Press, 1900), p. 480.

29. "Improvements at Hotel del Coronado," *San Diego Union*, November 13, 1902.

30. "Schonewald Takes Place of E. Babcock," *Riverside Independent Enterprise*, August 31, 1903.

31. "Coronado 'Monkey King' Is Deposed," *San Diego Union*, April 13, 1916.

32. Cecil C. Moyer, "When Cattle Roamed North Island," *San Diego Union*, July 21, 1968.

33. Benjamin Sacks, "The Duchess of Windsor and the Coronado Legend, Part 1," *Journal of San Diego History* (San Diego Historical Society Quarterly, Fall 1987, Volume 33, Number 4).

34. "J.D. Spreckels Estate Valued at $15,111,854," *San Diego Union*, July 6, 1929.

35. "Campione Must Leave Coast," *San Diego Union*, October 29, 1942.

36. "N.Y. Man Buys Coronado Hotel," *San Diego Union*, January 22, 1948.

37. "Hotel Del Coronado Sold in Quick Deal," *San Diego Union*, April 1, 1948.

38. "Hotel Del Coronado Orders End to 'Display Guests,'" *San Diego Union*, April 16, 1948.

39. Ormsby, 1966.

40. Edwin Martin, "Waiting for Marilyn," *San Diego Union*, September 21, 1958.

41. "4 Presidents Stayed at Hotel Del," *San Diego Union*, May 22, 1960.

42. Michael Neill, Arky Gonzalez, "San Diego's Stately Del Coronado Hotel Is 100, and the Star-Studded Old Girl Never Looked Splashier," *People Magazine*, March 21, 1988.

43. Ibid.

44. Roger Vincent, "Lowe to Sell Hotel del Coronado," *Los Angeles Times*, October 18, 2003.

45. Ibid.

46. Eileen Jackson, "Posada-Pinata Party Attracts 2,000 Guests," *San Diego Union*, December 22, 1961.

47. Jeannette Branin, "She's Haunted by the Fear of a Tardy Shipment," *San Diego Union*, November 26, 1977.

48. Ibid.

49. Greg Bear, "Spiritless Night in Room 502," *San Diego Union*, October 31, 1979.

50. Kathryn Phillips, "A Ghost of a Chance," *San Diego Union*, October 28, 1981.

51. Antoinette May, *Haunted Houses of California* (Wide World Publishing/Tetra, 2011), p.265.

52. Tom Blair, "Sunday's Sundries," May 15, 1983.

53. Christine Donovan, *Beautiful Stranger: The Ghost of Kate Morgan and the Hotel del Coronado* (Hotel del Coronado Heritage Department, 2001), p. 95.

54. Richard L. Carrico, *San Diego's Spirits: Ghosts and Hauntings in America's Southwest Corner* (Recuerdos Press, 1991), p. 29.

55. Alan M. May credits Carrico for being the first person to link Morgan to the Hotel del Coronado's hauntings, specifically citing the *San Diego Home and Garden Magazine* article. See Alan M. May, *The Legend of Kate Morgan: The Hunt for the Haunt of the Hotel del Coronado*, (Elk Publishing, 1990), p. 15.

56. Donovan, p. 8. This book contains the entire transcript of the coroner's inquest into the death of Kate Morgan.

57. "By Her Own Hand. A Young Woman, Suffering from Incurable Disease, Suicides," *San Diego Union*, November 30, 1892.

58. Ibid.

59. Ibid.

60. Ibid.

61. Lauren Donoho, "Kate Morgan: Her Life and Death," www.hoteldel.com/PressReleaseTemplate.aspx?id=520

62. "A Probable Theory. What a San Diego Physician Thinks About the Suicide," *San Diego Union*, December 8, 1892.

63. "The Beautiful Stranger. Love Troubles Doubtless Killed Her, But Who Is She?" *San Diego Union*, December 2,892.

64. "Identified. Mrs. Lottie A. Bernard was Lizzie Wyllie of Detroit," *San Diego Union*, December 4, 1892.

65. "Not Yet Fully Determined: The Coronado Suicide's Identity Still a Matter of Conjecture," *San Diego Union*, December 7, 1892.

66. "Identified. Mrs. Lottie A. Bernard was Lizzie Wyllie of Detroit," *San Diego Union*, December 4, 1892.

67. "Not Yet Fully Determined: The Coronado Suicide's Identity Still a Matter of Conjecture," San Diego *Union*, December 7, 1892.

68. "A Mystery Solved," *Los Angeles Times*, December 8, 1892.

69. "The Coronado Suicide," *Los Angeles Times*, December 9, 1892.

70. "Not the Coronado Woman," *Los Angeles Herald*, December 9, 1892.

71. "The Coronado Suicide," *Los Angeles Times*, December 9, 1892.

72. "The Facts Unfolding: Further Information as to the Identity of the Coronado Suicide," *San Diego Union*, December 11, 1892.

73. "He Owns Her: The Grandfather of the Unfortunate Suicide Will Bury Her," *San Diego Union*, December 12, 1892.

74. "The Coronado Suicide. Her Identity as Kate Morgan is Fully Established – Farmer's Letter," *Los Angeles Times*, December 14, 1892.

75. Jonathan Gaw, "Ghost Story: Solving a Hotel Del Legend Becomes an Obsession," *Los Angeles Times*, December 17, 1989.

76. May, pp. 12-14.

77. May, pp. 40, 45.

78. May, p. 69.

79. Ibid., p. 119.

80. Ibid., p. 70.

81. Ibid., p. 142.

82. May, p. 168.

83. Robin Mead, *Haunted Hotels* (Rutledge Hill Press, 1995), pp. 22-23.

84. Diane Hunter, "The Secret of Room 3502," *Orange Coast Magazine*, October 1990, 119.

85. Carrico, p. 32.

86. Gail White, *Haunted San Diego* (Tecolote Publications, 1992), p. 25.

87. Ibid., p. 26.

88. Dennis William Hauck, *Haunted Places: The National Directory: Ghostly Abodes, Sacred Sites, UFO Landings and Other Supernatural Locations* (Penguin Books, 2002), p. 67.

89. Cecilia Rasmussen, "A Historic Ghost Story Wrapped in an Enigma," *Los Angeles Times*, March 2, 2003.

90. John T. Cullen, *Dead Move: Kate Morgan and the Haunting Mystery of Coronado* (Clocktower Books, 2008).

91. Sandra Faleris, "Hotel del Coronado's ghost story," Examiner.com, October 29, 2011.

92. Robin Mead, *Haunted Hotels* (Rutledge Hill Press, 1995), p. 23.

93. Sharon Whitley, "ICONS: The Haunt of the Hotel Del," *Los Angeles Times*, January 3, 1993.

94. *Haunted Hotels, Episode 102: If Walls Could Speak*, Authentic Entertainment, originally aired November 26, 2002.

95. Ibid.

96. Donovan, pp. 91-92.

97. Author's conversation with a hotel security guard, December, 2010.

98. Donovan, p. 96.

99. YouTube interview between Katy Lewis and Cecilia titled, Hotel Del Coronado 1888 Ghost stories with employee, uploaded on August 30, 2011. http://www.youtube.com/watch?v=C8BBj5G9O2w

100. Author's interview with a security employee.

101. Donovan, pp. 96-97.

102. Ibid., p. 97.

103. Ibid., p. 97.

104. "Death of William Mann," *San Diego Union*, August 5, 1890.

105. "A Sudden Death," *San Diego Union*, October 25, 1890; Obituary, *New York Tribune*, October 27, 1890.

106. "His Work Finished," "Local Intelligence," *San Diego Union*, March 2, 1893.

107. "Jesse Seligman Dead," *Worcester Daily Spy*, April 24, 1894.

108. "Coronado Notes," *San Diego Union,* March 19, 1896.

109. "Merchant Donaldson Dead," *Bismark Tribune*, January 31, 1899.

110. "Died at Coronado," *San Diego Union*, August 24, 1899.

111. "Died of Apoplexy," *San Diego Union*, March 15, 1900.

112. "San Diego's Death List Swollen Yesterday," *San Diego Union*, March 14, 1902.

113. "Roland Reed's Widow Isadore Rush Dead," *Rockford Republic*, November 15, 1904.

114. "Member of Rich Colorado Springs Family a Suicide," *Denver Rocky Mountain News*, May 1, 1907.

115. "Nephew of Lord Clive Found Dead on Rocks of Coronado Sea Wall," *San Diego Union*, March 31, 1908; "Coroner's Jury Says Clive Met Death by His Own Hand," *San Diego Union*, April 1, 1908; "Inventive Genius Cut Short by Clive's Death," *San Diego Union*, June 25, 1908.

116. "Ex. Gov. Murphy of Arizona Dies Suddenly," *San Diego Union*, August 23, 1908.

117. "Death Calls to Woman on Beach," *San Diego Union*, June 18, 1912.

118. "Sir William Whyte, Canadian Millionaire Railroad Magnate, Dies at Hotel del Coronado," *San Diego Union,* April 15, 1914.

119. "Veteran to be Buried with Military Honors," *San Diego Union*, April 9, 1915. "Retired Army Officer Leaves Widow $65,000," *San Diego Union*, April 15, 1915.

120. "Murder is Committed in Kitchen of Hotel," *Riverside Daily Press*, May 17, 1919.

121. "Golfer Drops Dead on Coronado Links; Visitor from Boston," *San Diego Union*, February 23, 1922.

122. "Authorities Investigate Death," *San Diego Union*, November 17, 1925; "Believe Officer Murder Victim," *Trenton Evening News*, November 19, 1925; "Will Delve into Green Tragedy," *San Diego Evening Tribune*, February 25, 1926.

123. "Coronado Murder Victim Declared Nevada Contractor," *San Diego Union*, May 26, 1926; "Nevada Contractor Believed Victim in Coronado Slaying," *San Diego Evening Tribune*, May 26, 1926.

124. "Youth Drowns in Tide Current," *San Diego Union*, June 27, 1929.

125. "Veteran Hotel Man Called by Death," *San Diego Evening Tribune*, September 6, 1933.

126. "Visitor Fatally Stricken," *San Diego Union*, July 27, 1934.

127. "L.A. Man Expires on Coronado Visit," *San Diego Evening Tribune*, December 31, 1934.

128. "Santa Fe Official Dies in Coronado," *San Diego Union*, February 13, 1943.

129. "Police Search Beach for Drowning Victim," *San Diego Union*, September 8, 1943.

130. "Helen K. Mabie of Bay Village Dies, *Cleveland Plain Dealer*, March 24, 1948.

131. Driver Implicates Self: Hit-Run Death Suspect Held in Jail," *San Diego Union*, April 2, 1950.

132. "Services Set Friday for George Burke," *San Diego Union*, January 1, 1952.

133. "Visitor Dies in Coronado," *San Diego Union*, July 26, 1959.

134. "Speaker Dies After Talk at CATV Parley," *San Diego Union*, November 6, 1970.

135. "San Diego Obituaries: Claude Webb Is Dead; Rose from Waiter to Hotel Del Vice President," *San Diego Union*, December 3, 1982.

CHAPTER 2: THE VICTORIAN ROSE

1. E.M. Sheridan, *History of Santa Barbara, San Luis Obispo and Ventura Counties California*. (Chicago: Lewis Publishing Company, 1917). Also cited by the Historic Research Group, *Historic Resources Survey Update, City of Ventura County, Downtown Specific Plan Area*, April 2007, p. 34.

2. Brenda Loree, "Undergoing a Conversion," *Los Angeles Times*, January 19, 1998.

3. Historical archive of Richard and Nona Bogatch.

4. Ibid.

5. Ibid.

6. Ibid.

7. Ibid.

8. "Prayed for Murder," *Riverside Daily Press*, September 2, 1903.

9. "W.C.T.U. Vs. Preacher," *Los Angeles Times*, September 3, 1903.

10. Historical archive of Richard and Nona Bogatch.

11. "Methodists, Baptists Move As Historic Site Sold," *Ventura County Star-Free Press*, September 6, 1958.

12. Lyn Klodt, "Antiques and brides find a unique setting," *Thousand Oaks News-Chronicle*, August 26, 1979.

13. Ibid.

14. Leo Smith, "Historic Victorian Rose Bed and Breakfast Blooms in Ventura," *Los Angeles Times*, June 22, 1999.

15. Author's interview with Nona Bogatch, April 9, 2014.

16. Alexis Kindig, "Landmark bed and breakfast presents California history with down home style," *Ventura County Star*, October 12, 2008.

17. Alicia Doyle, "For Teri and Doug Kierbel, A Place of Peace is a vision come true," *Ventura County Star*, June 7, 2009.

18. Author's interview with Nona Bogatch, April 14, 2014.

19. Ibid.

20. *Haunted Hotels*, Episode 102: "If Walls Could Speak" (Authentic Entertainment), aired on the Travel Channel on November 26, 2002.

21. Author's interview with Nona Bogatch, April 14, 2014.

22. Ibid.

23. Richard Senate, "Haunted Church Becomes a Bed and Breakfast," *Ojai and Ventura Voice*, October, 2001.

24. Richard Senate, *Ghosts of Ventura* (Del Sol Publications, 2004), p. 53.

25. Author's interview with Nona Bogatch, April 9, 2014.

26. Robert and Anne Wlodarski, *California Hauntspitality* (Whitechapel Productions Press Publication, 2002), p. 200.

27. *Haunted Hotels*, Episode 102: "If Walls Could Speak," November 26, 2002.

28. Author's interview with Nona Bogatch, in which this was mentioned more than once.

29. Rick Nielsen, "County's 'Most Brutal' Murder Still Unsolved," *Oxnard Press Courier*, May 30, 1976.

30. Ibid.

31. Ibid.

32. Leslie Rule, *Ghosts Among Us* (Andrews McMeel Publishing, 2004), p. 214.

33. Ibid., p. 217.

34. Rob Wlodarski, *Victorian Rose Bed & Breakfast*, a file folder found on his Facebook page (accessed May 8, 2014).

35. Author's interview with Nona Bogatch, April 14, 2014.

36. Author's interview with Bill and Shannon Jeralds, April 9, 2014.

37. Ibid.

38. Ibid.

39. Ibid.

40. Author's visit to A Place of Peace in November of 2009.

41. Author's interview with Nona Bogatch on April 9, 2014.

42. Stacey Wiebe, "A rose by any other name," *Ventura County Recorder*, December 21, 2006.

CHAPTER 3: JULIAN GOLD RUSH HOTEL

1. According to Julian historian David Lewis, the *San Diego Union* suggested in March 1870 that Fred Coleman had discovered gold in early 1870.

2. "San Diego Gold Excitement," *San Francisco Chronicle*, March 9, 1870.

3. "Mysterious Murder at Julian," *San Diego Union*, February 1, 1873.

4. *Great Register of San Diego County in 1872*, p. 42.

5. Robert L. Carlton, "Blacks in San Diego County: A Social Profile, 1850-1880," *The Journal of San Diego History* (Fall 1975, Vol. 21, No. 4).

6. "Neighborhood Notes," *San Diego Union*, December 12, 1887.

7. "County Improvement Notes," *San Diego Union*, June 29, 1891.

8. "Real Estate Transfers," *San Diego Union*, May 31, 1894.

9. "Real Estate Transfers," *San Diego Union*, September 21, 1894. The person who sold the Robinsons the lot was R. Gardiner.

10. "Impressions of Julian," *San Diego Union*, April 24, 1902.

11. "Local Notes," *San Diego Evening Tribune*, June 9, 1902.

12. "Real Estate Transfers," *San Diego Evening Tribune*, June 3, 1902.

13. Scott Theodore Barnes, Alice Genevieve Barnes, *Gold Mines and Apple Pie* (Scott Theodore Barnes, 1999), p. 99.

14. Paula Parker, "Heyday of Julian Hotel," *Los Angeles Times*, February 3, 1980.

15. Ibid.

16. *Great Register of San Diego County in 1892*, p. 84.

17. The Julian Gold Rush Hotel website: http://www.julianhotel.com/html/julian-ca-history.asp (accessed Feb. 25, 2014).

18. Author's correspondence with David Lewis, May 24, 2015.

19. Classified ad, *San Diego Union*, July 11, 1906.

20. Parker, February 3, 1980.

21. "Lectured the Julian Men," *San Diego Union*, February 22, 1906.

22. "Have Responded Generously," *San Diego Union*, April 24, 1906.

23. "Jury Disagrees," *San Diego Union*, August 8, 1906.

24. Parker, February 3, 1980.

25. The Julian Gold Rush Hotel website: http://www.julianhotel.com/html/julian-ca-history.asp (accessed Feb. 25, 2014).

26. "Real Estate Transfers," *San Diego Union*, May 13, 1920.

27. In the *San Diego Weekly Union* (June 2, 1898, p. 28) there is a notice of a person named M. Jacoby (which could be Martin Jacobs) connected with "Julian lots, 1 to 5, block 15, real estate $140," which later became the site of the Robinson Hotel.

28. Barnes, p. 99.

29. There is a tax listing for Susan Tull's Julian property in the *San Diego Weekly Union*, (June 9, 1921, p. 30.) The fact that her name is still on land deeds 21 years after her death suggests that her estate did not go through probate and was probably paid by Margaret. The disappearance of Tull's tax listing after 1921 also coincides with Margaret Robinson's disappearance from Julian.

30. The first Julian Hotel, originally owned by George and Katherine Hoskings, burned down in 1900.

31. Roy Campbell, "Column Comments," *San Diego Evening Tribune*, June 19, 1923.

32. Barnes, p. 98.

33. "Weight of Snow Caves in Roofs of 3 Buildings," *San Diego Union*, January 13, 1930.

34. "Hotel at Julian Popular with Fisherman," *San Diego Union*, June 13, 1937.

35. "Cabins Available," *San Diego Union*, June 12, 1938.

36. "Name Appropriate," *San Diego Union*, June 12, 1940.

37. "Hotel 60 Years Old," *San Diego Union*, September 15, 1946.

38. Advertisement, *San Diego Union*, September 28, 1946. By November, the word "Gra," an archaic word that meant "dear or darling," was dropped.

39. Craig MacDonald, "Hostelries Have Room for Many Fond Memories," *San Diego Union*, October 19, 1975.

40. Mark Briant, "The Julian Hotel: Where every room has a view of the past," *San Diego Union*, January 26, 1978.

41. Ibid.

42. MacDonald, October 19, 1975.

43. Briant, "The Julian Hotel," January 26, 1978.

44. Parker, February 3, 1980.

45. Kathryn Phillips, "Haunted Houses Here? A Ghost of a Chance," *San Diego Union*, October 28, 1981.

46. Richard L. Carrico, *San Diego's Spirits: Ghosts and Hauntings* (Recuerdos Press, 1991), p. 86-87.

47. Ibid., p. 87.

48. Ibid., p. 88.

49. Ibid., p. 89.

50. Gail White, *Haunted San Diego: A Historic Guide to San Diego's Favorite Haunts* (Tecolote Press, 4th Printing, 1996), p. 100.

51. Ibid.

52. Dennis William Hauck, *The National Directory: Haunted Places: Ghostly abodes, sacred sites, UFO landings, and other supernatural locations* (Penguin, 1996), pp. 67-68.

53. White, p. 101.

54. Author's correspondence with David Lewis, May 24, 2015.

55. Ibid.

56. "Black Pioneers To Be Honored With Plaque Dedication," *The Julian News*, December 14, 2005.

57. John Berhman, "Fall's Crisp Air Brings Back Julian Apple Days," *San Diego Union*, September 22, 1970.

CHAPTER 4: MISSION INN

1. Elmer Wallace Holmes. *History of Riverside County, California: With Biographical Sketches of the Leading Men and Women of the County who Have Been Identified with Its Growth and Development from the Early Days to the Present* (Historic Record Company, 1912), p. 28

2. http://evergreen-cemetery.info/people/eliza-tibbets/ [Accessed September 12, 2014].

3. News from the Inn-Spector, "The Miller Acquisition of the Mission Inn Lot," http://www.missioninnmuseum.com/docents/Miller%20buys%20the%20lot.pdf (Accessed September 11, 2014).

4. Steve Lech and Kim Jarrell Johnson, *Riverside's Mission Inn* (Arcadia Press, 2006), p. 7.

5. "Town and Valley," *Riverside Press and Horticulturist*, December 21, 1878.

6. Maurice Hogden, *The Master of the Mission Inn* (CreateSpace Independent Publishing, 2014), p. 53.

7. Ibid., p. 53.

8. "Town and Valley," *Riverside Press and Horticulturist*, January 13, 1883.

9. Hogden, p. 69.

10. *Riverside Press and Horticulturist*, June 20, 1885.

11. Hogden, pp. 70-72.

12. *Riverside Press and Horticulturist*, January 7, 1888.

13. Hogden, pp. 75-76.

14. "A Hearty Welcome," *Riverside Daily Press*, April 24, 1891.

15. Mark Gutglueck, "Albert White: Capable and Accomplished Founder of Riverside County & Traitor to San Bernardino County," *San Bernardino County Sentinel*, September 26, 2014.

16. Hogden, pp. 81-84.

17. "The New Glenwood," *Riverside Daily Press*, January 1, 1897.

18. "A Name Wanted," *Riverside Daily Press,* December 27, 1897.

19. "Improving the Glenwood," *Riverside Daily Press*, October 11, 1898.

20. "Glenwood's Close Call," *Riverside Daily Press*, January 18, 1900.

21. "Riverside's Pride," *Riverside Daily Press*, July 18, 1901.

22. The Millers named the macaw after the Biblical character Joseph because of its multi-colored plumage.

23. "He Received an Ancient Chime of Mission Bells," *Riverside Independent Enterprise*, February 16, 1902.

24. "Tourist Hotels Are Coming in Pairs," *Riverside Daily Press*, March 21, 1902.

25. Hogden, pp. 113-116.

26. Ibid., p. 119.

27. "The New Glenwood Throws Its Doors Open to the Public," *Riverside Independent Enterprise*, January 23, 1903.

28. Hogden, p. 125.

29. http://www.shermanindianmuseum.org/history3.htm [Accessed September 12, 2014].

30. Bettye Miller, "New Book Recounts History of Sherman Institute," *UCR/Today*, November 29, 2012.

31. Hogden, p. 133.

32. "Trampled to death by wild elephant," *Riverside Daily News*, April 17, 1908.

33. "Owner of Famous Mission Inn Much Taken By Highway," *Oregon Daily Journal*, August 10, 1919.

34. "Laid to Rest at Sunset," *Riverside Enterprise*, July 26, 1908.

35. *The Mission Play* was completed in 1911, but was too "epic" (i.e., over-large) to be performed on Mt. Rubidoux or in the Mission Inn's Cloister Music Room. Miller, Huntington, oil tycoon Edward Doheny, and *Los Angeles Times* owner Harry Chandler bankrolled a staging in 1912 near the San Gabriel Mission. It became such a major cultural event in Southern California that playwright McGroarty hired Arthur Benton to build a California Mission-style theater next door to the Mission San Gabriel.

36. Zona Gale, *Frank Miller of Mission Inn* (New York: D. Appleton-Century Company, 1938).

37. Hogden, p. 71.

38. "Preparing for Dramatics," *Riverside Daily News*, October 24, 1913

39. "King of Comedians Visits Riverside," *Riverside Independent Enterprise*, January 22, 1917.

40. "Last Section of Trey O' Hearts," *Daily Illinois State Register*, November 12, 1914.

41. "Scenes Taken in Riverside," *Riverside Independent Enterprise*, May 4, 1917.

42. Oliver Underwood, "President Wilson in City," *Riverside Independent Enterprise*, January 3, 1919.

43. "Willard Coming to Riverside Sunday Night," *Riverside Independent Enterprise*, May 16, 1919.

44. Charles Conway Palmer, *Preserving the past and planning the future in Pasadena, Riverside and San Bernardino* (University of Nevada Las Vegas, 2010), p. 146.

45. "Charles Mack Dead in Crash," *San Francisco Chronicle*, March 18, 1927.

46. "'Riverside News' Made Defendant in Criminal Libel Suit Filed Today," *Riverside Daily Press,* December 15, 1928.

47. Untitled article, *Riverside Daily Press,* February 26, 1929.

48. "Dighton Responsible for 'News' Dilemma,'" *Riverside Daily Press*, January 31, 1929.

49. "Film Actress Marries Lawyer," *Los Angeles Times*, September 4, 1931.

50. "What the Hustling Reporter Saw Today," *Riverside Daily Press*, August 18, 1931.

51. "Group to serve 10-year period," *Riverside Daily Press*, June 19, 1935.

52. Ibid.

53. "Mission Inn Elects Head; Mrs. Frank Miller Made President," *Riverside Daily Press*, May 20, 1936.

54. Lucille Lewis Dugan, "Vacation Time Comes For Alice Richardson," *Riverside Daily Press*, August 24, 1938.

55. "Mission Inn Has $75,000 Blaze," *Riverside Daily Press*, December 30, 1943.

56. See http://evergreen-cemeteryinfo/people/allis-hardenburg--miller-hutchings/

57. Bob Stevens, "Seals Eye First Division," *San Diego Union*, March 19, 1953.

58. "S.F. Firm Buys Riverside Mission Inn," *Los Angeles Times*, May 19, 1956.

59. "Napoleon, Famed Bird of Mission Inn, Dies," *Los Angeles Times*, July 15, 1956.

60. "Man, Trapped at Fire, Gets Critical Burns," *Los Angeles Times*, August 31, 1956.

61. Donald H. Harrison, "Hotel celebrates Presidents, Einstein and Newman," *San Diego Jewish World*, July 12, 2014.

62. "Future Murky for Mission Inn," *San Diego Union*, July 13, 1969.

63. "Students Give New Life to Old Inn," *San Diego Union*, October 27, 1969.

64. Terrence M. Green, "New Era Begins for Riverside's Old Mission Inn," *Los Angeles Times*, July 8, 1973.

65. Mission Inn Syndicated to Private Investor Group," *Los Angeles Times*, January 12, 1975.

66. Wesley G. Hughes, "Riverside Seeks a New Life for Its Long-Troubled Mission Inn," *Los Angeles Times*, September 27, 1983.

67. Robert Reinhold, "Riverside Journal; New Reign For Queen Of Hotels In West?" *New York Times*, January 16, 1990.

68. Louis Sahugan, "Historic Mission Inn Prepares to Open After $40-Million, 3 1/2-Year Renovation," *Los Angeles Times*, November 26, 1988.

69. "Loan Denial Halts Restoration Work on Old Mission Inn," *Los Angeles Times*, November 26, 1988.

70. Megan Huard, "Mission Possible," *Pepperdine People Magazine* (n.d.).

71. Ibid.

72. Sharon Tetrault, "His Big Mission," *Orange Coast Magazine*, April, 2004, p. 120.

73. Notice," *Riverside Daily Press*, February 10, 1890. "Local News," *Riverside Independent Enterprise*, January 30, 1894.

74. "Funeral of Captain Blundell," *Riverside Press and Horticulturist*, February 15, 1896. "Up and Down the Valley," *Riverside Daily Press*, September 15, 1894.

75. Obituary, *Riverside Daily Press*, February 9, 1905.

76. "No One Who Cared For Him," *San Diego Union*, May 22, 1906.

77. "Alexis Bjornsen Laid at Rest," *Riverside Independent Enterprise*, May 22, 1906.

78. Ibid.

79. "No One Who Cared For Him," *San Diego Union*. May 22, 1906.

80. "Erratic Woman Once Guest Guest [*sic.*] of Glenwood," *Riverside Daily Press*, August 27, 1908. "Woman Who Made Leap from Window Was Here in July," *Riverside Independent Enterprise*, August 27, 1908.

81. Foster apparently survived the fall with a fractured skull after landing on another roof of the building.

82. "Within Two Months Glenwood Monastery Will Be Complete," *Riverside Independent Enterprise*. November 21, 1909.

83. "Midnight Caroling Ushers in the New Year," *Riverside Independent Enterprise*, January 2, 1912.

84. "Ghost Stories Told on Mountain Top," *Riverside Daily Press*, April 24, 1913.

85. "Ghost Stories Told on Mountain Top, April 24, 1913. "Costume Party For Employees," *Riverside Daily Press*, August 18, 1913.

86. "Noted Spiritualist Coming," *Riverside Independent Enterprise*, December 11, 1913.

87. Author's interview with a former Mission Inn docent, April 2016.

88. "Internal Hemorrhage Was Cause of Death of Young Man Working on Hotel Addition," *Riverside Enterprise*, October 3, 1913.

89. "Fairmount Park Scene of Suicide," *Riverside Daily Press*, May 7, 1929.

90. Louis Sahugan, "Historic Mission Inn Prepares to Open After $40-Million, 3 1/2-Year Renovation," *Los Angeles Times*, November 26, 1988.

91.	Louis Sahugan, "Tales of Spirits and Skinny-Dippers: Inn's Ghostly Last Supper Provides Taste of History," *Los Angeles Times*, June 1, 1985.

92.	Ibid.

93.	Richard Senate, *The Ghost Stalkers Guide to Southern California* (Charon Press, 1998), pp. 10-11.

94.	"Is The Mission Inn Haunted?" http://www.insideTheIE.com/haunted-mission-inn. [Accessed September 17, 2014.]

95.	Comments section of http://paranormalstories.blogspot.com/2009/09/mission-inn-hotel.html

96.	http://www.insideTheIE.com/haunted-mission-inn. [Accessed September 17, 2004.]

CHAPTER 5: PIERPONT INN

1.	Richard Hoye, Tom Moore, Craig Walker, and the Ojai Valley Museum, *Ojai* (Arcadia Publishing, 2010), p. 54.

2.	"For New Beach Hotel," *Los Angeles Times*, April 2, 2010.

3.	"County Seat Notes," *Oxnard Daily Courier*, April 27, 1917.

4.	"County Records," *Oxnard Daily Courier*, September 26, 1919

5.	"County Records," *Oxnard Daily Courier*, September 21, 1919. "The Pierpont Inn Is Open for Business," *Oxnard Daily Courier*, September 26, 1919. "Pierpont Manager Seeking Divorce," *Oxnard Daily Courier*, January 24, 1920.

6.	County Records, *Oxnard Daily Courier*, February 10, 1920.

7.	"Ventura May Get New Hotel Soon," *Oxnard Press-Courier*, February 13, 1920.

8.	"Oxnard's Already Losing Out," *Oxnard Press-Courier*, August 2, 1920. "Incident Shows Need Here of Better Hotel Facilities," *Oxnard Press-Courier*, August 26, 1920.

9.	"Bebe Daniels Spending Vacation at Pierpont Inn," *Oxnard Press-Courier*, January 12, 1922. "Noted Film Stars Like Oxnard," *Oxnard Daily Courier*, August 5, 1922.

10.	"Winning Courtroom Author Loses Battle With Death," *Pampa Daily News*, March 15, 1970.

11.	"Ojai Hotel Man Buys Ventura Pierpont Inn," *Oxnard Daily Courier*, May 4, 1921.

12.	"$50,000 Improvements to Pierpont Inn," *Oxnard Daily Courier*, March 14, 1923.

13.	"Will Take Over Inn for County [*sic*.] Club January 1," *Oxnard Daily Courier*, October 31, 1925.

14.	"County Records," *Oxnard Press-Courier*, October 5, 1923.

15.	"Will Take Over Inn for County [*sic*.] Club January 1," *Oxnard Daily Courier*, October 31, 1925.

16.	"New Club Opened," *Oxnard Daily Courier*, April 12, 1926.

17.	"Start Construction of Pierpont Plunge," *Oxnard Daily News*, May 14, 1926.

18.	"Pierpont Beach and Country Club Members Must Pay $250 or Drop Out," *Oxnard Daily Courier*, June 12, 1928.

19.	"Pierpont Club Worth Less Than 1ˢᵗ Price," *Oxnard Daily Courier*, August 8, 1928.

20.	"$40,000 Foreclosure Suit Filed Against Pierpont Beach Club," *Oxnard Daily News*, February 8, 1929.

21.	"Fashionable Club Votes to Disband," *Los Angeles Times*, March 1, 1929. "Foreclosure Mortgage on Club Property," *Los Angeles Times*, June 28, 1929.

22.	"Pierpont Inn Bought by Gus Gleichmann," *Oxnard Daily Courier*, October 31, 1929.

23.	San Buenaventura Research Associates, *Historic Resources Report, 6135 N. Rose Avenue Saticoy, CA*, July 18, 2011, p. 4.

24.	Glenda J. Jackson, *Ventura* (Arcadia Publishing, 2005), p. 88.

25.	City of Ventura Design Review Committee Staff Report prepared by A.K. Munaim, June 10, 2009, p. 2.

26.	*CITATION 70 CAL.2D 282 Pierpont Inn, Inc. v. State of California*, Feb. 6, 1969. The year Mattie Gleichmann's house was built can be found at https://www.redfin.com/CA/Ventura/1491-Vista-Del-Mar-Dr-93001/home/4741922. "Building Permits," *Oxnard Press-Courier*, December 23, 1957. Munaim, June 10, 2009, p. 2.

27.	*CITATION 70 CAL.2D 282 Pierpont Inn, Inc. v. State of California*, Feb. 6, 1969.

28.	"Manager of the Pierpont Inn Dies," *Oxnard Press-Courier*, November 25, 1975.

29.	David Goldman. "Restaurant Review Pierpont Inn: Unlike Old Days: Ventura's Pierpont Inn used to be a hotel of quality. Now its restaurant looks out across six lanes of howling traffic," *Los Angeles Times*, February 7, 1991.

30.	Leo Smith. "Pierpont Inn Transfer Marks End of an Era, but Not Tradition," *Los Angeles Times*, November 17, 1998.

31.	Munaim, June 10, 2009, p. 2.

32.	Stephanie Hoops, "Pierpont Inn is changing hands" *Ventura County Star*, April 22, 2009.

33.	Hoops, "Ventura's Pierpont Inn undergoing change," *Ventura County Star*, July 11, 2009.

34.	Hoops, Lisa McKinnon, "Pierpont Inn owner files for Chapter 11 bankruptcy protection," *Ventura County Star*, December 12, 2011.

35.	Michael Sullivan, "Updated: The Pierpont Inn sold!" *Ventura County Reporter*, September 13, 2012.

36.	Arlene Martinez, "Pierpont Inn in Ventura faces closure if work doesn't advance," *Ventura County Star*, June 27, 2016

37.	Author's interview with Ventura historian Cynthia Thompson, September 30, 2014.

38.	Robert and Anne Wlodarski, *California Hauntspitality* (Whitechapel Productions Press Publications, 2002), p. 199.

39.	Ibid. While Wlodarski doesn't discuss specific details, Cynthia Thompson recalls Wlodarski telling the story to the crew of *Mysterious Journeys*, which then recreated the disappearing pool for their television segment.

40.	Ibid., pp. 198-9.

41.	"Ventura's Historic Pierpont Inn a Votrex [*sic*.] for Ghostly Spirits," *American Chronicle*, October 11, 2007.

42.	Wlodarski, p. 197.

43.	Ibid., p. 197-8.

44. Ibid., p. 197.

45. Ibid., pp. 197-98.

46. Antoinette May, *Haunted Houses of California* (Wide World Publishing/Tetra, 2011), p. 192.

47. Kim Lamb Gregory, "Some say friendly apparitions are inhabiting Ventura's Pierpont Inn," *Ventura County Star*, January 11, 2008.

48. May, p. 192.

49. Wlodarski, 198. May, p. 192.

50. Senate, *Ghosts of Ventura* (DelSol Publications, 2004), p. 57.

51. Wlodarski. 197.

52. Gregory, *Ventura County Star*, January 11, 2008.

53. Ibid.

54. Ibid.

55. http://www.historichotels.org/press/the-eerie-archive-great-american-ghosts

56. Wlodarski, p. 198.

57. Gregory, *Ventura County Star*, January 11, 2008.

58. Ibid.

59. Ibid.

60. Tina Vervoorn, "Ghosts in the Attic Are Hard at Work at Southern California's Pierpont Inn," *Consortium Media Services*, September 25, 2009.

61. Ibid.

62. Author's interview with T., a former Pierpont Inn manager, October 2009.

63. Vervoorn, September 25, 2009

64. Author's interview with Pierpont front desk clerk in 2012.

65. Wlodarski, pp. 198-199. A Pierpont Inn front desk clerk later confirmed in 2012 that guests staying East Wing rooms facing the Vickers Estate complained more about paranormal activity than guests staying in other parts of the East and West Wings.

CHAPTER 6: THE ALEXANDRIA HOTEL

1. Ruth Wallach, Linda McCann, Dace Taube, Claude Zachary, and Curtis C. Roseman, *Images of America: Historic Hotels of Los Angeles and Hollywood* (Arcadia Press, 2008), p. 9.

2. "Great Hotel Work Begins," *Los Angeles Times*, September 10, 1904.

3. "Stately Bow of Alexandria," *Los Angeles Times*, February 11, 1906.

4. "Alexandria, and the Men Who Made It," *Los Angeles Times*, November 12, 1905.

5. "Sad Fall of 'Titled' One," *Los Angeles Times*, November 2, 1907.

6. "Annex Site Not Leased," *Los Angeles Times*, November 4, 1909. This article was written to refute rumors that negotiations were under way before the city passed its new height limit.

7. "Raise Limit Start Work," *Los Angeles Times*, November 24, 1909.

8. "Taunts Cause Fence Barrier," *Los Angeles Times*, August 9, 1910.

9. "Labor-Union Pickets Strike Down Bearers of a Workman's Corpse," *Los Angeles Times*, September 2, 1910.

10. "Fatal Crane Chain Claims 2nd Victim," *Los Angeles Examiner*, September 3, 1910.

11. Arelo C. Sederberg, *The Dynamite Conspiracy* (Writers Club Press, 2001), p. 25.

12. "Burning Words of the Press on Dynamiting of 'The Times,'" *Los Angeles Times*, October 16, 1910. Howard Blum, *American Lightning: Terror, Mystery, the Birth of Hollywood, and the Crime of the Century* (Crown, 2008), p. 4.

13. Harry Posner, "He lived through---THE BIG PARADE of the OLD ALEXANDRIA," *Los Angeles Times*, March 11, 1934.

14. "World-Wonder Here in a Hotel Kitchen," *Los Angeles Times*, August 13, 1911. "Fairy Dream Great Salon: Elite Christen the Alexandria Annex Dining Hall; Brilliance of Appointments Delights Guests," *Los Angeles Times*, October 10, 1911.

15. "Taft Banquet Plans," *Los Angeles Times*, September 14, 1911. "A Feast of Love and a Message of Peace," *Los Angeles Times*, October 17, 1911.

16. Blum, pp. 313-315.

17. "Shades of Glorious Past Linger in Darkened Lobby of Alexandria; Notable Names Crowd Register," *San Diego Union*, February 11, 1934.

18. Posner, March 11, 1934.

19. "Cow Chases Red-Gowned Girl in Hotel De Luxe," *Los Angeles Times*, March 15, 1913.

20. Kenneth McGaffey, "Lasky's Place in Picture World," *Photo Players Weekly*, December 18, 1915.

21. Mack Sennett, *King of Comedy*, The Lively Arts Series (Mercury House, 1990), p.118.

22. Posner, March 11, 1934.

23. Many biographers cite Griffith's champagne and ice bath routine. Posner claimed that he brought the ice and a half cup of champagne every morning to Griffith's room.

24. Rufus Steele, "The New Rialto," *Sunset: The Magazine of the Pacific and of All the Far West*, Volume 34, (January-June, 1915), p. 905.

25. Posner, March 11, 1934.

26. "Lodge Dinner Given to Movie Directors," *Photoplayers Weekly*, October 2, 1915.

27. Budd Schulberg, *Moving Pictures: Memories of a Hollywood Prince* (Ivan R. Dee, 2003), p. 90.

28. Posner, March 11, 1934.

29. Eric Malnic, "Universal City Rose on Egg Farm," *Los Angeles Times*, April 5, 1965.

30. See http://clkrep.lacity.org/onlinedocs/2013/13-1075_rpt_plan_8-12-13.pdf

31. "Film Stars Will Wed at Inn Today," *Riverside Independent Enterprise*, May 5, 1918.

32. Emily W. Leider, *Dark Lover* (Faber & Faber, Inc., 2004), p.84.

32. Allan R. Ellenberger, *Ramon Novarro: A Biography of the Silent Film Idol, 1899-1968* (McFarland, reprint edition, 2009), p.18.

34. Charles Chaplin, *My Autobiography*, (Melville House Publishing, 2003), p. 183.

35. "Women Are Bad Gamblers," *Greensboro Record*, September 3, 1966.

36. Schulberg, p. 92.

37. Ibid., pp. 91-2.

38. Charles Chaplin, *My Autobiography*, p. 220.

39. Cal York, "Plays and Players," *Photoplay Magazine*, April 1919, p. 86.

40. "Million-Dollar Rug Gone: Who Took It?" *Los Angeles Times*, April 27, 1919.

41. "Jimmie Fiddler in Hollywood," *Baton Rouge State Times Advocate*, January 1, 1938. "Alexandria Changes," *Los Angeles Times*, January 16, 1920.

42. Jane Frederickson, "Entertaining the Presidents," *Los Angeles Times*, March 23, 1930.

43. Grace Kingsley, "Film Folks Dance Impeccably," *Los Angeles Times*, December 1, 1919.

44. "Great Hotel Deal Closed," *Los Angeles Times*, April 5, 1919.

45. "Ten Great Hotels Are Involved in Transfer," *Los Angeles Times*, December 1, 1919.

46. "To Improve Alexandria," *Los Angeles Times*, January 9, 1920.

47. "Chaplin in Fist Fight," *Los Angeles Times*, April 8, 1920. "Feet vs. Fists. Chaplin's Feet on Job Again," *Los Angeles Times*, April 9, 1920. Scott Eyman, *Lion of Hollywood: The Life and Legend of Louis B. Mayer* (Simon and Schuster, 2012), p. 60. David Robinson. *Chaplin: His Life and Art* (DaCapo Press, 1994), p. 260.

48. Schulberg, p. 93.

49. Campbell James, "Where the Players Play," *Motion Picture Magazine*, September 20, 1920, p. 106.

50. Herbert Howe, "Main Street, Hollywood," *Motion Picture Magazine*, March 1922, p. 28.

51. Bob Thomas, "Douglas Fairbanks Jr. Returns as Civic Light Opera's Higgins," *Long Beach Independent*, May 30, 1969.

52. "Loungers Find New Haven," *Los Angeles Times*, October 10, 1923.

53. "Girl Still Haunts Chaplin," *Los Angeles Times*, April 5, 1923. Posner, March 11, 1934.

54. "Noted Hotel and Its New Owner," *Los Angeles Times*, May 9, 1927. "Millions Paid for Hostelry," *Los Angeles Times*, July 5, 1930

55. "Millions Paid for Hostelry," *Los Angeles Times*, July 5, 1930.

56. "Alexandria Bond Group Will Meet," *Los Angeles Times*, December 2, 1932.

57. Jim Murray, "The Immortal Blood," *Victoria Advocate*, July, 11, 1972. See also Denis J. Gullickson, *Vagabond Halfback: The Life and Times of Johnny Blood McNally* (Big Earth Publishing, 2006), pp. 106-107.

58. Posner, March 11, 1934.

59. "Receiver Named for Alexandria Leaseholders," *Los Angeles Times*, September 23, 1933.

60. "Alexandria Will Close," *Los Angeles Times*, February 1, 1934.

61. "Ghosts of Hostelrie's Past Grace Farewell Gathering of Staff," *Los Angeles Times*, February 2, 1934. Posner, March 11, 1934.

62. Last Guests Leave Famous Hostelry," *Los Angeles Times*, February 7, 1934.

63. Anthony Slide, *D. W. Griffith: Interviews* (University Press of Mississippi, 2012), p. 216.

64. "Alexandria Will Close," *Los Angeles Times*, February 1, 1934. "Alexandria Hotel's Opening Planned in Near Future," *Los Angeles Times*, September 5, 1937.

65. "Hotel Work Progressing," *Los Angeles Times*, July 24, 1938.

66. "Downtown Building Bought," *Los Angeles Times*, June 12, 1938. Apparently, William Chick and G.H. Pinney, listed as owners in 1934, were not a part of this sale.

67. Roger Vincent, "In downtown L.A., sealed-off hotel rooms offer peek into the past," *Los Angeles Times*, October 27, 2012. Ray Herbert, "She Won't Give Up the Ghost," *Los Angeles Times*, April 7, 1980.

68. "Alexandria Hotel Changes Hands," *Los Angeles Times*, September 18, 1946. "Lobby Will Match New Hotel Mart," *Los Angeles Times*, August 22, 1954.

69. Charles C. Cohan, "New Chapter Begins in Noted Hotel's History," *Los Angeles Times*, May 5, 1957.

70. Al Wolf, "Sportraits: Ballroom Novel Training Camp," *Los Angeles Times*, January 24, 1960. "Sports in Brief," *Los Angeles Times*, March 3, 1958.

71. Dwight Chapin, "The Alexandria: Bantamweights Take Over a Proud, Old Hotel," *Los Angeles Times*, August 19, 1968.

72. Mary Murphy, "Old Days Relived: Silent Stars Talk Nostalgia," *Los Angeles Times*, April 14, 1972.

73. Terrence M. Green, "Alexandria Changes Owners," *Los Angeles Times*, June 22, 1975.

74. Ray Herbert, "She Won't Give Up the Ghost," *Los Angeles Times*, April 7, 1980.

75. Ronald L. Soble, "The Alexandria Targeted by City as Worst Drug Trafficking Spot," *Los Angeles Times*, April 12, 1988.

76. Ronald L. Soble, "Smoking Out the Coke Trade," *Los Angeles Times*, April 18, 1988.

77. Gina Piccalo, "At the corner of Have and Have-not," *Los Angeles Times*, May 22, 2005.

78. Carol J. Williams, "$1 million for hotel tenants; Developers and L.A., accused of harassing residents, settle suit," *Los Angeles Times*, February 13, 2009.

79. Ryan Vaillancourt, "The Central City Crime Report: A Rundown on Downtown Incidents, Trends and Criminal Oddities," *Los Angeles Downtown News*, January 18, 2013.

80. Eddie Kim, "Developer Shomof Buys Alexandria, Plans Renovation and New Businesses," *Los Angeles Downtown News*, September 23, 2013.

81. "Ghosts of Hostelrie's Past Grace Farewell Gathering of Staff," *Los Angeles Times*, February 2, 1934. By most other accounts, the Imperial Suite was actually on the eighth floor.

82. "Woman, 41, Hurt by Man's Death Plunge," *Los Angeles Times*, December 13, 1961.

83. Turnley Walker, "A Fighter's Friend, Is Home Again," *Los Angeles Times*, November 23, 1969.

84. Laurie Jacobson and Marc Wannamaker, *Hollywood Haunted: A Ghostly Tour of Filmland* (Angel City Press, 1999), pp.107-111.

85. Derek Acorah, *The Psychic Adventures of Derek Acorah* (Lewellyn Publications, 2008), p. 13.

86. Janet Zimmerman, "Spirits Among Us," *San Bernardino Sun*, October 26, 1997.

87. Michael Quintanilla, "Hunting for a Haunting," *Los Angeles Times*, October 30, 1998.

88. Gina Piccalo, "A colorful bastion of L.A.'s lore," *Los Angeles Times*, May 22, 2005. Quintanilla, "Hunting for a Haunting."

89. Nicole Kristal, "America's Most Haunted," *Premiere Magazine*, November, 2001.

90. "Man Jumps to Death from Alexandria Hotel in Downtown L.A." LAist http://laist.com/2013/08/05/man_jumped_to_death_from_alexandria.php (Accessed September 19, 2014).

91. Colin Reid, "Ghostly grounds: Locations around Los Angeles offer spooks and scares," *Daily Bruin*, October 12, 2012.

92. Author's correspondence with Alexis Justman, July 31, 2016.

93. "Leg Crushed, Changes It and Resumes Work," *Trenton Evening Times*, January 29, 1916.

94. "Mystic Death Cycle of Three Complete," Los Angeles Times, March 19, 1913.

95. "Ends Misery As Desired," *Los Angeles Times*, May 28, 1915.

96. Ibid.

97. "Jilted S.F. Woman a Suicide," *San Francisco Chronicle*, May 28, 1915.

98. "Suicide Leads to Women's Arrest," *San Francisco Chronicle*, May 30, 1915.

99. Ibid.

100. "$250,000 Love Suit Crushed by Court," Oakland Tribune, June 25, 1915. "Damage Suit Collapses; Branded as Frame-Up," *San Francisco Chronicle*, June 25, 1915.

101. "Sudden Death of Financier," *Los Angeles Times*, February 5, 1916. "Isidore G. Fleischman Dies of Heart Attack," *Los Angeles Times*, March 9, 1918.

102. "Tired of Life, Kills Herself," *Los Angeles Times*, July 31, 1918.

103. "Dies Without Telling Story," *Los Angeles Times*, December 12, 1919. "Albee Smith Falls To His Death Out Of Hotel Window," *Oregon Daily Journal*, December 12, 1919.

104. "Air Hero is a Suicide Over Break with Wife," *New York World*, December 19, 1920.

105. "Lieut. Pat O'Brien Suicides," *Lowell Tribune*, December 22, 1920.

106. "Air Hero is a Suicide Over Break with Wife," *New York World*, December 19, 1920. "Confirms O'Brien's Suicide." *New York World*, December 24, 1920.

107. "Believe Woman Ended Own Life," *Los Angeles Times*, July 6, 1922.

108. "Youth of Hillsboro Proves to be Suicide," *Oregon Daily Journal*, November 28, 1922.

109. "Poison Death Baffles Police," *Los Angeles Times*, November 28, 1922. "Poison Mystery is Only Suicide. Elaborate Death Plot is Made by V. E. Boge," *Portland Oregonian*, November 29, 1922.

THE WYNDAM GARDEN PIERPONT INN

1. Richard Hoye, Tom Moore, Craig Walker, and the Ojai Valley Museum, Ojai (Arcadia Publishing, 2010), p. 54.

2. "For New Beach Hotel," Los Angeles Times, April 2, 2010.

3. "County Seat Notes," Oxnard Daily Courier, April 27, 1917.

4. "County Records," Oxnard Daily Courier, September 26, 1919

5. "County Records," Oxnard Daily Courier, September 21, 1919. "The Pierpont Inn Is Open for Business," Oxnard Daily Courier, September 26, 1919. "Pierpont Manager Seeking Divorce," Oxnard Daily Courier, January 24, 1920.

6. County Records, Oxnard Daily Courier, February 10, 1920.

7. "Ventura May Get New Hotel Soon," Oxnard Press-Courier, February 13, 1920.

8. "Oxnard's Already Losing Out," Oxnard Press-Courier, August 2, 1920. "Incident Shows Need Here of Better Hotel Facilities," Oxnard Press-Courier, August 26, 1920.

9. "Bebe Daniels Spending Vacation at Pierpont Inn," Oxnard Press-Courier, January 12, 1922. "Noted Film Stars Like Oxnard," Oxnard Daily Courier, August 5, 1922.

10. "Winning Courtroom Author Loses Battle With Death," Pampa Daily News, March 15, 1970.

11. "Ojai Hotel Man Buys Ventura Pierpont Inn," Oxnard Daily Courier, May 4, 1921.

12. "$50,000 Improvements to Pierpont Inn," Oxnard Daily Courier, March 14, 1923.

13. "County Records," Oxnard Press-Courier, October 5, 1923.

14. "Will Take Over Inn for County [sic] Club January 1," Oxnard Daily Courier, October 31, 1925.

15. "New Club Opened," Oxnard Daily Courier, April 12, 1926.

16. "Start Construction of Pierpont Plunge," Oxnard Daily News, May 14, 1926.

17. "Pierpont Beach and Country Club Members Must Pay $250 or Drop Out," Oxnard Daily Courier, June 12, 1928.

18. "Pierpont Club Worth Less Than 1st Price," Oxnard Daily Courier, August 8, 1928.

19. "$40,000 Foreclosure Suit Filed Against Pierpont Beach Club," Oxnard Daily News, February 8, 1929.

20. "Fashionable Club Votes to Disband," Los Angeles Times, March 1, 1929. "Foreclosure Mortgage on Club Property," Los Angeles Times, June 28, 1929.

21. "Pierpont Inn Bought by Gus Gleichmann," Oxnard Daily Courier, October 31, 1929.

22. San Buenaventura Research Associates, Historic Resources Report, 6135 N. Rose Avenue Saticoy, CA, July 18, 2011, p. 4.

23. Glenda J. Jackson, Ventura (Arcadia Publishing, 2005), p. 88.

24. City of Ventura Design Review Committee Staff Report prepared by A.K. Munaim, June 10, 2009, p. 2.

25. The year Mattie Gleichmann's house was built can be found at https://www.redfin.com/CA/Ventura/1491-Vista-Del-Mar-Dr-93001/home/4741922. "Building Permits," Oxnard Press-Courier, December 23, 1957. Munaim, June 10, 2009, p. 2.

26. CITATION 70 CAL.2D 282 Pierpont Inn, Inc. v. State of California, Feb. 6, 1969.

27. Ibid.

28. "Manager of the Pierpont Inn Dies," Oxnard Press-Courier, November 25, 1975.

29. David Goldman. "Restaurant Review Pierpont Inn: Unlike Old Days: Ventura's Pierpont Inn used to be a hotel of quality. Now its restaurant looks out across six lanes of howling traffic," Los Angeles Times, February 7, 1991.

30. Leo Smith. "Pierpont Inn Transfer Marks End of an Era, but Not Tradition," Los Angeles Times, November 17, 1998.

31. Munaim, June 10, 2009, p. 2.

32. Stephanie Hoops, "Pierpont Inn is changing hands" Ventura County Star, April 22, 2009.

33. Hoops, "Ventura's Pierpont Inn undergoing change," Ventura County Star, July 11, 2009.

34. Hoops, Lisa McKinnon, "Pierpont Inn owner files for Chapter 11 bankruptcy protection," Ventura County Star, December 12, 2011.

35. Michael Sullivan, "Updated: The Pierpont Inn sold!" Ventura County Reporter, September 13, 2012.

36. Arlene Martinez, "Pierpont Inn in Ventura faces closure if work doesn't advance," Ventura County Star, June 27, 2016

37. Author's interview with Ventura historian Cynthia Thompson, September 30, 2014.

38. Robert and Anne Wlodarski, California Hauntspitality (Whitechapel Productions Press Publications, 2002), p. 199.

39. Ibid. While Wlodarski doesn't discuss specific details, Cynthia Thompson recalls Wlodarski telling the story to the crew of Mysterious Journeys, which then recreated the disappearing pool for their television segment.

40. Ibid., pp. 198-9.

41. "Ventura's Historic Pierpont Inn a Votrex [sic.] for Ghostly Spirits," American Chronicle, October 11, 2007.

42. Wlodarski, p. 197.

43. Ibid., p. 197-8.

44. Ibid., p. 197.

45. Ibid., pp. 197-98.

46. Antoinette May, Haunted Houses of California (Wide World Publishing/Tetra, 2011), p. 192.

47. Kim Lamb Gregory, "Some say friendly apparitions are inhabiting Ventura's Pierpont Inn," Ventura County Star, January 11, 2008.

48. May, p. 192.

49. Wlodarski, p. 198. May, p. 192.

50. Senate, Ghosts of Ventura (DelSol Publications, 2004), p. 57.

51. Wlodarski, p.197.

52. Gregory, Ventura County Star, January 11, 2008.

53. Ibid.

54. Ibid.

55. http://www.historichotels.org/press/the-eerie-archive-great-american-ghosts

56. Wlodarski, p. 198.

57. Gregory, Ventura County Star, January 11, 2008.

58. Ibid.

59. Ibid.

60. Tina Vervoorn, "Ghosts in the Attic Are Hard at Work at Southern California's Pierpont Inn," Consortium Media Services, September 25, 2009.

61. Ibid.

62. Author's interview with a former Pierpont Inn manager, October 2009.

63. Vervoorn, September 25, 2009.

64. Author's interview with Pierpont front desk clerk in 2012.

65. Wlodarski, pp. 198-199. A Pierpont Inn front desk clerk later confirmed in 2012 that guests staying East Wing rooms facing the Vickers Estate complained more about paranormal activity than guests staying in other parts of the East and West Wings.

BANNING HOUSE LODGE

1. Alma Overholt, "The Catalina Isthmus," The Catalina Islander, July 29, 1931.

2. Another version of the story is that he broke his arm near his shoulder. Either injury is possible and in 1542 would have led to gangrene.

3. Harry Kelsey, Sir Francis Drake: The Queen's Pirate (Yale University Press, 2000), pp. 191-92.

4. Samuel Bawlf, The Secret Voyage of Sir Francis Drake: 1577-1580 (Penguin Books, 2004), p. 365.

5. Hubert Howe Bancroft, The Works of Hubert Howe Bancroft: Volume XIX. History of California (1801-1824), Volume II (San Francisco: The History Company, 1886), pp. 33-34.

6. John Boessenecker, Badge and Buckshot: Lawlessness in Old California (University of Oklahoma Press, 2003), p. 136.

7. Letter from Major Henry Hancock to Lieutenant Colonel James F. Curtis, November 26, 1863 in The War of the Rebellion: A Compilation of the Official Records of the Union and Confederate Armies, Series I, Vol. L, In Two Parts. Part II Correspondence, Orders, and Returns Relating to Operations on the Pacific Coast from July 1, 1862, to June 30, 1865 (United States War Dept., 1897), pp. 687-689.

8. "Catalina Island Sold," *Riverside Daily Press*, January 20, 1892.

9. "The Catalina Sale," *Riverside Daily Press*, May 4, 1889.

10. Ibid.

11. Tom Sitton, *Grand Ventures* (Huntington Library Press, 2010), p. 202.

12. "Great Attraction for Catalina Isthmus," *Los Angeles Times*, Apr 12, 1903.

13. Sitton, p. 214.

14. "Chinese Wall to Protect Avalon," *Riverside Daily Press*, August 17, 1907.

15. Sitton, p. 218.

16. "Society's Summering Plans Big with Fine Ideas for Pleasure," *Los Angeles Times*, June 4, 1911.

17. Ibid.

18. Alma Overholt, "The Log," *The Catalina Islander*, May 21, 1930.

19. "Perilous Drive on Island Hills," *Los Angeles Times*, June 25, 1911.

20. "Vote Costs $100," *El Paso Herald*, July 28, 1914.

21. Frederic J. Jaskin, "Answers to Questions," *Heraldo de Brownsville*, September 20, 1939.

22. H. K. Raymenton, "The Venerable Ning Po," *The Journal of San Diego History, San Diego Historical Society Quarterly*, October 1958, Vol. 4, No. 4.

23. Ernest Windle, "South Sea Island Scenes in Winter," [*Catalina Islander*, January 14, 1925.

24. Myrtle Gebhart, "A Letter from Location," *Picture-Play Magazine*, July 1924, p.74.

25. "Fourteen Buffalo Are Free on Catalina Island," *The Catalina Islander*, December 24, 1924.

26. Windle, January 14, 1925.

27. Grace Kingsley, "Stella Goes Locationing," *Los Angeles Times*, October 17, 1926.

28. Inez Wallace, "Inez Wallace Visits Catalina: Storm Holds Up Work on Pauline Starke's New Film," *Cleveland Plain Dealer*, April 17, 1927.

29. Alma Overholt, "The Log," *The Catalina Islander*, May 21, 1930.

30. George W. Lynn, "Catalina Sufficient Unto Itself," *Catalina Islander*, July 15, 1931.

31. "Great Care Used in Filming 'Rain,' Starring Joan," *Seattle Sunday Times*, November 27, 1932.

32. Dan Thomas, "Closeup and Comedy," *Niagara Falls Gazette*, June 21, 1935.

33. Willa Okker, "Hollywood Parade," *San Mateo Times*, September 21, 1935.

34. Jerry MacMullen, "Teredoes, Decay Write Last of Ship's History," *San Diego Union*, January 30, 1938.

35. Frederic J. Jaskin, "Answers to Questions," *Heraldo de Brownsville*, September 20, 1939.

36. John Angus Haig, "A Business Version of the Fuller Life: A Resume of Catalina's Progress," *The Nation's Business*, September, 1938. *Catalina Islander*, September 15, 1938.

37. Haig, op. cit.

38. Duncan Underhill, "Typhoon," *Screen Life*, January, 1940

39. Carolyn Roos Olsen, *Hollywood's Man Who Worried for the Stars: The Story of Bo Roos*, (AuthorHouse, 2008), p. 212.

40. "Isthmus Transformed into South Seas Island Haven," *Los Angeles Times*, July 25, 1941.

41. "Island Will Be Community Enterprise," *Los Angeles Times*, October 25, 1948.

42. Harry Medved, Bruce Akiyama, *Hollywood Escapes: The Movie Goer's Guide to Exploring Southern California's Great Outdoors*. (St. Martin's Griffin, 2006) p. 69.

43. Jack O. Baldwin, "Inn is quiet Island retreat," *Long Beach Independent Press-Telegram*, July 26, 1970.

44. Christopher Goffard, Kate Mather and Richard Winton, "L.A. County coroner changes Natalie Wood's cause of death," *Los Angeles Times*, January 14, 2013.

45. Doug Oudin, "Banning Reunion Celebrated 100 Years," *Catalina Islander*, April 16, 2010.

46. Robert and Anne Wlodarski, *Dinner and Spirits: A Guide to America's Most Haunted Restaurants, Taverns, and Inns*, (iUniverse, 2001) p. 39.

47. Robert and Anne Wlodarski, *California Hauntspitality*, (Whitechapel Productions Press, 2002), p. 32.

48. Robert and Anne Wlodarski, *Haunted Catalina II* (G-Host Publishing, 2011), p. 98.

49. Ibid., p. 99

50. Tom Sitton, pp. 160-161.

51. http://www.ghostpublishingco.com/IPRO.htm [Accessed 11-12-2016]

52. Rich Newman, *The Ghost Hunter's Field Guide: Over 1000 Haunted Places You Can Experience* (Llewellyn Publications, 2011), p. 30.

53. "Shipwreck at Catalina," Los Angeles Herald, November 14, 1890. http://islapedia.com/index.php?title=WILSON,_Charles_A. "Santa Ana Boy Accidentally Shot While Hunting," *Catalina Islander*, October 21, 1931.

54. "Fatal Honeymoon at the Isthmus," *Los Angeles Times*, August 3, 1901.

55. "Mrs. Chester Died of Morphine Poisoning," *Los Angeles Herald*, August 4, 1901.

GLEN TAVERN INN

1. Mary Alice Orcutt Henderson, *Santa Paula: Images of America* (Arcadia Press, 2006), p. 7.

2. James Miller Guinn, *Historical and Biographical Record of Southern California* (Chapman Publishing, 1902), p. 180.

3. Frank Taylor and Earle M. Welty, *The Black Bonanza* (McGraw-Hill Book Company, 1958), p. 38.

4. Horace McPhee, "Santa Paula's Fine Hotel Gets a Big Advertisement," *Santa Paula Chronicle*, March 6, 1919.

5. Marianne Ratcliff, "Santa Paula's 100-year-old Glen Tavern Inn has its own destiny," *Ventura County Star*, September 6, 2011.

6. "Honors O'Neal's Requisition," *Montgomery Advertiser*, September 23, 1911.

7. "Trouble and Scandal," *Santa Paula Chronicle*, April 12, 1912.

8. "H.O. Henderson Sells Santa Paula Hotel," *Oxnard Courier*, April 3, 1914.

9. "Deeds, Mortgages and Contracts," *Oxnard Courier*, June 11, 1915.

10. "Glen Tavern Sold," *Santa Paula Chronicle*, November 22, 1917.

11. Horace McPhee, "Santa Paula's Fine Hotel Gets a Big Advertisement," *Santa Paula Chronicle*, March 6, 1919.

12. "Hotel Is 36 Years of Age," *Santa Paula Chronicle*, August 5, 1948.

13. "Oxnard and Vicinity," *Oxnard Daily Courier*, October 19, 1922.

14. John Nichols, *Images of America: St. Francis Dam Disaster* (Arcadia Publishing, 2002), p. 7.

15. "Looting on Increase in Flood Area," *Morning Olympia*, March 17, 1928.

16. Mary Alice Orcutt Henderson, *Santa Paula (1930-1960)*, (Arcadia Publishing, 2009), p. 9.

17. "Spectacular Fire Menaces Glen Tavern," *Santa Paula Chronicle*, May 23, 1942. "Fire in Hotel," *Santa Paula Chronicle*, November 23, 1942. "Fire at Glen Tavern," *Santa Paula Chronicle*, February 1, 1942.

18. "S.P. Churches Wage Wet War," *Santa Paula Chronicle*, March 14, 1942.

19. "Glen Tavern Offering Fine Home For Hueneme Ladies," *Santa Paula Chronicle*, February 18, 1944.

20. "I Saw…," *Santa Paula Chronicle*, March 31, 1947.

21. "Santa Paula Hotel Is Reported Sold for $60,000 Price," *Los Angeles Times*, May 10, 1953.

22. "Glen Tavern celebrates 70th birthday," *Santa Paula Chronicle*, May 8, 1981.

23. "Glen Tavern's troubles begin again," *Santa Paula Chronicle*, December 4, 1981.

24. *Ibid.*

25. "Glen Tavern to be sold to pay off debts," *Santa Paula Daily Chronicle*, April 21 1983.

26. Kelli A. Jensen, "Glen Tavern owner wants to restore the luster of the past," *Santa Paula Chronicle*, January 18, 1984.

27. "Police Log," *The Santa Paula Chronicle*, April 11, 1986.

28. Ann Stockdill, "Glen Tavern back as full-time hotel," *The Santa Paula Chronicle*, March 17, 1987.

29. Bill Hughes, "Glen Tavern Inn: A Spirited History." *Los Angeles Times*, December 21, 1986.

30. Dave Stone, "Glen Tavern Inn being bought by Japanese college," *San Francisco Public Press*, March 2, 1989.

31. Patrick McCartney, "County Landmark Is on the Rebound: Santa Paula: Repairs are being made on the Glen Tavern Inn. Site will reopen as a school for Japanese students," *Los Angeles Times*, June 19, 1993.

32. Suzie St. John, "Gem of a Hotel Retains Its Luster," *Los Angeles Times*, September 1, 2002.

33. Peggy Kelly, "Historic hotel shut down by city for hazards," *Santa Paula Times*, November 7, 2003.

34. Joshua Molina, "State recognizes Glen Tavern in Santa Paula as historical site," *Ventura County Star*, December 27, 2010.

35. Rita Moran, "Savory new eatery takes up residence at Glen Tavern Inn," *Ventura County Star*, February 12, 2010.

36. Kim Lamb Gregory, "Spirits, ghosts and demons are stars of paranormal convention next week in Santa Paula," *Ventura County Star*, July 15, 2007.

37. Marianne Ratcliff, "Séance scares up ghosts at Glen Tavern," *Santa Paula Daily Chronicle*, October 16, 1986.

38. Ibid.

39. Ibid.

40. Ibid.

41. Shannon Rassmussen, "Santa Paula's Glen Tavern Inn," *Camarillo Daily News*, December 21, 1986.

42. Ratcliff, "Séance scares up ghosts at Glen Tavern."

43. Ibid.

44. Rassmussen, "Santa Paula's Glen Tavern Inn."

45. Bill Hughes, "Glen Tavern Inn: A Spirited History." *Los Angeles Times*, December 21, 1986.

46. Rassmussen, "Santa Paula's Glen Tavern Inn."

47. Hughes, "Glen Tavern Inn: A Spirited History."

48. Rassmussen, "Santa Paula's Glen Tavern Inn."

49. Thia Bell, "Ghost hunters capture image of specter," *Ojai Valley News*, January 28, 1987.

50. Meg Sullivan, "More Changes Haunt Historic Hotel," *Los Angeles Times*, September 29, 1988.

51. Dolores Riccio, *Haunted Houses U.S.A.* (Pocket Books, 1989), p. 12.

52. Ibid.

53. Ibid., p. 11.

54. Marianne Ratcliff, "Did photographer capture Glen Tavern 'ghost'?" *Santa Paula Chronicle*, January 28, 1987.

55. Stephen Craig, "Glen Tavern boasts of live-in ghost," *Fillmore Herald*, February 5, 1987.

56. "Cable television talk show to originate from Glen Tavern," *Santa Paula Chronicle*, April 14, 1987.

57. Marianne Ratcliff, "Psychic predicts population surge for SP," *Santa Paula Chronicle*, October 2, 1987.

58. Richard Senate, *The Haunted Southland*. (Shoreline Press, 1994), p. 65.

59. Ibid., p. 66.

60. Ibid.

61. Hughes, "Glen Tavern Inn: A Spirited History."

62. "Visitors 'roll sevens' at the Tavern," *The Santa Paula Chronicle*, December 30, 1987.

63. "Local Notes," *The Santa Paula Chronicle*, March 17, 1988.

64. Dolores Riccio, *Haunted Houses U.S.A.* (Pocket Books, 1989), p. 12.

65. Meg Sullivan, "More Changes Haunt Historic Hotel," *Los Angeles Times*, September 29, 1988.

66. Ibid.

67. Ibid.

68. Ibid.

69. Senate, *The Haunted Southland*, p.64.

70. Ibid., p. 66.

71. Robert and Anne Wlodarski, *California Hauntspitality* (WhiteChapel Productions Press, 2002), p. 227.

72. Richard Senate, "Ghosts Haunt the Inn," www.ghostvillage. com Accessed on April 2, 2014.

73. Matthew Singer, "To Catch a Ghost," *Ventura County Reporter*, July 26, 2007.

74. "Interview at the Glen Tavern Inn," YouTube, https://www. youtube.com/watch?v=f64i2d3oigU. Accessed October 19, 2014.

75. Matthew Singer, "To Catch a Ghost," *Ventura County Reporter*, July 26, 2007.

76. Ibid.

77. Kim Lamb Gregory, "Ghost Hotel," *Orange County Register*, July 20, 2007

78. Lisa Williams, *The Survival of the Soul*, (Hay House, 2011), pp. 85-6.

79. Ratcliff, "Santa Paula's 100-year-old Glen Tavern Inn has its own destiny."

80. Ibid.

81. Richard Senate, *The Ghosts of Santa Paula* (Richard Senate, 2011).

82. Ibid.

83. Richard Senate, "Ghosts haunt the inn," November 6, 2006. http://www.ghostvillage.com/resources/2006/features_ 11032006.shtml Accessed September 2, 2014.

84. Senate, *The Ghosts of Santa Paula*.

85. Ibid.

86. "Amanda Heacocks Taken By Death," *Santa Paula Chronicle*, March 6, 1941. "Glen Tavern Owner, Ray Bannister, Dies," *Santa Paula Chronicle*, January 18, 1962.

87. "Three Killed, Two Injured In Crash West Santa Paula," *Santa Paula Chronicle*, March 25, 1944. "The History of the Glen Tavern Inn," *Ventura County Star*, September 6, 2011.

88. Kelli A. Jensen, "Metamorphosis," *Santa Paula Daily Chronicle*, February 9, 1984.

ABOUT THE AUTHOR

Craig Owens graduated from Southern Methodist University in Dallas, Texas with a B.F.A. in Communications. He moved to Los Angeles in 1994, and continued his work in film and television production. Among his film credits are *The Gilmore Girls, The Christmas Box,* and *Wag the Dog*. Owens also worked for the Century City Chamber of Commerce, and the International Cinematographers Guild.

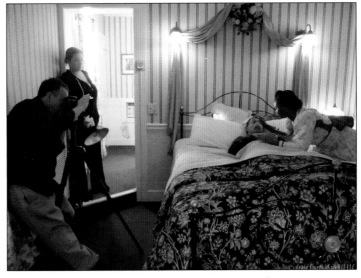

For seven years, Owens has dedicated his talents to research, investigate, and photograph hotels and inns believed to be haunted. His photograph of an apparition at a haunted inn in Temecula led to a featured spot on TV's *My Ghost Story: Caught on Film*. His paranormal research led to a feature story in the online magazine, *The Verge*. As a skeptic, Owens has established a solid reputation in paranormal research for carefully discerning fact from fiction.

In 2010, Owens created the popular Facebook blog, Bizarre Los Angeles, dedicated to L.A.'s forgotten history, especially Old Hollywood. He also has a following on Instagram. Owens lives with his family in Southern California.

www.bizarrela.com